Getting Started in 3D
with 3ds Max

Getting Started in 3D with 3ds Max

Model, Texture, Rig, Animate, and Render in 3ds Max

Ted Boardman

Routledge
Taylor & Francis Group

LONDON AND NEW YORK

First published 2013 by Focal Press

Published 2017 by Routledge
2 Park Square, Milton Park, Abingdon, Oxon OX14 4RN
711 Third Avenue, New York, NY 10017, USA

First issued in hardback 2017

Routledge is an imprint of the Taylor & Francis Group, an informa business

Library of Congress Cataloging in Publication Data
CIP data has been applied for

ISBN 13: 978-1-138-41783-0 (hbk)
ISBN 13: 978-0-240-82395-9 (pbk)

Typeset in Myriad Pro
by diacriTech

Contents

Contents

Contents

Contents

Contents

If you are using 3ds Max Design

Autodesk® offers users two, somewhat different, programs: 3ds Max and 3ds Max Design. The concepts and workflows presented in this book are very useful for both versions of the software. The author has used 3ds Max exclusively for consistency throughout the figures and exercises.

Let's begin this discussion by investigating the differences between 3ds Max and 3ds Max Design.

- **3ds Max:** 3ds Max ships with a set of programming tools called SDK (software developers kit) that allows companies to develop their own commands and routines using C++ programming language. 3ds Max is generally used by gaming companies and the film industry, for example.
- **3ds Max Design:** 3ds Max Design ships with specialized tools (Daylight Simulation) for accurate lighting analysis and an add-on for civil engineers (Civil View). 3ds Max Design is generally used by architects and engineers.

Autodesk® has provided two different versions of the software aimed at specific users, but unless you are taking advantage of the specialized tools in each program, you can comfortably use either one for any industry.

Both the programming language and the lighting analysis tools are beyond the scope of this book, but each versions of the 3ds Max ship with different default tools, interface layout, and a variety of settings.

Although the functionality of the versions is the same, the different interface and settings are confusing for new users of 3ds Max Design. However, Autodesk® has made it easy to switch from one set of defaults and interface to the other and then to switch back again.

If you are using 3ds Max Design, you need to access the Customize pull-down menu and then choose the Custom UI and Defaults Switcher option in the menu (See Figure P-1).

In the Choose Initial Settings for Tool Options and you are Layout dialog, Initial Settings for Tool Options column, highlight *Max.mentalray*. In the UI Schemes column, you can use the *DefaultUI* option. This dialog also provides you with a list of all the interface options and settings that will be changed to the default 3ds Max configuration (see Figure P-2). Left-click the Set button and then restart 3ds Max Design to affect the changes.

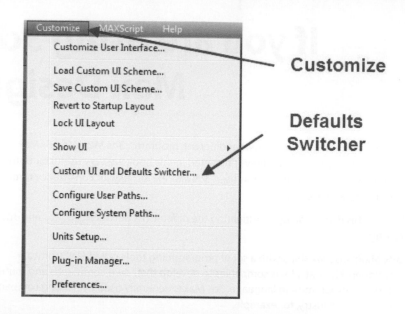

FIG P-1 You can change the user interface and startup defaults for 3ds Max and 3ds Max Design.

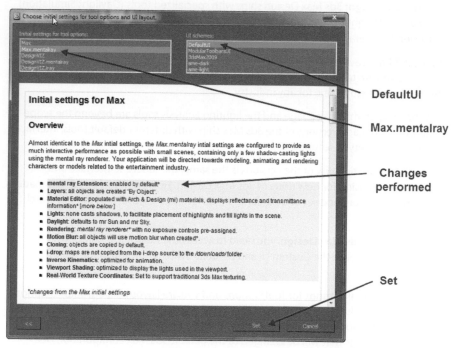

FIG P-2 The interface will now match the images in the book.

When you have finished working with the exercises in this book, you can then repeat the process to choose *DesignVIZ.mentalray* (or one of the other options) to return 3ds Max Design to its default configuration.

These changes are necessary only for users of 3ds Max Design.

Concepts

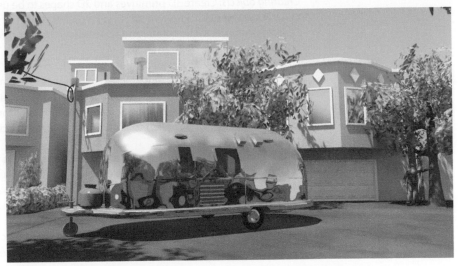

Concepts—image by Ted Boardman.

Concepts in 3ds Max

3ds Max is a "mature" piece of software that has evolved over many years into an extremely powerful and complex program. The original designers of 3ds Max could never have imagined what it would become, but in fact 3ds Max has evolved through constant refinement into the software you are using today.

There are a number of major concepts that are part of the core software that you need to know to be productive and to utilize the available computer hardware efficiently.

You need to learn and understand these concepts to maintain flexibility and efficiency throughout your workflow. For example, you'll learn why it's important not to scale or mirror objects in 3ds Max. The concept is simple and the workarounds are easy, but if you ignore this basic concept, its consequences will plague you throughout your 3ds Max career.

In Part 1—Concepts, you will be introduced to the important fundamental concepts without focusing much on what it is you are creating. Pay close attention to how the concepts fit into the "big picture" of 3D visualization. Once you understand how to take advantage of the fundamental concepts, the process of learning 3ds Max will become easier and more logical. You will understand why certain processes might be better than others in the long run when there are multiple methods of reaching the same goal.

3ds Max training simply walks you through a series of numbered steps to accomplish a task without explaining the concepts behind the approach and the methodology teaches you only to do and not to think. Problem solving is one of the most valuable lessons to be learned in this book. Having a good understanding of the fundamental concepts is essential in a production environment.

Part 1 will include the following topics presented in a form that frees you from getting bogged down into the details of which buttons to push in which order to complete a given task.

- *User Interface*: Learn to locate tools and commands and navigate through 3D scenes.
- *Creating objects*: Create 3D primitives and 2D shapes to be used as the basis for more complex 3D models.
- *Object transforms*: Move, rotate, and scale (safely) objects through space with accuracy and control.
- *Object selection*: Much of your production time is spent selecting objects in scenes, and here you'll learn important fundamental techniques to aid in that selection process.
- *Object cloning*: Proper cloning, or copying, objects can increase flexibility and efficiency.
- *2D Shapes*: Learn to create shapes that are used as a basis for 3D modeling.
- *Modifiers*: Modifiers are applied to 2D or 3D objects to provide complex editing and creation.
- *Lofting*: Lofting is a powerful modeling technique that offers flexibility and efficiency.
- *Lighting*: Learn the fundamentals of placing and adjusting lights in your scene.
- *Materials*: Enhance the surface of objects by learning to create and apply basic materials.
- *Mapping Coordinates*: Adjust the size and position of patterns used in materials to provide convincing results.
- *Camera basics*: Learn to place and adjust cameras in 3ds Max.
- *Rendering basics*: Render scenes and adjust parameters to create images for your clients.

Again, the purpose of the Part 1 chapters of this book is to provide you with a platform of knowledge about how to take advantage of the design and workflow of 3ds Max to help you make better choices for creating your 3D scenes quickly and efficiently. Other training and tutorials will make much more sense when you know why you are choosing one method over another rather than just learning to push a set number of buttons to reach an end result. You will learn to think about what you're doing.

] [Orthographic] [Wireframe]

User Interface

Much of your 3ds Max career will be spent navigating the user interface. It's important that you learn the layout and structure of the user interface to efficiently perform steps like finding commands, moving through 3D space in viewports, or animating objects just to name a few.

The software designers are constantly trying to make 3ds Max easier to use by redesigning the user interface, but in such a complex program, there will always seem to be cumbersome command sequences, hidden menus, and confusing workflow. You, the user, need to familiarize yourself with as much of the user interface as possible and adapt a workflow based on your preferences for navigating 3ds Max. No two users will use the same navigation techniques; there are many cases where commands can be accessed from several locations and might even perform a bit differently depending on the access method you choose.

Although trying to memorize all the buttons and options in the 3ds Max user interface is not a productive use of your time, this chapter will introduce you to the fundamentals of the default layout, some of the most commonly accessed menu options, and some of the navigation tools that may not be readily obvious to the new 3ds Max user.

The information presented here will be broken down into several sections that introduce you to the main areas and options, such as:

- *User interface overview*
- *Viewport display types*

3

Note

Many commands and processes in 3ds Max have preassigned keyboard shortcuts that allow you to choose options buried deep in the menu system with a few simple keystrokes. You can also customize the user interface to add your own keyboard shortcuts. In this book, you will learn a few of the more commonly used keyboard shortcuts, but the author feels that it is important for new 3ds Max users to understand the structure of the menus and the proper sequence of processes first before using a lot of shortcuts. In this way, you'll develop an overall feel for the software to utilize it productively.

As you learn the 3ds Max user interface, you can then begin to employ the keyboard shortcuts to increase your productivity.

- *UI (user interface) navigation*
- *Viewport navigation*
- *File management*

Once you have familiarized yourself with layout and navigation capabilities in the 3ds Max user interface, the best thing to do is to start work immediately and investigate and experiment to "learn by doing." Although many things might be confusing at first, it only takes a little bit of practice and experience before you are comfortable navigating through your daily workflow.

1.1 User Interface Overview

At first, 3ds Max can be overwhelming as you look at all the options and controls of the user interface and realize that there appear to be many more hidden below the surface. Again, by approaching the user interface systematically and then practicing a bit you'll find yourself working smoothly and efficiently without thinking about it.

Figure 1-1 shows an image of the default 3ds Max user interface as it appears when you first install the program.

Note

There may be some variations between the user interface figures shown here and exactly what you see on your display due to variations in the Windows version and various Windows options that you have set on your computer. The variations will not affect the functionality of the 3ds Max interface.

Viewports

Let's highlight a few of the important main features of the 3ds Max user interface beginning with the most noticeable feature; the viewports. Figure 1-2 shows the default viewports highlighted in light yellow as being four equally sized panes filling most of the user interface. These viewports are where you create your 3D geometry scenes. This section is only for familiarization – you'll learn more details as you progress through the chapters.

FIG 1-1 The default 3ds Max user interface

FIG 1-2 3ds Max default viewports highlighted in yellow

Figure 1-3 shows the default Perspective viewport. In the upper left corner of each viewport are the viewport labels. At the upper right corner of each viewport is a ViewCube used as a navigation tool within the viewport, and at the lower left of each viewport is a red, green, and blue "tripod" indicating the positive axes direction of the World Coordinate System. The lower right viewport pane has a yellow border indicating that it is currently the active viewport. The grid shown in the viewport represents the current work plane.

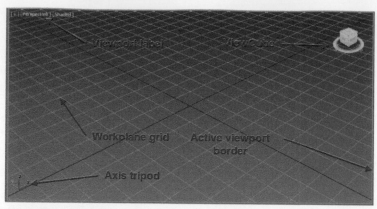

FIG 1-3 Default Perspective viewport elements

Application Button

At the upper left corner of the entire 3ds Max display, you'll see a green button with the 3ds Max logo. This button is called the Application button. Clicking the Application button displays a window with file commands and some management tools in the left column and a list of recent documents in the right column. Items in the left column which have a black arrow to the right of the command name will open a second menu in the right column where you can choose subsets of the command, or other options when you hover the mouse cursor over the command (see **Figure 1-4**).

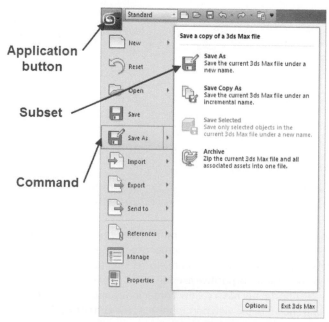

FIG 1-4 Application button showing some options

Pull-down Menus

To the right of the application button are other pull-down menus such as Edit and Tools.
Left-clicking a pull-down menu will open a submenu with appropriate tools for that
category. See Figure 1-5 for the Edit pull-down menu options. Down the right side of the
submenu, you will see the keyboard shortcut for that command (when a shortcut has been
assigned) or sometimes a black triangle indicating a second submenu level.

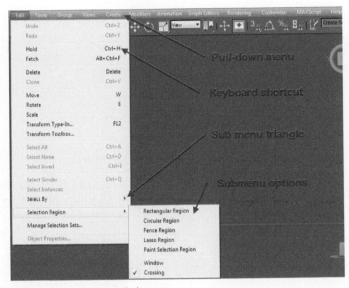

FIG 1-5 Default pull-down menus with menus and sub menus

Main Toolbar

Just below the pull-down menus is the main toolbar containing buttons for a number of
commonly used tools and several drop-down lists that contain a list of options. Some of the
buttons have a small triangle at the lower right corner indicating the availability of "flyout"
buttons that can be accessed by left-clicking and holding down the button. See Figure 1-6 to
see the buttons and a drop-down list in the main toolbar.

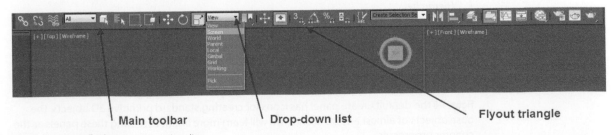

Main toolbar Drop-down list Flyout triangle

FIG 1.6 The main toolbar buttons and drop-down lists

Ribbon Menu

The Ribbon menu is a "strip" of commands grouped according to types of workflows. The Ribbon contains many commonly used tools that are otherwise available only deep in the menu structure. The submenus can be accessed by hovering the mouse cursor over the command option you want to use. In **Figure 1-7**, you'll see the Selection commands for the Graphite Tools ribbon menu. Most of the options are grayed out because there are no appropriate objects selected in the scene.

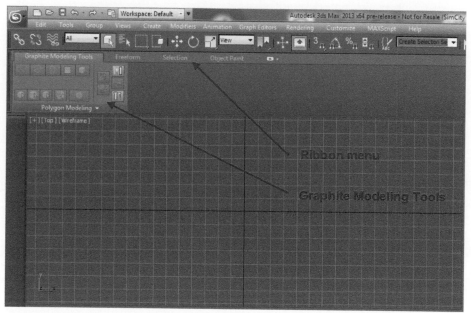

FIG 1.7 The ribbon menu runs horizontally below the main toolbar

Command Panel

At the far right side of the display is the command panel containing many of the commands that you'll use on a daily basis during production. The different command panels can be accessed by clicking one of the six icons along the top row from left to right:

- *Create*
- *Modify*
- *Hierarchy*
- *Motion*
- *Display*
- *Utilities*

The Create panel is the default panel, and the only panel to have a second row of icons representing creation categories such as Geometry, Shapes, and Lights. As you can see in **Figure 1-8** the default Create panel has icons for creating standard primitive 3D objects, the base objects of almost any 3D scene. You will learn more about accessing these panels as the chapter progresses.

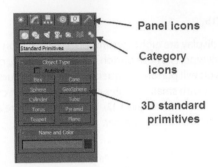

Panel icons

Category
icons

3D standard
primitives

Timeline

A couple of elements running horizontally along the bottom of the viewports make up the timeline in 3ds Max; there is a frame slider button with 0/100 printed on it, and there is a ruler line with tick marks 0 through 100. Several buttons to the right and below the timeline allow you to create animation keys defining the keyframes of your animation (see **Figure 1-9**).

Frame slider Timeline Keyframe buttons

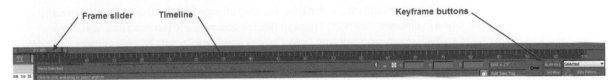

FIG 1-9 The Timeline and its controls are used to create animation

Status Line

Just below the timeline, we have the MAXScript listener window and status lines that contain information relevant to the current functions you are performing in 3ds Max, as well as a couple of useful tool buttons and coordinate numeric fields (see **Figure 1-10**). For new 3ds Max users, it is useful to glance at the status line to see if there are any prompts or information that might be helpful to your current work.

Listener window Status lines Tool buttons Coordinate
 numeric fields

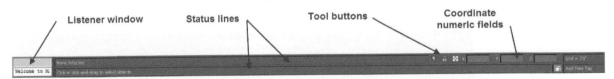

FIG 1-10 The Status line provides information and prompting as you work

Animation Playback

The next group of buttons to the right of the status line control animation playback in scenes with animation. The controls are relatively standard controls that you would be familiar with from real-life playback equipment such as DVD players (see **Figure 1-11**).

Animation
playback

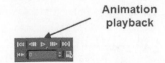

FIG 1-11 Playback buttons for animated scenes.

Navigation Buttons

At the lower right of the display are eight very important navigation buttons that are used to navigate your way in viewports. These buttons control zooming, panning, and rotating your scenes, operations you will perform frequently during the course of your work. As you learned earlier, the buttons with small triangles at their lower right corners have flyouts with variations on the command (see **Figure 1-12**). You will learn more about how to use these buttons to navigate a scene later in the chapter.

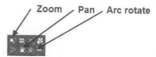

FIG 1-12 The Navigation buttons allow you to move around in your 3D scene.

Note

The navigation buttons are dynamic, i.e., they change form but have similar functions when in different viewports For example, the zooming and panning functions for a Perspective viewport become Dolly Camera and Truck Camera when a Camera viewport is active. This can be a bit confusing to the new user of 3ds Max. It can help to know that the navigation tools change just your view of the scene, not the objects in it, so you can play with them all you like without concern for losing work or damaging your scene.

Quad Menus

By default quad menus do not show up in the 3ds Max display but must be activated by right-clicking in a viewport. Quad menus are also dynamic and context-sensitive, i.e., they will adapt themselves to the current command and according to the location where the cursor is positioned when right-clicking. See **Figure 1-13** for the Quad menu that appears when you right-click in the active perspective viewport.

FIG 1-13 An example of a Quad menu called by right-clicking in the viewport.

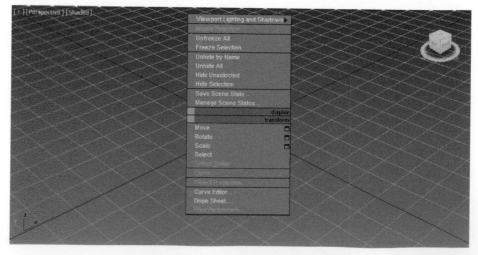

Take some time to familiarize yourself with the overall elements of the 3ds Max user interface and practice a bit with expanding drop-down lists and flyout buttons. Before you know, the actions will seem natural without requiring you to think about them. Also keep in mind that navigating the user interface takes up a lot of your day-to-day workflow and must be performed quickly and efficiently. Later in the chapter, you'll gain some hands-on experience with a few important aspects of the user interface.

1.2 Viewport Display Types

You have learned that the default 3ds Max user interface has four equally sized viewports labeled, from upper left clockwise, as Top, Front, Perspective, and Left. There are other viewports that can increase productivity by allowing you to view your scenes from a more appropriate angle or through a camera or light, for example. In this section, you'll learn how to switch from one viewport type to another and learn about orthographic and nonorthographic viewports.

Viewport Labels

The viewport labels at the upper left corner of each viewport are not simply textual information but can be used to open menus with viewport commands or options. Let's look at a couple of examples in the Perspective viewport to see some of the available options.

By left-clicking on the [+] symbol at the left of the perspective viewport label, you will open a menu that allows you to change various aspects of the viewport; for example, changing the options in the ViewCube from a submenus you see in **Figure 1-14**.

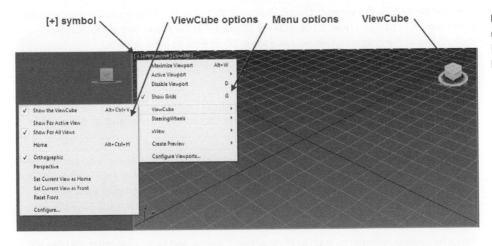

FIG 1-14 An example of menu options when left-clicking the [+] symbol in the viewport label

A different set of menus is accessed by left-clicking the viewport name, in this example Perspective, where you can change the type of viewport to the top, bottom, left, or right viewing directions, or change to a camera or a light view (if there are cameras and directional lights in the scene). As with other menus, some options have black triangles representing submenus and others have predefined keyboard shortcuts indicated on the right side of the menu (see **Figure 1-15**). Switching from Perspective to Front viewport viewing

directions does not affect the scene itself, but simply changes the direction from which you view it in that active viewport. It would be possible to have four Top viewports each at different zoom levels, for example.

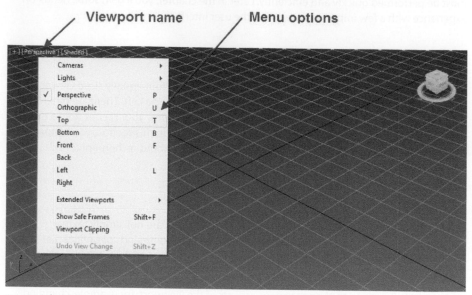

FIG 1-15 Left-click the viewport name in the current active viewport to change the viewport type

The next element in the viewport label, Shaded in this case, provides you with options when left-clicked for changing how 3D objects are displayed in the scene. We will look at this option later in the chapter when we have some 3D objects to work with.

Orthographic Viewports

Viewports are classified as either orthographic or nonorthographic to clarify how 3D objects are displayed in two dimensions. After all, the computer monitor is flat and, at this point in time, does not usually simulate 3D space.

In orthographic viewports objects are seen in parallel projection, i.e., there is no perspective where object's edges appear to converge or diverge. The typical orthographic viewports are Top, Bottom, Left, Right, Back, and Front. You can also have an Orthographic view with an axonometric projection, where the objects are viewed from an angle but still have parallel edges.

Nonorthographic viewports, such as Perspective, Camera, and Light viewports, display 3D objects with nonparallel edges to provide a more realistic view of a 3D scene. You can easily toggle back and forth between Orthographic and Perspective viewports by using the U and P keyboard shortcuts in a 3ds Max scene that contains a box, for example.

Although these facts may seem like unnecessary detail at this point in your learning about 3ds Max, the differences between orthographic and nonorthographic viewports will become important when learning about Reference Coordinate Systems in Chapter 6.

1.3 UI Navigation

Now that you have an overview of the 3ds Max user interface and some detail about viewports, let's learn about navigation using some of the features such as

- *Tooltips*
- *Flyouts*
- *Drop-down lists*
- *Rollouts*
- *Panning in panels*

It will be easier for you to learn user interface navigation with an actual 3ds Max scene, so you will start 3ds Max and load a simple scene to use in the upcoming exercises.

Exercise 1-3-1 Starting 3ds Max

1. Double-click the 3ds Max icon on your Windows desktop to launch 3ds Max. If this is the first time you have opened 3ds Max you will be presented with a "Welcome to 3ds Max" dialog that contains links to some essential skills movies in the left column and commands for starting a new scene or opening existing scenes.
2. Let's disable the welcome screen, so it doesn't pop up every time we start 3ds Max. Clear the "Show this Welcome Screen at Startup" checkbox in the lower left corner and then click the Close button at the lower right corner of the dialog (see Figure 1-16). This step will just save us a little time when we open 3ds Max. The information the welcome dialog contains can be accessed at any time through other menus.

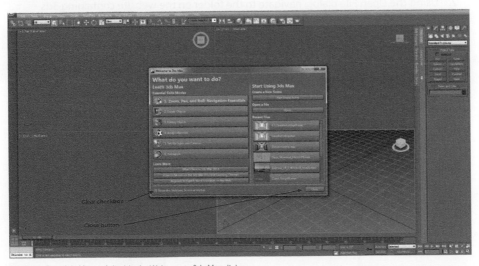

FIG 1-16 Start 3ds Max and disable the Welcome to 3ds Max dialog

3ds Max is now opened in its default state. At this point, you should take a few minutes to review some of the topics covered previously in this chapter, so you become familiar with the layout of the default display.

Exercise 1-3-2 Opening an Existing 3ds Max File

1. Click the Application button at the upper left of the display (green 3ds Max icon) and hover your mouse over Open in the left column to show a new menu with two choices. Click the Open option in the right column (see **Figure 1-17**) to open an existing file from the website associated with the book.

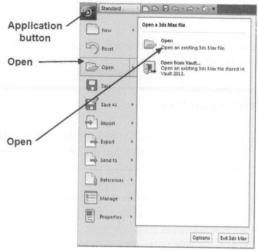

FIG 1-17 Use the Application button to open an existing file

2. Using the Open File dialog, navigate to the folder on the website containing 3ds Max files for Chapter 1 and then double-click on a file called 1-3-2_ElevatorLobby01. max to open it. **Figure 1-18** shows an example of the Open File dialog, although the path structure will be different. Click on the Application button and click the Save As option and save the file to your "My Documents/3ds Max/Scenes" folder with a new name 1-3-2_ElevatorLobbyTestUI.max. You'll be using the original elevator lobby file later on and saving the file in this way will prevent you from saving over it with any changes you may make during the user interface lessons.

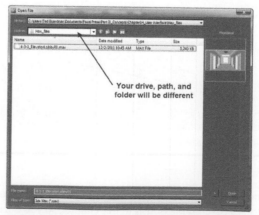

FIG 1-18 Navigate to the 3ds Max file with the Open File dialog and open the file

This simple scene of an elevator lobby with an overhead light fixture and two ashtrays will help make sense of some of the user interface navigation tools that you'll learn about in upcoming exercises. Let's first learn about a few of the common user interface elements that you'll encounter in your day-to-day work.

Exercise 1-3-3 Common User Interface Elements

1. Move your mouse cursor slowly over the buttons in the main toolbar, and you'll see that a tooltip appears with the name of the tool directly under the cursor, for example, the Select and Move button (see Figure 1-19). It is extremely helpful to know the correct names for tools because if you need to look up a command in the Help files, it is necessary for you to search for the proper name. As you become more comfortable with the user interface in 3ds Max you'll be able to ignore the tooltips.

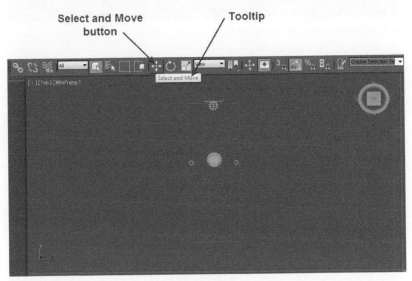

FIG 1-19 Tooltips will appear when you hover the cursor over a button

2. As mentioned earlier, some buttons have a small black triangle at the lower right corner indicating "flyouts" or buttons containing other similar commands. You access the flyouts by left-clicking on the button and holding until the flyouts appear. You can then move the mouse cursor to the appropriate new command button and release to select it. In the main toolbar left-click and hold on the Rectangular Selection Region button to reveal other selection options (see Figure 1-20). Notice that if you select another button inside the flyout, this button will now be on the main toolbar for this working session of 3ds Max.

3. In the main toolbar, you will notice several drop-down lists. Left-click on the View drop-down list at the left center of the main toolbar to view a drop-down list of available Reference Coordinate System options (see Figure 1-21). You can then move your cursor over the list and click the option you want.

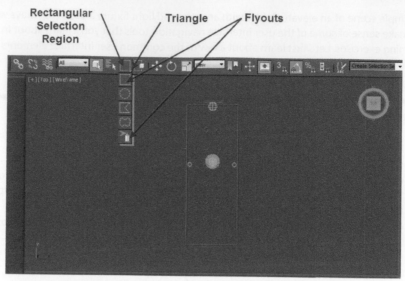

FIG 1-20 Flyouts appear when you left-click and hold on a button with a triangle in the lower right corner

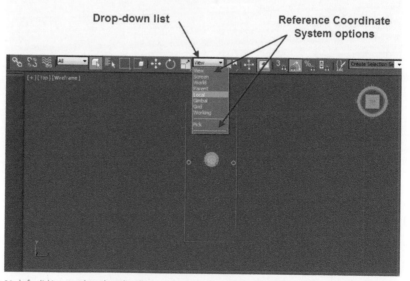

FIG 1-21 Left-clicking on a drop-down list allows you to choose from a menu of options

4. Let's have a look at some of the navigation options in the command panels to the right side of your display. Begin by left-clicking the Select Object button in the main toolbar and then by left-clicking on the elevator lobby in the Top viewport (see **Figure 1-22**). You have just selected the elevator object (you can see how the object is now drawn in white in the Top viewport). You will now move to the command panels to learn more navigation options, and having an object selected in the scene will make it easier to expand the panels.

Select
Object

Elevator_lobby01

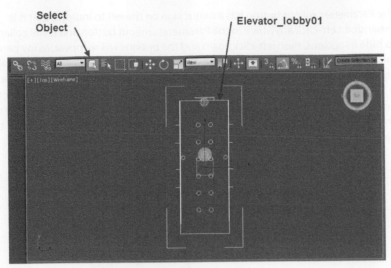

FIG 1-22 Select the Elevator_lobby01 object in the Top viewport

5. Left-click on the Modify command panel button to reveal the expanded command panel. The name of the selected object appears below the command panel buttons followed by a drop-down Modifier List, a Stack view, a rollout of modifier control buttons. The rest of the panel is occupied by the Parameters rollout (**see Figure 1-23**). For now, you'll focus on the functionality of the rollouts and some of the options found in those rollouts.

Command
panel buttons

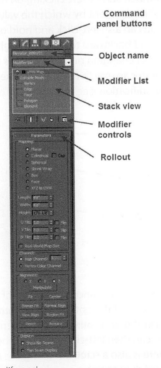

Object name

Modifier List

Stack view

Modifier
controls

Rollout

FIG 1-23 The major elements in the Modify panel

6. The Parameters rollout button has a minus sign on the left to indicate that it is expanded. Left-click anywhere in the Parameters rollout button and it will collapse to hide its options, then left-click again and the options will reappear. Many panels in 3ds Max have many rollouts, and the ability to expand and collapse rollouts allows you to view more or fewer options. In the Mapping area of the Parameters rollout is a list of "radio buttons," with the Planar radio button on by default. If you click the empty dot to the left of one of the other options in the list you will see that the new choice is activated while the Planar option is turned off. This behavior is similar to old-style car radios (see Figure 1-24).

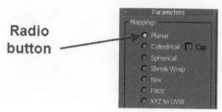

FIG 1-24 Only one radio button can be on in a list

7. In the Modify command panel are numeric fields, spinners, and checkboxes, which are all very common in the 3ds Max user interface. The use of checkboxes should be self-explanatory; check it to turn the option on or clear the checkbox to turn the option off. Spinners, which consist of two up-down arrows, are user interface elements for changing values in numeric fields. By left-clicking on the up arrow you can increment the number, and by left-clicking on the down arrow you can decrement the number. The increment by which the value is increased or decreased is preset in Preferences. You can also left-click and hold on the spinner buttons and move the mouse forward and backward to scroll through numeric values. However, the most accurate method of changing numeric fields is to highlight the number in the field with the cursor, enter an exact value with the keyboard, and then press the Enter key to finalize the modification (see Figure 1-25).

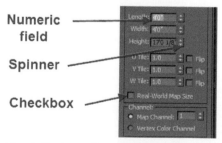

FIG 1-25 Numeric fields can be adjusted with spinners or by entering numeric values

8. Depending on your screen resolution and the amount of information in the panel, you might not be able to see all of the options in the command panel. You can pan the panel up or down by positioning your cursor in an empty area of the panel changing it to a hand: you can then left-click and hold the mouse button, and slide the panel up or down. There is also a scroll bar along the right edge of the panel, which you can left-click and drag to pan up or down (see Figure 1-26).

Pan hand

Scroll bar

FIG 1-26 The scrollbar on the right side can also be used to navigate up or down in the panels

Note

If you're working on a high-resolution screen, all of the options in the Modify panel might be displayed, and you won't be able to (or need to) pan rollouts on panels. If you want to try out panning on rollouts, you can simulate a lower resolution monitor by reducing the size of the 3ds Max display area until some of the Modify panel options aren't visible.

Take the time to practice navigating the user interface. Try the elements you have learned about and you will soon find yourself navigating 3ds Max without having to think about how things function.

1.4 Viewport Navigation

The next area of 3ds Max navigation you will investigate is the viewports. Your ability to automatically navigate scenes in the viewports will greatly affect your day-to-day production. It will seem as if there are a lot of options, but again, with time they'll become natural processes that you won't have to think about. Some of the topics you'll learn about in the next exercises are

- *Activating viewports*
- *Navigation buttons*
- *Resizing and resetting*
- *Maximizing and minimizing*
- *Isolate Selection*

Let's begin by looking at how to activate viewports in a nondestructive manner, so that you can avoid accidentally transforming (moving or rotating) objects when switching from one viewport to another. We'll then have a look at some of the navigation buttons and practice navigating in the elevator lobby scene. You'll also learn how to resize viewports to make it easier to work in the scene.

Exercise 1-4-1 Working in Viewports

1. You should still have the elevator lobby scene open. One viewport is always active; you can tell which one by the heavy yellow border around the viewport. Activate the lower right Camera01 viewport by positioning the cursor in the viewport and right-clicking. If the Camera01 viewport is already the active viewport you'll get a Quad menu which you can dismiss by right-clicking again.

2. Right-click in the Top viewport to activate it, and then work your way around the other viewports, activating each one before returning back to the Camera01 viewport as the active viewport. While it is possible to activate a viewport by left-clicking in it, doing so can be dangerous, as left-clicking is also the way you tell 3ds Max to perform the currently active command. You might be in a command that will move or rotate an object inadvertently without noticing that you have done so. Always right-click to activate viewports! Another important aspect of right-clicking to activate a viewport is that by doing so you don't lose your current object selection.

3. At the lower right corner of the 3ds Max interface are the navigation buttons. These buttons are dynamic and can change depending on the type of viewport that is currently active. Because you have the Camera01 viewport active, the buttons represent navigation tools for that type of viewport, using terminology and behavior common to a real-life camera (see **Figure 1-27**). Move the mouse cursor slowly over the buttons to see the tooltips. Right-click in the Top viewport to activate it, and you will see that the buttons have changed again. Review the tooltips for these buttons (see **Figure 1-28**). The actions the buttons perform for the Top viewport are similar, but more closely reflect terminology and behavior of navigating an orthographic viewport rather than a camera viewport.

Camera navigation

FIG 1-27 Camera viewport navigation buttons

Orthographic navigation

FIG 1-28 Orthographic viewport navigation buttons

4. With the Top viewport still activated, left-click the Zoom button at the upper left of the eight navigation buttons, and then left-click anywhere in the Top viewport when you see the new zoom cursor. Dragging the cursor upwards in the viewport will zoom in and dragging the cursor downward will zoom out (see **Figure 1-29**). Notice that you are only zooming in the currently active viewport.

FIG 1-29 Dragging the zoom cursor zooms in or out of the viewport

5. Left-click on the second button in the top row called Zoom All (see **Figure 1-30**) and repeat the zooming process in the Top viewport when you see the new cursor. This navigation option allows you to zoom all viewports (except the Camera01 viewport) simultaneously. Single viewport zooming can also be accomplished by spinning the middle mouse wheel with the cursor in the active viewport. This zooming method, however, causes zooming to occur in incremental steps rather than smooth continuous motion of the previous method.

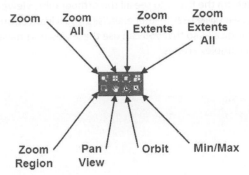

FIG 1-30 Orthographic viewport navigation buttons

6. You can pan in a viewport by clicking the Pan View button (second from left, bottom row), and then left-clicking and dragging the cursor in the viewport. Panning is also done by pressing down on the middle mouse wheel until you see the hand cursor, and then moving the mouse around. It is also possible to drag the cursor off the edge of the display for panning over large scenes.
7. With the Top viewport still activated, click the Zoom Extents button (third from left, top row) and the Top viewport will be filled with the entire scene. Click the Zoom Extents All button on the far right of the top row and all but the Camera01 viewports will be filled with the entire scene.
8. At the lower left of the navigation buttons is the Zoom Region button. If you left-click on it and then drag a region window in the Top viewport you will zoom in on that region (see **Figure 1-31**). The region window you describe in the viewport may be a different aspect ratio than the viewport itself, and the region will fit as best it can.

FIG 1-31 Drag a zoom region in the viewport and zoom to a best fit

9. Click the Zoom Extents All button to fill all orthographic viewports with the entire scene. Notice that some of the buttons have a small triangle at the lower right corner indicating flyouts. In the main toolbar, click the Select Object button, and then in the Top viewport, click on one of the green ashtrays in the scene to select it. Left-click and hold the Zoom Extents button and choose the second flyout (a green cube); click Zoom Extents Selected to see the viewport filled with the selected object only. Click and hold on the Zoom Extents All button and choose the Zoom Extents All Selected button from the flyout to see all the orthographic viewports filled with the selected object (see **Figure 1-32**). In later exercises, you'll learn about the importance of naming objects logically, so that you can use these viewport navigation tools to find objects easily in complex scenes.

FIG 1-32 Zoom in easily on selected objects

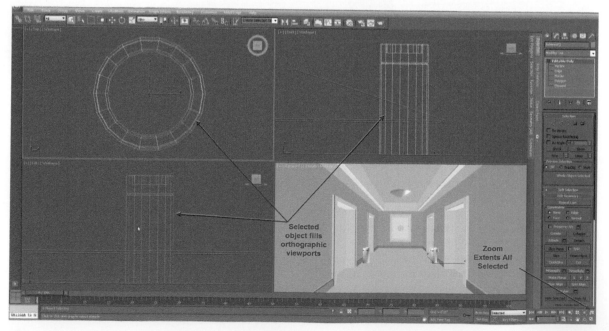

10. In the Top viewport, use the Zoom Extents All flyout to fill all orthographic viewports with the entire scene. Click the Orbit button buttons (third from left, bottom row) and you will see a yellow circle with squares appear in the top (active) viewport. Move your cursor outside the circle, inside the circle, and over each box to see that the cursor changes to indicate how the orbit will occur when you left-click and hold the mouse button (see **Figure 1-33**). Experiment with orbiting around the objects in your scene. If you get "lost in space" press the letter T on the keyboard to return to the Top view and start the orbiting again. You can also orbit by pressing and holding the Alt key on the keyboard, pressing down on the middle mouse wheel, and then moving the mouse around. Another option is to use the ViewCube at the upper right corner of each viewport. Experiment with clicking on the ViewCube for orbiting the viewport.

Note

The ViewCube is not often used in production because it takes up too much screen space; other methods of navigating viewports such as the keyboard shortcuts for Zoom, Rotate, etc. are much more efficient.

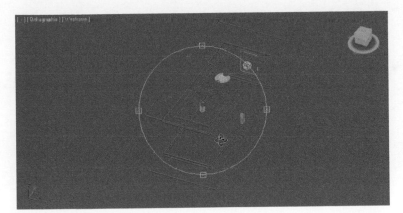

FIG 1-33 You can orbit around the scene in different ways

11. With the Top view active, click the Min/Max Toggle button at the lower right corner of the navigation buttons. This maximizes the active viewport to full-screen and pressing the Min/Max Toggle button again returns to the four viewport layout. The default keyboard shortcut for Min/Max Toggle is to hold the Alt key and then press W (Alt + W).

There are a few other useful features in 3ds Max that can be used to make working with viewports easier and more efficient. In the next exercise, you will investigate a couple of these features.

Exercise 1-4-2 Other Viewport Tools

1. If you move your cursor to the boundary between viewports, it will change shape to become horizontal, vertical, or a four-way arrow cursor at the intersection of the four viewports. By clicking and dragging when you see this cursor you can interactively resize viewports (see Figure 1-34). You can then reset the viewports back to the default configuration by positioning the cursor at the intersection of the four viewports, right-clicking, and choosing Reset Layout (see Figure 1-35).

FIG 1-34 Resize the viewports dynamically

2. Scenes can become extremely complex with many, many 3D objects making it difficult to work on single objects or small selection sets. There is a viewport navigation tool called Isolate Selection that is very useful. In the Top viewport, select one of the green ashtrays again. In the status bar at the bottom of the display, click the Isolate Selection button to toggle it on. All objects except the selected object are hidden from view and 3ds Max attempts to perform a Zoom Extents All so that you can now easily work on the object or objects you have selected (see Figure 1-36). You can return the scene to normal by toggling the Isolate Selection button off again or you can use the keyboard shortcut Alt+Q to toggle it on and off.

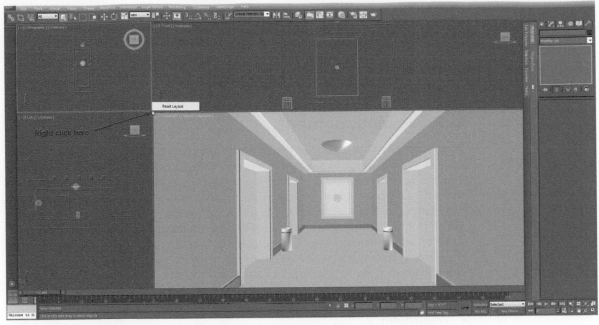

FIG 1-35 Reset Layout can be accessed by right-clicking at the intersection of the viewports

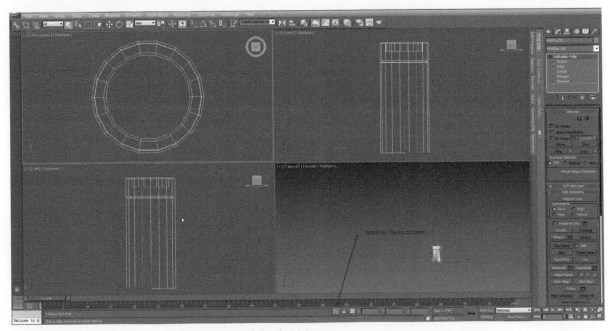

FIG 1-36 Isolate Selection toggle fills the orthographic viewports with the selected objects

Armed with the information in this section you should now be able to comfortably navigate and manipulate the viewports, and with just a little bit of hands-on practice all these commands will come naturally to you. Viewport navigation is an important part of your workday, and you must be comfortable with all these options as they will help increase your productivity.

1.5 File Management

Working on a 3ds Max project will involve not only the actual 3ds max file but also several other files such as image files, reference files, light definition files, audio files, motion capture files, and just to name a few. Organizing your project files so that you have immediate access to them is an important factor in your productivity. If you are working with a team, the importance of properly organized files becomes even greater. You need to have a central location for storing files and a common naming scheme that everyone on the team is aware of. Setting up a proper folder structure and file naming convention is all part of the pre-planning process. What you'll learn in this section is where to find the necessary tools and commands in the 3ds Max user interface to accomplish the task. You'll learn about things like:

- *Project folders*
- *File operations*
- *Backup files*
- *Safe working procedures*

Good housekeeping habits will increase your daily productivity, make it easier to transfer files from one computer to another, and keep track of editing history in case you need to go back to previous versions of files.

Let's look first at the concept of project folders in 3ds Max. A project folder is not just a single folder with the project name but includes a subset of folders that are automatically created to store important files for that particular project. This folder structure makes it easier to track and archive all of the files related to that one project. Here's how you set up project folders in 3ds Max.

Exercise 1-5-1 Project Folders

1. Start a new session of 3ds Max. Click the Application button and hover the mouse cursor over the Manage option. In the right pane click on the Set Project Folder option (see **Figure 1-37**). This will bring up the Browse For Folder dialog.
2. In the Browse For Folder dialog, navigate to the drive or folder where you want your projects stored (in this case My Documents), and then click the Make New Folder button. Rename the new folder with your project folder name (for example, *3ds Max Test Project*) (see **Figure 1-38**). Click the OK button to finish the process.

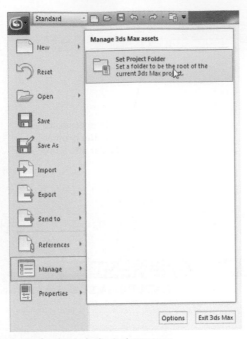

FIG 1-37 Common file operations are found in the Application button menu

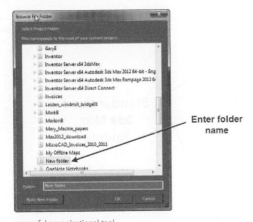

Enter folder name

FIG 1-38 Project folders are a powerful organizational tool

3. Click the Application button and then choose Save As in the left pane. You will see in the Save File As dialog that the automatically created Scene folder under your project folder has been chosen as the location to save files for this project (see **Figure 1-39**).

4. Using the Windows file Explorer, you can expand the new project folder to see the specific 3ds Max folders that have been created for you to store appropriate files in a standardized 3ds Max folder structure (see **Figure 1-40**).

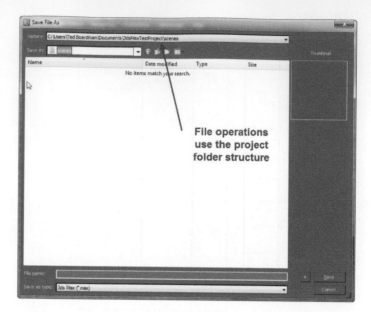

FIG 1-39 All 3ds Max files will now be saved to the project folders

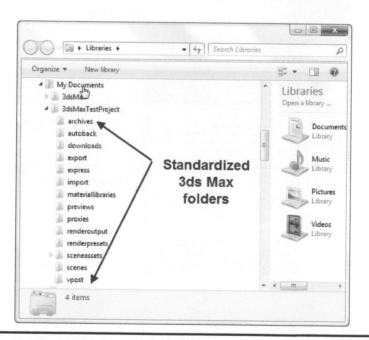

FIG 1-40 Standardized 3ds Max folders created for new projects

Creating and utilizing project folders in 3ds Max is not mandatory but will help ensure that files and assets are well organized and can be efficiently accessed by everyone on the team.

Now let's take a look at some of the file operations, such as

- *Save*
- *Save As*

- *Incremental files*
- *Save Selected*

Exercise 1-5-2 File Operations

1. You should still have 3ds Max open to a new empty file and a new project folder structure. Click the Application button and choose Save As in the left column, enter the file name Test01 in the Save File As dialog (see **Figure 1-41**) and then press the Save button. Once the file has been saved to disk, you can use the Save option to overwrite the file with new changes. The keyboard shortcut to save a file and overwrite the old file with the same name is Ctrl+S.

Note

Pressing the Ctrl-S keyboard shortcut to save files regularly while you are working is a good habit to get into, especially during the early development of scenes before the files get particularly large.

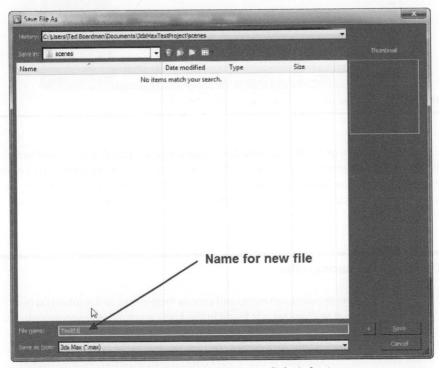

FIG 1-41 *Save As* allows you to save an existing with a new name or save a file for the first time

2. Click the Application button and click Save As in the menu. Now you should see the file called Test01.max that you saved earlier. In the Save File As dialog, at the lower right, you'll see a button with a + that can be used to save incremental files,

i.e., files with the name incremented by one with each new save action. Click on the + button and then opened the Save As command again to see that you now have a new file called Test02.max (see **Figure 1-42**). This is a great method for keeping a series of files saved at different stages so that you can fall back to a previous scene state if necessary.

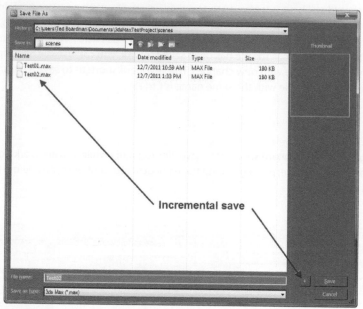

FIG 1-42 The + button saves an existing file with a numerically incremented name

Another safety feature of 3ds Max automatically creates backup files that are stored in a special folder within your current project folder structure. In cases of unexpected problems like power failures or system crashes, you can access the folder and rename the most recent backup file to recover the latest version of your work. Let's take a look at how backup files work in 3ds Max.

Exercise 1-5-3 Backup Files

1. Click the Customize pull-down menu and choose Preferences in the submenu (see **Figure 1-43**). Backup settings are not found in the Application menus even though it is a file operation.
2. In the Preferences Settings dialog, click the Files tab and in the lower left corner you will see an Auto Backup area with the auto backup feature automatically enabled. The number of backup files is set to 3 and the backup interval is set to 5 minutes by default (see **Figure 1-44**). This means that for every 5 minutes, 3ds Max will create a new backup file in the project's autoback folder; 5 minutes later, it will create a new backup file, and 5 minutes later, it will create a third backup file. Five minutes later, the first backup file (the oldest one) will be overwritten, and the process will

Open
Preferences
dialog

FIG 1-43 Backup file settings are found in the Preferences dialog

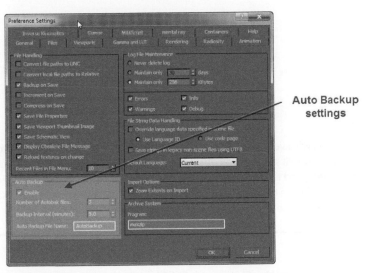

Auto Backup
settings

FIG 1-44 Auto Backup default settings

continue throughout the working session. So you are guaranteed to always have the three most recent backup files of your 3ds Max session, i.e., you can always refer back to your previous work done up to 15 minutes ago. Cancel the Preference Settings dialog as you will not need to change any of the Auto Backup settings at this time.

3. Yet another safety feature built into 3ds Max which saves files to your hard drive for later recovery is the complementary commands called Hold and Fetch that can be found in the Edit pull-down menu (see **Figure 1-45**). To try this out, you can click on the Edit pull-down menu and click the Hold option in the menu. This saves the entire 3ds Max scene into the project's autoback folder, where the automatic backup files are kept. This new

file is called maxhold.mx, and there can only be one of these files at a time. If you click Hold again it will overwrite the file with the new information. To recover the information stored in the file, you can click on the Edit pull-down menu and choose the Fetch option. Hold/Fetch acts like a bookmark and is extremely useful when you are about to perform steps that you're not quite sure of and feel that you need an easy way out of the changes.

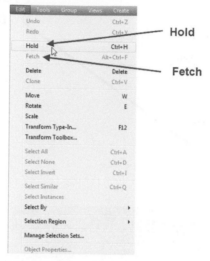

FIG 1-45 Hold and Fetch are found in the Edit pull-down menu

Warning

If you are working with very large 3ds Max scenes, it could take several minutes to save the file and 3ds Max will slow down considerably during the save operation. In such cases, don't be tempted to disable the autoback feature entirely. You can simply increase the backup interval time to more than 5 minutes, such as 30 or 60 minutes, and save yourself a lot of grief when something goes wrong.

By saving your working 3ds Max file with the Ctrl-S keyboard shortcut, using the Save As command to save incremental files, understanding the process by which 3ds Max creates backup files, and using the Hold/Fetch feature, you should be safe against any unforeseen file problems that could bring production to an abrupt halt.

Learning your way around the user interface of 3ds Max is an important step in becoming productive and efficient in your workflow. In this chapter, you have been exposed to an overview of the various areas such as viewports and command panels to provide you with the big picture of the layout of 3ds Max user interface.

You then learned more detail about these viewports themselves and how they represent your 3D scene from various points of view to make it easier to visualize objects or areas in the scene or even the entire scene.

Your ability to manipulate and navigate the user interface is dependent on your understanding of the various elements specific to 3ds Max, such as rollouts, spinners, numeric fields, and flyouts. Although these user interface elements are not difficult to learn, their efficient use is not always apparent to the new user. Once you see how they function, you can work them into your day-to-day production.

Another concept of 3ds Max you learned about was navigating within the viewports by using the various methods of zooming, panning, and orbiting through and around your 3D scene. Many times, there are several ways to accomplish any given viewport navigation task, for example zooming with the navigation buttons or with the middle mouse wheel, and you need to practice with each method to find which works best for your personal needs.

In this chapter, you also learned about file management techniques that allow you to open and save files in various ways, and about the safety features such as backup files and the Hold/Fetch "bookmarking" feature.

Selected object

Current parameters

Creating Objects

3ds Max has a good selection of 3D primitive objects and 2D shapes for you to use as a basis for the modeling of more complex objects. Most of these are classified as parametric objects, i.e., they have a number of parameters that can be adjusted during creation or modified later, such as radius, height, or number of segments. This important concept of working with parametric objects is a key to efficient and flexible editing.

Many objects created in 3ds Max began as a primitive object or shape that were then modified into something much more complex using the modifiers and tools available in 3ds Max. Much like a sculptor who starts with a block of marble and turns it into a fine sculpture, you will learn to develop a sense of which primitive might work best for the object you are creating.

Once a sculptor has chipped marble away from the block, it is impossible to put the chips back just as it's impossible to make the original marble block larger. But in 3ds Max, the parametric nature of the software gives you the opportunity to build your models in a way that allows you to go back and make changes to the original primitive's parameters to affect the end result.

In this chapter, you will learn the very basic steps of creating both 3D and 2D objects in 3ds Max and will have the opportunity to practice the hand–eye coordination required for the first few times you create the objects. Some of the topics that will be covered are as follows:

- *Object types* – This section will be an overview of the types of primitive objects you create directly in 3ds Max, generally to be used as base objects for modeling.

- *Creating primitives* – You learn the sequence of mouse clicking and dragging required to create 3D primitive objects such as boxes, spheres, or cylinders.
- *Creating shapes* – 2D shapes can be created in 3ds Max as basic construction elements or as paths for animated objects.

2.1 Object Types

In this section, you'll have a look at some of the common object types usually used as a starting point for more complex 3D models. The intent at this point is to learn where the objects are located in the user interface and the actions required to create objects in a scene.

Objects in 3ds Max can be three-dimensional (3D) objects or two-dimensional (2D) shapes and are located in separate categories of the Create panel. 3D objects are found in the Geometry category and 2D shapes are found in the Shapes category.

Exercise 2-1-1 Accessing Create Panel Categories

1. Open 3ds Max so that you have a new scene using the default user interface. The default command panel is set to the Create panel with the Geometry category selected. Standard Primitives is active in the drop-down list and the Object Type rollout displays 10 buttons containing "3D" object types (see **Figure 2-1**).

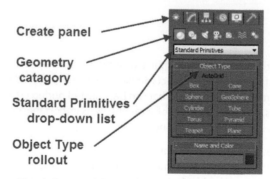

Create panel

Geometry catagory

Standard Primitives drop-down list

Object Type rollout

FIG 2-1 3D objects are created from the Create panel, Geometry category.

> **Note**
>
> 3D is in quotes in Step 1 of this exercise because one of the primitives is a Plane that, technically speaking, does not occupy 3D space but is considered as a 3D object because it has a surface.

2. In the Object Type rollout, click the Box primitive button and notice a list of parameters that appear in the Parameters rollout below. A Box primitive is defined by the length, width, height, and a number of segments in each direction (see **Figure 2-2**). You will not be creating primitive objects in this exercise.

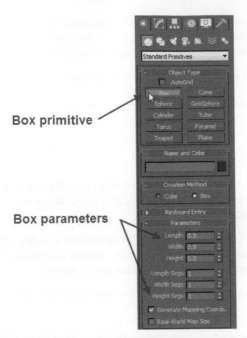

Box primitive

Box parameters

FIG 2-2 A Box primitive has several parameters.

3. Click on the other Standard Primitive buttons in the Object Type rollout and observe the parameters associated with each object.
4. In the Create panel, click the Shapes category button to the right of Geometry in the second row. The Object Type rollout, below a drop-down list named Splines, now displays 12 buttons that will allow you to create 2D shape primitives. Click on the Circle shape button and you will see that the only parameter associated with the circle is radius (see Figure 2-3).

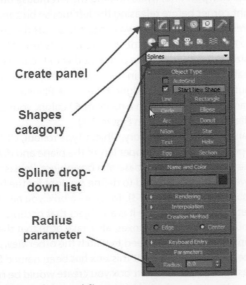

Create panel

Shapes catagory

Spline drop-down list

Radius parameter

FIG 2-3 2D shapes are created from the Create panel, Shapes category.

The Create panel is the only command panel with a second row of category buttons where you can switch from a variety of object categories. The Geometry category contains 3D primitive objects whereas the Shapes category contains 2D shapes.

Let's learn in the next exercise how these primitive objects are actually created in the viewports.

2.2 Creating Primitives

Each primitive object type that you want to create in 3ds Max has a specific process of defining the parameters through a series of clicking and dragging the cursor in a viewport to define the object in 3D or 2D space.

For the new user, the correct order of the clicks and drags to define certain parameters can be a bit confusing, but with just a little practice, creating primitives will become such an automatic process that you won't have to think much about it.

Let's begin by creating a few of the more commonly used 3D and 2D objects in 3ds Max.

Exercise 2-2-1 Creating Objects

1. Open a new scene in 3ds Max or continue working in the untitled scene from the previous exercise. Disable the visible grids in the three orthographic viewports by right-clicking to activate the viewport and then pressing the keyboard shortcut G. This will make it easier to see the plane in this case. Click on the Geometry category that should be set to Standard Primitives. Right-click in the Top viewport to activate it. Then, click the Plane button in the Object Type rollout. Left-click in the upper left corner of the Top viewport and, while holding the left mouse button down, drag to the lower right corner before releasing the left mouse button. The flat plane primitive requires that you describe two corners to adjust the Length and Width parameters (see **Figure 2-4**). At this point, you are not interested in creating a plane of any particular size, but should only be concerned with the process of clicking and dragging to create the plane. Notice in the Create panel, Name and Color rollout, the plane has automatically been assigned the name Plane001 and a color (because this color was randomly chosen from a pallet of 64 colors, your planes' color will probably be different from the one in Figure 2-4).

2. In the Create panel, Geometry category, Object Type rollout, click the Box button. In the Top viewport, click near the upper left of the plane and drag a short distance down and to the right to define the base of a box object. Release the left mouse button and move the mouse forward to define a height for the box, then left-click to set the height parameter (see **Figure 2-5**). To create a box, you need one extra process to define and set the height because it is an object that occupies 3D space. Again, don't worry about the exact size of boxes; also, take note that the height is not visible in the Top viewport, so you need to watch the other viewports to determine the height of the box. Notice also that this box has been named Box001 and has a different color assigned to it. The next box you create would be named Box002 and have a different color again, selected by the program from the 64 colors available.

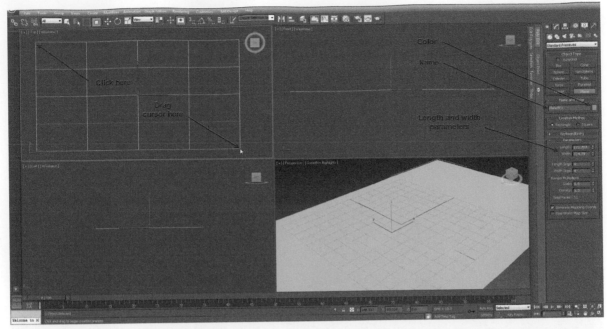

FIG 2-4 Plane primitive objects are defined by clicking and dragging to a diagonal corner.

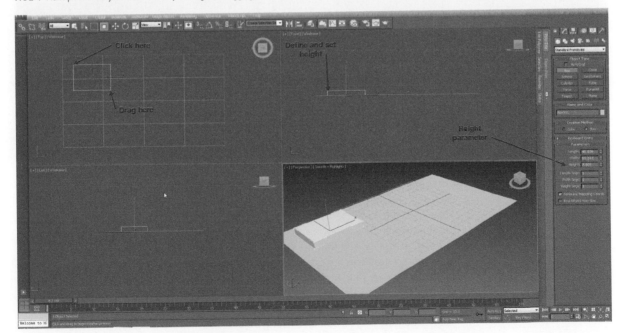

FIG 2-5 Box primitive objects have a third dimension; height.

Note

If you are using 3ds Max Design instead of 3ds Max, the colors of newly created objects will not cycle randomly through the 64 pallet of colors by default.

3. In the Object Type rollout, click the Sphere button. Click and drag near the center of the plane in the Top viewport to define the radius of a sphere. Because the radius is defined from the sphere's center, the sphere will be placed half below and half above the plane that was created on the current work plane in the Top viewport during Step 1 (see **Figure 2-6**).

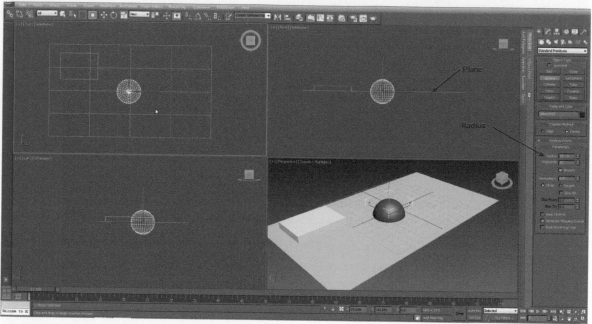

FIG 2-6 A Sphere primitive object has only one parameter; radius.

4. In the Top viewport, create a Cylinder primitive, a Tube primitive, and a Cone primitive to see how each object has slightly different combinations of clicks and drags to define the primitive shapes' parameters. Don't worry if the object is not created correctly on the first try, but try again until you get the desired results. Notice that the selected object in the scene can be identified by its white color in the wireframe viewports and the white "bounding box" brackets in the shaded perspective view, and that the current parameters for the object you have just created are visible in the Command panel (see **Figure 2-7**).

5. Left-click somewhere in the empty space around your objects in the Top viewport to deselect everything. Left-click again on the visible part of any object in the Top viewport and notice that the parameters are no longer available in the command panel. So how do you edit an existing object? 3ds Max is a program that follows a "create, then modify" concept. While you are in the process of creating an object, you can adjust its parameters, but once you have left the creation process, you must go to the Modify panel to edit its parameters further. With an object selected in the viewport, click the Modify button (second from left, top row) at the top of the Command panel and you will see that the parameters appear in the panel for editing (see **Figure 2-8**).

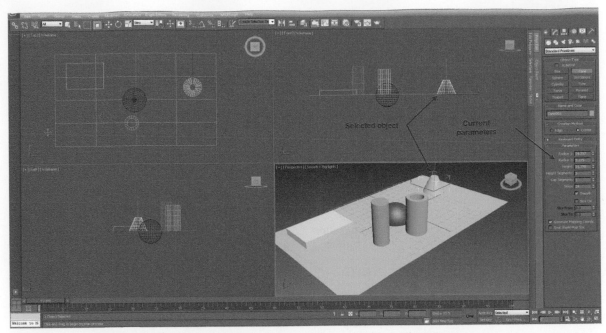

FIG 2-7 Create a Cylinder, Tube, and Cone primitive to experiment with mouse clicks and drags required for each different object.

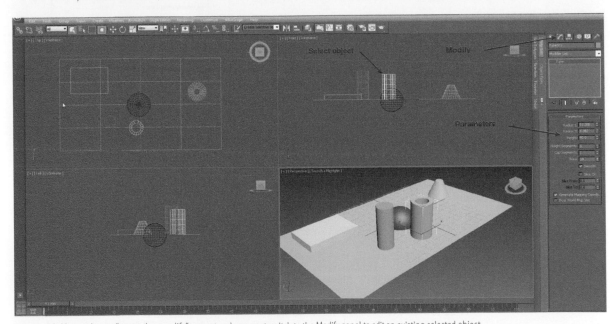

FIG 2-8 3ds Max works on a "create, then modify" concept and you must switch to the Modify panel to edit an existing selected object.

Creating 3D primitive objects in 3ds Max is a straightforward process, but it will require a little bit of practice for you to get the right sequence of clicking and dragging in the viewports for any given object type. While you are in the process of creating an object, you can also change its parameters in the Create panel, but if you select an existing object in the scene, you must go to the Modify panel to edit its parameters.

The process of creating 2D shapes is very similar to the process you just learned to create 3D objects, but let's have a look at the menu structure and some of the options.

Exercise 2-2-2 Creating Shapes

1. Let's begin by creating a completely new scene that replaces the current scene of 3D objects. Click the Application button and choose Reset in the menu. If you hover your cursor over the command, a description of the command will appear and a tip on how to access the 3ds Max Help is included (see Figure 2-9).

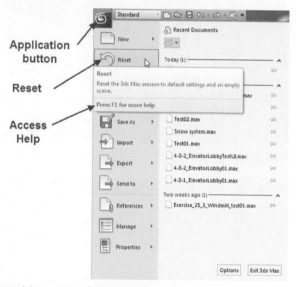

FIG 2-9 The Reset command clears everything from the current scene and starts a new scene.

2. A dialog appears warning that this scene has been modified and asks if you want to save your changes. Click the No button (see Figure 2-10). This scene is only for testing the creation of objects and there's no reason to save it.

FIG 2-10 The Reset command warns that you have unsaved changes in the current scene.

3. Another dialog appears asking whether you are sure you want to reset the scene (see Figure 2-11). Click the Yes button. The reset command discards everything in your current scene, so 3ds Max wants to make sure that you really want to reset. Once the scene has returned to its default state, right-click in each of the orthographic viewports (top, front, and left), then press the keyboard shortcut G in each viewport to disable the grid. This will make it easier to see the random shapes you will be creating.

FIG 2-11 The Reset command clears everything from the current scene and starts a new scene.

4. Right-click in the Top viewport to activate it. In the Create panel, click the Shapes category button (second row, second from left) to show the Object Type rollout containing the possible shapes that can be created (see Figure 2-12).

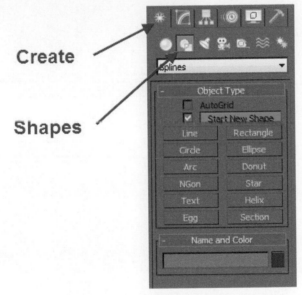

FIG 2-12 There are 12 2D shapes available in 3ds Max.

5. In the Object Type rollout, click the Rectangle button. In the Top viewport, somewhere near the center of the viewport, click and drag from upper left to lower right to define a rectangle much in the same way you created the Plane primitive in the previous exercise (see Figure 2-13). This is a 2D shape that has a name and a randomly chosen color, but has no surfaces, so it will not show up as a shaded object in the Perspective viewport or in a rendered image. It is a construction object that can be modified into a 3D object or used as an animation path.
6. Let's create a simple straight line that requires just a click of the mouse at each endpoint of the line. At this point, do not click while dragging the mouse, because doing so will create curvature that will be explained later in this book. Click the Line button in the Object Type rollout, click in the Top viewport (quickly and release left mouse button), and then move the mouse to where you want the end of the line to be and click quickly again. Right-click to end the line creation sequence (see Figure 2-14). If you don't succeed at first, try again until you can create a straight line with no curvature.

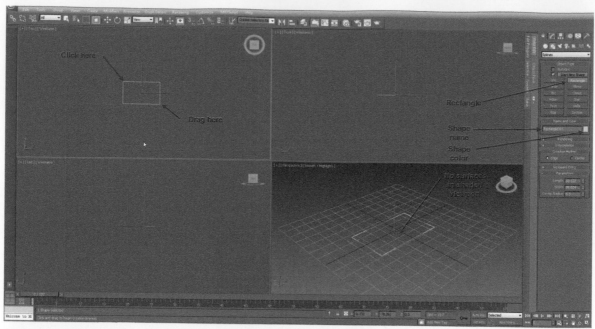

FIG 2-13 Create a Rectangle shape by clicking and dragging to define its diagonal corners.

FIG 2-14 To create a straight line, you need to click and release with no dragging and then right-click to end the line command.

7. You should be comfortable enough with creating objects in 3ds Max now to try a few of the other types of shapes in the Top viewport. Concentrate on the sequences of clicking and dragging with the mouse until it begins to feel natural to you.

> **Note**
>
> The Text, Helix, and Section shapes are specialized types of shapes. You can try creating Text and Helix (like creating a 3D cone) in this exercise, but it would not be possible to create a Section shape at this point.

Shapes, except for the helix, are created in 2D space. Shapes are extremely useful as the basic element to begin creating 3D objects or to use as animation paths for animated objects. Shapes are parametric, providing easy editing in the Modify panel once you have left the creation process. As with 3D primitives, a shape must be selected before its parameters appear in the Modify panel.

3D primitives and 2D shapes are the basic elements of many of the objects that will eventually populate your scenes and can provide you with a high degree of accuracy when animating objects. Take the time to practice creating these basic objects so that the process becomes an automatic part of your workflow, and then investigate some of the parameters that make up each object by going into the Modify panel and making basic edits to your selected primitive or shape.

Some of the important concepts introduced in this chapter are the fact that the objects are automatically assigned a name and a color. Although the color is there simply to differentiate between new primitives or shapes, you will learn later that the name of objects become extremely important. The name must be edited to provide a logical and recognizable identification that ultimately improves organization. Also, 3ds Max works on a create–modify design where it is possible to change the parameters of an object as it is being created, although after leaving the creation process you must select the object and switch to the Modify panel to make any subsequent edits to its parameters.

Working with the tools and techniques for creating each type of object might seem a bit confusing at first, but with a little practice, you'll become more comfortable, performing the steps without thinking about them.

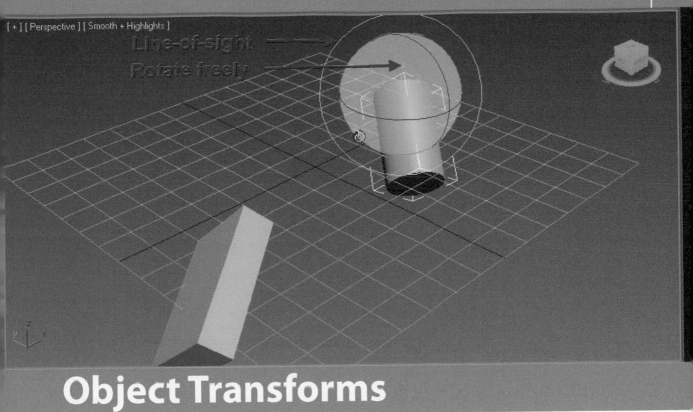

Line-of-sight

Rotate freely

Object Transforms

Although the topics covered in this chapter may not be the most glamorous or exciting in 3ds Max, still it is very important for you to learn the fundamentals of coordinate systems and transforms. You will then begin applying these methods and techniques, incorporating them into your workflow. Some of the topics you'll learn about in this chapter are as follows:

- *Reference Coordinate Systems*
- *Transforms*
- *Transform Type-in*
- *Pivot Points*

The use of Reference Coordinate Systems in 3ds Max is an essential part of fully implementing transformations in your day-to-day workflow. They can be a bit confusing for new users, but with a little bit of practice you'll find yourself using the appropriate Reference Coordinate System automatically.

Moving, rotating, and scaling objects in 3ds Max can take up a considerable amount of your time and energy during a typical workflow, and it is critical that you learn the options available, which allow you to quickly and accurately perform these functions.

You'll learn a very important lesson about how to safely scale and mirror objects in a way that will avoid potential problems later in your scene development. Moving and rotating objects can always be done safely, but it's important that you take advantage of the 3ds Max features that add accuracy and control through the use of "transform gizmos" in the viewports and transform type-in numeric fields in the interface.

Every object in 3ds Max has a pivot point associated with it that defines a point of rotation in 3D space. The pivot point is indicated by the apex of a transformation tripod that also has the function of defining a particular set of *X*, *Y*, and *Z* axis. You'll learn the fundamentals of accessing and adjusting pivot points for added control over object transformation.

3.1 Reference Coordinate Systems

As mentioned earlier in the chapter, it is very important that you understand how the Reference Coordinate Systems function in 3ds Max, and to allow you a higher degree of control over the transformation of objects in the scene.

The 3D space in 3ds Max where you can build and animate your scenes is defined mathematically by the values calculated from a fixed origin point in the virtual world that you see through your viewports. These values are described as positive or negative numbers in the three axis *X*, *Y*, and *Z*. This World coordinate system is the basis within which all values are determined.

However, the World coordinate system is fixed in space and is not always ideal for describing the position, rotation, or scaling of objects that are not aligned with the World coordinate system. Therefore, 3ds Max provides several Reference Coordinate Systems which always refer back to the World coordinate system, but have a variety of options that make it easy to transform objects through more logical and flexible transformation axis.

You'll begin by learning about the World coordinate system that defines the 3D environment space in which 3ds Max scenes are developed; the origin point and the axis directions form the default working planes on which you build your models.

Once you have a fundamental understanding of the World coordinate system, you can begin to learn some of the options available in the Reference Coordinate Systems, which provide more flexibility in transforming objects and laying out your 3ds Max scenes. Depending on the viewport that is active and the current Reference Coordinate System, the *XYZ* axis could point in different directions. Some of the Reference Coordinate Systems you'll learn about are as follows:

- *View*
- *Screen*
- *World*
- *Local*

These are some of the most commonly used Reference Coordinate Systems that you will be able to apply early in the 3ds Max learning process. Once you become comfortable with these basic options and have more complex scenes, you can use the Help files in 3ds Max to learn about the remaining Reference Coordinate Systems.

Exercise 3-1-1 The World Coordinate System

1. Open 3ds Max to a default state or use Reset to return your current scene to the default settings. You should have four viewports with their grids toggled on. Remember, the keyboard shortcut G can be used in each viewport to toggle the grid on or off (see **Figure 3-1**). These grids are based on the World coordinate system to define the working planes for each viewport.

FIG 3-1 The default 3ds Max display with grids on.

2. At the lower left corner of each viewport you will see a red, green, and blue tripod indicating the positive axis directions of the World coordinate system (see **Figure 3-2**). Take some time to study the tripod in each viewport to see the relative direction of each positive coordinate axis and compare it with the other viewports.

FIG 3-2 The World coordinate system axis tripod.

Note

A useful "formula" in 3ds Max is RGB = *XYZ*. The colors red (R), green (G), and blue (B) can be used in many instances to identify the *X*, *Y*, or *Z* axis directions.

3. The origin of the World coordinate system is a point in space defined by the intersection of the black lines of each grid (see **Figure 3-3**). The mathematical

coordinates of this point are (0, 0, 0) providing a starting point from which all other coordinates are derived. Keep in mind that it is a single point in space that you are viewing from four different viewports.

FIG 3-3 The World coordinate origin (0, 0, 0) is located at the intersection of the black gridlines.

4. The working planes of each viewport are defined by pairs of black origin lines. In the Create panel, Geometry category, Object Type rollout, click the Box button and create a small, flat box in each viewport to see that the base of the box is defined on a plane passing through the black lines (see **Figure 3-4**). Again, take some time to study the orientation of each box and the location of its base.

FIG 3-4 Each viewport's working plane is defined along the black lines passing through the origin.

5. Click the Application button and choose Reset in the menu. In the 3ds Max dialog, click the No button to indicate that you do not want to save the file, and then in the next 3ds Max dialog, click the Yes button to indicate that you really do want to reset. This returns you to an empty and untitled default 3ds Max configuration.

The World Reference coordinate system is fixed in 3D space and cannot be altered. The origin from which all coordinates are calculated begins at the intersection of the black gridlines with the X, Y, and Z values of (0, 0, 0). You will now learn about Reference Coordinate Systems that are based on the World coordinate system but which adapt based on the active viewport to more accurately transform the objects in 3D space.

Exercise 3-1-2 View Reference Coordinate System

1. Open 3ds Max to the default configuration if it isn't open already and right-click in the Top viewport to activate it. In the Create panel, Geometry category, Object Type rollout, click the Box button and, in the upper left of the Top viewport, create a small flat box. Notice that when the box is selected, another tripod appears with its apex indicating the pivot point of the box. This axis tripod is also called the transform axis tripod, as it provides three axis X, Y, and Z along which the object can be moved or around which the object can be rotated. It displays the positive x-axis pointing toward the right, positive y-axis pointing up, and positive z-axis pointing out directly toward the viewer (notice how the X and Y axis are displayed in red, whereas the z-axis is displayed in gray). You can also see that the transform axis tripod directions match the World coordinate system axis (see **Figure 3-5**).

FIG 3-5 A transform tripod appears at the pivot point of the selected object and indicates that the positive axis directions are currently associated with that object.

2. Look at the orientation of the transform tripod in the Top viewport and then right-click in the Front viewport to activate it while watching the transform tripod in that viewport. You may have to right-click back and forth between viewports to see clearly what is happening with the transform tripod. The transform tripod flips to match the viewport that is currently active with the x-axis pointing to the right, the y-axis pointing up, in the z-axis pointing out from the viewport. In other words, the axis are not necessarily aligned with the World coordinate system axis, but

have adapted themselves to the viewport, as a direct result of the current default Reference Coordinate System settings (see **Figure 3-6**). Right-click in the Left viewport to activate it and you will see similar behavior with the positive *x*-axis pointing to the right, the *y*-axis pointing up, and the *z*-axis pointing out. It is important to note that these are all orthographic viewports.

FIG 3-6 The transform tripod flips to adapt to the active orthographic viewport. Positive *x*-axis is to the right, *y*-axis is pointing up, and *z*-axis is outward.

3. Right-click in the Perspective viewport to activate it and you will see that the transform tripod once again matches with the World Reference coordinate system tripod. The behavior of the transform tripod is different for orthographic or nonorthographic viewports (see **Figure 3-7**). The transform tripod is conforming to the current Reference Coordinate System selected and the current active viewport. Orthographic viewports have the positive *x*-axis to the right, the positive *y*-axis pointing up, and the positive *z*-axis pointing toward the viewer. Nonorthographic viewports correspond to the World coordinate system. Let's learn a little more about why this is occurring and what advantages it has in production.

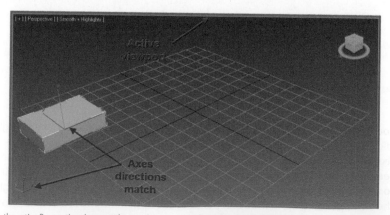

FIG 3-7 In the active Perspective viewport, the transform axis tripod matches the World coordinate system axis directions.

4. In the main toolbar, you will see that the Reference Coordinate System drop-down list is set to View by default. This current Reference Coordinate System determines the behavior of the transform tripod. Click on the drop-down list to open it for a menu of Reference Coordinate System options (see Figure 3-8).

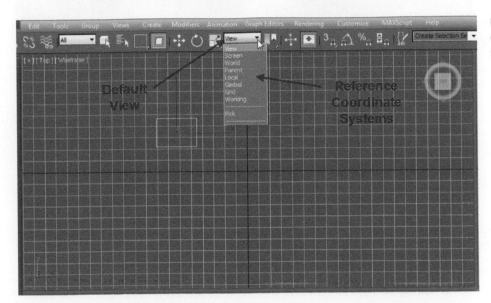

FIG 3-8 View reference coordinate system is the default setting for 3ds Max.

5. Although still in the View reference coordinate system, right-click through the viewports to learn the behavior of the transform tripod in both orthographic and nonorthographic viewports. Make sure that you understand how the transform tripod is changing the positive axis directions so that you can compare what happens when you change the Reference Coordinate System to Screen mode in Exercise 3-1-3. Remember, you are learning about the concept at this point and you will put this knowledge into practice later in the chapter.

The View reference coordinate system is the 3ds Max default and can be confusing to new users because it keeps changing the XYZ axis directions based on the active viewport. The basic concept is quite simple; however, for orthographic viewports, the positive x-axis points to the right, the positive y-axis points up, and the positive z-axis points out from the viewport, whereas for nonorthographic viewports, the axis tripod aligns with the World coordinate system. Again, this will all become very important when you start transforming objects in later exercises. Now let's have a look at the Screen reference coordinate system to see how it compares with the View reference coordinate system.

Exercise 3-1-3 Screen Reference Coordinate System

1. You should still have the scene open from Exercise 3-1-2 that contains the small flat box. If you are beginning this exercise fresh, then simply re-create the box in the upper left area of the Top viewport. Right-click in the Top viewport to make sure that it is active. In the main toolbar, click the View reference coordinate system drop-down list and choose Screen in the menu (see Figure 3-9).

FIG 3-9 Change the Reference Coordinate System from View to Screen.

2. You should notice that the transform tripod has not changed in the Top viewport: positive *x*-axis is to the right, positive *y*-axis is up, and positive *z*-axis is outward. This is the same behavior as for the View reference coordinate system for this orthographic viewport. Right-click in the Front viewport to activate it and watch the tripod flip the same as it did in View reference coordinate system. Right-click in the Left viewport to see the same behavior; positive *x*-axis to the right, positive *y*-axis up, and positive *z*-axis outward (see **Figure 3-10**). Again, the same behavior as for the View reference coordinate system.

FIG 3-10 In all orthographic viewports, the Screen and View reference coordinate systems display the axis in the same manner.

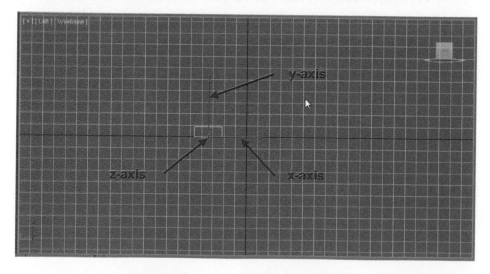

3. Right-click in the Perspective viewport and look at the transform tripod in all the other viewports. Screen reference coordinate system adapts itself to the viewing directions of nonorthographic viewports. This enables you to transform the objects perpendicular to or parallel with your line-of-sight when the nonorthographic viewport is active (see **Figure 3-11**).

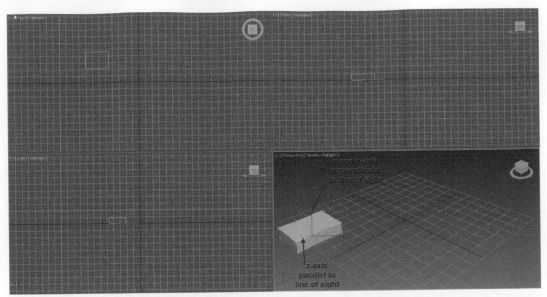

FIG 3-11 Screen reference coordinate system aligns with the line-of-sight of nonorthographic viewports.

Note

The positive z-axis leg of the transform tripod doesn't appear to be parallel with the line-of-sight of the Perspective viewport because of the nature of a perspective view's distortion of parallel lines.

Making accurate moves with objects perpendicular to or parallel with the line-of-sight would be impossible without the Screen reference coordinate system. Take the time to familiarize yourself with these options and practice a little until they become second nature to your workflow. Once you have learned these simple concepts, the tools will be at your disposal to increase your productivity. Without a good knowledge of Reference Coordinate Systems, you will still be able to get your work done, but you will waste too much time "fudging" your transformation of objects. Let's have a quick look at the World reference coordinate system.

Exercise 3-1-4 World Reference Coordinate System

1. With the 3ds Max scene opened from Exercise 3-1-3, use the Reference Coordinate System drop-down list in the main toolbar to switch from Screen to World reference coordinate system.
2. Right click each viewport to activate it and watch how the transform tripod does not change but always remains oriented to the World reference coordinate system. Using the World reference coordinate system is sometimes useful for maintaining consistency throughout all viewports while transforming objects.
3. Right-click in the Front viewport to activate it. In the Create panel, Geometry category, Object Type rollout, click the Cylinder button, and then create a small cylinder to the right of the existing box in the scene. Notice that its transform tripod is also locked to the World reference coordinate system (see **Figure 3-12**).

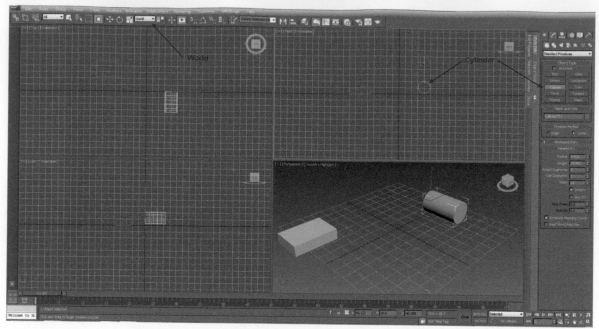

FIG 3-12 World reference coordinate system is useful for the consistency of axis directions throughout viewports.

4. In the main toolbar, click the Select Object button, and in each viewport select the box in the scene and then the cylinder, to verify that the transform tripod remains the same regardless of which the object is selected or viewport is currently active.

Perhaps the most useful Reference Coordinate System is Local, but it is helpful to understand how the objects are created before investigating the behavior of the Local reference coordinate system. For example, when you created the cylinder in the Front viewport, the cylinder's base was created on the viewport's current working plane and the height of the cylinder was extruded toward or away from the viewer. The box in the scene, however, was created in the Top viewport. Let's see how the Local reference coordinate system differs from what you have learned so far.

Exercise 3-1-5 Local Reference Coordinate System

1. In the current 3ds Max scene containing the box and the cylinder, right-click on the Top viewport to activate it. Click the Select Object button in the main toolbar and select the box in the top viewport. Notice the transform tripod. In the Reference Coordinate System drop-down list, choose Local and you will see that the tripod orientation has not changed, but remains the same as World reference coordinate system (see **Figure 3-13**). This is because the box was created originally in the Top viewport, and therefore, its Local reference coordinate system is aligned to the World reference coordinate system.

FIG 3-13 For the box in the Top viewport Local reference coordinate system is the same as that of World reference coordinate system.

2. Select the cylinder in the Top viewport and you will see that it does not share a common reference coordinate system with the box. This is because the transform tripod orientation shows the cylinder's Local reference coordinate system, which differs this time from the World reference coordinate system because the cylinder was created in the Front viewport (see Figure 3-14). The Local reference coordinate system is specific to each object, always oriented to the object itself, enabling you to transform objects along their own local axis. The usefulness of this Local reference coordinate system will become very apparent when you learn to rotate objects so that they are not aligned to any current viewport working planes.

FIG 3-14 The Local reference coordinate system remains oriented to the object irrespective of where it was created.

3. Activate each of the other viewports and select the box and then the cylinder to verify that regardless of the active viewport the transform tripod always remains oriented to the object's Local reference coordinate system.

There are no hard and fast rules for setting and using Reference Coordinate Systems, but you must be comfortable with each option so that you can choose the appropriate Reference Coordinate System during production. Practice on simple scenes until you understand the concepts and behavior of each Reference Coordinate System. Then these tools will become an integral part of your workflow. Without learning the Reference Coordinate Systems, you will waste time when transforming or aligning objects in your scenes. Although there are other Reference Coordinate Systems in the drop-down list, the ones that we have covered so far are most commonly used, whereas the others require much more knowledge of 3ds Max, beyond the scope of this lesson.

In Section 3.2, you will apply the lessons presented here while learning to transform objects in 3D space.

3.2 Transforms

Move, Rotate, and Scale are the three transforms in 3ds Max, which allow you to position, orientate, and size the objects in 3D space. In this section, you'll learn how to use the "transform gizmos" to move and rotate the objects in the scene. Accuracy in moving and rotating objects will not be important for now, you'll instead focus your attention on restricting transformations to either one axis or multiple axis.

The Reference Coordinate Systems are an important part of learning how to transform objects in 3ds Max because you need to know and understand where the *XYZ* axis point to, which can differ based on active viewport and current Reference Coordinate System.

Remember that you were previously introduced to the formula RGB = *XYZ*, meaning that the *x*-axis is colored Red, the *y*-axis is colored Green, and the *z*-axis is colored Blue. This can assist you as a visual cue when choosing the transformation axis. The transform gizmos are color-coded using this formula.

In this section, you'll learn about:

- *Transform Gizmos*
- *Select and Move*
- *Select and Rotate*

Warning

Do not Scale or Mirror objects in 3ds Max. Owing to a design issue in the original 3ds Max software, you cannot use the Select and Scale tool directly on 2D or 3D objects. Doing so can result in major problems with your models later in the production process that are very difficult to troubleshoot. Further in this book, you will learn the reason for this warning and the very simple workaround that will allow you to safely scale objects.

The Mirror command simply applies a −1 scale value to objects, creating the same dangerous situation as the Select and Scale command.

When transforming objects, the transform gizmos provide you with options for restricting the movement or rotation of objects along individual axis or multiple axis. Let's have a look at the gizmo's options before learning how to actually transform objects.

Exercise 3-2-1 Transform Gizmo

1. You should have the scene from Exercise 3-1-5 with a box and a cylinder opened, or you can re-create it in a new 3ds Max scene. Create the box in the Top viewport and the cylinder in the Front viewport. Make sure that the Top viewport is activated and the Reference Coordinate System is set to the default View. Select the box object (see **Figure 3-15**).

FIG 3-15 Begin with a scene with a box and a cylinder to learn about transform gizmos.

2. In the main toolbar, click the Select and Move button. The box's transform tripod now changes to the Select and Move transform gizmo. The three axis are aligned based on the current Reference Coordinate System and the active viewport. Right-click in each of the other viewports to activate it and observe the behavior of the transform gizmo, it is exactly the same as the transform tripod. Activate the Top viewport and hover the cursor over the shaft of the red x-axis leg. The arrow shaft will be highlighted in yellow (see **Figure 3-16**).

FIG 3-16 The Select and Move transform gizmo is color-coded and indicates the positive axis directions based on the selected Reference Coordinate System and active viewport.

3. Activate the other viewports and hover the mouse over each of the arrow shafts to see them being highlighted, indicating that a Select and Move transform can be restricted to any of the axis that may be different based on the current Reference Coordinate System and viewport.

Note

The transform tools are called Select and Move, Select and Rotate, and Select and Scale, because you don't need to click on the Select Object button and then select the object in the viewport before transforming it, but you can select and transform the object in one single action.

4. Right-click in the Top viewport to activate it and hover the cursor over the red and green lines between the shafts of the X and Y axis legs to see the yellow square appears at the apex of the tripod legs (see **Figure 3-17**). This square indicates that the object may be moved freely in both the X and Y axis in one motion rather than being restricted to only one of the axis.

FIG 3-17 Movement can be restricted in two axis with the yellow square at the apex of the tripod legs.

5. Activate the other viewports and see that the yellow square indicates movement restriction in just two axis of the viewport. In the Perspective viewport, you can position the cursor to activate any of the three yellow squares for more control (see **Figure 3-18**).

FIG 3-18 You can often access three pairs of axis in the Perspective viewport.

6. In the main toolbar, click the Select and Rotate button and you will see the rotation transform gizmo appear. Again, the axis are color-coded according to the RGB = *XYZ* formula. Hovering the cursor over a circle turns it yellow and left clicking and dragging allow you to rotate the object about the selected axis. The gray circle restricts rotation around the line-of-sight of the active viewport (see Figure 3-19). In orthographic viewports with the View reference coordinate system selected, the gray circle functions the same as rotating about the *z*-axis. By hovering the cursor between the restriction circles and left clicking, you can rotate freely in all axis.

FIG 3-19 Rotation is restricted with the Rotate transform gizmo.

Practice a little by highlighting the various options in the Select and Move and Select and Rotate transform gizmos. In Exercise 3-2-2, you'll practice actually moving objects in the scene to try out what you have learned.

Exercise 3-2-2 Move Transform

1. Use the 3ds Max scene from Exercise 3-2-1 or re-create a similar scene with a box, created in the Top viewport, and a cylinder created in the Front viewport. Activate the Top viewport and select the box in the scene. In the main toolbar, click the Select and Move button and the Move transform gizmo should appear with its apex at the pivot point of the box.

Note

If you do not see the Move transform gizmo after clicking the Select and Move button you might have toggled the transform gizmo off accidentally by pressing the keyboard shortcut X key. Pressing X again will toggle the gizmo on.

2. Hover the mouse cursor over the x-axis arrow shaft and left click and hold when it turns yellow. Drag the mouse to the right, moving the box in the same direction while restricting it to the x-axis. Hover the cursor over the y-axis arrow shaft and click and drag it downward to restrict the movement to the y-axis (see **Figure 3-20**).

FIG 3-20 Movement is restricted to a single axis when the corresponding arrow shaft is used (highlighted in yellow).

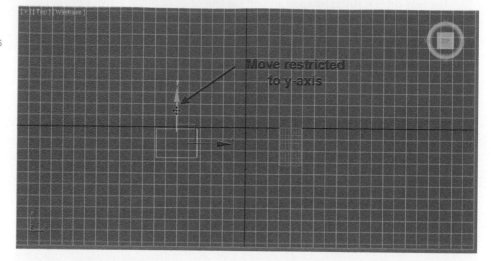

3. Right-click in the Perspective viewport to activate it and position the cursor over one of the three sets of colored lines that define a square at the apex until the square turns yellow, and then click and drag to move the box in two axis at once (see **Figure 3-21**). Where you move the box is not important, just focus on the process of using the Move transform gizmo.

FIG 3-21 Highlighting the square at the Move transform gizmo apex restricts movement in two axis.

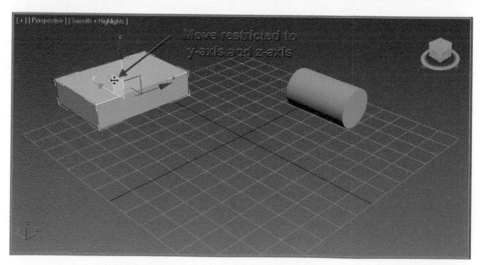

Getting used to using the Move transform gizmo to move objects through the scene will only take a short time and is an important step in controlling the repositioning of objects in 3D space, where optical illusions can sometimes trick the users into thinking that they are moving in one direction while they are actually going in another. In Exercise 3-2-3, you'll practice using the Select and Rotate transform gizmo.

Exercise 3-2-3 Rotate Transform

1. Use the 3ds Max scene from Exercise 3-2-2 and activate the Top viewport. In the main toolbar, click the Select and Rotate button to activate the Rotate transform gizmo; a series of circles appear to be colored according to the RGB = *XYZ* formula. Hover the cursor over the red *x*-axis circle until it turns yellow, and then click and drag the mouse downward to rotate the box about the *x*-axis. As you rotate the box, you will notice that the amount of rotation in the *x*-axis is displayed, as well as a small yellow arrow indicating the direction of rotation (see **Figure 3-22**).

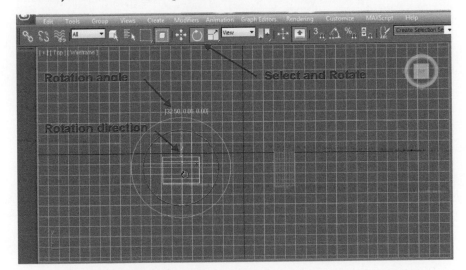

FIG 3-22 Rotation about a particular axis can be restricted with the appropriate circle.

2. Activate the Perspective viewport and rotate the box and the cylinder using each of the Rotate transform gizmo circles as well as clicking between the circles for free rotation in all axis. Use the outer gray circle to rotate the object around the line-of-sight (see **Figure 3-23**). The line-of-sight rotation only makes sense in the nonorthographic viewports. In the orthographic viewports, it is the same as rotating about the *z*-axis when in the default View reference coordinate system.

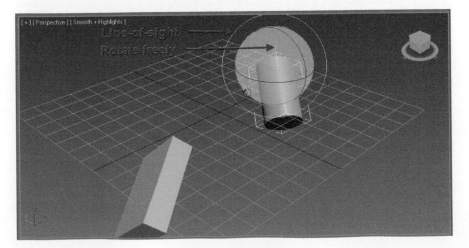

FIG 3-23 Click and drag between circles of the transform gizmo to rotate freely in all axis.

3. The transform gizmos have been oriented according to the current View reference coordinate system and the particular active viewport. With the cylinder selected in the Perspective viewport and the Select and Rotate button toggled on, click the View reference coordinate system drop-down list and choose Local reference coordinate system. The transform gizmo aligns itself to the Local coordinates of the cylinder which remained oriented along the axis of the cylinder as it was created. Rotate the cylinder about its X, Y, and Z axis to see the current behavior (see Figure 3-24).

FIG 3-24 Local reference coordinate system uses the object's creation axis, a powerful transform option.

4. In the main toolbar, click the Select and Move button, and then look to see which Reference Coordinate System is active; it is the View reference coordinate system and not the Local that you set in Step 3. This is because the Reference Coordinate Systems are "sticky" for each transform, i.e., each transform will remain set to the default Reference Coordinate System until you change it, and then will remain set to the option you choose until changed again or until you close the scene (see Figure 3-25). Click the Select and Rotate button and you will see it remains set to Local reference coordinate system.

FIG 3-25 The Reference Coordinate System is sticky for each transform.

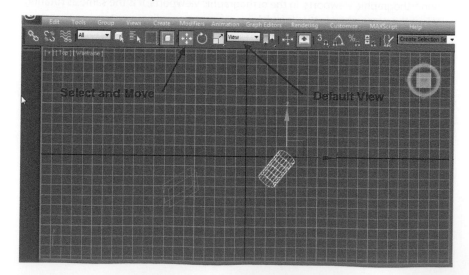

5. With the Select and Move button toggled on, set Local reference coordinate system in the drop-down list, and then move the cylinder along its own creation axis in the Perspective viewport (see Figure 3-26). Select the box object in the Perspective viewport and move and rotate it using the Local reference coordinate system.

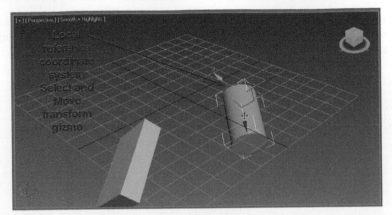

FIG 3-26 Select and Move transform gizmo in Local reference coordinate system.

Experiment moving and rotating the two objects in different viewports with the World and Screen reference coordinate systems to see how they differ from each other. Also notice the difference whether an orthographic or nonorthographic viewport is currently active. Take the time to become comfortable with the process of switching viewports and Reference Coordinate Systems to optimize your ability to move objects as necessary. It is not difficult, but does require a little practice initially before it becomes a part of your natural workflow.

3.3 Transform Type-In

Often you need to move or rotate an object accurately and so far you have only learned to move or rotate an object randomly by clicking and dragging. In this section, you'll learn about using tools in 3ds Max to move or rotate objects by exact numerical values entered into the transform type-in fields.

The transform type-in fields are labeled as *XYZ* and your knowledge of Reference Coordinate Systems is critical to moving objects in the desired direction. Because of the combination of Reference Coordinate System and orthographic or nonorthographic viewports, the *XYZ* directions are not always the same, so you must pay close attention to the variables while learning to transform objects accurately.

You must also learn to toggle transform type-in from Absolute mode to Offset mode to obtain the desired results. Let's refresh your knowledge of the difference between the two modes:

- *Absolute mode* – coordinate values are measured from the World coordinate system origin (0, 0, 0).
- *Offset mode* – coordinate values are measured from the objects current position.

Working in Absolute mode for the transform type-in generally requires considerable math to calculate your way from an object's current position back to the origin, and then to the new position. Offset mode allows you to enter a numeric value for the transformation amount without regards to the objects current position. You only need to know how far an object needs to move, or the angle an object must be transformed, without any extra math.

You'll use the scene from Exercise 3-2-3 and learn to use the transform type-in fields and the Absolute/Offset toggle button in the status line at the bottom of the 3ds Max display (see Figure 3-27).

FIG 3-27 The transform type-in fields and the Absolute/Offset toggle are at the bottom of the 3ds Max display.

Let's learn to transform objects accurately.

Exercise 3-3-1 Accurate Transforms

1. Use the scene from Exercise 3-2-3 or re-create it approximately. Right-click in the Top viewport to activate it, and then click the Select and Move button. Set the current Reference Coordinate System to View. Select the box in the Top viewport and notice that the numeric values appear in the transform type-in fields. These values represent the current absolute position of the pivot point of the box in the World *XYZ* axis (see Figure 3-28).
2. Enter **10** in each of the transform type-in numeric fields and press the Enter key to finalize each entry. The pivot point of the box moves to a position that is 10 units in the positive direction of each axis from the World coordinate system origin (see Figure 3-29). Now if you need to move the box, another 10 units in either direction you

FIG 3-28 Absolute coordinates of box's pivot point in World coordinates.

FIG 3-29 The Absolute coordinates are values measured from the World origin.

would have to mentally add that to the current coordinate value measured from the origin. This is not an intuitive or easy process, so let's learn about Offset mode.

3. Click on the Absolute/Offset toggle button to switch from Absolute mode to Offset mode. The numeric values in the transform type-in fields reset to 0.0 to indicate the object is in its current position. The Top viewport is active and the current Reference Coordinate System is set to View. Enter **10** in the *X*: transform type-in numeric field, and then press the Enter key. The box moves 10 units in the positive *x*-axis direction of the Top viewport. The position was offset by 10 units and the numeric value resets itself to zero to indicate it's in its new position (see **Figure 3-30**).

FIG 3-30 Values entered in Offset mode transform the object an exact amount and then the numeric fields reset to 0.0.

4. In the main toolbar, open the View reference coordinate system drop-down list and choose Local reference coordinate system. In the Z: transform type-in field, enter **30** and press the Enter key. The box moves 30 units along its Local positive z-axis direction and the transform type-in fields reset to 0.0 (see **Figure 3-31**). In Local reference coordinate system, the active viewport doesn't matter because the Local reference coordinate system is based on the object itself and is not viewport dependent.

FIG 3-31 In Offset mode and Local reference coordinate system, the object moves an exact amount along its own axis.

5. In the main toolbar, click on the Select and Rotate button, and then make sure the Local reference coordinate system is set. The values in the transform type-in fields now represent the angles of rotation in degrees, but the functionality is the same as with Select and Move. Enter **90** in the X: numeric field (see **Figure 3-32**) and press the Enter key and you will see that the box rotates 90° about its own x-axis and the number resets itself to 0.0.

Note

Positive rotation values rotate the object counterclockwise, measured as you look down the axis of rotation.

FIG 3-32 Using Select and Rotate in Local reference coordinate system allows you to rotate objects on their own axis.

6. Continue practicing rotating objects by exact amounts in different viewports, using different Reference Coordinate Systems, and by entering the values in different rotation transform type-in fields.

Learning and practicing techniques for transforming objects may seem to be little boring, but an analogy might be that of a musician practicing the scales. No matter how good a musician gets they must always come back to the fundamental techniques and methods of creating music as a basis on which to build more complex knowledge. The same principle holds true for learning 3ds Max. Let's investigate pivot points in a little more detail in Section 3.4.

3.4 Pivot Points

You now know what pivot points are and that they are identified either by the transform tripod or by the transform gizmo apex location. Each primitive object you have created so far has a pivot point in a default location on the geometry that you, so far, have had no control over. There are times, however, when you want an object to rotate about a specific point other than where the default pivot point is.

You know about transforming objects. Now, you will learn how to transform pivot points independent of the objects they are associated with. This will allow you to place the pivot point of any object in any location within the geometry or anywhere else in the 3ds Max scene.

The point of this section is to teach you where you can access the pivot point's location and how you can use the transform tools to reposition it.

Exercise 3-4-1 Transform Pivot Points

1. In the 3ds Max scene from Exercise 3-3-1 or a similar scene that you have re-created, make sure that the Top viewport is active and the cylinder is the selected object. In the main toolbar, click the Select and Move button and make sure that you are in Local reference coordinate system (see Figure 3-33). The default location for a cylinder's pivot points is at the center of the base of the cylinder as it was created. You would like to have the pivot point be in the geometric center of the cylinder.

FIG 3-33 The pivot point of a cylinder is at the bottom center by default.

2. In the Command panel, click the Hierarchy button in the top row. This opens a series of rollouts which, among other things, allows you control of the pivot point independent of the object itself (see Figure 3-34).

FIG 3-34 The Hierarchy panel contains tools to adjust pivot points of objects without affecting the object itself.

3. In the Hierarchy panel, Adjust Pivot rollout, Move/Rotate/Scale: area, click the Affect Pivot Only button. This makes buttons available in the Alignment; area changes the transform gizmo into the transform pivot tripod, still coded with red, green, and blue to help identify the *XYZ* axis (see **Figure 3-35**). At this point, you could use the Select and Move or Select and Rotate to reposition the pivot point in 3D space, but there is a shortcut for positioning it in the geometric center of the object which you will learn in the next step.

FIG 3-35 You can transform the pivot point without affecting the object.

4. In the Hierarchy panel, Adjust Pivot rollout, Alignment: area, click the Center to Object button. This will move the pivot point to the geometric center of the cylinder to provide a new point of future rotations (see **Figure 3-36**). Click the Affect Pivot Only button to toggle it off, and then use Select and Rotate to rotate the cylinder about its new pivot point.

FIG 3-36 Center to Object positions the pivot point in the geometric center of the cylinder.

Note

It is important to remember to toggle the Affect Pivot Only button off when you are done transforming the pivot point to avoid any surprises during future transforms.

5. Practice adjusting the pivot point of the box in the scene in the same manner, and try using Select and Move while in Affect Pivot Only mode to reposition it by hand or using transform type-in. When you have finished experimenting, you can close 3ds Max without saving this file.

Transforming objects in 3D space is something you will spend a lot of your production time on during a typical workflow, and it's important that you take the time to learn these fundamental steps of Reference Coordinate Systems, viewports, the transform tools and transform type-in, as well as adjusting pivot points so that you can use all of the tools in concert with each other to position objects accurately and efficiently.

None of these techniques are particularly difficult but when you are new to 3ds Max, the process as a whole can be confusing. Practice with simple examples and work your way up to more complexity as you develop a feel for how the tools work in conjunction with each other. Make sure that you understand the fundamentals before moving on.

Object Selection

You already have some experience in selecting objects in 3ds Max by clicking the Select Object button in the main toolbar and then clicking on an object in a viewport. The object turns white in the wireframe viewports and displays "bounding box" corners in the shaded viewports to indicate that it is selected. But what happens when you need to select several objects that are scattered around a complex 3ds Max scene?

There is a wide selection of options, which allows you to add individual objects to a selection set, either by defining an area to select a group of objects or by selecting objects by their names. You must familiarize yourself with the basic techniques of selecting objects in the scene and then practice until it becomes a seamless part of your day-to-day workflow. Once you understand the fundamental techniques of selecting objects, you can go on to build a wider knowledge of selection techniques that speed your workflow and make collaboration with other team members in a smoother process.

Some of the fundamental techniques you'll learn in this chapter are as follows:

- *Object naming* – learn the importance of logical naming of objects.
- *Object selection* – learn some of the fundamental techniques of selecting objects in viewports.
- *Select by Name* – logically named objects can be selected easily with this tool.
- *Scene Explorer* – organize and select objects by attributes with this tool.

73

A surprising amount of production time can be spent in selecting the objects that you want to work on for any given task and it's imperative that you become as comfortable as possible with the many selection options 3ds Max has to offer, making the process as efficient as possible.

Selecting objects in 3ds Max is another inherently simple task that, until you learn the fundamentals, is not intuitive to the new user. This chapter will help you to get started with the fundamental tools for developing powerful selection techniques.

4.1 Object Naming

When you learned to create primitive 3D objects or 2D shapes in Chapter 2, you also learned that they were automatically assigned by a name like Box001 or Circle001. At the time you created these objects, the names made sense because that was the end result of the creation process and no editing was performed to change the appearance of the object. In production, however, when you start with a primitive object or shape, usually, it will be edited into a more complex object that no longer resembles the basic primitive, so the default name no longer makes any sense if you want to find that object. For example, you could start with a box primitive to create a table and then afterward you could start with another box primitive to create a house. But if both the objects still have the default names Box001 and Box002, it becomes very difficult to identify which object is which by its name, because neither object looks like a box anymore.

You must develop a habit of renaming objects as soon as they are created, so that everyone in the production team can clearly identify what the object is. This makes it easier to select objects in the scene and to build libraries of assets that people can retrieve quickly because the names are logical.

In Exercise 4-1-1, you'll refresh your knowledge about creating and naming objects and learn about a useful tool built into 3ds Max that helps you to rename objects that are still using the default names or are not named logically for your purposes.

Exercise 4-1-1 Naming Objects

1. Open 3ds Max and toggle the grid off in each of the orthographic viewports, keyboard shortcut G, to reduce the visual clutter, and then right-click the Top viewport to activate it. In the Create panel, Geometry category, Object Type rollout, click the Box button and create four small boxes horizontally across the viewport. The exact size and position of the boxes are not important. Click the Zoom Extents All button in the group of eight navigation buttons at the lower right corner of the 3ds Max display (see **Figure 4-1**). This fills each viewport with the newly created boxes.

2. You learned previously that 3ds Max follows a Create, then Modify concept and it is seldom efficient to rename objects during the creation process. Once creation is complete, you should go to the Modify panel as soon as possible to rename your object and do any necessary editing. Click the Modify panel button and, in the object name field, rename the selected box (it should be Box004) Crate001 as if these objects were going to be crates in your scene (see **Figure 4-2**). Select each of the other boxes and rename each Crate00?, with the "?" being replaced by the next

FIG 4-1 Create boxes with the automatically assigned default names.

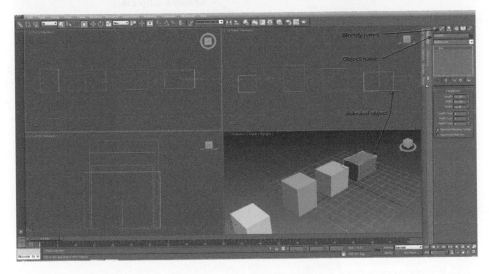

FIG 4-2 Objects can be renamed in the Modify panel.

incremental number. You should now have all boxes named Crate001 to Crate004. Although it was not so difficult to individually select each box and rename it in the Modify panel for just a few objects, it would be very time-consuming and confusing if you had, for example, 25 columns in a building all incrementally named. Let's learn about a faster method of renaming objects.

Note

It almost always makes sense to end an object's name with an incremental multidigit number, so that when multiple new copies are created automatically, they will be properly incremented.

3. You are almost certainly going to encounter 3ds Max files that have improperly named incremental sequences of objects that you want to rename, so this is an appropriate time to learn about this powerful feature. In the Tools pull-down menu, choose Rename Objects…; the ellipsis to the right of the name indicates that a dialog will appear (see **Figure 4-3**). Let's assume that these objects will be the blocks in our new scene.

FIG 4-3 3ds Max has a useful tool called Rename Objects.

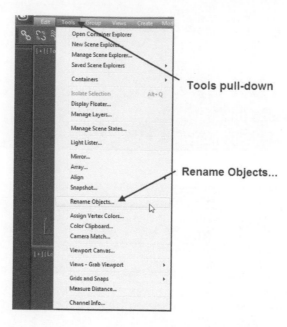

4. In the Rename Objects dialog, choose the Pick radio button and left-click and drag your cursor down over the names in the Pick Objects to Rename dialog that appears (see **Figure 4-4**).

FIG 4-4 The Pick option allows you to select objects by name.

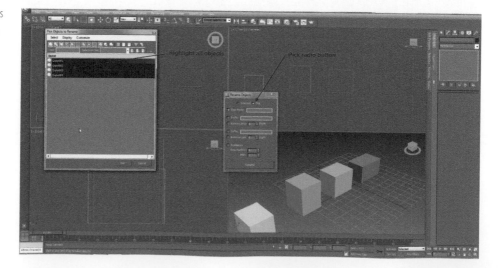

5. In the Pick Objects to Rename dialog, click the Use button at the lower right to accept your selection. In the Rename Objects dialog, enter the name Block in the Base Name field and make sure that the checkbox at the left is checked. Check the Numbered options checkbox and enter 1 in the Base Number: field (see **Figure 4-5**). Click the Rename button.

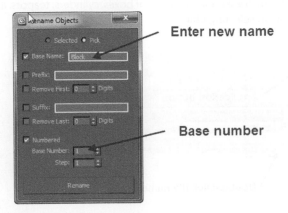

Enter new name

Base number

FIG 4-5 Assign the objects a new base name and a base number to increment from.

6. Click on each of the objects in the Top viewport and notice in the Modify panel that they have been renamed to Block01 through Block04. When many objects have to be renamed in the scene, a situation you will often encounter, this is a handy tool that is not easily spotted by new users.

> **Note**
>
> In this example, the objects you wanted to rename had the same base name and were numbered sequentially, but this command also works on randomly named objects to assign a single logical name that is incrementally numbered.

4.2 Object Selection

Now that you have been introduced to the process of naming objects and understand that it is an important function for maintaining productivity, it's time to learn some of the options for selecting objects in a 3ds Max scene. You will open a scene with multiple objects and learn the following techniques:

* *Add/Subtract using Ctrl/Alt keys*
* *Window/Crossing modes*
* *Selection regions*

These techniques are the fundamental processes commonly used in selecting objects in a 3ds Max scene. You will open a scene that contains multiple objects from the website, save it to your hard drive with a new name, and then use the new file to practice selecting objects.

Exercise 4-2-1 Add/Subtract Selections

1. Start 3ds Max. Click the Application button, choose Open and navigate to the folders containing the 3ds Max files on the website for Chapter 4. In the Open File dialog, double-click on the file name Exercise 4-2-1_Object_selection.max to open it (see Figure 4-6). The file contains an array of boxes, cylinders, teapots, and spheres for you to practice in selecting objects.

FIG 4-6 Open a file containing multiple objects.

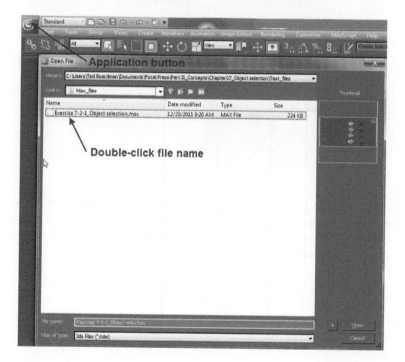

2. Click the Application button and choose Save As in the menu. Navigate to an appropriate folder on your hard drive. In the Save File As dialog, click the + to the left of the Save button to increment the filename and save it to the hard drive (see Figure 4-7). This workflow allows you to maintain the original files and create a series of new files with incremental names as a method of going back in time in case something happens to the current file.
3. Make sure the Top viewport is active. In the main toolbar, make sure that the Select Object button is toggled on, and then click on the upper leftmost box to select it. It will turn white in the wireframe viewports and will show bounding box corners in the shaded viewport to indicate that it is selected (see Figure 4-8). You have already learned how to select individual objects, but let's learn how to add and subtract objects to and from the selection set.
4. Although you are still in Select Object mode, you can use the Ctrl key to add other objects to the current selection set. Hold the Ctrl key and you will see a + appear near the cursor, and as you click on other objects, they will be selected and added to the current selection set. Using this method, select the other objects in the top row (see Figure 4-9).

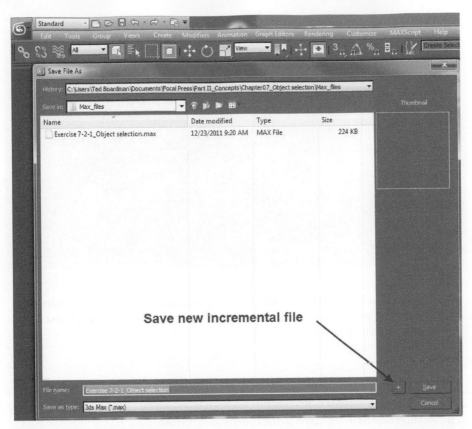

FIG 4-7 Save the file with a new incremental name.

FIG 4-8 Select a single box with Select object.

FIG 4-9 Use the Ctrl key to add objects to a selection set.

5. Although you are still in Select Object mode, you can use the Alt key to subtract objects from the current selection set. Use this method to deselect the cylinder and the teapot from the selection set.

Using the Ctrl/Alt keys while selecting objects is a relatively fast way to build selection sets of a few objects that are visible in the current viewport; practice a bit to get the hang of adding or subtracting objects in the scene to the current selection set.

Let's find a way to speed up the process of creating selection sets of objects in the current viewport in Exercise 4-2-2.

Exercise 4-2-2 Window/Crossing Modes

1. In the main toolbar, to the right of the Select Object button, there is another button with a little cube half-in and half-out of a dotted square. This button is the Windows/Crossing mode toggle. Click it a few times to toggle between Windows and Crossing modes, and set it to Windows mode (the little cube is INSIDE the dotted square). This method allows you to click and drag a Rectangular Selection Region around objects in the active viewport: all objects that are entirely inside the rectangle will be added to the selection set (see **Figure 4-10**). When you release the left mouse button only the objects that are completely inside the selection region will become a new selection set, and any previous selection set is lost.

2. In the main toolbar, click the Windows/Crossing button to toggle it from Windows mode to Crossing mode. The button will change to a cube half-in and half-out of the dotted square. In the Top viewport, click and drag roughly the same selection region as in the previous step (see **Figure 4-11**). In the Crossing mode, all objects that are completely inside the selection region or crossed by it will be added and any previous selection set is lost.

FIG 4-10 A Windows selection region selects all objects completely inside the defined boundary.

FIG 4-11 Crossing mode selects objects inside or crossed by the selection region.

3. Try using Windows/Crossing selection mode in conjunction with the Ctrl/Alt keys to verify that you can build relatively complex selection sets rather quickly by adding or removing several objects at once.

When you need to make selection sets of many objects that are near each other in the viewports, the Windows/Crossing mode, especially in conjunction with Ctrl/Alt keys, can increase your productivity during the task of selecting objects. The default Rectangular Selection Region is fine for many selection sets you may create, but there are other options which expand the capabilities of the Windows/Crossing selection mode; you'll learn them in Exercise 4-2-3.

Exercise 4-2-3 Selection Regions

1. Continue with the file from Exercise 4-2-2 or open the incrementally named file that you saved to your hard drive. If you are continuing with the current file, you can left-click anywhere in the active viewport's empty space to clear the current selection set. In the main toolbar, left-click and hold on the Rectangular Selection Region button to expand the flyout button (**Figure 4-12**).

FIG 4-12 Selection region options are flyouts below the Rectangular Selection Region button in the main toolbar.

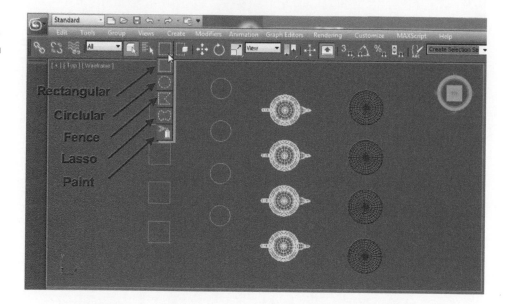

2. Click on the Circular Selection Region flyout and, in the Top viewport, click and drag near the center of the objects to define a circular selection region that behaves according to the current Windows/Crossing mode (**Figure 4-13**).
3. Choose the Fence Selection Region flyout, click and drag in the Top viewport to begin a series of straight line segments, release the left mouse button and click several times, and then double-click to close the fence region (see **Figure 4-14**).
4. Choose the Lasso Selection Region flyout, click and hold it in the Top viewport, and then drag the mouse to define a free-form closed selection region (see **Figure 4-15**). Again, the current Windows/Crossing mode is always respected.
5. Choose the Paint Selection Region flyout, and then click and drag to paint over the objects in the Top viewport. The Windows/Crossing mode is respected, so if you are in Windows mode and the object is larger than the "brush" region, the object is not selected. You can change the brush size by right-clicking on the Brush flyout button in the main toolbar, and then in Preference Settings dialog, General tab, Scene Selection area, enter a new value for Paint Selection Brush Size (see **Figure 4-16**). If you are in the Crossing mode then you just need to "touch" each object with your brush to select them.

FIG 4-13 Circular selection region respects Windows/Crossing mode.

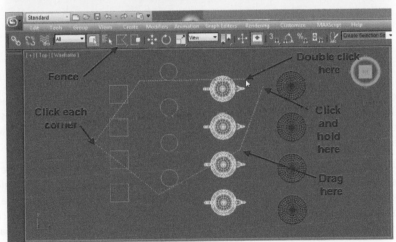

FIG 4-14 A Fence selection region is defined by straight line segments.

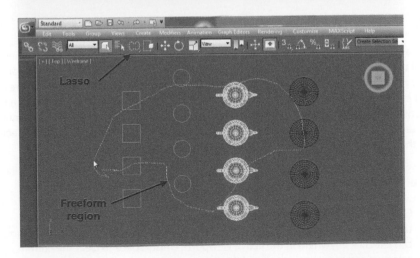

FIG 4-15 A Lasso selection region is a free-form closed region.

FIG 4-16 Paint Selection Region uses a variable brush size to select objects.

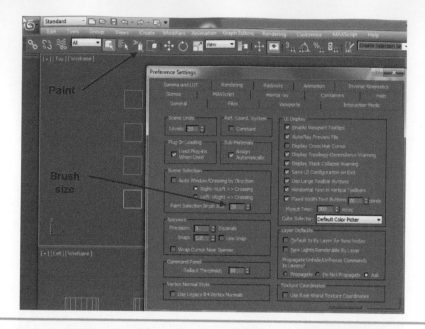

The process of selecting objects in 3ds Max scenes can be time-consuming if you do not apply the many options available for creating complex selection sets. Practice on this scene with the different selection techniques you've learned until you become comfortable and proficient with them.

Earlier in the chapter you learned how to rename objects and were introduced to some of the reasons why it is important to select logical names for all the objects in your scenes. Selecting objects by their logical names is also a helpful method of selecting objects in the scene when those objects are scattered around the scene, making it difficult to select them with pick or region selection methods. In Section 4.3, you'll learn about selecting objects by their names.

4.3 Select by Name

Let's say that you have a 3ds Max scene containing a building with a number of columns that are all the same and you need to select them to make a global change, for example, apply a new material. The columns are randomly distributed throughout the building and are not good candidates for selection by picking individually or by using one of the selection region options. You should, however, have named those objects something logical like Column001 with sequential numbering for the rest of the columns. These objects can be easily selected with the Select by Name command, so let's learn how the process works.

Exercise 4-3-1 Selecting Objects by Name

1. Continue with the file from Exercise 4-2-3 or open the incrementally named file that you saved to your hard drive. If you are continuing in the current file, then you can left-click anywhere in the active viewport's empty space to clear the current selection set. In the main toolbar, left-click on the Select by Name button to the

right of the Select Object button. This brings up the Select From Scene dialog with a listing of all of the objects in your scene (see **Figure 4-17**). The objects in the scene are listed in an alphabetical order.

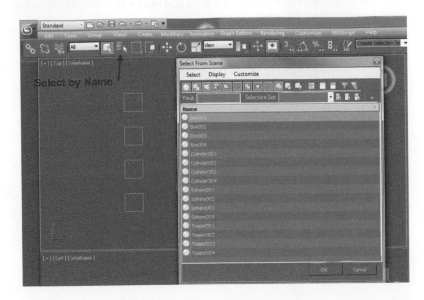

FIG 4-17 The Select by Name button opens the Select From Scene Dialog.

2. You can click on individual object names in the list to highlight them in blue, and you can use the Ctrl and Shift keys in typical Windows fashion to add or remove objects from your selection, thereby creating more complex selection sets. You can also click and drag the cursor across the names you want to select and when you have finished highlighting the objects in the list you must click the OK button to actually create the selection set (see **Figure 4-18**). Once you have them selected, you can use the method that you previously learned to add or subtract from the current selection set.

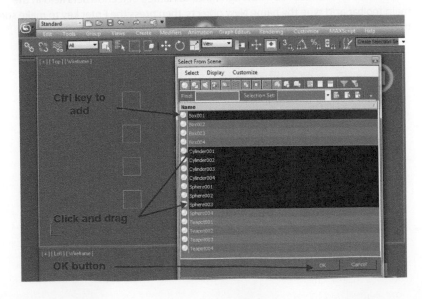

FIG 4-18 Highlight object names in the Select From Scene Dialog and click the OK button to select them.

3. In production, you can use the corresponding keyboard shortcut by pressing the H key to bring up the Select From Scene dialog again. Highlight the Find text field and press the T key and you will see that all of the objects whose names begin with the letter T are tentatively highlighted (light gray) (see **Figure 4-19**). Click the OK button and all teapots will be selected.

FIG 4-19 Object names can be highlighted with the find field.

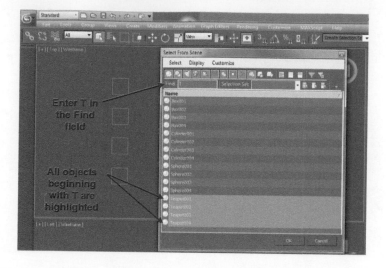

Note

Text entered into the Find field can include standard Windows wildcard characters for a more powerful selection by name (tea*, for example, would select all **tea**pots and **tea**cups objects in a scene).

4. In the Top viewport, click in an empty space to deselect everything. Using the Ctrl key, select a few random objects. Highlight the Named Selection Sets field in the main toolbar and type the name New objects, then press the Enter key to make sure that the Named Selection Set is created (see **Figure 4-20**).

FIG 4-20 Create a named selection set and press the Enter key.

5. Click in the empty space in the Top viewport to deselect everything. Open the Named Selection Sets drop-down list (see **Figure 4-21**) and click New objects in the list to reselect the objects saved in that Named Selection Set. This tool allows you to quickly reselect complex selection sets that may have taken some time to originally compile. Press the keyboard shortcut Ctrl-S to save the latest changes to the file named Exercise 4-2-1_Object_selection01.max.

FIG 4-21 Previously created named selection sets can be accessed from the drop-down list in the main toolbar.

Now you can perhaps more clearly understand the important need for logical naming of objects in 3ds Max. First, everyone on the production team will know what the objects are by their names, and second, you can employ these powerful Select by Name options to select objects that are randomly distributed throughout the scene.

Some selection sets can be difficult to create, but you have learned that the Named Selection Sets allow you to assign a name for a complex selection set, and then invoke it at any time through the drop-down list. This drop-down list is also available in the Select by Name dialog.

4.4 Scene Explorer

The Select by Name dialog is a useful tool for selecting objects according to their names, and then creating a selection set from the named objects. This section will introduce you to a similar tool called Scene Explorer where not only you can select objects by name but also you can find and sort objects on parameters such as color, the number of faces that make up the object, or whether the object has a material assigned to it, just to name a few examples. Once you have configured a Scene Explorer dialog to display certain objects and attributes, you can then save the Scene Explorer dialog with a specific name for easy retrieval.

In this section, you will learn the fundamentals of opening Scene Explorer, configuring the columns of data, and saving the Scene Explorer with a logical name.

Exercise 4-4-1 Opening and Adjusting Scene Explorer

1. Open the 3ds Max file that you saved in the previous exercise, Exercise 4-2-1_Object selection01.max. In the Tools pull-down menu, choose New Scene Explorer in the menu (see **Figure 4-22**). This opens the Scene Explorer-Scene Explorer 1 dialog.

FIG 4-22 New Scene Explorer is found in the Tools pull-down menu.

2. The Scene Explorer dialog looks similar to the Select by Name dialog, showing you a list of all the objects in the scene alphabetically by name. You can search for objects or choose Named Selection Sets if there are any in the scene (see **Figure 4-23**). Let's learn to customize the information displayed in columns.

FIG 4-23 Many of the options found in the Select by Name dialog are found here.

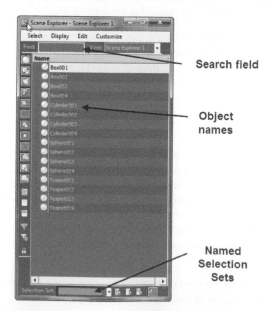

3. In the Scene Explorer-Scene Explorer 1 dialog, right-click on the Name column bar above the list of names, and then choose Configure Columns (see **Figure 4-24**). You will add a column that displays the number of faces (triangles) that define the surface of each object. This will be important information to have later in the book.

FIG 4-24 New columns of data can be added to Scene Explorer.

4. In the Configure Columns dialog that appears, use the scrollbar to the right until you find Faces (see **Figure 4-25**). You will add this column to the Scene Explorer dialog.

FIG 4-25 Locate Faces in Configure Columns dialog.

5. Left-click on Faces and then drag and drop it on the Name text in the column bar at the top of the list. Faces will be moved from the Configure Columns dialog and should appear to the left of the Name column bar showing a list of numbers indicating the faces in each object (see Figure 4-26).

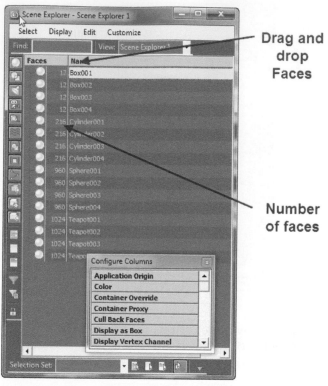

FIG 4-26 Drag-and-drop faces to add the column to the list.

Note

If the column Faces does not appear to the left of the Name column, then it may have been inserted to the right by mistake. Expand the Scene Explorer dialog by clicking and dragging on its right edge until the column appears.

6. Many different configurations are possible to achieve with the Scene Explorer, and it can sometimes take a while to configure the dialog according to your requirements. Highlight the View drop-down list at the top of Scene Explorer 1 and enter the name Object Select Test, and then press the Enter key to rename the Scene Explorer you have configured (see Figure 4-27). It is important that you press the Enter key to actually save the new name. You can now retrieve this configuration at any time by choosing its name from the View drop-down list in the Scene Explorer dialog.

FIG 4-27 Scene Explorer dialogs can be reconfigured, renamed, saved, and retrieved later.

Rename
Scene
Explorer

There are many methods of selecting objects in 3ds Max and organizing them into useful selection sets. These methods will reduce the amount of production time you spend for reselecting objects. You've learned that objects can be selected individually in small selection sets using the Ctrl/Alt keys to add or subtract to the current selection set.

Logical naming of objects is necessary to make it easy to identify objects and to use these names as a means of selecting objects in a 3ds Max scene.

For selecting more than a few objects, you have various selection regions with the Windows/Crossing option, providing control over which the objects are selected or not by the region. The types of selection regions can range from rectangles to painted brushstrokes across objects, in conjunction with the other selection options for complex results.

Once you have created a complex selection set you learned that it is often wise to use the Named Selection Sets drop-down list in the main toolbar to assign a logical name to that selection set for easier retrieval later.

The Select by Name and the Scene Explorer tools allow you to take advantage of the logical names you assigned to objects for creating selection sets by the object name, and then Scene Explorer makes it possible for you to sort objects by many of the attributes assigned to them.

Practice using the fundamental tools you have learned and build your knowledge of selecting objects until it becomes an integral part of your workflow.

Object Cloning

The concept of object cloning in 3ds Max is one of its most powerful features for increasing efficiency and flexibility. It establishes editing connections between objects and reduces memory overhead by decreasing the amount of information required to be saved with each object.

You'll learn two methods of creating clones from original objects; the most popular method is to clone objects while transforming them and the other method is to clone objects in place. Each one has its own uses, but the end result is the same with either of the methods.

Some of the fundamental techniques you'll learn in this chapter are:

- *Cloning concepts*
- *Clone types*
- *Transform cloning*
- *Edit menu cloning*

For maximum productivity, you must fully understand and take advantage of the cloning process so that when you need to edit similar objects in a scene you can simply select one of the objects, modify it, and it will pass its modifications to all other similar clones and, in some cases, back to the original object. This saves many hours of searching for similar objects and editing each one individually. Also, as you will learn throughout this book, it is important to reduce the computer system overhead produced by all the objects in your scene. Cloning is a method of creating objects that don't carry the overhead of the original object, but refer back to the original object instead. This reduces the amount of computer memory used by

each clone resulting in potentially significant savings for large scenes. Reduced memory usage means better performance.

This chapter will focus on helping you understand the concepts behind cloning which you will then put in practice in later chapters.

5.1 Cloning Concepts

When you need multiple objects in 3ds Max, you have options available to make different types of "copies" or clones with no connectivity to the original object, a two-way connection to the original object, or a one-way connection to the original object. Each type allows the objects to be edited with varying flexibility and efficiency.

Objects can be cloned while holding the Shift key during a transformation (move, rotate, and/or scale) or by using the Clone command found in the Edit pull-down menu. The Clone command is useful for cloning objects in place.

Clones can be one of three types: Copies, Instances, or References.

Each type of clone has a different relationship with the original object. You need to understand them for maximum editing flexibility and efficiency reasons. For example, you may want to copy an object that is used as a starting point which is then edited into an entirely different object without affecting the original (Copy clone). Another option would be to copy an object many times, such as a column in a building, and be able to select any one of those objects and edit it while affecting all the other objects in the same way (Instance clone). Other times you might want to copy an object, so that you can edit the original object and affect all the copies, but any edits you perform on the copies will not be passed back to the original object (Reference clone). This might be useful when you only need to make slight changes to a few of the copies, but not affect the original object.

Even if you do not intend to make changes that will affect multiple objects, cloning can be useful to save computer memory space. Each object you create has information attached to it, which describes the original object and takes up some amount of memory. This information is also known as a node. Instance and Reference clones contain pointers that refer back to the original object node; they do not have to store all of the information describing them as they refer back to the original object, thereby saving memory space. Copy clones always take up exactly the same amount of memory space as the original object.

In Section 5.2, you'll learn about the individual types of clones and how they interact with each other and the original object in more detail.

5.2 Clone Types

When you clone an object in 3ds Max, you are presented with several radio button options in a dialog to choose from:

- *Copy*
- *Instance*
- *Reference*

The following diagram shows the interconnectivity of the original object to each type of clone (see Figure 5-1).

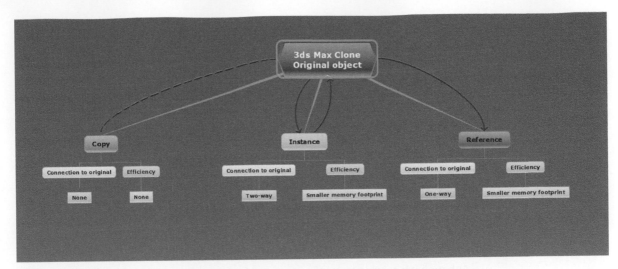

FIG 5-1 Cloning options.

Copy Clone

Copy-type clones are exactly the same as the original object and have no connectivity between the clone and the original, so any edits to one or the other are applied only to the object you are editing. There is no memory savings or increased efficiency because each object contains the full node description. You can make a single clone or multiple clones to create an array of copies.

Instance Clone

When you choose Instance-type clone, as you can see from Figure 5-1, there is a two-way connectivity from the original to each instance. If you edit the original object then the edits will be applied to all the other Instance clones of that object. If you edit any one of the Instance clones then those edits will be passed to all other Instance clones and back to the original object. There are memory savings because the clone "looks back" to the original object for the node description. You can make a single clone or multiple clones to create an array of instances.

Reference Clone

When choosing the Reference clone option, a one-way connection from the original object down to the cloned object is established. If you edit the original object then those edits will be passed to the clone, but any edits made to the clone will not be passed back to the original object. Reference clones save memory because they look back to the original object for the node description. You can make a single clone or multiple clones to create an array of references.

Once you understand the cloning process in 3ds Max, you need to plan ahead (this requires some experience) to choose which connectivity will make the most sense for your editing needs. You can also set up complex connections by cloning Instance clones of Reference clones or Reference clones of Reference clones, etc. However, keeping track of the complexity can be a problem.

Objects that have been cloned as Instances or References can be turned into Copy clones by using a command called Make Unique. This breaks any connections between the objects in the original and adds the node information to the clone that is now unique, but makes the object less efficient in terms of memory.

Let's learn to create clones in Section 5.3 using the transforms.

5.3 Transform Cloning

Perhaps the most commonly used method of cloning objects is to select the object, choose Select and Move or Select and Rotate, hold the Shift key, and transform the object in any viewport. The dialog will appear with the clone type radio buttons, a Number of Copies numeric field, and an opportunity to rename the object.

> **Note**
>
> Although it is possible to use the Select and Scale transform to clone objects, you should remember the warning issued previously "Do not Scale or Mirror objects in 3ds Max."

Let's try using the Select and Move command in 3ds Max to clone a cylinder into each clone type and then edit the cylinder to see the difference in connectivity.

Exercise 5-3-1 Clone Objects by Transforming the Object

1. Click the Application button, and then open the 3ds Max file from Chapter 5 folder on the website called Exercise 5-3-1_Transform clone.max. In the Application menu, choose Save As, then save the file to an appropriate folder on your hard disk with a new incremental name using the + in the Save File As dialog (see Figure 5-2). This will name the new file as Exercise 5-3-1_Transform clone01.max. The file contains one Cylinder standard primitive object.

FIG 5-2 Open a 3ds Max file and save it to your hard disk with a new name.

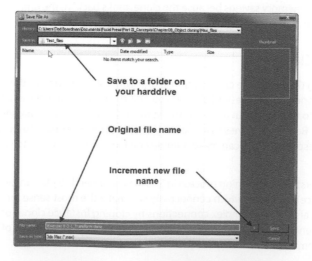

2. Select the cylinder in the Top viewport. In the main toolbar, click the Select and Move button. Hold the Shift key and click and drag on the transform gizmo X-axis arrow shaft and move the new clone cylinder a little to the right. Release the left mouse button and the Shift key and you will see the Clone Options dialog appear (see Figure 5-3).

FIG 5-3 The Shift key clones objects while transforming them.

3. In the Clone Options dialog, make sure that the Copy radio button is selected and rename the object Copy in the Name field (see Figure 5-4). Click the OK button to finish the cloning process.

FIG 5-4 The copy option creates a clone with no connection to the original.

4. In the Top viewport, select the original object again. Hold the Shift key and move the new clone through the Copy clone and slightly beyond. In the Clone Options dialog, choose the Instance radio button and rename the object Instance (see Figure 5-5). Click the OK button to finish the process.

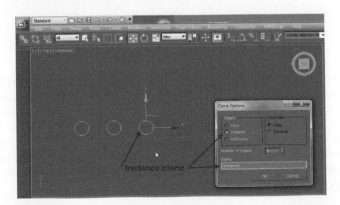

FIG 5-5 Create an Instance clone to the right of the copy clone.

5. In the Top viewport, select the original object again and clone it through the others just to the right of the Instance clone. Choose the Reference radio button and rename the object Reference in the Clone Options dialog (see **Figure 5-6**). At this point, the objects still look identical, but in the next step you'll change the parameters of the original cylinder and the Instance clone. Then, you'll apply a modifier to the Reference clone.

FIG 5-6 Create a Reference clone to the right of the others.

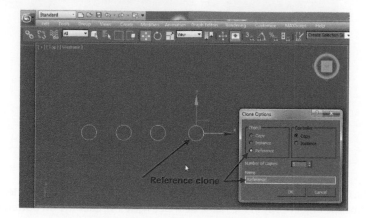

6. In the Top viewport, select the original cylinder at the far left. In the Modify panel, Parameters rollout, click and hold on the spinner's to the right of the Radius numeric field and move the mouse forward and backward to dynamically adjust the radius. You will notice that three of the cylinder's radii are also changed. The Copy clone has no connection (see **Figure 5-7**).

FIG 5-7 The copy clone is the only one that is not connected to the original cylinder.

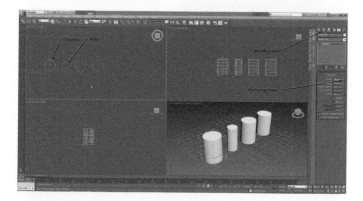

7. In the Top viewport, select the Instance clone (third from left) and, in the Modify panel, adjust the Height spinner to alter the height of the objects (see **Figure 5-8**). The edits are passed from the Instance clone to the original because of the two-way link. The Reference clone changes because of the one-way link between the original and the Reference clone. There is no direct connection from the Instance clone to the Reference clone because it was the original that you cloned each time. Modifying the Instance clone affects the original, and then the original affects the Reference clone.

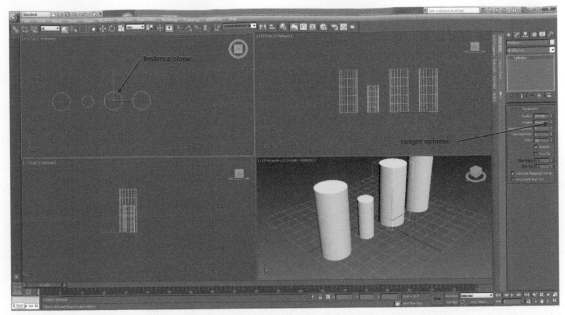

FIG 5-8 Modifying the Instance clone affects the original, and then the original affects the Reference clone.

8. In the Top viewport, select the Reference clone at the far right. In the Modifiers pull-down menu, hover your mouse over Parametric Deformers and then choose Bend in the menu (see **Figure 5-9**). This applies a Bend modifier that you'll learn more about later to the Reference clone object.

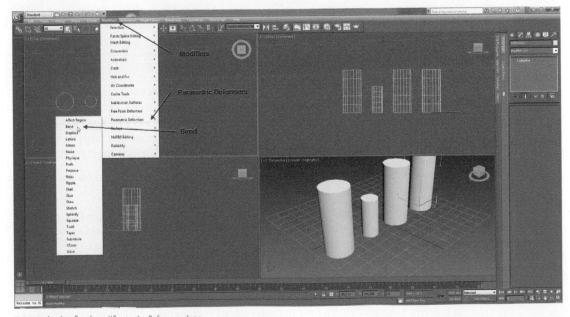

FIG 5-9 Apply a Bend modifier to the Reference clone.

9. In the Modify panel, Parameters rollout, enter **90** in the Angle numeric field (see **Figure 5-10**). This bends only the Reference clone object, which only has a one-way connection from the original down to the Reference clone. This modifier is applied as a new level of modification on top of any of the original editing parameters. Press Ctrl+S to save the current file with its incremented name to your hard disk. Don't worry about modifiers at this point as they will be addressed in more detail later in the book. Focus your attention on the connections created by the clone objects.

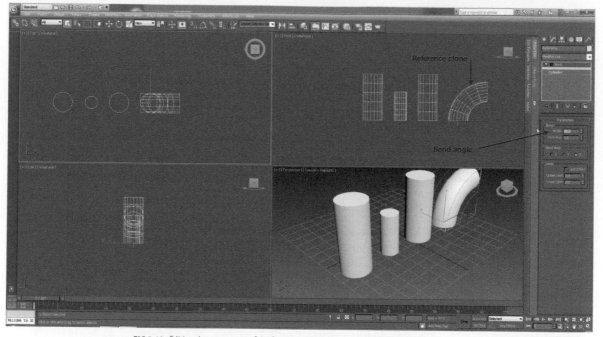

FIG 5-10 Editing the parameters of the Bend modifier affects only the Reference clone with its one-way connection to the original.

The fundamental concepts of cloning are that a Copy clone has no connection to the original and takes up the same amount of memory space, an Instance clone has a two-way connection with the original and takes up less memory space, and a Reference clone has a one-way connection with the original down to the Reference clone and takes up even less memory space. Any modifier applied to the Reference clone does not affect the original.

You could also have cloned the objects using the Select and Rotate tool in conjunction with the Shift key.

Cloning requires a little bit of preplanning to ensure your connections are set for your production needs, but with a little practice you'll realize how it brings extra flexibility and efficiency into your workflow.

5.4 Edit Menu Cloning

In Exercise 5-4-1, you'll learn how to create clones in place from the Edit pull-down menu. This has no effect on the behavior of cloning, but creates clone objects without transforming

them through space, thereby allowing you to more accurately transform them after they have been created. For example, you clone a building column as an Instance clone in the same position as the original, and then you use the transform type-in fields to move it 10′6″ in the X-axis.

Exercise 5-4-1 Cloning Objects in Place

1. Use the 3ds Max file from Exercise 5-3-1 or open it from the folder on your hard drive where you saved it. It is the scene with the original cylinder and the three clones. In the Top viewport, select the Copy clone (second from left).
2. In the Edit pull-down menu, choose Clone (see **Figure 5-11**). This brings up the Clone Options dialog which is similar to Exercise 5-3-1, except that there is no option for creating multiple clones. Choose the Instance radio button, rename the object Edit Clone (see **Figure 5-12**) and then click the OK button to finish the process.

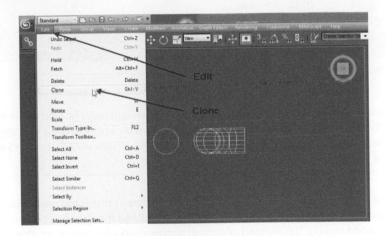

FIG 5-11 A Clone command is found in the Edit pull-down menu.

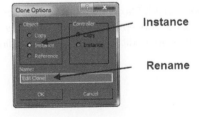

Instance

Rename

FIG 5-12 Clone options allows only one clone object from the Edit pull-down menu.

3. You won't see another cloned object in the scene because it is exactly in the same position as the original object. Use the H key shortcut to open the Select by Name dialog and see that Edit Clone is the selected object. Click OK. In the main toolbar, click the Select and Move button. In the status line, toggle from Absolute mode to Offset mode and then enter **20** in the Y-axis numeric field (see **Figure 5-13**). Press the Enter key and the Instance clone object will move 20 units in the positive y-axis.

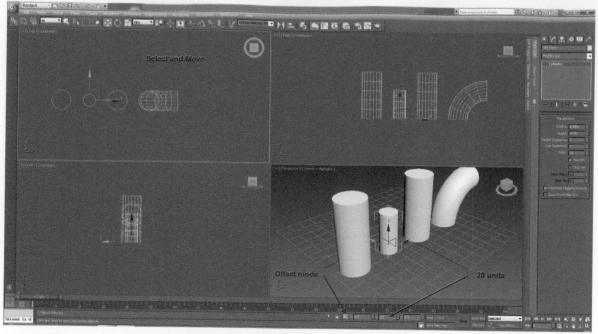

FIG 5-13 Move the Instance clone with the transform type-in set to offset mode.

4. In the Modify panel, Parameters rollout, adjust the Height numeric field to see that both the Copy clone from Exercise 5-3-1 and the Instance clone share a two-way connection while none of the other objects is affected in any way. Press Ctrl+S to save the file.

The only difference in cloning from the Edit pull-down menu is that the cloned object is created exactly in the same position as the original object and there is no option for creating multiple cloned objects. This method of cloning is more conducive to moving objects in exact amounts.

The concept of cloning objects in 3ds Max is very important for both flexibility in editing and efficiency in memory savings. The concept is not intuitive for new 3ds Max users and you will need to think ahead to calculate your editing needs before deciding which type of clones to create.

Scene Setup

When you start 3ds Max for the first time each day or when you press the Reset command to return the current scene to the default settings, those settings that shipped with 3ds Max are not always ideal for your workflow. In this chapter, you will learn how to make changes to the viewport configuration and numerical unit settings that you would like to have for each new file created in 3ds Max.

In this chapter, you will learn the concepts and process behind setting up a "prototype" file that automatically reconfigures 3ds Max on startup or when you reset the scene. Some of the topics covered in this chapter will be as follows:

- *Unit setup*
- *Grid and snaps*
- *Maxstart.max prototype file*

Unit Setup

Setting up your display units so that numeric values in the 3ds Max interface conform to the type of units you use is important. For example, you might work with values such as a 10'6", or 200 mm, or 101", but 3ds Max uses something called Generic units as the default unit display. These numeric values are simply decimal numbers that have no visible markings to indicate which measurement system they use. Most real-world projects standardize on a specific system of measurement, so that everyone on the production team is building objects in real-world sizes.

There are also system units in 3ds Max, which are used during the internal calculations based on a specific measurement system. The default system units are 1 unit = 1 inch, which users in the USA seldom need to be concerned with. In most other parts of the world, the metric system is standard and you may need to change the system units to represent meters or centimeters, for example. For best results, the measurement system of the system unit should also be used in the display units.

You'll learn about the importance of building your 3ds Max scenes around the World coordinate system origin (0, 0, 0) and about some of the problems you might have if objects are imported from other software with a different coordinate system origin.

Grid and Snaps

You'll learn to adjust the visible grid spacing in viewports and the concept of using "snaps" as aids for construction accuracy. It can be important for new 3ds Max users to utilize the viewport grids as a guide for creating objects in real-world sizes. Since the grids can be toggled on or off with a keyboard shortcut you always have the option of using them only when necessary, and turning them off to avoid visual clutter in the viewports.

Snaps can be configured to lock the cursor to elements in the viewports or to other objects in the scene. For example, creating a primitive object might be more accurate if you snap to grid at intersections set with a spacing of 1'0" or if you want to create a cylinder whose pivot point and starting location snaps exactly to the corner of a box. You'll learn to adjust the grid system to maximize flexibility.

Maxstart.max Prototype File

Once you have your scene set up with your preferences, you will learn to save a special file that will be read each time 3ds Max starts or each time you press the Reset command, reloading your specific configuration as a starting point for the new file. This ensures that the entire production team is working with the same configuration, thereby minimizing incompatibilities in the production pipeline.

Let's start by adjusting the Display units and learning some details about the System units.

6.1 Units Setup

You'll learn to configure the Display units in 3ds Max for a particular measurement system; in this case we will use feet and inches with fractions, a typical measurement system used in the USA by architects and, sometimes, civil engineers. Remember that the settings we use here are not necessarily the ones that you will use in production, but you are learning the fundamentals of how units function in 3ds Max and you can change them to your preference at any time.

3ds Max contains settings for two different numeric values as follows:

- *Display units* – this sets the system of measurements displayed in the numeric fields and readouts of the user interface.
- *System units* – this is the system of measurements used internally by 3ds Max calculations.

The System units are generally changed only when you are building scenes using the metric system or sometimes when importing and exporting 3ds Max files to software that uses another measurement system. It is a good habit to get into adjusting the measurement system of the Display units to match the measurement system in the System units.

You learned earlier that your scenes in 3ds Max should be constructed around the origin point of the World coordinate system (0, 0, 0) as indicated by the black gridlines in the viewports. This is the origin of the absolute coordinate system that defines 3ds Max space. The design of 3ds Max uses Single Precision Math to allocate more computer memory to specialized tasks such as reflections, shadows, and lighting. Objects that are constructed or animated at great distance from this origin point can have severe problems with accuracy, resulting in distorted geometry and random animation. CAD software, by comparison, is Double Precision Math based and has a significantly higher accuracy.

Note

Civil engineers and architects often create scenes in CAD software based on a surveying system known as "State Plane Coordinates" that is measured from a single datum point for each US state. The coordinates of these objects are, therefore, extremely large in numbers, which can overwhelm the memory used by 3ds Max causing inaccuracy. These imported models should be moved to the 3ds Max origin point.

Let's open a max file and learn how to set up units systems.

Exercise 6-1-1 Display and System Units

1. Start 3ds Max. It should open the default configuration of four viewports, grids visible in all viewports, perspective viewport active, and Display units set to Generic. In the Customize pull-down menu, choose Units Setup (see **Figure 6-1**). This will open the Units Setup dialog.

FIG 6-1 The default 3ds Max interface and Units Setup.

2. In the Units Setup dialog, Display Unit Scale area, choose the US Standard radio button. This is currently set to use a display configuration of feet w/fractional inches in the drop-down list and is set to display the nearest 1/32 of an inch precision (see **Figure 6-2**). In the US Standards area, you'll also notice that the Feet radio button is set for Default Units. This might seem a little bit confusing at first, but you will learn about it in more detail later. This is for setting the Display units, but let's have a look at the System units before leaving the Units Setup dialog.

FIG 6-2 Set the Display units to US Standard feet and inches.

US Standard

Feet and inches

Precision

Default Units

3. In the Units Setup dialog, click the System Unit Setup button to display the System Unit Setup dialog (see **Figure 6-3**). The default System Unit Scale is *1 Unit = 1.0 Inches,* which is fine for our Display units of feet and inches. Again, this setting is usually changed only when you switch to a metric system of measurement. What is important in the System Unit Setup dialog at this point in time is the information in the Origin area. It is reporting an extremely precise Resulting Accuracy value when an object is 1.0 unit (inches in this case) distant from the origin for reference.

FIG 6-3 The default system unit configuration.

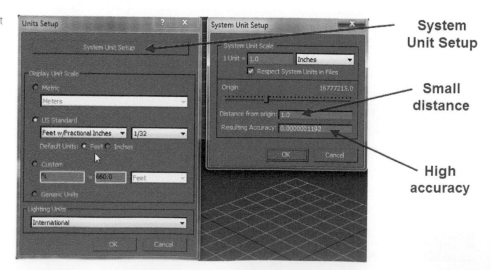

System Unit Setup

Small distance

High accuracy

4. In the Distance from Origin numeric field enter **100,000,000** and then press the Enter key. This would not be an unusual number of inches away from a datum point in a large US state. You can see now that the Resulting Accuracy would be 8.0 inches at best. This is completely unacceptable working accuracy for 3ds Max (see **Figure 6-4**). This accuracy calculator doesn't have any other functionality than to determine the accuracy tolerance factor for your particular scenes.

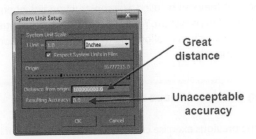

Great distance

Unacceptable accuracy

FIG 6-4 The System Unit accuracy reference.

5. In the System Unit Setup dialog, click the Cancel button to dismiss the dialog, and then in the Units Setup dialog, click the OK button to finalize the Units Setup process. You will notice now that the numeric field for the grid spacing in the status line has changed from 10.0 generic units to 0'10" and the coordinate readouts are in feet and inches indicating the change in the Display units (see **Figure 6-5**). Save the file to your hard drive with the name Chapter 6_Units.max.

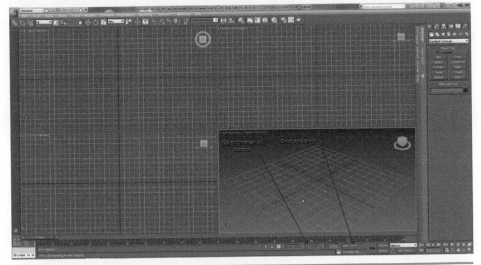

FIG 6-5 Display units are now set to feet with fractional inches.

Once the Display and System units are set, they usually won't need to be adjusted unless the project switches to a new system of measurement. However, this information should be established as part of the preplanning process for each project and maintained as a standard throughout the project to avoid inconsistencies in 3ds Max scenes.

Many problems that arise during 3ds Max projects such as animated objects that jump randomly or geometry that distorts inexplicably can often be traced back to how far any object in the 3ds Max scene is from the (0, 0, 0) World coordinate system origin.

In Section 6.2, you'll learn to adjust the visible grid in viewports for accuracy and flexibility when creating objects in 3ds Max.

6.2 Grid and Snaps

The visible grids in the viewports can be a useful tool for reference in creating and placing objects in a 3ds Max scene, and they can be used as a construction aid when creating objects in conjunction with the Snaps system. You will learn the fundamentals of adjusting the grids and enabling the Snaps system to allow you to use grid intersections for constructing objects more accurately.

Exercise 6-2-1 Using Grids and Snaps as Construction Aids

1. Open the file from the previous exercise called Chapter 6_Units.max if it isn't already your current scene, or open it from the website. It should have the US Standard system of measurement set for display units. In the main toolbar, right click on the Snaps Toggle button to open the Grid and Snap Settings dialog. Click the Home Grid tab to adjust the grid settings first (see **Figure 6-6**).

FIG 6-6 Grid and Snap Settings dialog.

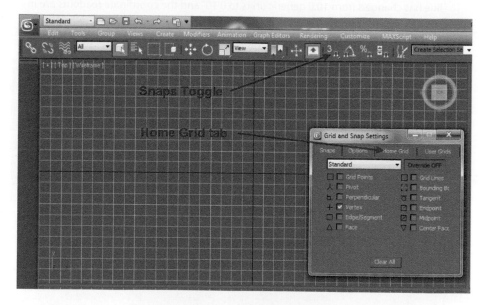

2. In the Home Grid tab, Grid Dimensions area, enter **1"** in the Grid Spacing numeric field and then press the Enter key to see the numeric value update to 0'1" inch. In Step 2 of the previous Exercise 6-1-1, you observed that Default Units was set to Feet. What this means is that if you type in a numeric value with no inch or foot sign, the value will be understood as feet in numeric fields. For values containing inches, you need to add the inch sign. In the Major Lines every Nth Grid Line numeric field, enter **12**. In the Perspective View Grid Extent numeric field, enter **960** (see **Figure 6-7**). Grid Spacing is the distance between grid lines, Major Lines is the darker gray grid line visible at every 12th grid line, and Perspective View is the size of the grid visible in the Perspective viewport. Close the Grid and Snap Settings dialog.

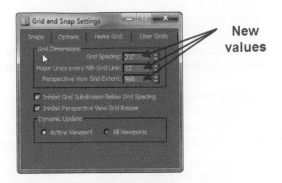

New values

FIG 6-7 Adjust the Home Grid values.

Note

The Home Grid dialog in 3ds Max is not consistent when entering numeric values. The Grid Spacing is entered in feet and inches, the Major Lines is an integer number, And Perspective View is the size in inches which must be entered as an integer (with no foot or inch sign). This inconsistency is often confusing to new users, but it's the way it works in 3ds Max and you need to live with it.

3. In the status line notice that the grid size information field reads Grid = 1'0", even though you set grid spacing to 0'1". This is a secondary effect of the Major Lines setting. It acts as a zoom factor to automatically resize the grid by a factor of 12, in this case, as you zoom in and out. If you use the mouse wheel to zoom out in the Perspective viewport, you will see that the grid spacing shifts to 12'0" (see Figure 6-8) and if you zoom in you will see that it goes to 1'0", and then 0'1". Zooming in further will not go below 1 inch because of a setting in the Home Grid tab. Click the Zoom Extents All button to reset the grid spacing zoom level for all viewports to 1'0".

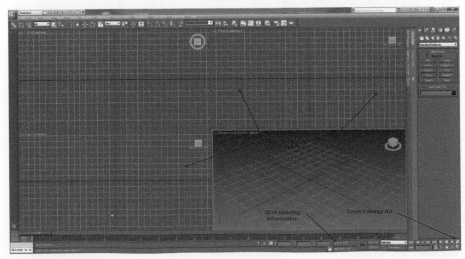

FIG 6-8 The Major Lines setting has two functions.

Note

Some computer graphics cards and displays make it very difficult to see the Major Lines in the viewports, but they have no special function other than visual reference.

4. Right click in the Top viewport to activate it. In the main toolbar, right click on the Snaps Toggle button and, in the Grid and Snaps Setting dialog, Snaps tab, make sure that the only option checked is Grid Points (see **Figure 6-9**). This sets the snaps to use the grid intersections as a construction aid, but it does not enable Snaps.

FIG 6-9 Set Snaps to Grid Points.

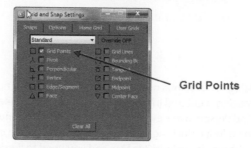

5. In the main toolbar, left click the Snaps Toggle button to toggle it on. Snaps are now activated, so let's see how they work. In the Create panel, Geometry category, Object type rollout, click the Box button. In the Top viewport, move the cursor over the grid and you will see a yellow box with crosshairs each time the cursor crosses the intersection of grid lines (see **Figure 6-10**).

FIG 6-10 Snaps Toggle must be toggled on.

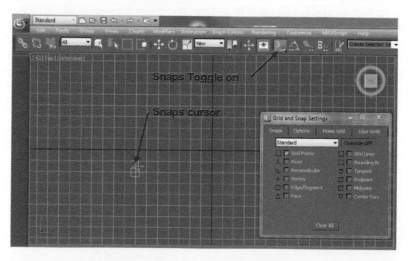

6. When you see the yellow snap cursor, click and drag, and then snap to another grid intersection to define the base of a box primitive. The snap cursor will turn green. Release the left mouse button and move the mouse to define a height of the box, and then click to set the height. In the main toolbar, click the Snaps Toggle button to toggle snaps off. It is a good habit to turn snaps off when you are not using them.

You have set the grid spacing to a value that would generally be useful for creating "architectural" scenes. It might be pure architecture or it could be a level for a computer

game, but the grid will assist you as a reference for the size of objects as you create them.

You then set snaps settings for grid intersections and then had to toggle Snaps Toggle button on to actually use the snaps. Review the Snaps options available in the Grid and Snap Settings dialog, Snaps tab to see what types of geometry components or interface elements can be used for snapping purposes. You may also select multiple options for more flexible snapping.

In Section 6.3, you will make a couple of new adjustments to the viewports and then learn to save a prototype file that will be read each time you start a new 3ds Max scene.

6.3 Maxstart.max Prototype File

While it's not particularly difficult or time consuming to make the few changes for unit setup, grid and snaps that you have learned so far, it would be handy to have that information read and adopted automatically each time you open 3ds Max or perform the Reset command. In Exercise 6-3-1, you will create a new file on your hard drive that stores some of the changes you have made to the interface with the specific filename of *maxstart.max*. This is the only file that 3ds Max recognizes as a prototype settings file and it must be stored in one of the active 3ds Max folders.

For a production team, it is advisable for this file to be distributed to all the team members, so that everyone starts their files in the same way for consistency throughout the production. Let's make a few more interface changes and then create the file.

Exercise 6-3-1 Saving the Maxstart.max File

1. Close the Grid and Snap Settings dialog in the scene you have been working on from the previous Exercise 6-2-1. Delete the box object you created by pressing the Delete key on the keyboard when the box is selected. In the main toolbar, toggle the Snaps Toggle button off. Turn off the grid in both the Front and Left viewports by activating each one and pressing the keyboard shortcut G. Right-click in the Top viewport to activate it again (see **Figure 6-11**).

FIG 6-11 Configure the viewports.

2. Click the Application button and choose Save As. In the File Save As dialog, navigate to the My Documents/3dsMax/Scenes folder on your hard drive. In the File Name text field, enter the filename **maxstart**. Click the Save button to save the file to your hard drive (see **Figure 6-12**). You have now created a new file that contains no objects, but has been configured to your needs.

FIG 6-12 Save the file in the /3dsMax/Scenes folder on your hard drive.

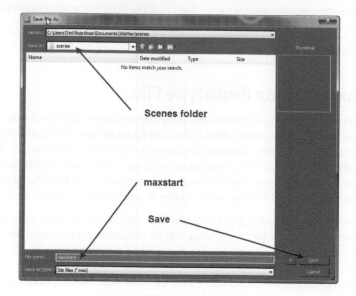

3. The file that is now active is the maxstart.max prototype file and anything you do from this point on will be saved to that file, so it's important to reset the machine for a new file. Click the Application button and then choose Reset in the menu (see **Figure 6-13**). Watch the display as you click the Yes button to tell 3ds Max you really want to reset and you will see the screen load the default settings, and then read the maxstart.max and automatically reconfigure your preferences.

FIG 6-13 Reset 3ds Max to start a new scene with your prototype configuration.

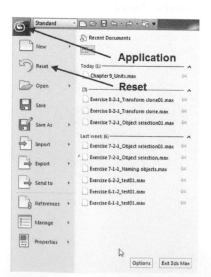

Note

In a collaborative production environment, this file can be placed on the main 3ds Max server, so that everyone in the production team has access to the file from their computer. Check with your system administrator for more information.

The maxstart.max prototype file is used to make sure that everyone in the production team is starting their scenes with the same basic information and viewport configurations. This helps reduce inconsistencies in the production workflow. The file can be overwritten with new information at any time, for example, if your next project uses the metric measurement system rather than the US standard that you set here.

Proper configuration of the Units Setup is important to make sure all objects created in 3ds Max have the same relative real-world sizes. This ensures that objects may be reused in other scenes without problems. You also learned that it is extremely important to create your 3ds Max scenes centered around the (0, 0, 0) World coordinate system origin to maintain accuracy throughout production.

Grids and snapping are useful aids to construction, but are not mandatory. New users should try implementing them, especially when learning 3ds Max initially, and then as you become comfortable working in 3ds Max, you will know when they are necessary and when they are not.

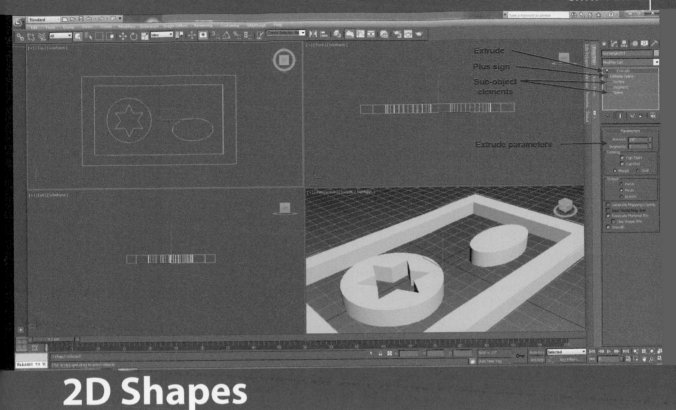

2D Shapes

You might ask yourself why you would want to create 2D shapes in a complex 3D program such as 3ds Max. The two biggest reasons are efficiency and flexibility.

By starting your models with 2D shapes, you gain access to many powerful editing options that are not available when you start your models with 3D primitive objects. You have already learned to edit 2D shapes by changing their parameters, the length or width of a rectangle or the radius of a circle, for example. This chapter will cover the following topics:

- *2D shape concepts* – learn about the concepts that make 2D shapes efficient and flexible when modeling.
- *Create basic shapes* – create both simple and compound shapes.
- *Compound shapes* – learn to attach simple shapes into a single compound shape and the related effects of nesting levels of the splines within the shape.
- *Editable Spline* – a 2D shape that has been converted to allow access to subobject entities.
- *Subobject editing* – here you will access and edit 2D shapes at vertex, segment, and spline subobject level.

7.1 2D Shape Concepts

2D shapes can be used as a basis for creating complex 3D objects with a high degree of efficiency and flexibility, while helping to maximize computer resources and allowing you to make complex changes to 3D objects using simple edits performed on the underlying 2D shapes.

A simple 2D shape, a circle for example, can be extruded into a 3D cylinder. However, 2D shapes can be attached to each other to become a *Compound* shape, a single shape containing multiple *Spline* subobject entities. When a compound shape is extruded into a 3D object, each of its subobject Splines become a solid or a void, depending on the nesting level within the shape. This powerful concept can increase your productivity in making complex 3D objects while minimizing the use of computer memory.

You can also take advantage of a concept in 3ds Max called subobject editing where you can modify the basic entities that make up the 2D shape: vertex, segment, and spline. In this chapter, you'll learn to identify, access, and transform these shape building blocks at sub-object level.

2D shapes can also be used as animation paths, provided they are simple shapes and not compound shapes. By default, shapes are nonrenderable.

7.2 Create Basic Shapes

Let's have a little refresher on how to create 2D shapes in 3ds Max and then learn a little more detail about some of the different types of shapes beyond the basic simple shape. You learned earlier in the book to create parametric rectangles and circles and then to go to the Modify panel to adjust the parameters associated with each type of shape.

A shape is a 2D object in 3ds Max, which has a name and a randomly selected color assigned to it during creation.

Here you'll learn how some of the other types of shapes have different parameters, for example, a NGon or multisided polygon, a Donut compound shape, and Text. The purpose of this lesson will be to learn to access the command for creating the shape and the sequence of clicks and drags necessary to describe a basic shape.

Exercise 7-2-1 New 2D Shapes

1. Open 3ds Max to begin a new scene. The maxstart.max prototype file that you created and saved in the last chapter should configure your user interface and units. Use the Application button, Save As, in the Save File As dialog to navigate to an appropriate folder on your hard drive, and then name the file **Exercise 7-2-1_New shape01.** Click the Save button (see **Figure 7-1**). This creates a file that can be accessed later if you are interrupted during the exercise.
2. In the Top viewport, use the keyboard shortcut G to turn off the grid. In the Create panel, Shapes category, Object Type rollout, click the NGon button. In the Top viewport, click and drag to define a radius describing the polygon shape. The size is not important (see **Figure 7-2**). A NGon is a simple multisided polygon. Circles, rectangles, ellipses, or stars are other examples of simple 2D shapes.

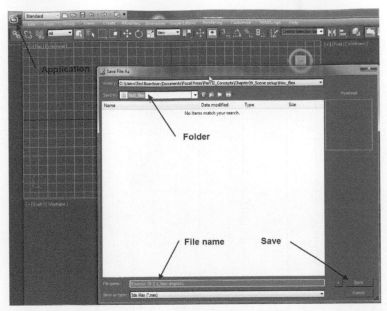

FIG 7-1 Begin by saving a new 3ds Max file.

FIG 7-2 A default 6 sided NGon.

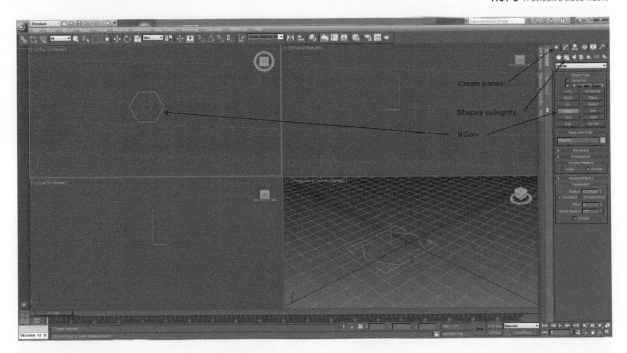

3. In the Create panel, Shapes category, Object Type rollout, click the Donut button. Click and drag in the Top viewport to describe the radius of a circle, and then move the mouse to describe a second circle and click to set its radius (see Figure 7-3). This shape is a compound shape made up of two splines, which you'll learn more about in Section 7.3.

FIG 7-3 A Donut is made up of two splines and requires more input to describe both circular splines.

4. In the Create panel, Shapes category, Object Type rollout, click the Text button and then click in the Top viewport. Click the Modify panel button to see some of the parameters for editing the text shape (see **Figure 7-4**). This creates default text with a single click in the viewport, which is a compound 2D shape with many splines. You can then edit the text itself, the font, and some layout parameters in the Modify panel.

FIG 7-4 Text is a compound 2D shape with editable parameters.

Remember that this is a 2D shape and that these are nonrenderable shapes that must be turned into a 3D object before they would be visible in a rendered scene.

5. Click the Zoom Extents All button (in the group of eight navigation buttons at the lower right of the display) to zoom all objects in all viewports. Press the Ctrl+S keyboard shortcut to save the file. It should already be named Exercise 10-2-1_New shape01.max, so this will update the existing file with the new shapes you have just created.

You have learned that some of the 2D shape primitives are simple shapes containing one spline, whereas others are compound shapes containing two or more splines. The shapes are created in the current work plane of the active viewport. Let's learn more about the difference between simple and compound shapes and why it's important in 3ds Max.

7.3 Compound Shapes

Compound shapes are shapes with multiple splines, but why does that matter?

When simple shapes are edited into 3D objects, they appear as if they were solid objects, but when compound shapes are edited into 3D objects, they create surfaces with solid areas and voids depending on the configuration of the splines within the shape. As mentioned earlier, this attribute can be used to create complex yet flexible 3D objects efficiently without the use of mathematically intensive Boolean operations.

In the following exercises, you will learn to apply a modifier to 2D shapes to create 3D objects, and then you will learn to access and edit the splines contained in the shape for more control in defining your 3D objects.

Exercise 7-3-1 Compound Shape as 3D Object

1. If it isn't already the current file in 3ds Max, then open the file called Exercise 7-2-1_New shape01.max that you saved to your hard drive in Exercise 7-2-1. Save the file with a new incremental name to your hard drive. The scene contains the three new shapes that you created in the last exercise. In the Top viewport, select the NGon. In the Modify panel, click on the drop-down Modifier list, and then choose Extrude from the list (see Figure 7-5).

2. The resulting object has no height and appears as a flat surface. In the Modify panel, Parameters rollout, enter **1** in the Amount numeric field and press the Enter key. This extrudes the 2D shape into a hexagonal solid that is 1'0" tall (see Figure 7-6). The 3D object appears solid because it was extruded from a simple 2D shape.

3. In the Top viewport, select the Donut 2D shape. In the Modify panel, Modifier list, choose the Extrude modifier. The new modifier remembers the height you assigned to the previous modifier and extrudes the compound shape as a cylinder with a hole running through it (see Figure 7-7). The concept of compound shapes allows you to create complex objects more efficiently than other modeling techniques. The extruded compound shape creates a solid from its outer boundary until it finds an "island," which becomes a void in the 3D model.

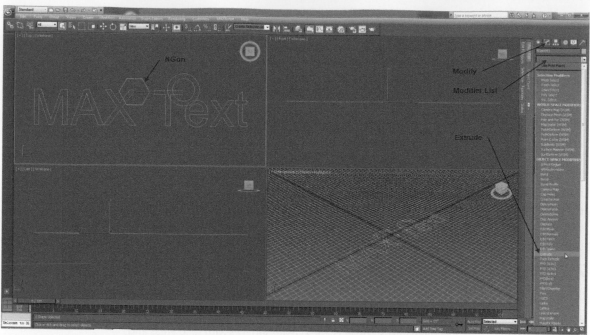

FIG 7-5 Apply a modifier to the 2D shape to create a 3D object.

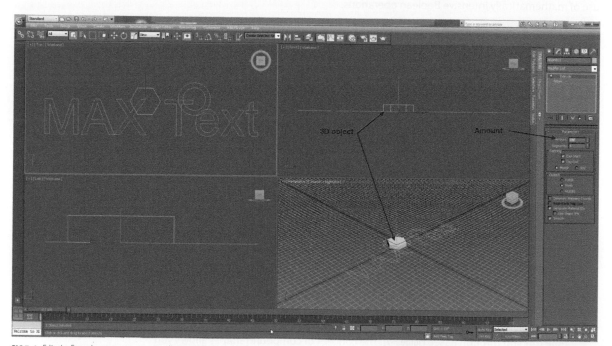

FIG 7-6 Edit the Extrude parameters to give the new 3D object height.

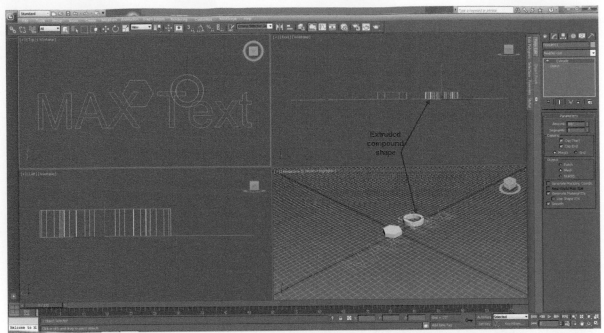

FIG 7-7 A compound shape results in a more complex 3D object.

4. In the top viewport, select the Text shape, then apply the Extrude modifier to It. The configuration of the new 3D solid is a combination of standalone solids from individual splines and nested splines that create solids with voids (see **Figure 7-8**). The extruded text is a single 3D object with many parts; some of the letters are solid while the letter **A** and the letter **e** have the correct voids created by nested splines.

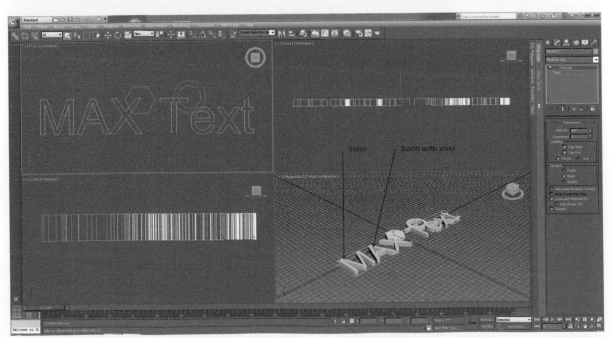

FIG 7-8 Text 2D shapes can be complex compound shapes.

5. Press the Ctrl+S keyboard shortcut to save the file. It should already be named Exercise 7-2-1_New shape02.max. You should be able to begin to see the power of compound 2D shapes when they are edited to become 3D objects. Let's learn a little more about nested compound shapes containing more than two levels of nesting.

Exercise 7-3-2 Nesting Shapes

1. Open the 3ds Max file from the website called Exercise 7-3-2_Nested shapes01.max and save it to an appropriate folder on your hard drive with a new incremental name. This scene contains a number of simple shapes. You can see that each shape has its own color and if you hover the mouse over a visible part of a shape, you will see a tooltip appear with the name of the shape (see **Figure 7-9**). Remember that those are the two indicators of a shape; name and color.

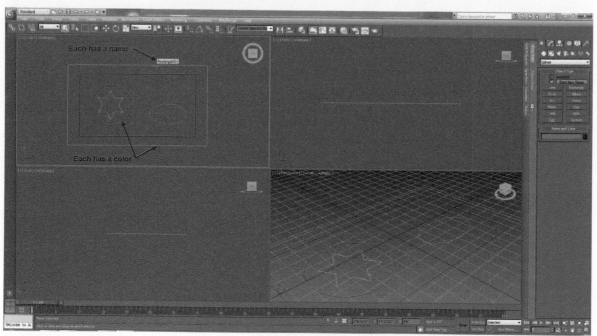

FIG 7-9 Shapes have a color and a name.

2. Press the H keyboard shortcut and, in the Select From Scene dialog, select all of the shapes by name by clicking and dragging down across the names to highlight them in blue (see **Figure 7-10**). Click OK to select the shapes. You will apply an Extrude modifier to the selected individual shapes keeping in mind that this is not a compound shape.

3. In the Modify panel, Modifier list, choose the Extrude modifier. In the Modify panel, Parameters rollout, enter **1** in the Amount numeric field to extrude all of the shapes to a height of one foot. The result is a number of individual 3D objects all extruded to the same height (see **Figure 7-11**). What you really wanted was a solid object with voids and interior solids. In Exercise 7-3-3, you'll learn to combine individual shapes into a compound nested shape.

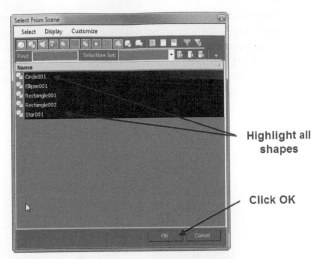

Highlight all
shapes

Click OK

FIG 7-10 Select multiple individual shapes.

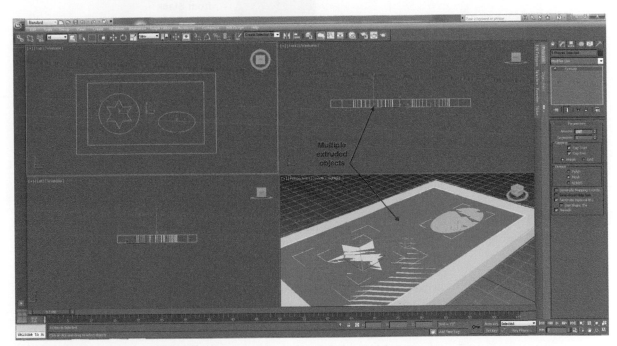

Multiple
extruded
objects

FIG 7-11 Individual 2D shapes become individual 3D objects.

Note

The result of applying an Extrude modifier to multiple independent shapes that are nested in this way will cause problems due to coincidence surfaces at the top and bottom of the resulting 3D objects. You can see in the Perspective viewport that 3ds Max does not know which of the surfaces to display, causing artifacts and distortions in the display of these surfaces.

4. Remove the Extrude modifier from the objects by clicking on the Remove Modifier From the Stack trashcan button just above the Parameters rollout (see **Figure 7-12**). Do not try to drag the Extrude modifier from the stack view to the trashcan button (this is not Photoshop!!). The Extrude modifier must be highlighted in the stack before you can remove it. All of the objects now become individual 2D shapes once again. Use the Ctrl+S keyboard shortcut to save the file.

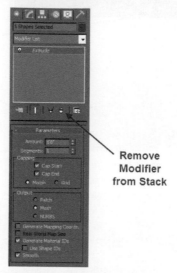

Remove Modifier from Stack

FIG 7-12 A modifier can be removed with the remove Modifier From the Stack button.

You have learned that extruding multiple yet independent shapes that are nested results in a number of individual 3D objects, whereas extruding a compound shape doesn't. The result you want is a single solid object with voids and islands determined by the position of each shape that will involve attaching the multiple shapes into a single compound shape. Let's learn to attach individual shapes in Exercise 7-3-3 to create a compound shape.

In Exercise 7-3-3, you will open the scene that you used in Exercise 7-3-2 and save it again to your hard drive, overwriting the existing file. All of the 2D shapes in the scene are parametric shapes and the Modify panel will allow you to adjust the parameters only. In order to attach the shapes, you will need to learn to convert the shape to an *Editable Spline* 2D shape that allows access to more editing tools. Then the Modify panel will provide you with options to attach shapes.

Exercise 7-3-3 Attach/Detach

1. Open the 3ds Max file from the website called Exercise 7-3-2_Nested shapes01.max and save it to an appropriate folder on your hard drive with a new incremental name. This should produce a Save File As dialog warning that the file already exists and asks if you really want to replace it (see **Figure 7-13**). Click the Yes button to overwrite the file. This is the same file you opened in Exercise 7-3-2 and saved to your hard drive, and its fine to overwrite it in this case, but you should always heed the warning and make sure you are not overwriting something important. If you do not get the warning, then you either didn't save the last time or you are saving the file to a different folder this time.

FIG 7-13 Saving a file that already exists produces a warning.

2. In the Top viewport, select the outermost rectangle named Rectangle 001. In the Modify panel, you'll see that you can edit the parameters of the rectangle (see Figure 7-14). There is no option to attach shapes while the shape is still a parametric shape. Let's learn to convert the shape from parametric to Editable Spline.

FIG 7-14 All 2D shapes in the scene are parametric.

3. In the Top viewport, right-click to open the Quad menu. Hover your mouse over Convert To and then choose Convert to Editable Spline in the new menu (see Figure 7-15). The rectangle does not change appearance, but it is no longer a parametric rectangle and the Modify panel now shows completely different editing options.

Quad menu

Convert to:

Convert to
Editable Spline

FIG 7-15 From the quad menu, you can convert shapes to Editable Splines.

Note

It is important that you choose Editable Spline in the Convert To menu. Any of the other choices in the menu will convert the 2D shape to a 3D object that cannot be used for this exercise. If you mistakenly convert the 2D shape to another type of object, you can use the Ctrl-Z keyboard shortcut to undo the process.

4. In the modify panel, Geometry rollout, click the Attach Mult. button. In the Attach Multiple dialog, highlight the names of the four remaining shapes in the list (see **Figure 7-16**). Click the Attach button to attach all of the remaining shapes to the rectangular Editable Spline to create a compound shape named Rectangle001. You will now notice that all shapes in the scene have the same color. In the main toolbar, click the Select Object button to make sure the Attach process is completed.

FIG 7-16 You can attach multiple shapes by name with Attach Mult.

Hightlight shapes

Attach Mult.

5. Press the H keyboard shortcut to open the Select From Scene dialog and you will notice that there is now only one 2D shape appearing in the Select From Scene dialog. This shape is a compound shape with multiple nested splines. Click OK to exit the dialog and make sure the shape is selected. In the Modify panel, Modifier list, choose the Extrude modifier. In the Modify panel, Parameters rollout, enter **1** in the Amount numeric field and press the Enter key (see **Figure 7-17**).

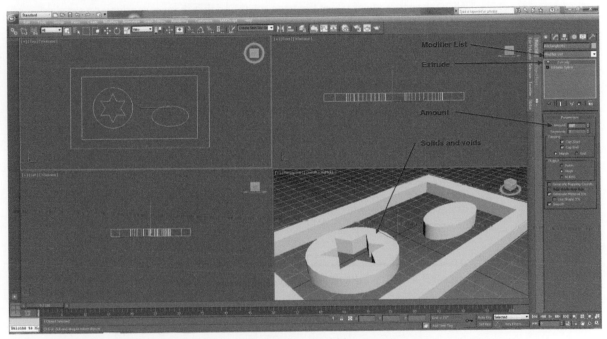

FIG 7-17 An extruded compound shape is made of solids and voids based on spline nesting levels.

6. Save the file. It should already be named Exercise 7-3-2_Nested shapes02.max. The object was created from the outside spline inward when extruded. It starts with a solid until it detects an island spline to create a void. The process then continues looking for island splines, creating alternating solids and voids as deeply as the available nesting of splines.

The concept of compound shapes, shapes containing multiple nested splines, is a powerful tool for creating complex but efficient 3D objects. To create this object with Boolean operations by subtracting 3D objects from 3D objects would be very inefficient because of the complex math involved in cutting and mending the surfaces appropriately.

The resulting object is also easily edited, as you will learn in Exercise 7-4-1. You will be introduced to the new concept of subobject editing of the underlying 2D compound shape that is the basis for this 3D object. As an introduction, you will learn to edit at the subobject Spline level to transform interior splines for a different 3D object configuration.

7.4 SubObject Editing

All 2D shapes and 3D objects are assembled from sub-elements that make up the shape or surface. In this section, you'll learn about these "building blocks" of 2D shapes:

- *Vertex* – a point in 3D space with no dimensions.
- *Segment* – a visible line connecting two vertices of a 2D shape.
- *Spline* – a collection of contiguous vertices and segments.

All 2D shapes must contain at least one spline and that shape is considered a simple shape. When a shape contains two or more splines, it is a compound shape. In Exercise 7-4-1, you will learn to access and edit at the Spline subobject level in the Modify panel. The 2D shape must have been converted to Editable Spline or to have a modifier called Edit Spline applied. In Exercise 7-3-3, you converted the rectangle to Editable Spline and then attached the other shapes to it resulting in a Editable Spline compound shape.

You'll use the object you created in Exercise 7-3-3, which is a 3D object and not a 2D shape. However, you'll also learn about the flexible editing technique of using the modifier stack view to drop-down the history of the creation of the object below the Extrude modifier level to the Editable Spline level. These concepts of modifier stack view history and subobject editing is a key combination in working with 3ds Max efficiently and flexibly.

You will select a subobject Spline and move it to a new location within the shape to change its nesting level that will result in a new configuration for the 3D object.

Exercise 7-4-1 Edit at SubObject Level

1. Open the file from the previous exercise called Exercise 7-3-2_Nested shapes02.max. It contains the odd 3D object that is a result of extruding a compound shape with many splines. Save the file to an appropriate folder on your hard drive with a new incremental name. Make sure the 3D object is currently selected in the Top viewport.
2. In the Modify panel, stack view, click the + to the left of Editable Spline in the stack view list to expand it, revealing a list of subobject elements: vertex, segment, and spline. The Extrude modifier is still highlighted in the stack view, so the parameters rollout shows the parameters for that modifier (see Figure 7-18).
3. In the stack view, highlight the subobject Spline below Editable Spline. The 3D object in the viewports will disappear, the vertices, segments, and splines are visible, and the Modify panel rollouts now show tools for editing at that subobject level (see Figure 7-19). Let's select a spline and move it.
4. Make sure the Top viewport is active, click the Select and Move button in the main toolbar, and then click the star shaped spline. When the spline is selected, it will turn red to indicate that you can now edit it and, because you are in Select and Move mode, the transform gizmo will appear. Move the cursor over the transform gizmo until the yellow square appears at the apex, click on the yellow square and move the star-shaped spline up and to the right so that it is clear of the circular and elliptical

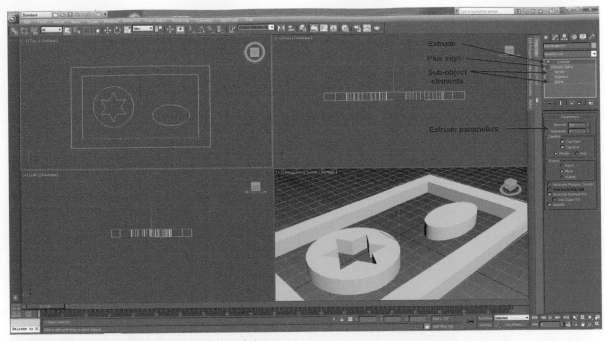

FIG 7-18 Expand the Editable Spline subobject elements list in stack view.

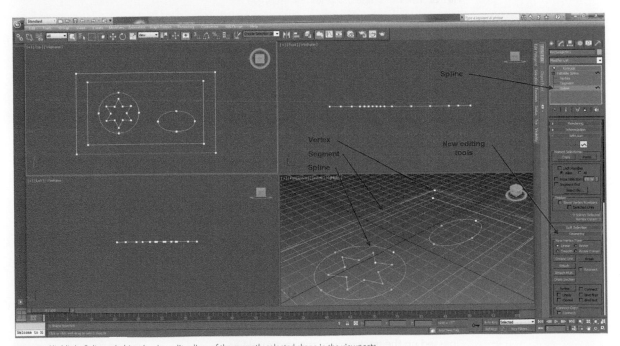

FIG 7-19 Highlight Spline subobject level to edit splines of the currently selected shape in the viewports.

splines, but still within the interior rectangle (see **Figure 7-20**). The star-shaped spline, which formed a void because of its nesting level, is now at the same nesting level as the circular spline and elliptical spline.

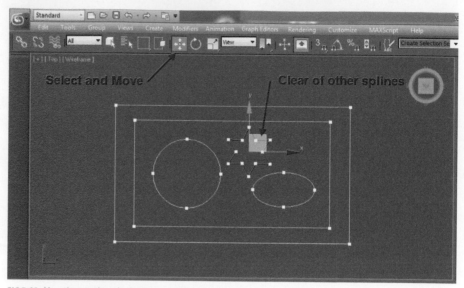

FIG 7-20 Move the star-shaped spline to a new nesting level.

Note

Splines should not overlap other splines in a compound shape. Overlapping splines can create coincidence surfaces when turned into 3D objects and coincidence surfaces are difficult to render.

5. In the Modify panel, stack view, click on the Editable Spline line (not the plus symbol) to exit subobject mode. The Spline symbol will disappear from the right-hand edge of the stack view and the blue highlighting of Spline subobject level will be turned off. Highlight Extrude in the stack view to return to that level and activate the Extrude modifier again (see **Figure 7-21**). The 3D object reappears in the scene and the star-shaped spline no longer describes a void, but is now a solid because of its new nesting level. Press Ctrl+S to save the file.

Note

It is often important to exit subobject mode after editing, so that the entire shape is passed up the stack view to the next modifier.

FIG 7-21 First exit subobject mode (select the Editable Spline line in the stack), and then highlight Extrude at the top of the stack to return to that level.

You have now been introduced to the fundamentals of accessing and editing a 2D shape at subobject level. This is an important modeling technique for maximizing the efficiency and flexibility when creating 3D objects. Learning to navigate the Modify panel and stack view is a crucial part of the process. Compound shapes are shapes containing two or more splines that may be easily edited to form a completely different 3D object based on the nesting level of the splines that make up the shape.

Working with 2D shapes is a powerful method of creating complex 3D objects easily and efficiently, while having a high level of flexibility when it comes to editing. You have learned to convert parametric shapes to Editable Splines to access subobject editing, attached individual shapes to create a single compound shape, and then learned about the concept of spline nesting levels and their effect on the resulting 3D object.

You have now been introduced to the fundamentals of screening and adding a 2D shot in
to correct level. This is an important modeling technique for maximizing the efficiency and
flexibility when creating 3D space. Learning to respond to the Vicinity panel and stack view is
a crucial part of the process. Compound shapes are shapes containing fairly more splines
that may be easily edited into a completely different 3D object based on the detailing level
of the splines that make up the stack.

Modifiers

You already have some experience in the previous chapter of adding a modifier, specifically the Extrude modifier, to a 2D shape to create a 3D object. You also learned that you could adjust the parameters of the Extrude modifier in the Modify panel, stack view.

In this chapter, you'll learn more about the flexibility and power of applying multiple modifiers to 3D objects, and then editing their parameters in the Modify panel to make changes without affecting the original object or other modifier's parameters.

Throughout the chapter, focus your attention on the concepts and processes of working with modifiers to develop a base knowledge of how things work so that you may experiment with the many different modifiers in 3ds Max. A productive 3ds Max user must use his or her imagination to apply modifiers to a wide variety of design challenges. Working with modifiers is much more of an art form than it is a technical workflow. Yes, you must know the mechanics of adjusting modifier parameters, and you must also develop a "feel" for using modifiers to solve your particular needs.

The following topics will be covered to help you learn the logic behind modifiers in 3ds Max:

- *Modifier concepts* – learn about the concepts that will provide you with a flexible workflow.
- *Applying modifiers* – learn to stack modifiers onto 3D objects to form a workflow history.
- *Editing modifiers* – change modifier parameters to affect the end result and learn how cloning can provide increased flexibility.
- *Modifier stack view* – learn to reorder modifiers in the Modify panel, stack view to affect the end result.

Let's begin by having a closer look at the underlying concept of working with modifiers.

8.1 Modifier Concepts

You have learned in the previous chapter that a modifier can be applied to a 2D shape to turn it into a 3D object, and that the modifier's parameters can be adjusted in the Modify panel to edit the 3D object. That's only the beginning of the power of modifiers in 3ds Max, so let's take a look at a few of the fundamental steps involved in working with modifiers.

Each modifier contains a set of parameters that operate on the base object independent of all other modifiers and the base object's own parameters. There are no technical limits on the number of modifiers that can be applied to a single object, but the order in which modifiers are applied can greatly affect the end result.

Modifiers respect the clone type of the object they are applied to; for example, if you apply a modifier to an instance clone, you can then change its parameters on any of the instance clones to affect all of them and the original object as well. If you apply a modifier to a reference clone, any changes to the modifier are not passed back to the original. Modifiers themselves can be cloned as instances or references from one object to another to allow you to apply instanced or referenced modifiers to different objects that have no connection at the base level.

The Modify panel, stack view provides you with a visual history of all modifiers applied to the selected object so that you can navigate from one modifier to another to change its parameters, remove or disable modifiers, and reorder the modifiers for different results.

Working with modifiers is a very dynamic editing process that provides you with the means to make experimental changes without destroying the underlying object or any effects of other modifiers.

Let's try applying a sampling of modifiers to a set of cloned objects as a means of learning the power and flexibility inherent in using modifiers in 3ds Max. You don't need to be concerned about the actual object that is being created, instead focus your attention on these fundamental concepts of working with modifiers. This will give you a base of knowledge for you to continue experimenting with the many modifiers in 3ds Max.

8.2 Applying Modifiers

In this section, you'll perform a number of exercises that go beyond adding a single modifier as you did in the previous chapter. The scene will begin with four cloned cylinders similar to the one you used in Chapter 5 on cloning. You'll then apply the Bend and Taper modifiers to the cylinders so that you can see the power of a modifier workflow.

Again, the cylinders and the specific modifiers are not as important as learning the workflow of applying and adjusting modifiers to 3D objects.

Exercise 8-2-1 Apply Bend and Taper Modifier

1. Start a new session of 3ds Max and click the Application button and then choose Open in the menu. Navigate to the Max file folders for Chapter 8 on the website and then double-click the 3ds Max file called Exercise 8-2-1_Modifiers01.max to open it, and save the file with a new incremental name to an appropriate folder on your hard drive. This scene contains four cylinders: the original at the far left of the Top viewport, a copy clone, an instance clone, and a reference clone at the far right (see Figure 8-1).

FIG 8-1 The original cylinder and three clones.

2. In the main toolbar, make sure the Select Objects tool is active and then select the original cylinder in the Top viewport (far left). In the Modify panel, Modifier list, choose Bend (see Figure 8-2). This applies the Bend modifier to the original object, but doesn't affect the geometry because no parameters have been adjusted.

FIG 8-2 The Bend modifier is applied to the original cylinder.

3. In the Modify panel, Parameters rollout, enter **45** in the Angle numeric field and then press Enter. You will notice several things in the viewports: the modifier is applied above the cylinder in the stack view and becomes the selected level, and several objects seem to be contained in an orange "gizmo" and are affected by the change in the angle parameter. The original cylinder passed its modification to the instance clone and the reference clone as you learned in Chapter 5. The Bend center is located at the pivot point of the original cylinder (bottom center) as indicated by crosshairs (see **Figure 8-3**).

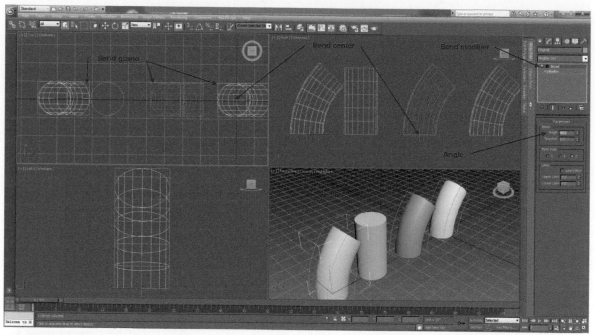

FIG 8-3 Visual cues help identify the modifier's effect on objects.

4. In the Top viewport, select the instance clone (third from left). In the Modify panel, Modifier list, choose Taper. You'll need to scroll down in the Modify drop-down list or press the letter T (first letter of modifier name) to navigate the long list of modifiers. Taper is now the active level at the top of stack view. A new gizmo appears on the original and on the reference clone because of the connectivity in cloned objects. In the Modify panel, Parameters rollout, enter **−0.5** in the Amount numeric field and then press Enter. The negative value causes the top of the cylinder to become half the size of the original (see **Figure 8-4**). 3ds Max evaluates the modifiers from the original object up to the last modifier applied in the stack view. The cylinder is first bent, and then the bent cylinder is tapered, resulting in some odd distortion of the geometry. Perhaps not what you expected, though you will learn how to adjust it later.

5. Notice the text in the stack view; Cylinder, Bend, and Taper are all bold text, indicating a dependency with something else in the scene. You can also see in the viewports that dependency is caused by cloning and has affected the original, the instance

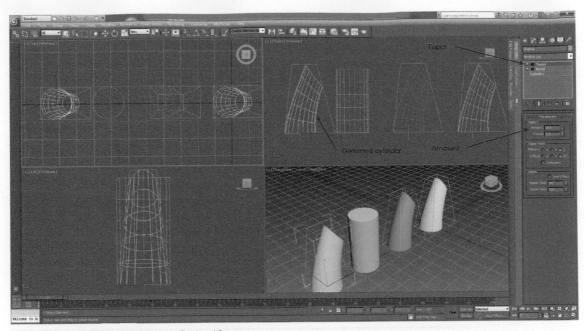

FIG 8 4 The Taper modifier is applied above the Bend modifier.

clone, and the reference clone. The orange gizmos on all objects, but the copy clones are also an indication of a dependency between objects. In the Modify panel, stack view, click the light bulb icon to the left of Taper to temporarily disable it. The Taper gizmo still shows its intended effect, but the Taper is not applied to the object (see Figure 8-5). Click the light bulb icon to enable the Taper modifier again.

FIG 8-5 Modifiers can be temporarily disabled or enabled with the light bulb icon in stack view.

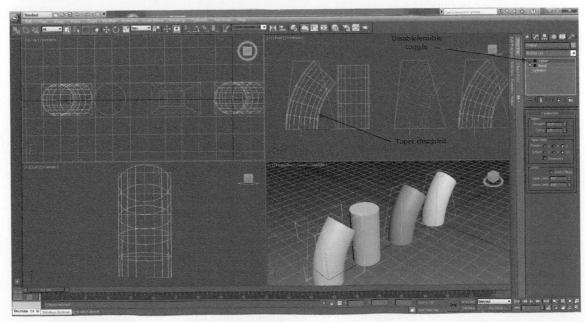

> **Note**
>
> The ability to enable or disable modifiers is very useful in troubleshooting modeling problems or analyzing how a coworker has created a particular 3D object by disabling all modifiers and then enabling them one at the time from the bottom up.

6. Press Ctrl+S to save the file, and it should already be called Exercise 8-2-1_Modifier02 .max. This simple exercise should give you a hint of the incredible power inherent in taking full advantage of modifiers in 3ds Max for a flexible workflow.

You have learned that when applying multiple modifiers to an object in 3ds Max, each new modifier is applied above the active level in the stack view. Modifiers are affected by the connectivity created by cloning, and each modifier may be enabled or disabled in the stack view to analyze their effect on the objects. But the particular order of applying a Bend modifier and then a Taper modifier results in a somewhat distorted object, which you will learn to correct later in this chapter. Visual cues such as bold text in the stack view and gizmos in the viewports help identify the dependency relationships caused by cloning.

In the next exercise, you'll learn to edit various parameters of the modifiers to affect the end result of the 3D object in the scene.

8.3 Editing Modifiers

Along with learning what modifiers are supposed to do when applied to objects, you will eventually need to learn the myriad of parameters particular to each modifier. This may seem like a daunting task, but once you understand some of the fundamentals of editing modifiers that knowledge can be transferred to make the next modifier parameter options less intimidating.

In this section, you'll learn some of the editing parameters available for the Bend and Taper modifiers that you applied to your cylinder. This will introduce you to some of the possibilities to be aware of as you work with modifiers, and you should always remember that the Help files in the Help pull-down menu will explain in detail the function of various parameters.

Let's make adjustments to some parameters of the modifiers applied to the cylinders to learn some of the power inherent in the modifiers.

Exercise 8-3-1 Modifier Parameters

1. If it isn't already the current file in 3ds Max, open the file called Exercise 8-2-1_Modifier02 .max and save it to your hard drive with a new incremental name. Saving incremental files can be a good habit in production to provide extra backup safety in case of a crash or file corruption. In the Top viewport, select the instance clone (third from left).
2. In the Modify panel, stack view, make sure the Taper modifier is highlighted at the top of the stack. In the Parameters rollout, Taper Axis area, choose the Y radio button in the Primary row. This applies the Taper effect along the Local y-axis of the cylinder instead of along the default z-axis (see **Figure 8-6**). The resulting taper is quite different. Choose the x-axis radio button to see its effect and then return to the z-axis radio button.

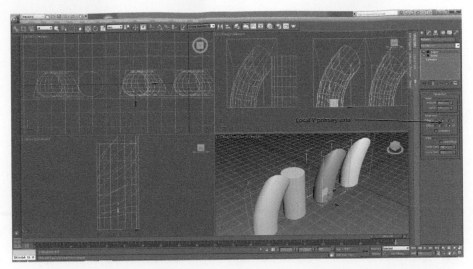

FIG 8-6 The taper effect can be applied to either of the Local axes directions of the selected object.

3. In the Modify panel, stack view, highlight the Bend modifier in the stack and you will see that its parameters appear in the Parameters rollout with somewhat similar options. In the Parameters rollout, Bend axis area, check the Y radio button and you will see that the Bend effect is now applied along the Local y-axis of the cylinder (see Figure 8-7). Try the x-axis radio button and then return to the default z-axis radio button. By navigating the stack view, you are able to edit the parameters of only the modifier at the selected level in stack view without affecting any other parameters. And, because of the cloning connectivity, the edits are passed from the instance clone to the original and then from the original down to the reference clone.

FIG 8-7 By navigating the stack view, you can change the parameters of any modifier.

4. In the Modify panel, stack view, highlight the Taper modifier to return to the top of the stack. This is a good habit to get into so that you see the effects of all modifiers in the viewports and not just to, and including, the selected level. Press Ctrl+S to save the file, and it should already be called Exercise 8-2-1_Modifier03.max.

Note

There is a button called Show End Result On/Off Toggle at the bottom of the stack view (second from left) that determines whether you see the end result of all modifiers in the viewports (On) or only the modifiers to the highlighted modifier (Off). This is useful for troubleshooting modifier problems or seeing how a coworker built a model.

This important exercise illustrates the power of navigating discrete modifiers to edit parameters at any level without affecting any other modifiers or the parameters of the original object, but having a potential major effect on the end result.

Let's learn a bit more detail about the cloning process and its relationship to modifiers.

Exercise 8-3-2 Modifiers and Cloning

1. Open the 3ds Max file from the Exercise 8-2-1_Modifier03.max if it is not already your current file. Save the scene to your hard drive with a new incremental name. In the Top viewport, select the original cylinder at the far left. In the Modify panel, stack view, make sure that the Taper modifier at the top of the stack is highlighted.

2. In the Modify panel, click the Remove Modifier from the Stack button just below stack view (fourth button from left) (see **Figure 8-8**). This completely removes and discards the Taper modifier from the object and, of course, passes the edit accordingly to the cloning connections.

FIG 8-8 Modifiers can be removed from objects and discarded without affecting other modifiers or the base object.

3. Apply a new Taper modifier to the original cylinder and then adjust the Amount parameter to be **0.5** so that the objects appear as they did in Step 1 of this exercise. In the Modify panel, click the Make Unique button just below the stack view (third from left) (see **Figure 8-9**). The only noticeable effect that you'll see is that the text in the stack view is no longer bold. This indicates that the selected modifier has no more dependencies with other objects in the scene.

FIG 8-9 Make Unique command breaks the cloning connectivity of the selected object and/or its modifiers.

4. In the Modify panel, Parameters rollout, enter **−0.75** in the Amount numeric field and press Enter. Make Unique has turned the original modifier into a copy with no connection to the instance clone or the reference clone (see **Figure 8-10**). This allows for edits specific to this modifier, but also has the effect of increasing the memory footprint by making the modifier unique, and therefore less efficient.

FIG 8-10 Modifiers and parameters affect only this object.

5. Save the file. It should already be called Exercise 8-2-1_Modifier04.max. The easiest method of restoring the connectivity is to delete this object and clone the instance clone again. You should always analyze your situation before using the Make Unique command.

Modifiers can be removed from any level in the stack view. This discards the modifier and its parameters so you might consider simply disabling the modifier so that the parameters may be restored at a later point in time. With practice, you will develop a sense for the best option in your workflow.

Clone objects with modifiers can also have the cloning link severed by using Make Unique so that the modifier parameters now only affect the object they have been applied to. Dependencies due to cloning are indicated by the bold text in the stack view and the orange gizmos in the viewport.

Let's learn a bit more information about the stack view and some of its options in the next exercise.

8.4 Modifier Stack View

The Modify panel, stack view contains a lot of information about the currently selected object. You have learned that the stack view evaluation is from the bottom up; 3ds Max evaluates the base object first and then evaluates each modifier in the order determined by the stack view. This means that the order of modifiers can have an effect on the end result. For example, you applied a Bend modifier to a cylinder and then you applied a Taper modifier to taper the bent cylinder, which results in a rather distorted object. You also learned that if modifiers are applied to instance or reference clone objects, the dependency is indicated as bold text in stack view. This means that changing the parameters of one modifier will affect the others depending on whether they are instance or reference clones. You also learned that you could break the dependency link by using the Make Unique button just below stack view. This converts the object and its modifiers to copies that have no connection to other objects in the scene.

In this section, you'll learn more in detail about manipulating modifiers in the stack view, cloning only modifiers onto dissimilar objects, and other visual cues that help you understand the interconnectivity of modifiers in the scene.

Let's begin by reordering modifiers in the stack view to obtain a different end result on the modified object. You'll then learn to clone modifiers independently of the base object.

Exercise 8-4-1 Modifier Order and Cloning Modifiers

1. Open the file from website called Exercise 8-4-1_Stackview01.max and save it with an incremental name to an appropriate folder on your hard drive. The scene contains three cylinders and a box with height segments added to allow bending. The cylinders from left to right are original, instance, and reference clones (see **Figure 8-11**). The box, of course, is not a clone because it's a dissimilar object.
2. In the Top viewport, select the original cylinder on the left, and then in the Modify panel, Modifier list, apply a Bend modifier with a Bend Angle of 90°, followed by a Taper modifier with a Taper Amount set to **−0.5**. This is the same as in previous exercises and results in the somewhat distorted cylinders (see **Figure 8-12**). If you think about what you have done, first bent and then tapered the cylinder, the results are exactly what you should expect. However, let's presume you wanted a bent cylinder that was initially tapered.

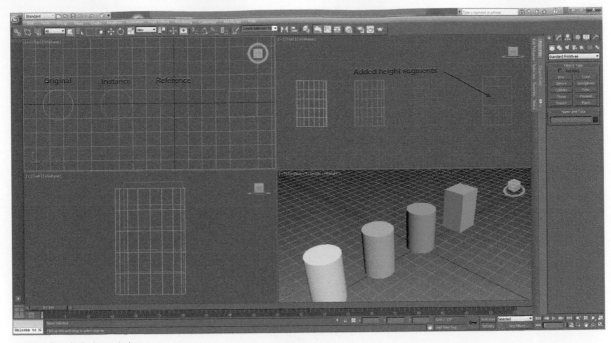

FIG 8-11 Cloned cylinders and a box.

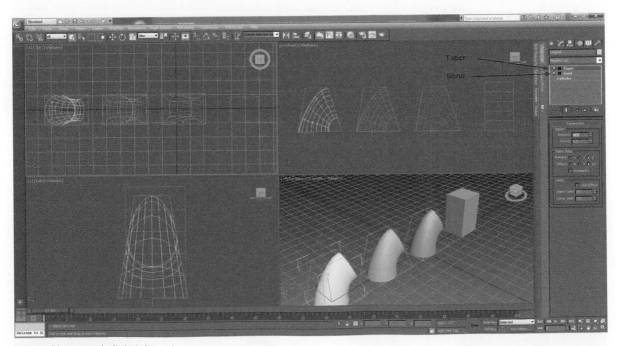

FIG 8-12 A bent, tapered cylinder is distorted.

3. With the original cylinder still selected, in the stack view, click and drag the Taper modifier at the top of the stack until you see a blue line appear between Cylinder and Bend (see Figure 8-13). Release the left mouse button and you will see that the new order results in a very different object: a tapered and then bent cylinder (see Figure 8-14). Let's learn to apply clone modifiers to dissimilar objects.

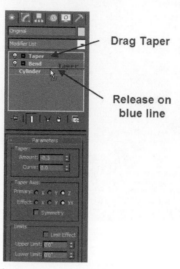

FIG 8-13 Drag and drop modifiers in stack view to reorder them.

FIG 8-14 A tapered cylinder that has been bent.

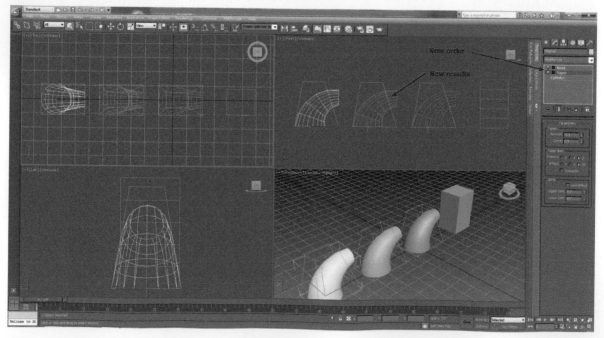

Note

Not all combinations of modifiers can be reordered with predictable results; however, it is important for you to learn the concepts of the modifiers and stack view to understand how 3ds Max functions so that you can put these concepts to work in your production workflow.

4. In the Modify panel, stack view, use the Shift key to highlight both the Taper and Bend modifiers. Then right-click on the modifiers and choose Copy in the menu (see Figure 8-15). This copies the modifiers from the selected object and places them in a temporary memory buffer, similar to Copy and Paste in other programs.

FIG 8-15 Right-click in stack view to copy highlighted modifiers.

5. In the Top viewport, select the box at the far right. In the Modify panel, stack view, you will notice that there are no modifiers on the box and the object name is in lowercase to indicate no dependencies in the scene. Right-click on Box in stack view and then choose Paste Instanced in the menu (see Figure 8-16). Only the modifiers are instanced in this case because a box can't be a clone of the cylinder.

FIG 8-16 Paste the modifiers only as instance clones onto the box object.

6. The box now bends and tapers and the modifiers are instanced as indicated by italics in the stack view. In the Modify panel, Parameters rollout, enter **–90** and then press Enter. All the objects in the scene respect the parameter changes (see **Figure 8-17**). Save the file, and it should already be called Exercise 8-4-1_Stackview02.max. Select one of the cylinders in the scene, and you will see that the text in the stack view is bold and the modifiers are also in italics to indicate the new dependency.

FIG 8-17 Stack view text can be bold and italicized to indicate dependencies.

As you work in 3ds Max, take the time to watch the Modify panel, stack view closely to see the wealth of information on the dependency of objects and modifiers in your scene. You have learned that modifiers can often be reordered in the stack view to change the currently selected object and that modifiers can be copied (or cut) and pasted onto dissimilar objects for more flexibility and control.

In the next exercise, you will apply a new modifier to the cylinder reference clone to learn a bit more about visual cues in the stack view.

Exercise 8-4-2 Apply Twist Modifier

1. Open the file from the Exercise 8-4-1_Stackview02.max and save it to an appropriate folder on your hard drive with a new incremental name. In the Top viewport, select the blue reference clone cylinder (third from left). In the Modify panel, Modifier list, choose the Twist modifier. In the Modify panel, Parameters rollout, enter **45** in the Angle numeric field and then press Enter. This twists the cylinder 45° on its Local Z-axis, but because the cylinder is a reference clone, it does not pass the modification back to the original cylinder (see **Figure 8-18**).

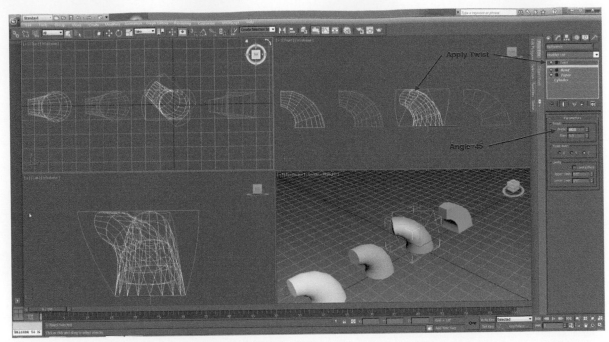

FIG 8-18 A new modifier applied to a reference clone operates on only the reference clone.

2. Several changes can be seen in stack view with the current scenario. A light gray line appears below the Twist modifier to indicate a boundary that blocks the effects of Twist from passing through to other objects through dependency. This cylinder is a reference clone with a one-way connection. The text for the Twist modifier is not bold or italicized to indicate that it has no dependencies (see Figure 8-19).

FIG 8-19 New visual cues in stack view provide information about the reference clone.

3. Save the file, and it should already be called Exercise 8-4-1_Stackview03.max. Again, it is important to get into the habit of watching the Modify panel, stack view closely to determine how the selected object relates to other objects or modifiers in the scene. With a little practice, this will become second nature in your workflow.

The Modify panel, stack view might be considered the "heart" of 3ds Max editing. In this chapter, you have learned to apply modifiers and adjust modifier parameters and how modifiers relate to clone objects to provide more power and flexibility in editing.

You learned that the order in which modifiers are applied to selected objects can affect the end result of the editing, and that in many cases the modifiers can be reordered in the stack view to obtain a different result.

You learned to read some of the visual cues provided in the stack view to help you understand the relationships and dependencies that have been established with other objects in the scene as you modify them. This workflow provides you with a high degree of flexibility in making changes over many objects or to restrict those changes to individual objects. Practice applying modifiers to objects without much thought of what it is you are creating while focusing on the functionality and parameters of the modifiers themselves.

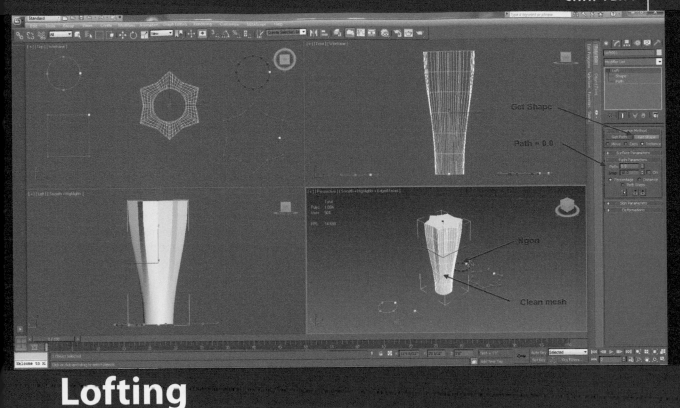

Lofting

Lofting is an underutilized modeling technique in 3ds Max that uses 2D shapes to generate 3D geometry. In Chapter 6, you learned about the Local reference coordinate system that maintains a constant orientation relative to the object as it is moved or rotated through 3D space. In lofting, the orientation of the 2D shape and the 2D path are based on the shape's Local reference coordinate system. This basic orientation method is constant and must be understood to effectively use lofting.

Lofting requires a minimum of two 2D shapes: a path and a shape. The loft path is a 2D shape that is used to define the direction and length of a lofted object. The loft shape is a 2D shape that defines the cross section of the 3D object along the path.

You will also be introduced to the concept of *first vertex* and how it affects the creation of lofted objects. The pivot point of shapes is also important to the orientation of the lofting process and you will be reintroduced to instance cloning with respect to editing shapes and paths used to generate lofted objects.

When editing lofted objects, you will learn to control the number of triangular faces that form the surface, giving you a high degree of control of the efficiency of the 3D object while maintaining an acceptable level of visible detail.

In order to find the Loft command in the 3ds Max interface, you'll need to learn to access the Create panel, Geometry category, Standard Primitives drop-down list, and choose a new class of modeling tools called Compound Objects.

The following topics will be covered to help you understand the process of lofting 2D shapes to create 3D objects in 3ds Max:

- *Lofting concepts*—Local reference coordinate system, pivot point, and first vertex are key components to the lofting concept.
- *Lofting an object*—Learn to create a simple lofted object, first with a single shape lofted along a path, and then with multiple shapes on the path.
- *Editing a lofted object*—Learn to edit a lofted 3D object to correct unwanted twisting, adjust the object's efficiency and detail, and edit the loft path.

Lofting is a powerful modeling technique when you understand a few very basic rules. Let's begin by having a closer look at the underlying concept of lofting 2D shapes. Keep in mind that lofting always uses 2D shapes, but 3ds Max uses specific terminology that can sometimes be confusing to the new user. The loft path is a 2D shape that defines the direction and length of the lofted object. The loft shape(s) is a 2D shape that defines the cross section of the lofted object.

9.1 Lofting Concepts

Lofting is simple. It requires a minimum of one 2D path and one 2D shape. You can only have one path and it must not be a compound shape (shape containing multiple splines). You can have an unlimited number of cross-sectional shapes and each shape must have the same number of splines. For example, you cannot create a lofted object that has a circle shape defining the cross section at one end and a donut shape at the other end because the circle is a simple shape and the donut is a compound shape (two circular splines).

The initial orientation of the shape to the path is that the shape's pivot point automatically attaches itself to the first vertex of the path. The first vertex of an open 2D shape can be at the beginning or end of the shape you have created. The first vertex of a closed 2D shape is determined by 3ds Max. You will be able to identify the first vertex by going to the subobject level and looking for a vertex tick mark that appears as a white square in the viewports (other vertices appear as yellow squares) (see **Figure 9-1**). Each spline in a compound shape has a first vertex as you can see in the donut. A simple shape or each compound shape spline can only have one first vertex.

FIG 9-1 First vertex appears as a white square in subobject mode for 2D shapes.

Note

The first vertex is usually displayed as a white square and the other vertices as yellow squares, but your graphics card or your copy of 3ds Max may be adjusted differently to show first vertex as a different color.

The pivot point of a selected shape is indicated by a tripod or a transform gizmo, if you are in one of the transform modes (see **Figure 9-2**).

FIG 9-2 A tripod indicates the pivot point of a selected shape.

Once a shape has been lofted along a path, it generates a 3D surface. Perhaps the most common workflow is to create the loft path in the position and orientation where you want the 3D object and then allow an instance clone of the loft shape (the default method) to move to the path's location. In **Figure 9-3**, you will see a 2D shape that has been lofted along a straight line. The original shape is still in its initial location while the 3D object has been created at the path's location. The first vertex of the path is indicated by a yellow X when the lofted object is selected in the scene.

FIG 9-3 A 2D shape lofted on a straight line path.

In Figure 9-3, a feature has been enabled in the viewports called Edged Faces, which displays the edges of polygons on the selected geometry as white lines so that you can see the relative efficiency of the object; the fewer edges the object displays, the more efficient it is in terms of the amount of memory used and the number of calculations that are necessary when editing or rendering the object. Later in this chapter, you will learn to adjust the number of polygons in a lofted object to balance efficiency and visual detail for best performance. This ability to adjust the "density" (number of polygons or faces) of objects is one of the most powerful features of lofting in terms of both flexibility and efficiency.

The Lofting Process

Let's learn how a lofted object is created as a reference for the Section 9.2 where you will actually create and edit lofted objects.

- *When you use Get Shape, the shape you select creates an instance clone that attaches its pivot point to the first vertex of the path.*
- *The positive local z-axis of the shape orients itself "down" the path (away from first vertex). The positive local y-axis of the shape aligns itself to the negative local z-axis of the path. In the example shown in Figure 9-3, you can see red, green, and blue arrows that indicate the positive local axes directions of the shape and the path. Remember that the shape was created in the Top viewport, while the path was created in the Front viewport creating different local axes system for each shape.*

In the next few exercises, you will learn to loft a few different shapes along a straight line path to learn the process of creating and adjusting geometry with lofting. Keep your attention focused on learning the fundamentals of lofting and not on the objects being created.

9.2 Lofting an Object

In this section, you'll create a simple object using lofting to learn the functionality and workflow of this powerful 3ds Max tool. You'll begin by lofting a 2D shape along a straight line path and will learn about the important concept of *path steps* and *shape steps*, which are intermediate steps between the vertices of the shape, which determine curvature in the surface of the lofted object. By adjusting the path steps and shape steps, you can increase or decrease the number of polygons that make up the surface, achieving a balance between efficiency and visual detail. You'll also learn to set an object property to display the first vertex of shapes without being in subobject mode so that you have a better idea of how the first vertex affects the lofting process.

You will then perform an exercise that will introduce you to the process of applying multiple shapes to a single path to create much more complex objects while maintaining efficiency and flexibility.

Exercise 9-2-1 Loft a Shape on a Path

1. Start a new session of 3ds Max and click the Application button, and then choose Open in the menu. Navigate to the Max file folders for Chapter 9 on the website, double-click the 3ds Max file called Exercise 9-2-1_Lofting01.max to open it, then save the file with a new incremental name to an appropriate folder on your hard drive. This scene contains five 2D shapes: two circles, a rectangle, a six-sided star, and a line (see **Figure 9-4**). You will use these shapes to learn about lofting.

FIG 9-4 The scene contains five 2D shapes for lofting.

2. Press the H keyboard shortcut to call up the Select from Scene dialog, and then highlight all of the shapes in the list. Click the OK button. Right-click in the Top viewport, and then choose Object Properties in the Quad menu (see **Figure 9-5**). In the Object Properties dialog, General tab, Display Properties area, check the Vertex Ticks checkbox (see **Figure 9-6**). Click the OK button. Vertex ticks will enable the display of vertices on all the shapes in the scene without being in subobject mode.

FIG 9-5 Object Properties is found in a Quad menu.

FIG 9-6 Vertex Ticks object properties option displays vertices in the viewports.

3. In the Perspective viewport, select the line shape. This will become the loft path and will remain in place during the lofting process. In the Create panel, Geometry category, click on the Standard Primitives drop-down list, and choose Compound Objects (see **Figure 9-7**). This calls up new rollouts containing a new class of tools called Compound Objects, including the Loft tool.

FIG 9-7 Compound Object tools are found in the Standard Primitives drop-down list.

Note

With only one shape selected in the viewport you can now see that the first vertex of each shape is white while the other vertices are the shape's color.

4. In the Create panel, Geometry category, Object Type rollout, click the Loft button. This opens new rollouts required to loft objects. In the Creation Method rollout, click the Get Shape button. In the Perspective viewport, move the cursor over the blue circle at the left until you see the loft cursor and a tooltip with the shape name (see Figure 9-8). Click on the circle to create a lofted object. An instance clone of the circle places its pivot point at the first vertex of the line and a cylinder is lofted.

FIG 9-8 The Get Shape command is used to choose a cross-sectional shape for the selected loft path.

5. In the Perspective viewport, right-click on the Smooth + Highlights viewport label, and choose Edged Faces from the menu (see Figure 9-9). This displays the edges of the polygons that make up the lofted geometry so that you can more easily estimate the efficiency level at a glance.

FIG 9-9 Edged Faces displays the underlying mesh of the geometry.

Note

The terms "polygons" and "faces" are often used interchangeably in 3ds Max documentation and interface. Faces are triangular entities that make up the surface of objects while polygons are four-sided or multisided entities. For maximum performance of 3ds Max, you should be concerned with minimizing the number of faces or polygons in the scene while maintaining the necessary visual detail.

6. Press the 7 keyboard shortcut to enable scene statistics at the upper left of the active viewport. It is reported that the 3D object in the scene contains 332 polygons (see **Figure 9-10**). Save the file. It should already be called Exercise 9-2-1_Lofting02.max. Congratulations, you have lofted your first object.

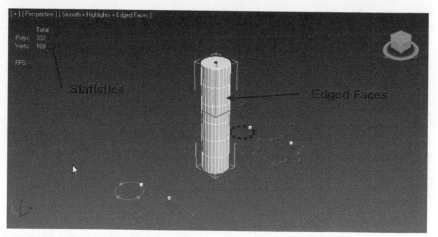

FIG 9-10 Statistics can be enabled to see the actual number of polygons in your scene.

The steps you have just performed seem to be much more difficult than simply creating a cylinder standard primitive. However, a cylinder primitive only has a few parameters that can be adjusted and, as you will learn, the power of this lofted cylinder will become more apparent as you learn to modify it in 3ds Max.

In Exercise 9-2-2, you will learn to use the Modify panel to adjust the efficiency of the lofted cylinder by changing its path steps and shape steps parameters, and you'll learn to add a second shape to the loft path for a much more complex 3D object.

Exercise 9-2-2 Controlling Lofted Object Efficiency

1. Open the file called Exercise 9-2-1_Lofting02.max and save it to an appropriate folder on your hard drive with a new incremental name. In the Perspective viewport, select the lofted cylinder. Go to the Modify panel and expand the Skin Parameters rollout by clicking on it. In the Options area are two numeric fields for Shape Steps and Path Steps (see **Figure 9-11**). Remember that shape steps and path steps are intermediate steps between the vertices that define curvature.

FIG 9-11 Shape Steps and Path Steps are set to 5 by default.

2. In the Path Steps numeric field enter **0**, and then press Enter. This removes all of the horizontal segments along the length of the lofted object. The number of polygons has gone from 332 down to 92; a significant increase in efficiency (see **Figure 9-12**). The straight line path has no curvature; therefore, the extra segments created by path steps are unnecessary in this particular example, and when removed, the cylinder is still visually acceptable.

FIG 9-12 The segments created by path steps define no curvature and can be removed.

3. In the Shape Steps numeric field, enter **0**, and then press Enter. Shape steps are intermediate steps in the circle that define curvature and when the shape steps are removed the cylinder becomes a box, which is no longer visually acceptable, even though the object may be very efficient (12 polygons) (see **Figure 9-13**). The circle shape has four vertices and, with the default five shape steps, the cylinder originally had 24 segments running along the path for a smooth, round cylinder.

FIG 9-13 The segments created by shape steps are necessary to define curvature.

4. Enter **3** in the Shape Steps numeric field and press Enter. The extra shape steps only increase the number of polygons to 60 and the resulting cylinder is visually acceptable (see **Figure 9-14**). Much of the power of lofted objects is related to your ability to easily balance the number of polygons in the object with the visual detail needed by adjusting the path steps and shape steps.

FIG 9-14 Shape steps set to 3 provides a balance of efficiency and visual detail.

5. Enter **5** in both Path Steps and Shape Steps numeric fields, pressing Enter to finalize the process (see **Figure 9-15**). Save the file, it should already be called Exercise 9-2-1_Lofting03.max. This returns the lofted cylinder to its default state in preparation for the next exercises.

FIG 9-15 Return lofted cylinder to default settings.

You might be asking yourself "how much effect does reducing the number of polygons in this cylinder really have on overall efficiency?" The answer is, not much. However, if you have 300 similar cylinders in the scene and all of your other objects are created with more polygons than necessary for proper visual detail, then you are adding significant overhead that reduces productivity and cost-effectiveness.

There is a good saying that "your modeling isn't finished until you CAN'T remove anything else." Building efficient models is easy when you know how, and with the flexibility of lofting you can always edit the amount of detail at any time it becomes necessary. Get into the habit of using these flexible and efficient tools and your entire workflow will become smoother and more productive.

Let's learn to add a second shape along the path of an existing lofted object to create a more complex object that would be difficult to model with other techniques in 3ds Max while maintaining the flexibility and efficiency of lofting.

Exercise 9-2-3 Adding Shapes to Lofted Objects

1. Open the file called Exercise 9-2-1_Lofting03.max and save it to an appropriate folder on your hard drive with a new incremental name. In the Perspective viewport, select the lofted cylinder. In the Modify panel, Path Parameters rollout, you can see that the Path numeric field is set to 0.0 and the Percentage radio button is active. This means that the Get Shape command brought an instance clone of the circle to 0% of the way along the path, that is, at the first vertex. In the viewports, you see a yellow tick indicating the currently active percentage level along the path (see **Figure 9-16**).

FIG 9-16 The default Get Shape location is 0.0 percentage along the path.

2. Enter **100** in the Path numeric field and press Enter. The yellow tick moves to the other end of the path line (see **Figure 9-17**). This location on the path now becomes the active level for the Get Shape command.

FIG 9-17 The Path value is the distance along the path in percentage for the active Get Shape level.

3. In the Creation Method rollout, click the Get Shape button, and then pick the orange square in the Perspective viewport. The lofted object is no longer a simple cylinder, but begins with a round cross section and ends with a square cross section. However, the lofted object has an unexpected twist (see **Figure 9-18**).

4. Save the file, it should already be called Exercise 9-2-1_Lofting04.max. This is a point when many new users give up on lofting because they don't understand the twist or how to get rid of it. There is a simple, logical reason and the fix is easy.

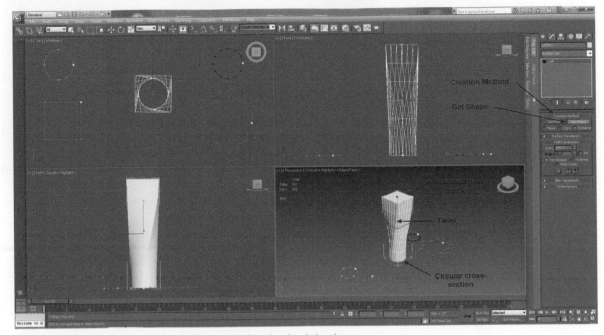

FIG 9-18 The lofted object begins as a circle and ends as a square, but twists along its length.

In Section 9.3, you will review the process of lofting and learn how to correct the twist caused by adding a square shape along the path of a cylindrical lofted object.

9.3 Editing a Lofted Object

Think about the previous description of how a lofted object is created. A shape is added to the beginning of the path and a mesh is generated from the shape's vertices (first vertex and then the others) and the shape steps in between each pair of vertices.

The shapes are aligned to the path in a very particular order. The shape's positive local z-axis points down the path starting at first vertex. The shape's positive local y-axis is then aligned to the path's negative local z-axis. Take the time to look over the scene from Exercise 9-2-3 and formulate that alignment in your mind.

You then add a rectangular shape 100% of the way along the path. It follows exactly the same rules of alignment. The twist is caused by the fact that the first vertex of the square is 45° off the position of the circle's first vertex with respect to the Local reference coordinate system. Thus, the same alignment rules cause a 45° twist (see **Figure 9-19**).

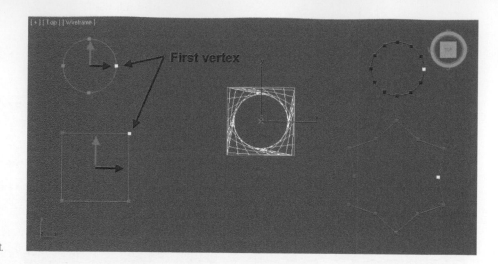

FIG 9-19 The relative positions of the shape's first vertices are off by 45° to the Local reference coordinate system, causing a twist.

In Exercise 9-3-1, you will learn to correct the twist by editing the lofted object.

Exercise 9-3-1 Edit Unwanted Twist

1. If it isn't already the current file in 3ds Max, then open the file called Exercise 9-2-1_ Lofting04.max and save it to your hard drive with a new incremental name. Saving incremental files can be a good habit in production to provide extra backup safety in case of a crash or file corruption. In the Perspective viewport, select the lofted object.
2. In the Modify panel, stack view, click the + to the left of the loft to access subobject level editing, and then highlight Shape. In the Perspective viewport, select the instance clone of the rectangle at the top of the lofted object. It will turn red when selected (see **Figure 9-20**). You should not edit the original shape, only the instance clone in the loft object.

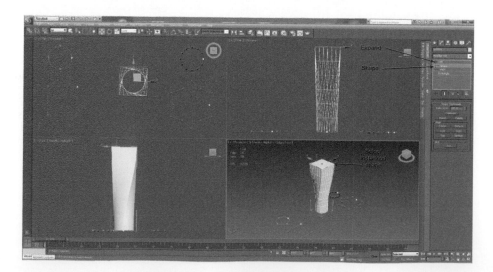

FIG 9-20 Select the square shape at the top of the lofted object in subobject Shape mode.

3. In the main toolbar, click the Select and Rotate button. Notice that the Local reference coordinate system is automatically active and gray indicating it cannot be changed for rotating shapes on a lofted object. In the transform type in numeric fields in the status bar at the bottom of the display, enter **−45** in the z-axis numeric field (see **Figure 9-21**) and then press Enter.

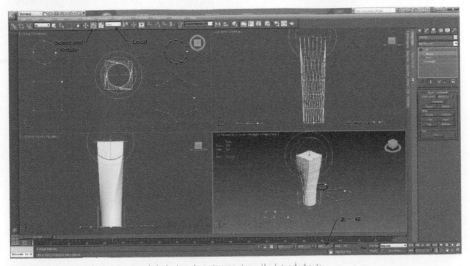

FIG 9-21 Negative angles are measured clockwise when viewing down the intended axis.

4. Save the file, it should already be called Exercise 9-2-1_Lofting05.max. The twist is now removed from the object. In the Modify panel, stack view, click on Loft to exit subobject mode (see **Figure 9-22**). Rotating the original square shape wouldn't have solved the problem because its Local reference coordinate system rotates with it and the alignment would be the same. You could also use this method to add a twist to lofted objects if that was appropriate for your needs.

FIG 9-22 It is a good habit to exit subobject mode when finished editing.

Lofting, again, has proven to be a powerful modeling tool with a high degree of flexibility and efficiency. There are, however, a few fundamental rules that you have learned so that you understand how lofting functions and some of the options you have if the unexpected happens during the lofting.

In Exercise 9-3-2, you will learn to edit the loft path and to replace a current shape on the lofted object with a new shape. You'll then learn a method of creating "clean" geometry that might be easier to edit or animate further.

Exercise 9-3-2 Edit Shape and Path

1. Open the 3ds Max file from Exercise 9-3-1, if it is not already your current file, it should be called Exercise 9-2-1_Lofting06.max. Save the scene to your hard drive with a new incremental name. In the Perspective viewport, select the lofted object. In the Modify panel, Path Parameters rollout, make sure that the current Get Shape level in the Path numeric field is set to 100.0 (see Figure 9-23). The yellow tick will appear at the top of the lofted object. You will replace the current square shape that defines the cross section at the top of the lofted object with the star shape in the scene.

FIG 9-23 The current Get Shape level should be 100 percent along the path.

2. In the Modify panel, Creation Method rollout, click the Get Shape button. In the Perspective viewport, click on the blue star shape to send an instance clone to the top of the lofted object. The square shape will be replaced with the star and the lofted object will change accordingly; circular cross section at the bottom and start cross section at the top (see Figure 9-24). There is no twist with the new shape because the first vertex of the star and the circle are in the same relative position.

FIG 9-24 The star shaped replaces the square shape at the current level.

3. The new lofted object would be very difficult to model using other techniques with as much potential flexibility. However, if you look closely at the edged faces, you'll see that the mesh surface is now a complex tangle of many triangles and not regular polygons as in the previous lofted object. This is because the circle shape at the base has four vertices with five shape steps between each pair of vertices, and the star has 24 vertices with five steps between each pair of vertices (see Figure 9-25). While it is technically possible to loft multiple shapes with different numbers of vertices, it is not always ideal. Let's learn what we can do to fix the surface.

FIG 9-25 Lofting between shapes with different numbers of vertices creates complex surfaces.

4. One of the shapes in the scene is an NGon, a multisided polygon, which has 12 sides and the circular option checked. In the Path Parameters rollout, enter **0** in the Path numeric field, and then press Enter. This makes the beginning of the lofted object

the active Get Shape level. In the Creation Method rollout, make sure that the Get Shape button is toggled on, and then pick the red NGon in the Perspective viewport. The resulting lofted object is much cleaner because the shapes have the same number of vertices. However, the object now has 1004 polygons (see **Figure 9-26**). Let's make the object more efficient in the next step.

FIG 9-26 Shapes with equal numbers of vertices create cleaner geometry.

5. In the Modify panel, expand the Skin Parameters rollout. In the Options area, Shape Steps numeric field, enter **1** and press Enter. In the Path Steps numeric field, enter **3** and press Enter (see **Figure 9-27**). This reduces the number of polygons from 1004 to 236, yet the lofted object probably still maintains enough visual detail for most situations. Save the file.

FIG 9-27 Efficient lofted object with good visual detail.

Once you understand the fundamentals of lofting in 3ds Max, it becomes an extremely powerful tool in terms of flexible editing capabilities matched with flexible efficiency controls. A lofted object can have only one path, but has the ability to use as many shapes along a path as required to create complex objects.

Look around your office for objects that may be potential candidates for lofting and practice by trying to re-create them in 3ds Max. Typical objects might be door and window trim, cables and piping, countertops and architectural trim, and parts of lamps and furniture, just to name a few examples. Use your imagination.

Lighting Basics

Lighting a scene in 3ds Max is perhaps one of the most difficult tasks in a production workflow. There are many variables and parameters that will affect the physical aspects of lighting, and this chapter will introduce you to the fundamental techniques that will form a basis for learning lighting in 3ds Max.

You'll begin by learning some of the concepts of lighting and about photometric lights that you will be using throughout this lesson. Understanding how lighting works in 3ds Max is an important first step to avoid being overwhelmed by unfamiliar terminology and complex physical science behind lighting in the real world. You'll then create the two most commonly used types of light: Free light and Target light, and then be introduced to a few parameters necessary for the basic adjustments in lighting values. You'll also learn to create Spotlight distribution, a common form of lighting in the real world, which casts its light from the light source outward within a cone toward the surfaces.

Some of the topics covered in this chapter are

- *Lighting concepts* – You will learn some of the important concepts in the process of creating, positioning, and adjusting lights in a 3ds Max scene.
- *Photometric lighting* – 3ds Max can use photometric lights to simulate real world physical lighting values.
- *Create lights* – Learn to create Free and Target lights in a scene.
- *Light parameters* – Investigate some of the basic light parameters used to adjust lighting.

- *Light distribution* – Learn to control light distribution by setting Spotlight parameters.
- *Three-point lighting* – An introduction to three-point lighting: a basic studio lighting technique with three lights.

Lighting is a very subjective topic that can greatly affect the influence of your rendered images on the viewer. Although this chapter is focused more on the technical aspects involved in placing and adjusting lights, you are also encouraged to investigate the effect of light and dark values in paintings, as well as photographic and film lighting techniques.

Learn to see the world around you in terms of lighting. Keep in mind that in life you never actually see the object, but you only see light reflected from the object. Without light, you would exist in a world of black so understanding the properties and psychological impact of light and shadow will inevitably improve your final renders. Without the power of observation focused on the effects of lighting in the real world, you won't be able to reproduce those effects in 3ds Max.

10.1 Lighting Concepts

If you have had training in traditional art forms such as film and video, photography, or painting, you will understand that lighting is an extremely important element in conveying information about the image to the viewer. Without formal training, we tend to take lighting for granted in our day-to-day lives and don't pay much attention about how light interacts with objects to influence our perception of the real world.

In 3ds Max, you are trying to interpret "reality" to suit the needs of your client and the project. The images you deliver to the client can range from "photorealistic" to rather abstract interpretations of real or imaginary worlds. Lighting plays a critical role in establishing the mood and the viewer's perception of any image.

Although 3ds Max is considered to be 3D software, the end product is always a 2D image. Lighting concepts in traditional art have long been used to enhance the perception of "3D-ness" or depth in a painting. Psychologically speaking, white areas of an image come forward, while dark areas appear to fall back. You can take advantage of this while adjusting your lighting to increase or decrease the apparent depth of your images. Dark shadows form negative areas to guide the viewer's gaze toward the light or more important areas in the image.

Take the time to investigate traditional paintings such as those by Rembrandt or Vermeer and black and white photographs by Ansel Adams to see examples of how light and dark are used as basic elements of the images.

There are two main types of light that are important in 3ds Max: direct light and indirect light. In this chapter, you will learn about direct light that beams in a straight line from a light source to a surface (see **Figure 10-1**). You'll learn to adjust light parameters to affect the intensity of light at the source and about the effects of attenuation and angle of incidence.

Light attenuation is the decay of light intensity based on the distance of the light from the surface. Angle of incidence affects the intensity of light on a surface based on the angle of the light to the surface (see **Figure 10-2**). With a fundamental knowledge of these lighting concepts, you will be able to control the light quality in your 3ds Max scenes.

FIG 10-1 Direct light from source to surfaces.

Direct light

Shadow

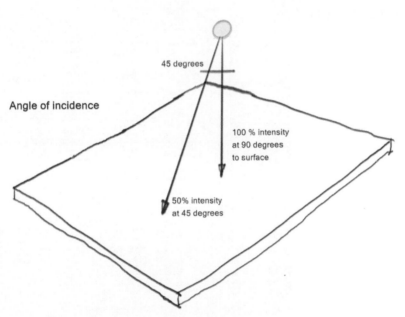

FIG 10-2 Angle of incidence affects light intensity.

45 degrees

Angle of incidence

100 % intensity
at 90 degrees
to surface

50% intensity
at 45 degrees

In previous chapters, you have created or opened 3ds Max scenes and you could clearly see the 3D objects in the viewports, though you haven't placed any lights in any of the scenes. 3ds Max has default lighting that enables you to work in viewports and see what you are doing. As soon as you create a light source in a 3ds Max scene, the default lighting is automatically switched off and no longer has any effect in your scene or in rendered images.

The viewports in 3ds Max are capable of displaying different levels of lighting and shadow detail, depending on the currently active render engine, the viewport settings, and the graphics card capabilities in your computer. But to see an accurate representation of lighting, you must render the scene. In Exercise 10-1-1, you will set 3ds Max to use the mental ray renderer engine to calculate only direct light. This will ensure that everyone performing the exercises are seeing the same results.

Exercise 10-1-1 Setting the 3ds Max Mental Ray Render Engine

1. Start 3ds Max. In the main toolbar, left-click the Render Setup button to open the Render Setup dialog (see **Figure 10-3**).

FIG 10-3 Open the Render Setup dialog.

2. In the Common tab, scroll the dialog upward and then expand the Assign Renderer rollout. Left-click on the ellipsis button (three dots) to the right of the Production field. In the Choose Renderer dialog, double-click on *NVIDIA mental ray* or *mental ray*, whichever option is available for your computer (see Figure 10-4). If there is no mental ray option in the list, then it is already the current render engine and it will show in the Production field. Close the Render Setup dialog.

mental ray

Ellipsis button

FIG 10-4 Set the active render engine to *NVIDIA mental ray* or *mental ray*.

3. In the Render Setup dialog, Indirect Illumination tab, clear the Enable Final Gather checkbox in the Basic area (see Figure 10-5). This disables the calculation of bounced or indirect light by the mental ray renderer so that you can better evaluate the effects of direct light.

Indirect Illumination

Enable Final Gather

FIG 10-5 Disable final gather for direct light calculations only.

4. In the Application menu, save the current empty scene with the name *maxstart*
 .max, and in the Save File As dialog, click the Yes button to overwrite your existing
 prototype file. Overwriting this file will save the new render engine settings so that
 the settings will be loaded each time you start a new scene or reset 3ds Max.
5. In the Application menu, choose the Reset command, and then in the 3ds Max
 dialog, click the Yes button to reset the scene. This ensures that you will not
 accidentally save other information into the 3ds Max prototype file.

The mental ray renderer will be used throughout this book to maintain consistency. Mental
ray produces good rendering results across a wide range of graphics cards and is commonly
used in 3ds Max production environments.

The most common type of 3ds Max light used with the mental ray renderer is called
photometric lights. In Section 10.2, you'll learn some of the concepts associated with
photometric lights.

10.2 Photometric Lighting

Photometric lights in 3ds Max are designed to closely simulate the physical behavior of light in the real world from the sun to light bulbs and glowing objects. Photometric lights are also designed to work accurately with 3ds Max materials applied to objects in your scene.

One of the important physical properties associated with photometric lights in 3ds Max is attenuation, that is, the decay of light intensity over distance from the source. The physical phenomena of attenuation can have a profound effect on the quantity and quality of lighting in your scenes and is the reason why you need to create scenes using the real world sizes. A default photometric light would appear very different in a room that is $1' \times 1' \times 1'$ compared to a room that is $100' \times 100' \times 100'$.

3ds Max has two different types of photometric lights:

* *Free* – A Free light source is a freestanding light that casts light equally in all directions.
* *Target* – A Target light source is paired with a target object that defines a light's direction.

Generally speaking, Free lights are useful for lights that will be animated through a scene, for example, the headlights of a car or a flashlight. Target lights can be used to simulate lights that are aimed in a particular direction like studio spotlights. However, Free lights can be converted to Target lights and vice versa, so 3ds Max provides flexibility during production.

When you use the mental ray renderer and create your first photometric light, 3ds Max will prompt you with a message stating "It is recommended that you use the mr Photographic Exposure Control" that is loaded when you click the Yes button. Exposure control regulates the amount of light in your scene that reaches the renderer to control underexposure or overexposure. This is similar to the iris on a typical camera that allows you to photograph in bright sunlight or in a dimly lit room. You will learn more about mr Photographic Exposure Control in Chapter 22.

In Section 10.3, you'll learn to create each of the photometric light types and then learn to switch from one light type to another and back again.

10.3 Create Lights

Creating photometric lights in 3ds Max is a simple process: either a single click is all that is required to create a Free light or just click and drag to create a Target light. In the next two exercises, you'll create one of each light in a 3ds Max scene containing a "room" with one end wall missing and a cylinder and sphere positioned near the back of the room (see Figure 10-6). All the objects in the scene have been assigned a mid-gray color. Your task will be to light the scene with photometric lights. In the Perspective viewport, you can see the effects of default lighting which appears to be positioned behind the viewer, high and to the right. The light is brightest on the top and front surfaces while the sides receive no light. Remember that you are seeing the effects of direct light only because the calculation of bounced light has been disabled.

> **Note**
>
> If you right-click on the Shaded viewport label in the Perspective viewport and then choose Realistic in the menu, you will see more of a convincing lighting representation. Set it back to Shaded for more efficient viewport performance.

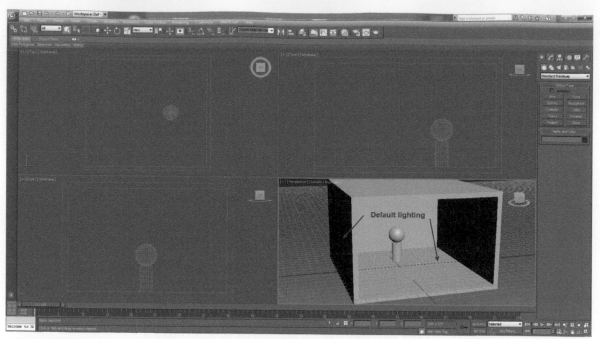

Default lighting

FIG 10-6 A simple 3ds Max scene with default lighting in the shaded Perspective viewport.

The goal of the exercises in this section is to illustrate the differences between the two light types and learn how to position lights in 3ds Max. You will also learn the effects of attenuation and angle of incidence on the brightness of the light on surfaces.

Let's begin by creating a Free light.

Exercise 10-3-1 Free Lights

1. Open the 3ds Max file from the website called Exercise 10-3-1_Free lights01.max and save it to an appropriate folder on your hard drive with a new incremental name. Right-click in the Top viewport to activate it. In the Create panel, Lights category, Object Type rollout, click the Free Light button. In the Photometric Light Creation dialog, click the Yes button to enable mr Photographic Exposure Control (see **Figure 10-7**).

2. In the Top viewport, left-click just inside the lower-left corner of the room to place the Free light. Placing a light in the scene disables the default lights, and in the Perspective viewport, you can see that the quality of the light has changed radically. The light was placed on the active work plane of the Top viewport as described by the grid (see **Figure 10-8**). You can clearly see the effects of angle of incidence on the surfaces. The light is brightest where a surface is 90° (perpendicular) to the light source, and there is no light where the angle of incidence is 0° or less, that is, in the floor and the outside walls of the room. The curved surfaces of the sphere and cylinder show a shading effect due to angle of incidence. Free lights cast light equally in all directions. The effects of attenuation are not visible in the viewports by default.

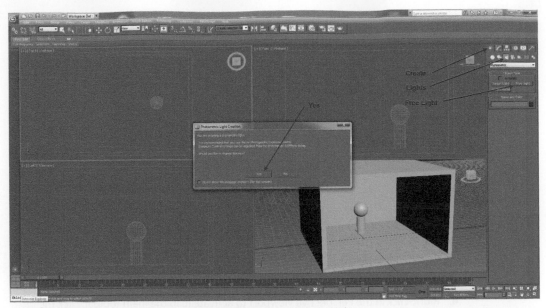

FIG 10-7 You are prompted to enable exposure control when you create the first photometric light.

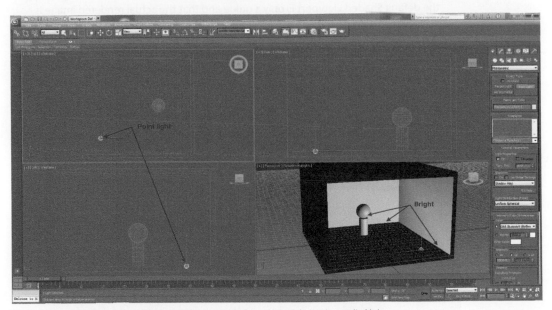

FIG 10-8 A Free Light placed in the Top viewport is created on the floor and the default lights are disabled.

3. In the main toolbar, click the Select and Move button to toggle it on. Right-click
 in the Front viewport to activate it and then move the light source in the positive
 y-axis to just below the inside of the ceiling (see Figure 10-9). The lighting effects in
 the shaded Perspective viewport update interactively as you move the light, and the
 "mood"of the new light position is noticeably different.

FIG 10-9 Move the light near the ceiling in the Front viewport.

4. Right-click in the Perspective viewport to activate it. In the main toolbar, click the Render Production button at the far right. This renders the scene and displays the result in the Virtual Frame window. You can see that the approximation of lighting in the default Shaded viewport is only a guide and that the actual rendered image is noticeably different. In the rendered image, the effects of attenuation and angle of incidence can be seen as the surfaces darken at greater distances and lesser angles to the light source (see **Figure 10-10**). The light intensity also needs adjusting.

FIG 10-10 The lighting in default Shaded viewports is only an approximation of the rendered lighting.

5. Use the keyboard shortcut Ctrl+S to save the file. It should already be called Exercise 10-3-1_Free lights02.max. Congratulations, you have created and rendered your first 3ds Max scene with lights in this book.

A single click in a viewport places a Free light in the scene, but as you see that is only the beginning of lighting a scene. Free lights cast their light equally in all directions from the light source, and the brightness of the light on a surface is controlled by the intensity of the light, attenuation based on the distance from the light source, and angle of incidence of a surface to the light source.

In Exercise 10-3-2, you'll create a Target light in the Front viewport. The default Target light also casts light equally in all directions but has a "look at" target attached to it to control the direction the light shines in. A Target light requires you to click to place the light source and then drag the mouse to position the target.

Exercise 10-3-2 Target Lights

1. Open the 3ds Max file from the previous exercise called Exercise 10-3-1_Free lights02.max and save it to an appropriate folder on your hard drive with a new incremental name. Right-click in the Front viewport to make sure it is the active viewport.
2. In the Create panel, Lights category, Object Type rollout, click the Target Light button. In the Front viewport, click just to the right of the existing Free Light, drag the mouse straight down to the floor level and then release the mouse button. This creates the source of the Target light and the target itself on the work plane defined by the Front viewport and indicated by the black lines of the Perspective view grid (see Figure 10-11).

FIG 10-11 Left-click and drag to create a Target Light source and its target.

3. In the main toolbar, click the Select and Move button in the Front viewport and move it along the positive x-axis to the center of the cylinder (see Figure 10-12). In the Top viewport, move the yellow light source in the positive y-axis to just inside the wall of the room (see Figure 10-13).

FIG 10-12 Move the target to the cylinder in the Front viewport.

FIG 10-13 Move the source to the wall in the Top viewport.

4. Activate the Perspective viewport and then use the Render Production button to render the viewport. The default Target light has exactly the same attributes as the Free light. It casts its light equally in all directions, and at this point, the target has no effect on the quality of light. The intensity of the default lights are additive and the rendered image is much too bright. (see Figure 10-14).

FIG 10-14 Two default lights are much too bright for a room of this size.

5. Use the keyboard shortcut Ctrl+S to save the file. It should already be called Exercise 10-3-1_Free lights03.max. You have placed two lights of equal intensity that casts light equally in all directions in a relatively small room. The default intensity of the lights and the adjustment of mr Photographic Exposure Control allows too much light for the renderer and the result is an overexposed image.

In Section 10.4, you will learn to adjust some of the more commonly used light parameters to reduce the intensity of the lights in the scene and to enable shadow casting for a more convincing lighting effect.

10.4 Light Parameters

Photometric lights have many parameters that can be edited to control intensity, color, distribution, and shadow quality, just to name a few. In the following exercises, you'll learn to adjust the intensity of lights and to enable shadow-casting capabilities.

The intensity of photometric lights can be adjusted to achieve a desirable and therefore subjective degree of lighting in a scene, or the lighting intensity values can be set to match real world lighting. For the purposes of this fundamental lesson, you'll be controlling lights subjectively to get the look you want in your scene.

All lights in the real world cast shadows, so shadows are very important to our perception of lighting because they provide a feeling of depth and "weight" for objects that are casting shadows. The shadow helps anchor the object visually to the surface it is sitting on. However, shadow calculation can be computationally expensive and can slow rendering times in

scenes with many lights and shadows. You should only enable shadow casting for lights that are necessary for the level of visual quality required to make your scene convincing.

You'll also learn about the 3ds Max tool called Light Lister that allows you to access some of the parameters of all the lights in the scene for easier editing.

Both the lights that you have created in your scene, a Free light and a Target light, cast light equally in all directions. You will perform an exercise to learn how to change the distribution of the Target light from an omnidirectional distribution to a Spotlight distribution with the light emitted from the source focused within a cone. This provides you with much more control of the coverage of the light.

Exercise 10-4-1 Adjust Light Intensity

1. Open the file from the previous exercise called Exercise 10-3-1_Free lights03.max and save it to an appropriate folder on your hard drive. This is the scene from Exercise 10-3-1, which has a Free light and a Target light near the ceiling on opposite walls. The default light intensity is too much brighter for the current scene.
2. Right-click in the Top viewport to activate it and select the Free light at the lower left of the room. In the Modify panel, Intensity/Color/Attenuation rollout, Intensity area, enter **150** in the numeric field and then press Enter. The light intensity in the Perspective viewport diminishes noticeably (see Figure 10-15).

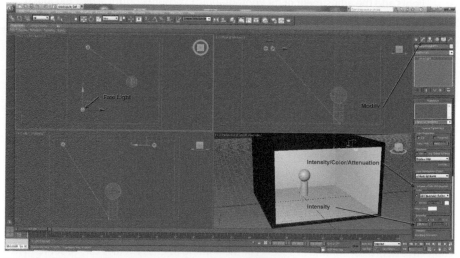

FIG 10-15 Light intensity of an existing light can be changed in the Modify panel.

Note

The default light intensity for photometric lights in 3ds Max is measured in candelas (cd) as you can see by the radio button above the Intensity numeric field. Candelas are a scientific measurement of light intensity.

3. In the Top viewport, select the Target light and adjust its intensity value to **150** and then press Enter. The apparent lighting in the Perspective viewport is now much darker with only 10% of the default lighting values (see **Figure 10-16**).

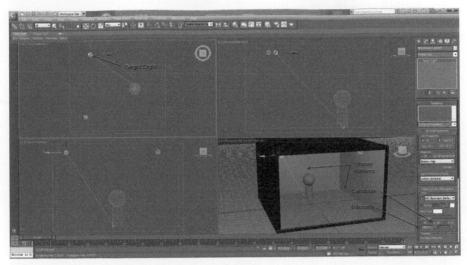

FIG 10-16 The parameters of a Target Light are the same as a Free Light.

4. Right-click in the Perspective viewport to activate it. In the main toolbar, click the Render Production button to render the scene with the new lighting values (see **Figure 10-17**). The new scene is much more convincing than the overexposed result of the original light intensity values. In the Rendered Frame window, there is still a noticeable hotspot on the wall caused by the proximity of the light to the surface. Angle of incidence and attenuation create variations in light values as the distance from the source increases.

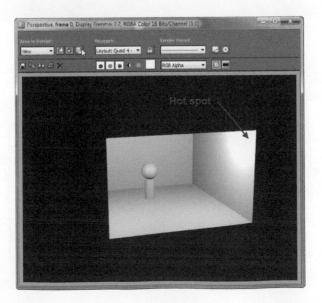

FIG 10-17 The rendered scene shows a more convincing lighting result from the reduced intensity.

5. Save the file, and it should already be called Exercise 10-3-1_Free lights04.max. The default intensities of photometric lights are almost never appropriate and are one of the first parameters to be adjusted. Remember that the size of the room is one of the key components of how the intensity of lights affects a scene, followed by the angle of incidence and the attenuation.

Let's try turning Shadows On to add visual weight to the objects in the scene.

Exercise 10-4-2 Enable Shadows

1. Open the scene from the previous exercise called Exercise 10-3-1_Free lights04. max and save it to an appropriate folder on your hard drive with a new incremental name. In the Top viewport, select the Free light at the lower-left corner of the scene. In the Modify panel, General Parameters rollout, Shadows area, check the On checkbox. Right-click in the Perspective viewport to activate it and then click the Render Production button in the main toolbar. You will see that the sphere and the cylinder are now casting shadows on the floor and wall (see **Figure 10-18**). Close the Rendered Frame window.

> **Note**
>
> Make sure you do not clear the On checkbox in the Light Properties area as that will turn the light off.

FIG 10-18 Shadows are enabled with a checkbox.

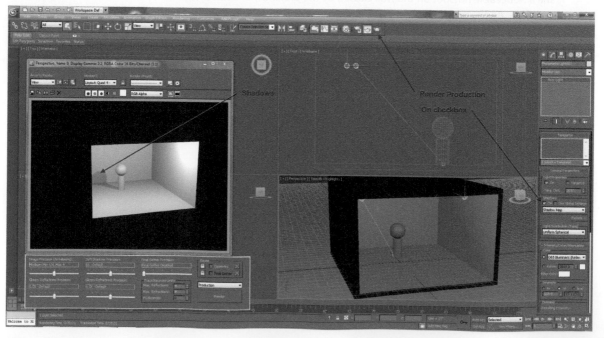

2. In the Top viewport, select the Target light source icon, and then in the Modify panel, General Parameters rollout, check the On checkbox also. Right-click in the Perspective viewport to activate it and then render the scene. Both lights now cast shadows of the sphere and cylinder (see **Figure 10-19**).

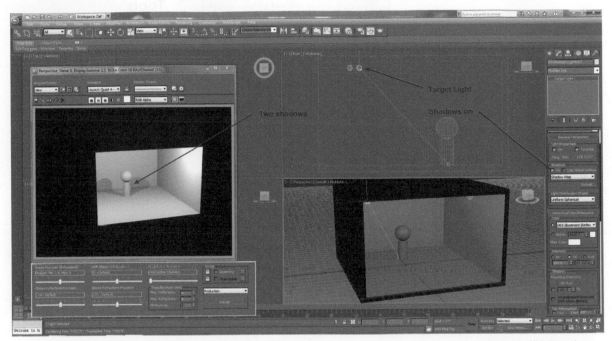

3. Save the file. It should already be called Exercise 10-3-1_Free lights05.max. Close the Rendered Frame window. All the lights in a 3ds Max scene can have shadow casting enabled. However, keep in mind that multiple shadows can sometimes create a confusing image and each shadow casting light must be calculated by the computer resulting in potentially lost production. Use shadows only when necessary.

FIG 10-19 All lights in the scene can have shadow casting enabled if required.

Up to this point, you have selected each light that you wanted to edit and made the changes in the Modify panel. This is no problem for a small scene with a minimum number of lights, but when you have a large scene with many lights it can be rather slow to identify the correct light, select it, go to the Modify panel and edit it, and then move onto the next light. Let's see how you can make the process a little easier with Light Lister.

Exercise 10-4-3 Light Lister

1. Open the 3ds Max file from the previous exercise called Exercise 10-3-1_Free lights05.max and then save it to an appropriate folder on your hard drive with a new incremental name. In the Tools pull-down menu, choose Light Lister (see **Figure 10-20**). In a scene with many lights, the Light Lister may take a few seconds the first time you open it to search for the lights in the scene.

FIG 10-20 Light Lister is found in the Tools pull-down menu.

2. In the Light Lister dialog, you will see narrow vertical buttons at the far left that can be used to select lights in the scene. Left-click on the button in the first row and you will see that the Free light is selected in the scene (see **Figure 10-21**). Only one light at a time can be selected with this method.

FIG 10-21 One light at a time can be selected in the Light Lister.

3. In the Light Lister dialog, top row, enter **75** in the Intensity(cd) numeric field and then press Enter. This halves the intensity of the selected Free light. Right-click in the Perspective viewport and render the scene. The scene is darker overall, and the shadow is less intense from the lower intensity light (see **Figure 10-22**). You may need to rearrange the dialogs in the viewports to see everything.

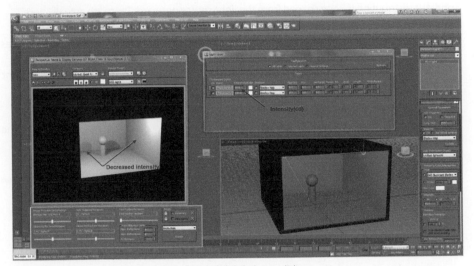

FIG 10-22 Decreased intensity darkens the scene, and the light's shadows are lighter.

Note

It is not necessary to have the light selected when changing any of the parameters in Light Lister. Also, the default names of photometric lights are too long to show in the name field of the Light Lister. You can rename your lights in the Light Lister or in the Modify panel.

4. Close all windows and dialogs and then save the file. It should already be named Exercise 10-3-1_Free lights06.max. Many of the commonly edited parameters for lights and shadows can be accessed through the Light Lister, providing you with an overview of all the lights in the scene. This can be a handy productivity tool in your workflow.

Lighting a scene is often a subjective process, and you need to make adjustments for the scene to be convincing to you and the viewer (client). You need to study lighting in the real world and in more traditional art forms such as painting and photography to develop an "artist's eye" for lighting.

By beginning with direct lighting in 3ds Max, you will begin to develop a sense for controlling and adjusting lighting values. Study the rendered scene in Exercise 10-4-2 to see how angle of incidence and attenuation are also important aspects of lighting quality.

In Section 10.5, you'll learn about photometric light's distribution options and how to change the Target Light from the default Uniform Spherical (equal distribution in all directions) to Spotlight distribution.

10.5 Light Distribution

Spotlight distribution is cone shaped from the light source outward. There are actually two boundaries defining the distribution pattern: Hotspot/Beam and Falloff/Field. The Hotspot/Beam's inner cone defines an area of full light intensity, while the outer Falloff/Field cone defines an area of diminishing light. Outside the Falloff/Field cone there is no light. This provides you with more control over the objects or areas in the scene being affected by the light. The amount of light within the cones is also affected by the angle of incidence and attenuation.

The Target Light is useful for Spotlight distribution because either the light source or the light target can be moved to aim the light, and the area covered by the light is obvious in the viewports. Let's change the distribution of the Target light in the scene.

Exercise 10-5-1 Spotlight Distribution

1. Open the scene you saved in the previous exercise called Exercise 10-3-1_Free lights06. max and save it to an appropriate folder on your hard drive with a new incremental name. In the Top viewport, select the target light source at the upper left of the room. In the Modify panel, General Parameters rollout, Light Distribution (Type) area, click on the Uniform Spherical drop-down list and choose Spotlight (see **Figure 10-23**).

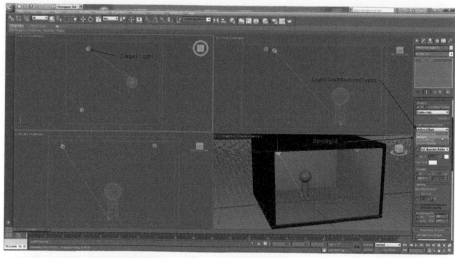

FIG 10-23 Spotlight distribution affects the parent of light from the source.

2. The light icon has changed from a sphere to a cone, and you can see the Hotspot/Beam inner cone and the Falloff/Field outer cone. The Modify panel also has a new rollout: Distribution (Spotlight) with numeric fields to adjust the angles of the two cones (see **Figure 10-24**).

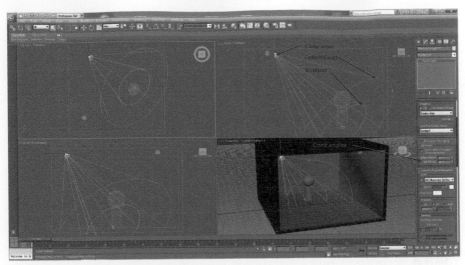

FIG 10-24 Spotlight distribution contains light within two cones.

3. Right-click in the Perspective viewport to activate it and then click the Render Production button in the main toolbar. The Hotspot/Beam inner cone defines the area of full intensity light, while the Falloff/Field outer cone defines the area where the light ends. The falloff area in between the two cones controls the softness of the light Falloff. In Figure 10-25, you can see a very soft-edged brighter area at the front left of the cylinder.

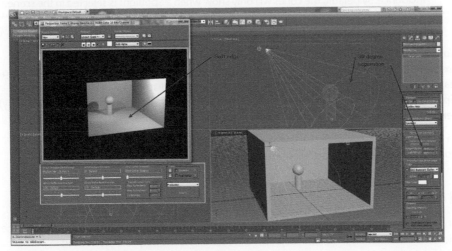

FIG 10-25 The greater the angle between the cones, the softer the edge of the beam.

4. In the Modify panel, Distribution (Spotlight) rollout, enter **35** in the Falloff/Field numeric field, and then press Enter. This reduces the angle between the cones significantly by making the outer Falloff/Field cone smaller while leaving the Hotspot/Beam cone the same. Render the Perspective viewport (see Figure 10-26). The area of full intensity light defined by the Hotspot/Beam cone becomes more apparent because of the sharper edge resulting from the 5° separation between the cones.

FIG 10-26 The edge of the Spotlight beam is controlled by the separation between the cones.

5. Close the Rendered Frame window and save the file, and it should already be called Exercise 10-3-1_Free lights07.max. Spotlights in 3ds Max can be used like spotlights in the real world to highlight objects in your scene by focusing the light distribution within cones and controlling the sharpness of the edge of the light beam on the surface. The smaller the difference in angles between cones, the sharper the edge of the beam becomes. Within the cones, the lights are still affected by attenuation and angle of incidence. By default, the cones will only show when a Spotlight is selected in the scene.

Your 3ds Max scenes now looks significantly different than it did when you had two extremely bright default Uniform Spherical distribution lights and no shadows. By reducing each light's intensity to different values and changing the distribution of one light to Spotlight, and then adding shadows, you have created a more pleasing (in a subjective way) rendered image.

In Section 10.6, you will learn about creating a traditional studio lighting scenario to help control the viewer's perception of the objects in your scene.

10.6 Three-Point Lighting

Three-point lighting is a traditional method in photography, film, and video for focusing the viewer's attention on the main subject in the scene. The technique is often used in portrait photography, and you'll see it on the evening television news.

In this lesson, three-point lighting will provide you with a good tool for experimenting with variations in lighting values and placement. The lighting you have created in the previous exercises is a good beginning for three-point lighting, which consists of a main light, a fill light, and a backlight.

- *Main light* – the main light is the brightest one in the scene and establishes the upper level of illumination from an angle of about 45° over the viewer's shoulder.

- *Fill light* – the fill light is positioned about 45° over the viewer's opposite shoulder (90° to the main light) at about one-half intensity of the main light to reduce strong shadows.
- *Backlight* – the backlight is behind and above the subject to create a "halo effect" to separate the subject from the background.

In the previous exercises of this chapter, you have already positioned two lights in the main light and fill light locations. Let's revisit the scene and make some adjustments to create a typical three-point light system.

Exercise 10-6-1 Positioning Lights

1. Open the 3ds Max file called Exercise 10-6-1_3 point lights01.max and save it to an appropriate folder on your hard drive with a new incremental name. This is the scene from Exercise 10-5-1 with a change to the Perspective viewport, and the Free light has been turned off as indicated by the black icon. The Spotlight is positioned over the viewer's left shoulder, and the Free Light is positioned over the viewer's right shoulder, forming an angle of about 90° between the lights (see Figure 10-27).

FIG 10-27 The main light is over the viewer's left shoulder.

2. Make sure the Perspective viewport is active and then click the Render Production button in the main toolbar. The scene is being lit entirely by the main Spotlight over the viewer's left shoulder. The right side of the sphere and cylinder are very dark and the shadow is black (see Figure 10-28).
3. In the Tools pull-down menu, choose Light Lister. In the Light Lister dialog, check the On checkbox in the top row to turn the Free Light back on. Render the Perspective viewport (see Figure 10-29). The Free Light is now used as a fill light at half the intensity of the main light. This lightens the right side of the cylinder and sphere and brightens the main light's shadow to make it less distracting. However, the new shadow from the fill light is very distracting. Close the Render Frame window.

FIG 10-28 The main light illuminates the scene from upper left.

FIG 10-29 The fill light reduces black shading and main light shadow for a more balanced image.

4. In the Light Lister, clear the Shadows checkbox in the top row to turn off the fill light shadows. In the main toolbar, click the Select and Move button to toggle it on. In the Top viewport, select the main light. Hold the shift key and move the main light clone directly over its target. In the Clone Options dialog, make sure that the Copy radio button is chosen (see **Figure 10-30**). Click the OK button.

FIG 10-30 Clone the main light as a copy to become the backlight.

5. In the Light Lister, click the Refresh button at the upper right to add the new light to the list. Clear the Shadows checkbox for the new light. In the Front viewport, click the vertical blue line that connects the new light source with its target. This selects both the source and the target so that they can be moved in unison. In the Front viewport, move the light and its target in the positive *x*-axis until the inner Hotspot/Beam cone intersects the middle of the sphere. Activate and then render the Perspective viewport (see **Figure 10-31**). The new backlight brightens the outer edge of the sphere and the top of the cylinder to make them contrast with the background for better definition.

FIG 10-31 The backlight is used to separate the subjects from the background.

Note

Though all lights in the real world cast shadows, photographers and videographers can use diffusers to soften these shadows.

6. Close all windows and dialogs and then save the file. It should already be named Exercise 10-6-1_3 point lights02.max. Three-point lighting is useful for 3ds Max projects like product design or "talking head" character animations where you want to present a foreground object while drawing the viewer's attention to the object and away from the background. By disabling shadows for some lights, you reduce distractions and increase computer efficiency by reducing calculation.

Experiment with this scene by changing some of the parameters and settings you have learned in these exercises and see if you can create different moods for the scene.

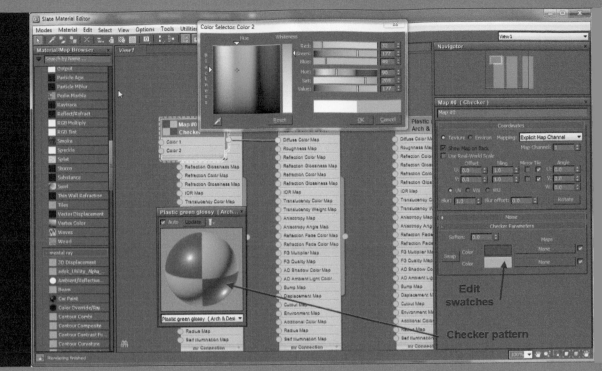

Materials

Materials are the attributes of an object's surface. 3ds Max ships with many predetermined materials that you can assign directly to the objects in your scene without ever learning how to create materials yourself, but this chapter will focus on showing you the process of creating materials from scratch. If you use the materials that are supplied with 3ds Max, your presentations will undoubtedly look very much like the scenes your competition is delivering. However, if you create your own materials, you can provide your presentations with a "signature" look that helps you stand apart from your competition.

Some of the surface attributes contained in the materials are color or pattern, reflectivity and shininess, surface texture, and transparency, just to name a few. This chapter will focus on a material type called the Arch & Design material. This material forms a basis of attributes that is extremely flexible and efficient to render, which makes it a good choice for many of the materials you use in your scenes, especially as a new user of 3ds Max.

By default, materials are created in the 3ds Max Slate Material Editor; a graphical interface where the surface attributes are combined and then applied to the objects in the scene. Materials can be highly realistic or "artistic" depending on the project requirements. Materials can be solid colors or can use maps or images to create complex patterns within the material.

You'll begin by learning some of the concepts of creating Arch & Design materials and then learn about basic navigating, both in the Slate Material Editor. Your ability to navigate quickly and organize your materials is an important part of a productive workflow in 3ds Max.

You'll then assign materials to objects and learn to make adjustments that will automatically be updated on the objects they have been applied to in the scene.

Some of the topics covered in this chapter are as follows:

- *Material concepts* – Materials are applied to objects to define surface attributes such as color, glossiness, and transparency, for example.
- *Slate Material Editor* – Slate is a graphical environment for creating materials.
- *Create and assign materials* – Learn to create basic materials and assign them to the objects in 3ds Max.

Let's begin with some of the basic concepts involved in creating materials in 3ds Max.

11.1 Material Concepts

Materials, working in conjunction with lighting in the scene, elevate your renderings from the dull, default colored objects you have created so far in this book to much more convincing presentations.

Materials can be extremely complex with many layers of attributes combined to simulate various real or imaginary surface conditions. As with many aspects of 3ds Max, it is important to become familiar with the fundamental concepts of material creation to have a solid basis for learning about and experimenting with materials.

An important component of your ability to create materials is to develop an artist's eye when observing the real world. What is it that makes materials readily identifiable as you look around your environment? Colors and patterns are usually recognizable at a glance, but reflections and glossiness are often taken for granted if you haven't trained yourself to look at them specifically. There is no way to create convincing materials if you can't "see" the world around you. Again, it's worth looking at traditional art, specifically paintings, to see how an artist has interpreted materials in a picture. This can help provide an important insight into what makes materials support the objects in the scene.

Often, your clients want you to create "realistic" materials, for example in an architectural presentation, but it's more important to create "convincing" materials that enhance the viewer's perception of your presentation.

There are two terms in computer graphics that are often used interchangeably, but are actually very different: materials and maps.

- *Materials* – materials contain all the surface attributes applied to the objects in the scene.
- *Maps* – maps are patterns within a material; color, texture, or transparency, for example.

So when you hear someone in a tutorial say that they assigned a map to an object's surface in 3ds Max, they are actually assigning a material that contains a map pattern. The terminology can sometimes be confusing to new 3ds Max users, so it's an important difference to understand when learning about materials.

In the next sections, you will learn about the Slate Material Editor and the process of creating materials and assigning them to objects in the scene.

11.2 Slate Material Editor

Let's begin by looking at the Slate Material Editor where materials are created in 3ds Max (see Figure 11-1).

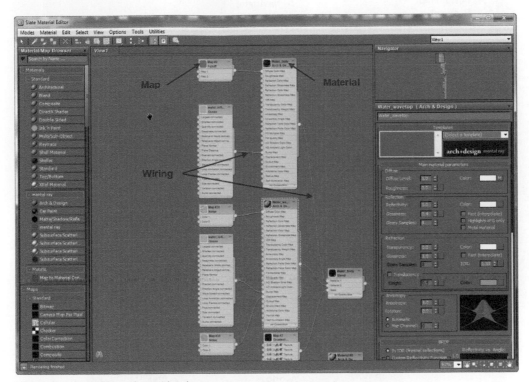

FIG 11-1 Slate Material Editor with materials and maps.

The default Slate Material Editor in 3ds Max provides you with a graphical interface for building materials that will be applied to objects in the current scene. As you can see from the example shown in the image above, there are blue colored nodes representing materials and green colored nodes representing maps. Maps can be "wired" to the various surface attributes of a material and materials can be wired to other materials for added complexity and layering. The depth and complexity is primarily limited by your knowledge and imagination.

New and existing materials can be accessed in the left-hand pane called Material/Map Browser and the current active material can be edited in the right-hand pane. A Navigator panel provides you with an overview of the material layout and allows you to navigate through the various materials at the upper right corner of the Slate Material Editor dialog (see Figure 11-2).

Slate editor material nodes and map nodes have sockets along the sides to enable wiring; input sockets are on the left and output sockets are on the right. Wiring can be accomplished by dragging from one socket to another. At the top of the material and map nodes are sample windows for previewing the material or map (see Figure 11-3).

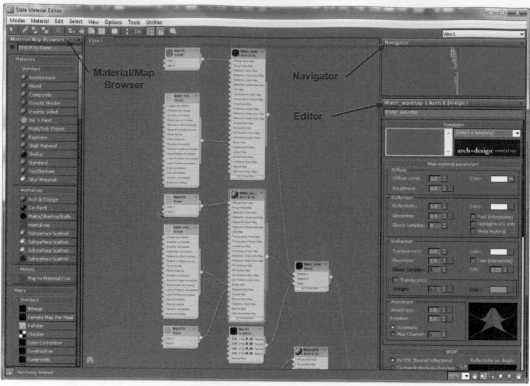

FIG 11-2 Material/Map Browser, Navigator, and Editor pane are used to create materials.

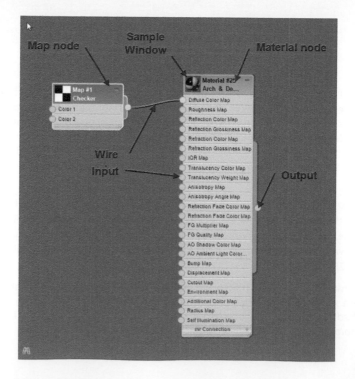

FIG 11-3 Material and map nodes.

Let's have a look around the Slate Material Editor to learn some basic navigation techniques.

Exercise 11-2-1 Introduction to the Slate Material Editor

1. Open the 3ds Max file from the website called Exercise 11-2-1_Slate01.max and save it to an appropriate folder on your hard drive with a new incremental name. The scene contains three primitive objects with basic materials assigned to each. In the main toolbar, click the Material Editor button to open the Slate Material Editor. The three material nodes assigned to the objects in the scene are visible and a white border around the sample window indicates that they are "hot" materials; editing a material will automatically update the materials in the shaded viewports (see Figure 11-4).

FIG 11-4 The Slate Material Editor contains the current scene materials.

2. In the Slate Material Editor, View1, double-click the header of the Red material node to open the editing parameters in the editing pane on the right. A dashed line appears around the material node to indicate it is active in the editing pane (see Figure 11-5). This is an Arch & Design material with the Diffuse Color swatch set to bright red.

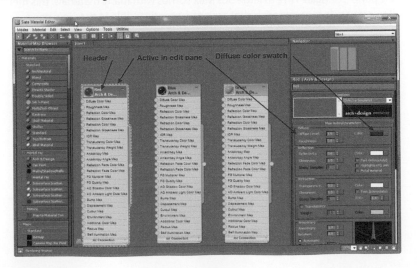

FIG 11-5 Double-clicking a material header makes it active in the editing pane.

3. Left-click the Diffuse Color swatch to access the Color Selector dialog, and then click and drag the Value slider to the left to darken the value of the red color. You will see the color swatch update and the red box in the shaded viewport will also become darker (see **Figure 11-6**). Close the Color Selector dialog.

Note

The Color Selector provides you with several methods of editing color; the Hue panel at the left, the RGB (red, green, blue) sliders at top right, and the HSV (hue, saturation, value) sliders at the bottom right. The three editing methods are interlinked and changing values using one method will affect the other values automatically. This provides you with a variety of options for adjusting color in 3ds Max.

FIG 11-6 Editing the Diffuse Color swatch affects the swatch and the material in the viewports.

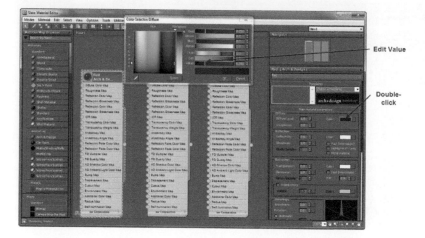

4. In the Material/Map Browser pane, scroll down to the Scene Materials rollout. Double-click on Green (Arch & Design) in the rollout to center that material node in the view pane and then double-click on the header to open its parameters in the edit pane (see **Figure 11-7**). In large 3ds Max scenes with many materials, this method allows you to locate materials that are not currently visible in the view pane.

FIG 11-7 Materials are centered in the view pane when double-clicked in the Scene Materials rollout.

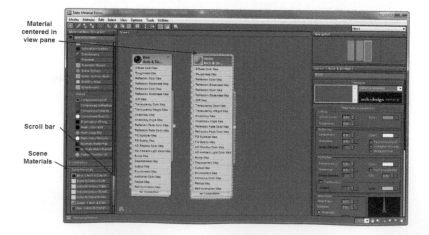

5. Right-click the header for the active Green material and then choose Open Preview Window in the menu. This opens a resizable sample window dialog for a more detailed view of the material applied to the sample sphere (see Figure 11-8).

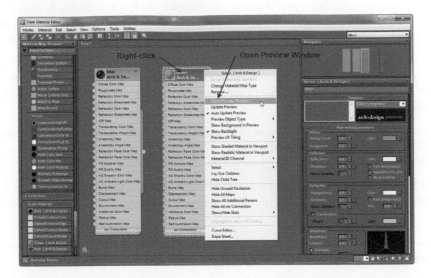

FIG 11-8 Material Preview Windows can be expanded for easier editing.

6. Click and drag a corner of the Preview Window to make it larger. In the edit pane, Reflection area, enter **0.5** in the Glossiness numeric field and then press Enter. The results are more apparent in the Preview Window than in the small sample window of the material node (see Figure 11-9).

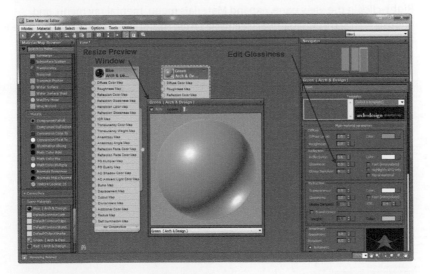

FIG 11-9 Resize the Preview Window for easier editing.

7. Close the Slate Material Editor dialog and then save the 3ds Max scene. Learning to navigate the Slate Material Editor smoothly requires a little practice, but this node-based environment is a powerful feature in 3ds Max.

In Section 11.3, you will create three more realistic Arch & Design materials in the Slate Material Editor and then assign the materials to three objects in another 3ds Max scene.

11.3 Create and Assign Materials

Each object in a 3ds Max scene needs materials to convince the viewer of its physical composition: steel, rubber, wood, or plastic are examples of a few possibilities. In this section, you will use the Arch & Design material to create materials with color, patterns, and transparency to learn the process of building materials from a variety of parameters and components.

You'll practice navigating the Slate Material Editor, create materials, and then assign the materials to objects in the scene that you created in previous exercises. The materials will be as follows:

- *Flat beige paint* – the paint material will have beige color and no glossiness or reflectivity.
- *Glossy green plastic* – the plastic will be dark green and moderately shiny.
- *Red clear plastic* – the light red plastic will be semitransparent.

Once the materials are created, you will learn to assign materials to many objects in the scene at once and then to assign materials individually to objects.

Exercise 11-3-1 Create Materials

1. Open the 3ds Max file from the website called Exercise 11-3-1_Materials01.max and save it to an appropriate folder on your hard drive with a new incremental name. This is the scene that you applied lighting to in Chapter 10. In the main toolbar, click the Material Editor button to open the Slate Material Editor dialog. Right-click in the view pane, expand Materials menu, mental ray menu, and choose Arch & Design material (see **Figure 11-10**). This opens a new material node in the view pane.

FIG 11-10 Create a new Arch & Design material node in the view pane.

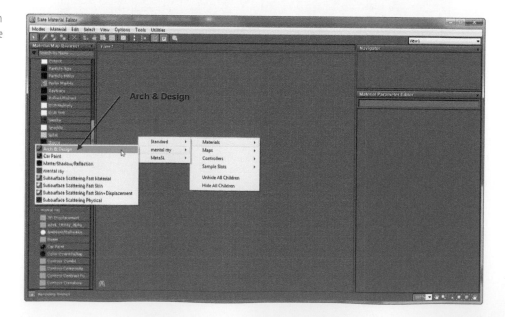

2. In the main toolbar, click the Select by Name button to open the Select From Scene dialog. Highlight the three objects: Room001, Sphere001, and Table001 in the list (see Figure 11-11). Click OK to select the objects.

FIG 11-11 Use Select by Name to select the 3D objects in the scene.

3. In the Slate Material Editor dialog, view pane, right-click the header of the new material and then choose Assign Material to Selection in the menu (see Figure 11-12). This assigns the material to all of the selected objects at once.

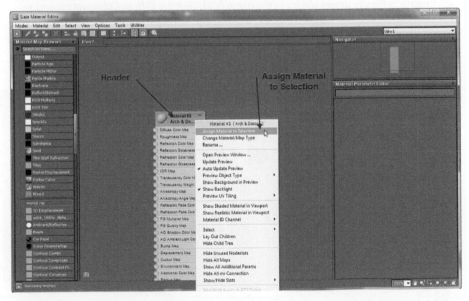

FIG 11-12 Materials can be assigned to many selected objects at once.

4. In the view pane, double-click the material node header to open it in the edit pane. Rename the material **Paint beige** in the name field at the top of the pane. In the Main material parameters rollout, click the Diffuse Color swatch to open the Color Selector and then change the color to beige (use your judgment to determine

203

the color). Click OK in the Colors Selector to finalize the color change. In the edit pane, Reflection area, enter **0.0** in the Reflectivity and Glossiness numeric fields (see **Figure 11-13**). This creates a flat material with no shininess or reflectivity.

FIG 11-13 Create a flat, beige paint material.

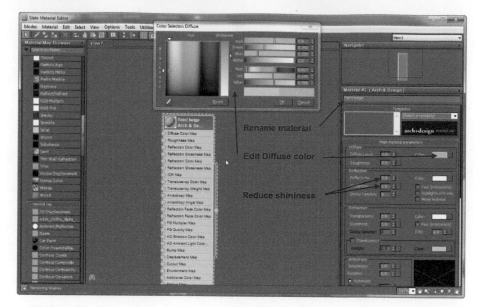

5. Hold the Shift key and drag the material node to the right to clone it as a copy. Double-click the new material node header to open it in the editing pane and then change the name to **Plastic green glossy** in the name field. Click the Diffuse Color swatch and, in the Color Selector, change the color to dark green. In the Reflection area, enter **0.3** in the Reflectivity numeric field and enter **0.5** in the Glossiness numeric field. Right-click on the material editor and choose Open Preview Window, and then resize the new sample window for a better view of the level of glossiness on the material (see **Figure 11-14**).

FIG 11-14 Create a green glossy plastic material.

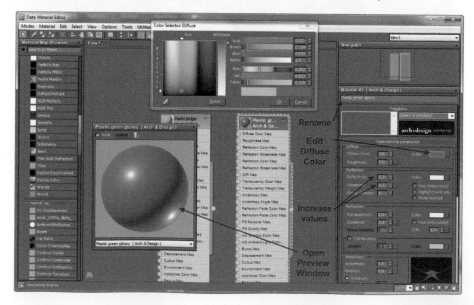

6. Use the Shift key to clone this material, double-click the material header to open it in the editing pane, and then rename it to **Plastic red clear**. In the Templates rollout, click the (Select a template) drop-down list and then choose Translucent Plastic Film, Light blur in the list. The template changes many of the material attributes to simulate transparent red plastic and provides a description of the material (see Figure 11-15). Edit the Diffuse Color swatch to create a light red color. Material templates found in the Arch & Design material can change many parameters and are sometimes useful to establish a starting point for a particular material.

> **Note**
>
> By naming a material "Plastic red clear" instead of clear red plastic, the material will be easier to find in long lists of materials because all of the plastic will be grouped together, for example.

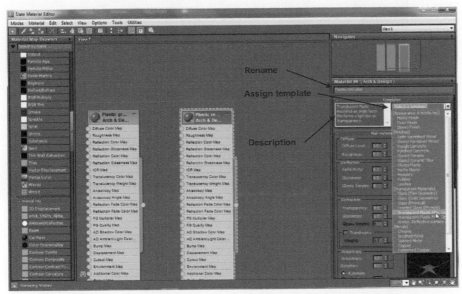

FIG 11-15 Create a transparent red plastic using an Arch & Design material template.

7. Close the Slate Material Editor and then use the keyboard shortcut Ctrl+S to save the file; it should already be called Exercise 11-3-1_Materials02.max. You have created two new materials, glossy green plastic and transparent red plastic, but have not assigned those materials to any objects in the scene.

 Let's learn to assign a map as a pattern within a material to alter the color of the Plastic green glossy material in Exercise 11-3-2.

Exercise 11-3-2 Maps

1. Open the 3ds Max file that you created in the previous exercise called Exercise 11-3-1_Materials02.max and save it to an appropriate folder on your hard drive with a new incremental name. Open the Slate Material Editor if it isn't open already. In the view pane, double-click the header for Plastic green glossy material to open its attributes in the editing pane. In the Main material parameters rollout, Diffuse area, left-click the gray map shortcut button just to the right of the Diffuse Color swatch to open the Material/Map Browser dialog. In the Material/Map Browser dialog, Standard rollout, double-click Checker (see **Figure 11-16**). The procedural Checker map overrides the Diffuse Color swatch with a black and white checker pattern.

FIG 11-16 Open the Checker map in the Diffuse Color.

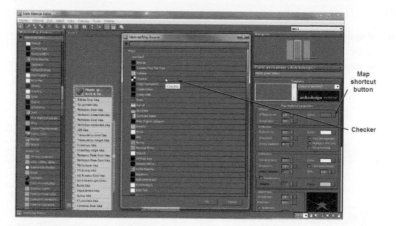

2. In the view pane, right-click on the material header and then choose Open Preview Window to see that the sample sphere is now colored by a checker pattern. Pan in the view pane so that you can see the entire material and you will see that the Checker map is now wired from its output to the input of the Diffuse Color Map slot of the material. Double-click on the Checker map header to open its parameters in the editing pane (see **Figure 11-17**).

FIG 11-17 A Checker map overrides the Diffuse Color with a black and white checker pattern.

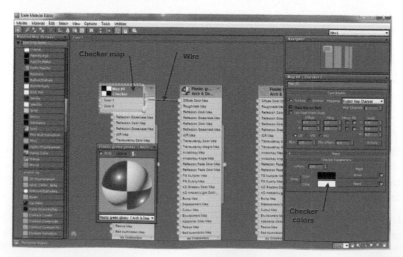

3. In the editing pane, Checker Parameters rollout, edit the Black Checker Color swatch to make it a dark green and then edit the White Checker Color swatch to a lighter green color (see **Figure 11-18**). The checker pattern is now providing 100% of the Diffuse material color.

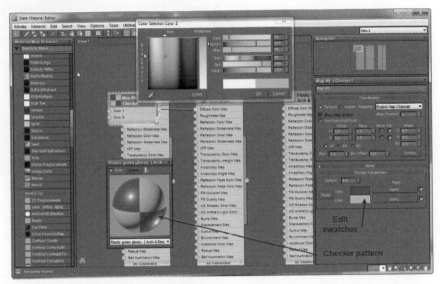

FIG 11-18 The Diffuse Color is now provided by a Checker map.

4. Close the Slate Material Editor and save the file. It should already be called Exercise 11-3-1_Materials03.max. Simple materials can have solid colors, but much more complex materials can be created using maps to define patterns within the material.

 You have created new materials in the Slate Material Editor, but have not assigned the materials to objects in the scene. In Exercise 11-3-3, you will learn to "wire" the output of the new materials directly to objects in the viewports to assign the materials to the objects.

Exercise 11-3-3 Assigning Materials to Scene Objects

1. Open the 3ds Max scene from the previous exercise called Exercise 11-3-1_Materials03.max and save it to an appropriate folder on your hard drive with a new incremental name. Open the Slate Material Editor and double-click the header for Plastic green glossy material node to activate it. Make sure that you can see the cylinder and the sphere in the Perspective viewport. Left-click and drag a red wire from the output of the material to the cylinder in the Perspective viewport until you see this cursor change to an arrow and rectangle (see **Figure 11-19**). Release the left mouse button and the material will be assigned to the cylinder. If you have not closed the file from the previous Exercise 11-3-2, you might still have all three objects selected, and in this case select Assign to Object in the Assign Material dialog box that should appear once you drop the material onto the cylinder.

FIG 11-19 Materials can be assigned to individual objects by wiring the material output to the object in a viewport.

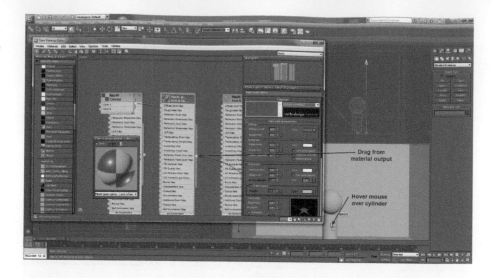

2. Pan in the view pane to see the Plastic red clear material node. In the view pane, click and drag from the output to the sphere in the Perspective viewport. Release the left mouse button to assign the materials to the sphere (see **Figure 11-20**). The material does not have to be currently active in the editing pane to be assigned to the objects in the scene. The white border around the sample window indicates the material is "hot" in the scene.

FIG 11-20 Materials do not need to be active to wire the material to objects in the viewports.

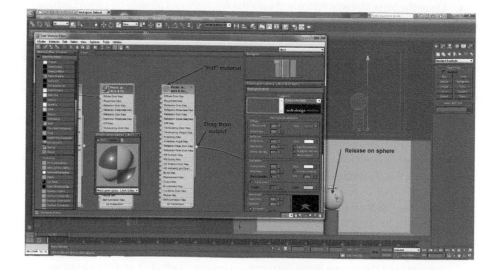

3. The room in the scene now has beige paint material, the sphere has clear red plastic, and the cylinder has green Checker material assigned. In the view pane, navigate to the Checker map node and double-click to activate it. Right-click on the map header and then choose Show Shaded Material in Viewport from the menu (see **Figure 11-21**). This displays the map on the assigned object in the shaded viewport (see **Figure 11-22**).

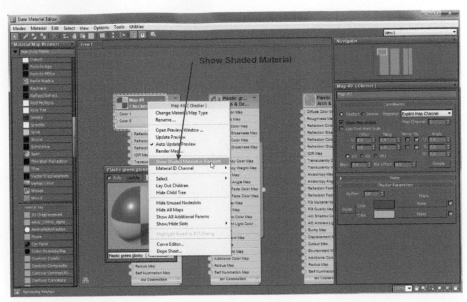

FIG 11-21 Enable Show Shaded Material in viewports for the Checker map.

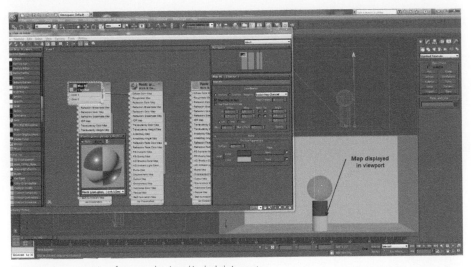

FIG 11-22 A representation of maps can be viewed in shaded viewports.

4. Close the Slate Material Editor and save the file. It should already be called Exercise 11-3-1_Materials04.max. The Checker map pattern has been assigned to the Diffuse Color slot of a material and the map has been displayed in the viewport. However, the size of the checker pattern on the cylinder may need adjusting.

In Chapter 12, you will learn to apply mapping coordinates to patterns used in materials to resize the pattern in the viewports and in the rendered images.

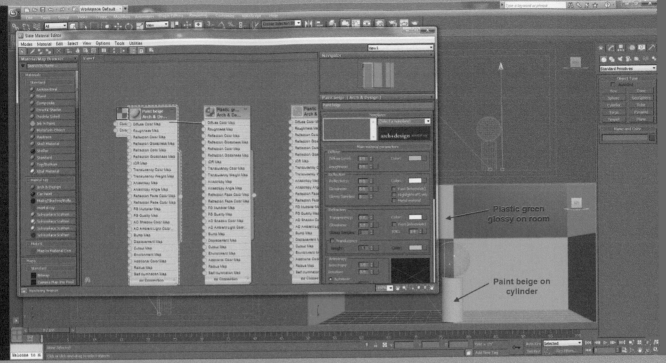

Mapping Coordinates

Mapping coordinates are information stored in an object's vertices that describes how the maps or patterns used in the materials applied to the object are projected onto the surface. The most common method of applying specific mapping coordinates is using the UVW Map modifier, which has adjustable parameters for projecting the maps onto object's surfaces.

Some of the topics covered in this chapter are as follows:

- *Mapping coordinate concepts* – Learn how mapping coordinates can affect the positioning and sizing of maps used in materials on 3D surfaces.
- *UVW map modifier* – Learn some of the options available for projecting maps onto 3D surfaces.
- *Sizing maps correctly* – Learn the easy steps to scale maps for real-world patterns in 3ds Max.

Let's begin with some of the basic concepts of how mapping coordinates function in 3ds Max.

12.1 Mapping Coordinate Concepts

When you apply materials that contain specific maps or patterns for representing real-world materials, it is important to size and position the maps or patterns so that they are convincing to the viewer. For example, if you apply a material with a brick pattern where the

bricks are represented as 4' × 2' in size, the resulting image is cartoonish and unbelievable (see Figure 12-1). You need to apply proper mapping coordinates to represent real-world bricks, unless otherwise specified by the type of presentation.

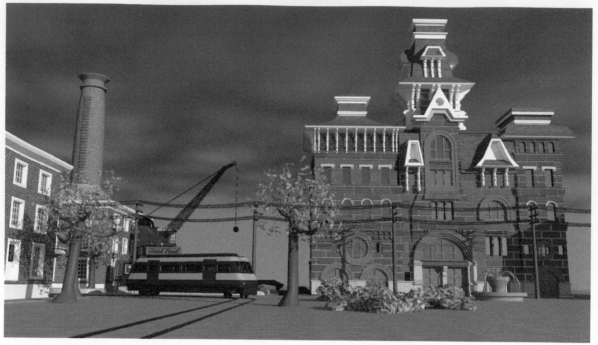

FIG 12-1 Improperly sized brick is not convincing to the viewer.

Maps used in materials in 3ds Max often represent a specific area of a pattern. For example, a Tiles map has a default setting of four tiles across and four tiles down (see Figure 12-2).

FIG 12-2 The default Tiles map in 3ds Max.

When applied to a 3D surface this default pattern must be sized by editing mapping coordinates so that each tile is represented in real-world sizes. The UVW Map modifier helps you project the map correctly onto a surface.

Let's learn to control mapping coordinates with the UVW Map modifier.

12.2 UVW Map Modifier

The UVW Map modifier projects a material's maps or patterns onto 3D surfaces with adjustments for placement and size.

Primitive 3D objects created in 3ds Max usually have general mapping coordinates applied so that you can view maps in the shaded viewports and in a rendered image, providing you with a starting point for how the material will look (see Figure 12-3). However, these general mapping coordinates almost never provide an acceptable pattern.

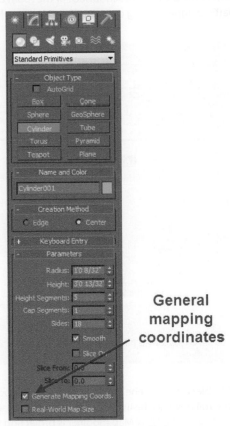

General mapping coordinates

FIG 12-3 A newly created a cylinder primitive has mapping coordinates enabled.

Most of the mapping coordinates you define with the UVW Map modifier will provide you with sufficient control to resize and reposition the patterns on the object's surface. The UVW Map modifier projects one repetition of the map you are using onto the surface, and then a process called "tiling" repeats the pattern horizontally and vertically over the entire surface.

Exercise 12-2-1 Applying UVW Map Modifier

1. Open the 3ds Max file from the website called Exercise 12-2-1_Mapping01.max and save it to an appropriate folder on your hard drive with a new incremental name. This is the scene from the Chapter 11 containing a room with a cylinder and the sphere. The room has a beige paint material with no pattern, the sphere has a clear plastic material with no pattern, and the cylinder has a green plastic material with a checker pattern. The checker pattern is visible in the viewport because the cylinder has general mapping coordinates. Let's swap the materials on the room and the cylinder.

2. In the main toolbar, click the Material Editor button to open the Slate Material Editor. Click and drag from the output of the *Plastic green glossy* material node to the room in the Perspective viewport. Click and drag from the output of the *Paint beige* material node to the cylinder in the Perspective viewport (see **Figure 12-4**). One repetition of the checker pattern is now shown on each surface of the room based on general mapping coordinates assigned during creation. Close the Slate Material Editor.

FIG 12-4 Swap the materials on the cylinder and the room.

3. Select the *Room001* object in the scene. In the Modify panel, Modifier list, choose UVW Map; you can scroll down in the list or begin typing the modifier name to find it (see **Figure 12-5**). By default, the UVW Map modifier is projecting the checker pattern along the Local z-axis of the room, zoom out in the Perspective viewport so that you can see the whole room and you will notice the full checker on the floor and ceiling, but not on the walls. The default mapping mode is planar, as seen from the orange gizmo in the viewports, with this gizmo fitting the extent of the room as seen from the Top viewport (see **Figure 12-6**). The checker pattern is "streaked" on the vertical walls.

UVW Map

FIG 12-5 Apply a UVW Map modifier to the room.

FIG 12-6 Default projection is planar along the Local z-axis.

4. In the Modify panel, Parameters rollout, Mapping area, choose the Box radio button. This uses a box-shaped gizmo to project one repetition of the checker pattern in six directions (see Figure 12-7). A general rule is to use the mapping mode that most closely represents the object on which the UVW Map modifier has been applied. The orange projection gizmo is now a box and one repetition of the checker pattern appears on each wall and floor surface.

FIG 12-7 Box mapping mode projects the checker pattern in six directions.

5. Save the 3ds Max file. It should already be called Exercise 12-2-1_Mapping02.max. By applying the UVW Map modifier to an object you override the general mapping coordinates assigned at creation and are provided with controls for projecting, positioning, and sizing the patterns within the material assigned to the object.

Let's learn to correctly size a pattern to represent real-world units.

12.3 Sizing Maps Correctly

Sizing maps correctly for the majority of your material maps and patterns is a simple process consisting of four steps:

- *Analyze the map pattern*
- *Determine the size of the area covered by one repetition of the map pattern*
- *Apply a UVW Map modifier*
- *Adjust the size of the projected gizmo to match the size of the area covered by one repetition of the map pattern*

216

You have already performed step 3 by applying the UVW Map modifier to the room. Let's perform an exercise where the client has requested that each individual "check" in the pattern will be 1' × 1' in this situation.

Exercise 12-3-1 Create Convincing Tiles

1. Open the 3ds Max file called Exercise 12-2-1_Mapping02.max and save it to an appropriate folder on your hard drive with a new incremental name. The UVW Map modifier gizmo is set to Box mode and is sized, by default, to project one repetition of the checker pattern (four checks) per side, with the size of each pattern based on the dimensions of the room (see Figure 12-8).

FIG 12-8 The default UVW Map gizmo size is based on the room dimensions.

2. Open the Slate Material Editor, and select the Checker map node linked to the Plastic green glossy material's Diffuse Color Map input node. Let's analyze the map. Right-click on the Checker map header, and then choose Open Preview in the menu (see Figure 12-9). Click and drag a corner of the Preview Window to make it a little larger. You can see that the map consists of 4 square checks, alternating light green and dark green in this case.

3. The next step is to determine the size of the area you want to cover by one repetition of the map. If the client wants 1' × 1' checks, then the size of the area covered by this map is 2' × 2'. Make note of the size of the area covered (see Figure 12-10).

FIG 12-9 Analyze the map by opening it in a Preview Window.

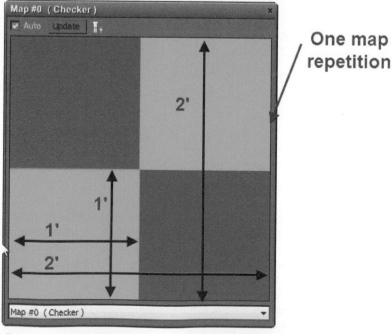

FIG 12-10 The size of the area covered by one repetition of this map is 2' × 2'.

4. The third step in the process, applying a UVW Map modifier, has already been performed. The last step is to adjust the size of the UVW Map modifier gizmo to match the size of the area covered by one repetition of the map. Close the Slate Material Editor. In the Modify panel, Parameters rollout, Mapping area, enter **2'** in the length, width, and height numeric fields, and then press Enter. The orange UVW Map gizmo will become a 2' × 2' × 2' cube and will project the checker map on all six directions. 3ds Max then "tiles" the checker pattern horizontally and vertically to cover the surfaces (see **Figure 12-11**).

FIG 12-11 Entering the size of the area covered into the UVW Map gizmo sizes the checks correctly.

5. Save the file. It should already be called Exercise 12-2-1_Mapping03.max. Following these four simple steps will allow you to correctly size many maps in day-to-day production.

You have learned to analyze a map pattern by looking at it in a Preview Window and determining the size of each element in the pattern, and then calculating the size of the area covered by one repetition of the entire map. The UVW Map gizmo is then adjusted in size to match the area of the size needed to project it correctly onto the surfaces.

Unless you are developing a fantasy world that has absolutely no basis in reality, you will usually need to size the map patterns in your materials so that they are convincing to the viewer. As you have learned in this chapter, the process is quite simple for a majority of day-to-day materials you may encounter.

Take some time to open a new scene in 3ds Max, create a few simple materials with patterns using some of the built-in procedural maps or image maps, and then experiment with the steps you have learned in this chapter for sizing the patterns appropriately.

Camera Basics

Cameras in 3ds Max are either of two types: Target or Free. The concept is very similar to the Target and Free lights you created in Chapter 10; Target cameras are usually fairly stationary and pointed at a particular object or in a particular direction, whereas Free cameras are best for animating freely along a path.

Some of the topics covered in this chapter are as follows:

- *Camera concepts* – 3ds Max cameras are based on traditional 35 mm photography.
- *Target and Free cameras* – Learn to create and transform Target cameras and Free cameras.
- *Camera parameters* – Learn to adjust the focal length and field of view (FOV).
- *Camera viewport controls* – Turn a Perspective viewport into a Camera viewport and learn about the new navigation tools specific to this viewport.
- *Camera principles* – Learn some of the basic principles of traditional camera placement in scenes.

Let's begin with some of the basic concepts of creating and adjusting cameras in 3ds Max.

13.1 Camera Concepts

Cameras in 3ds Max are based on traditional 35 mm photography. For example, a "normal" lens for a 35 mm camera is considered to have a 50 mm focal length. This creates a perspective that most closely represents what humans see from one eye. Focal lengths that are less than 50 mm are considered to be wide-angle, whereas focal lengths greater than 50 mm are telephoto lenses.

Note

The focal length of digital still cameras and video cameras do not correspond directly to 3ds Max cameras. The film in a traditional camera is measured 35 mm diagonally, which required a 50 mm focal length lens to cover the film while maintaining normal perspective. The new digital sensors in most cameras today are much smaller, making a 50 mm lens function as a telephoto lens.

Cameras are used in 3ds Max to provide the viewer with a convincing composition that helps maintain the viewer's focus on the message you are presenting. The psychological effects of even slight changes in perspective and FOV of cameras can have a major effect on how the viewer perceives the presentation.

When you are positioning cameras in 3ds Max, it is important to understand that, by default, what you see in the Camera viewport is not necessarily what the camera will render in the final image. Although it is not part of camera parameters, you'll learn to enable Safe Frames that matches the viewport aspect ratio to the image output ratio when rendered, providing you with an accurate Camera viewport. This is an important step to make sure that "what you see is what you get" when rendering your scene.

As you view photography or watch videos and films, you should focus on how the artist has composed the camera and what effect it has on your perception of the scene. You'll learn about the concept of "rule-of-thirds," imaginary lines dividing the camera view in thirds both vertically and horizontally. The main focal point of your presentation should then be placed at one of the intersections of the rule-of-thirds lines for major impact. Rule-of-thirds has been used in all forms of art for many, many years.

Camera shots are also a composition tool that enables you to focus the viewer on appropriate areas of your presentation. For example, a wide-angle camera shot introduces the viewer to the overall scene, whereas a telephoto shot focuses the viewer's attention on a much more specific point of action. Again, these are traditional tools used by artists in all media.

Let's begin by learning to create Target and Free cameras.

13.2 Target and Free Cameras

Target cameras, like Target lights, require a click and drag action, creating the camera with the first click and then dragging the mouse to position the target, which is created when you release the mouse button. This provides you with the ability to move the camera in

the scene while maintaining a line of sight to the target. Of course, the target may also be moved to change the point of view seen by the camera.

Free cameras are created with a single click in a viewport and can be moved without affecting the rotation of the camera; they can also be rotated freely in space. This makes Free cameras ideal for animating along a path in 3ds Max without the need to be concerned with moving a target as well.

Let's begin by creating both a Target camera and a Free camera in a 3ds Max scene.

Exercise 13-2-1 Create a Target and Free Camera

1. Open the 3ds Max file from the website called Exercise 13-2-1_Cameras01.max and save it to an appropriate folder on your hard drive with a new incremental name. The scene contains few buildings, trees, a trailer, and a character to introduce you to creation and adjustment of cameras (see Figure 13-1).

FIG 13-1 A San Francisco street scene.

2. Right-click in the Top viewport to activate it; in the Create panel, Cameras category, Object Type rollout, click the Target button. In the Top viewport, click between the lower pair of trees (salmon colored) and then drag to the right side of the trailer (green colored). Release the left mouse button to create the camera's target (see Figure 13-2).

FIG 13-2 Create a Target camera in the Top viewport.

3. Right-click in the Perspective viewport to activate it and then press the letter C, the keyboard shortcut for the currently selected camera's Camera001 viewport. The Camera001 viewport now shows what the default camera sees and, because the camera and target were created on the current work plane in the Top viewport, the scene's ground plane is at eye level (see **Figure 13-3**). You will adjust the camera later.

FIG 13-3 A camera created in the Top viewport is at ground level.

4. Right-click in the Front viewport to activate it. In the Create panel, Cameras category, Object Type rollout, click the Free button. In the Front viewport, click near the top of the green trailer, above the current camera. This creates a Free camera facing in the negative z-axis direction of the viewport.

5. Right-click in the Camera001 viewport and then press the C keyboard shortcut. The Camera002 viewport (currently selected camera) shows the top of the trailer and the trees beyond (see **Figure 13-4**).

FIG 13-4 A Free camera requires only a single click to create the camera.

6. In the main toolbar, click the Select Object button, and then in the Front viewport, click in an empty space to deselect all cameras. Press the C keyboard shortcut and you will be presented with the Select Camera dialog listing the cameras in your scene (see **Figure 13-5**). Double-click Camera001 in the list to change from the Front viewport to the Camera001 viewport.

FIG 13-5 Keyboard shortcut C opens the Select Camera dialog when multiple cameras are in the scene and none are currently selected.

7. Save the file. It should already be called Exercise 13-2-1_Cameras02.max. You now have a scene with two cameras and two Camera viewports, but neither Camera viewport is particularly useful without further adjustment of camera parameters.

Creating cameras, both Target and Free cameras, is a simple process in 3ds Max, but cameras usually require parameter changes and transformations to create interesting views of your 3ds Max scene.

Let's learn about some of those camera parameters in Section 13.3.

13.3 Camera Parameters

The two camera parameters you will be primarily concerned with in 3ds Max are as follows:

- *Lens (focal length)*
- *FOV (field of view)*

The numeric values for the Lens parameter and the FOV parameter are interlinked so that when you change one, the other also changes.

The Lens parameter adjusts the focal length of the camera based on 35 mm photography and is probably the most familiar one to users. The FOV is the horizontal angle covered by the current camera view and is especially useful for forensic professionals where real-world cameras must be matched accurately.

The Lens focal length is set to 43.456 mm to approximate human sight with one eye closed. You can enter any new value for the Lens numeric field, or you can choose preset buttons ranging from a wide-angle 15 mm stock lens for 35 mm photography to a 200 mm telephoto lens. The smaller the focal length value is, the wider the FOV becomes. Both Target cameras and Free cameras share the same parameters.

Let's adjust the Lens focal length for the cameras you have created in the San Francisco street scene.

Exercise 13-3-1 Adjust Basic Camera Parameters

1. Open the 3ds Max file from the website called Exercise 13-2-1_Camera02.max and save it to an appropriate folder on your hard drive with a new incremental name. Right-click in the Camera002 viewport to activate it. Press the keyboard shortcut H to open the Select From Scene dialog and then double-click on Camera002 in the list (see **Figure 13-6**).This is the Free camera, so there is no corresponding target object in the list.

Camera and target

Camera002 (Free camera)

FIG 13-6 Select Camera002 to edit its parameters.

2. In the Modify panel, Parameters rollout, Stock Lenses area, click on the 28 mm button and you will see the Camera002 viewport change to a wider view. Click the 15 mm button and you will see even more of the scene in the Camera002 viewport (see **Figure 13-7**).

FIG 13-7 Change the Free camera to a 15 mm focal length.

3. Use Select From Scene to select Camera001. In the Modify panel, Parameters rollout, Stock Lenses area, click the 15 mm button again. The Target camera, with the same 15 mm focal length, shows more of the scene (your results may be slightly different) than the Free camera (see **Figure 13-8**). The reason for the difference is that the Target camera is further away from the trailer, so the camera with the same FOV shows more of the scene.

FIG 13-8 Cameras of equal focal length are affected by the distance from objects in the scene.

227

4. Save the file. It should already be called Exercise 13-2-1_Cameras03.max. Modifying the focal length of cameras is a small, but important, part of creating effective camera views in 3ds Max.

In Section 13.4, you'll learn to adjust camera views by navigating the position and orientation of the cameras using the camera navigation buttons that appear when a Camera viewport is active.

13.4 Camera Viewport Controls

Once a viewport has been set for a camera in the scene, the viewport navigation buttons at the lower right of the 3ds Max display change to represent terminology used when adjusting camera settings and position in the real world. You can, of course, always move and rotate cameras as you would do with any other object in 3ds Max, but the camera navigation buttons can provide slightly different controls such as Dolly Camera, Truck Camera, and Roll Camera. These terms are commonly used in film and video to describe basic camera transformations.

In Exercise 13-4-1, you will perform some hands-on camera adjustments to familiarize yourself with the navigation tools.

Exercise 13-4-1 Navigate a Camera Viewport

1. Open the 3ds Max file from the previous exercise called Exercise 13-2-1_Camera03. max and save it to an appropriate folder on your hard drive with a new incremental name. Right-click in the Camera001 viewport (the Target camera) to activate it and you will see new navigation buttons at the lower right corner of the 3ds Max display (see Figure 13-9).

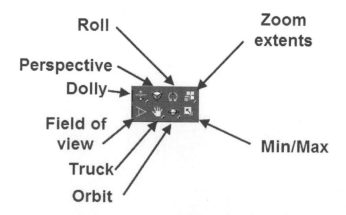

FIG 13-9 When a Camera viewport is active, the navigation buttons represent camera transformations.

2. In the Camera001 viewport, right-click on Wireframe in the viewport label and then choose Shaded from the menu (see Figure 13-10). Click the Truck Camera button,

and then, in the Camera001 viewport, click and drag the "hand" cursor downward until the trailer wheel is near the bottom of the viewport (see Figure 13-11). The Truck Camera command moves both the camera and its target, so that the perspective does not change.

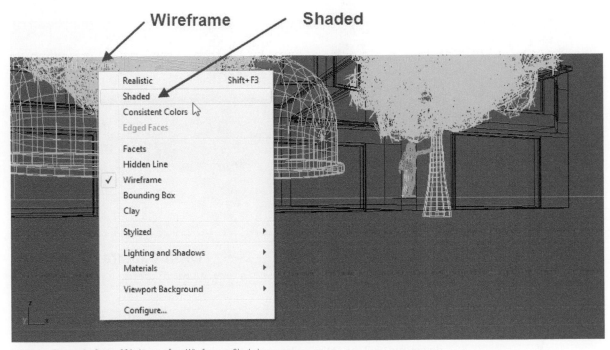

FIG 13-10 Change the Camera001 viewport from Wireframe to Shaded.

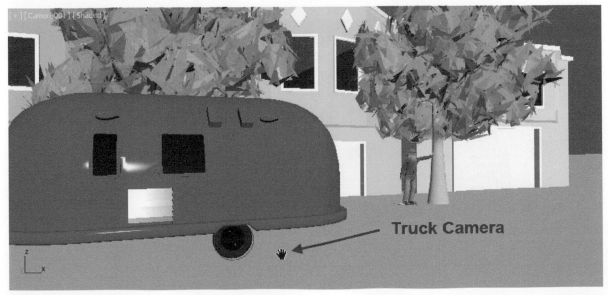

FIG 13-11 Move a Target camera and its target simultaneously with Truck Camera.

3. Click the Orbit Camera button, and then, in the Camera001 viewport, click and drag to the right until the rear of the trailer is near the character. Orbit Camera moves the camera freely, but leaves the target in place (see **Figure 13-12**). Orbiting the camera changes the scene perspective.

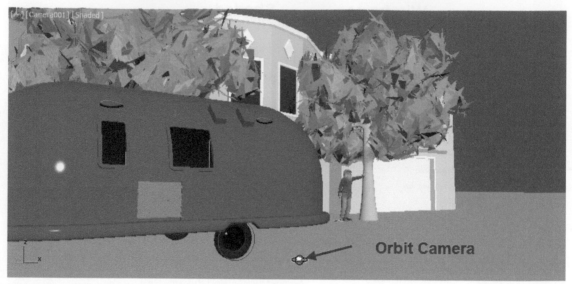

FIG 13-12 Move only the Target camera and not the target with Orbit Camera.

4. Click the Dolly Camera button, and then, in the Camera001 viewport, click and drag downward until the entire trailer comes into view (see **Figure 13-13**). Dolly Camera moves a Target camera toward and away from its target along the line of sight.

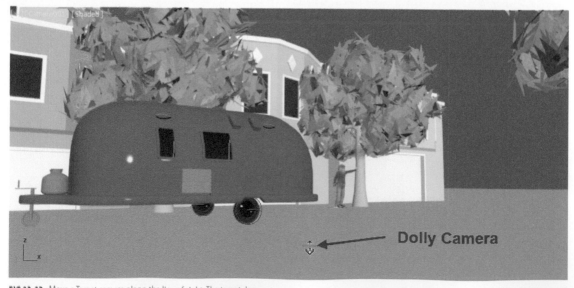

FIG 13-13 Move a Target camera along the line of sight. The target does not move.

5. Click the FOV button and then, in the Camera001 viewport, click and drag downward slightly. FOV changes the FOV and Lens focal length simultaneously for a wider angle or more telephoto lens (see **Figure 13-14**).

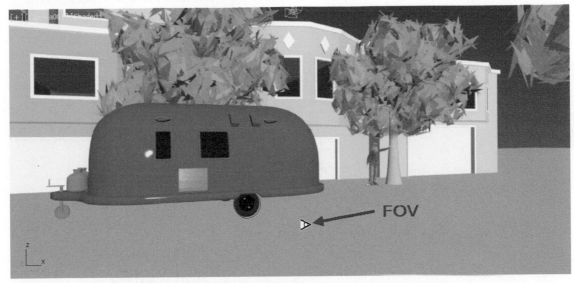

FIG 13-14 Field of view changes the Lens focal length and the FOV settings of a camera.

6. Click on the Perspective button and then click and drag upward in the Camera001 viewport. Perspective changes the FOV and dollies the camera along its line of sight to change the perspective and position simultaneously (see **Figure 13-15**).

FIG 13-15 Use Perspective to Dolly and change field of view simultaneously.

7. Click the Roll Camera button and then click and drag slightly to the right in the Camera001 viewport. While still holding the left mouse button down, click the right mouse button to cancel the operation (see **Figure 13-16**). Rolling a camera rotates it around the line of sight. Tilting the horizon of an image is usually done only in special cases. Use the Ctrl+Z keyboard shortcut to undo the camera roll if you didn't cancel it in time.

Roll Camera

FIG 13-16 Roll Camera rotates a camera around its line of sight.

8. Activate the Camera002 viewport and then try the navigation buttons for the Free camera. The commands function similarly for each camera type. Save the file. It should already be called Exercise 13-2-1_Cameras04.max. The other two navigation buttons, Zoom Extents All Selected and Maximize Viewport Toggle, have the same functions as in other viewports and are not camera specific navigation tools.

Again, although it is possible to transform cameras using the Select and Move and the Select and Rotate commands, it is often useful to work directly in the Camera viewport with the special navigation tools for the best result.

In Section 13.5, you'll learn some of the principles of adjusting the composition of your camera views.

13.5 Camera Principles

The basic technical operation of cameras in 3ds Max is relatively simple. The challenge comes in applying traditional cinema and photography principles of camera placement for effective scene composition.

You will learn about the 3ds Max option of Safe Frames. What you see in a 3ds Max viewport can be very different from what the rendered camera image will contain. Safe Frames matches the aspect ratio of the viewport with the rendered output so that "what you see is what you get." Figure 13-17 shows a comparison of the rendered image and the viewports for Camera002. The rendered image shows much more sky and foreground and some leaves at the upper right corner.

Rendered image Shaded viewport

FIG 13-17 The rendered output on the left does not match the Camera002 viewport scene on the right.

Also in this section, you'll learn some of the basic principles of traditional scene composition including the following:

- *Rule-of-thirds* – The rule-of-thirds divides a scene into thirds horizontally and vertically with imaginary lines. The main topic of the scene is then placed at one of the intersections of the lines for the greatest impact on the viewer.
- *Camera shots* – High and low camera viewing angles along with wide-angle and telephoto FOV can greatly affect the emotional impact of the scene on the viewer.

Let's look at the examples of images that represent some of the principles of camera composition.

Safe Frames

Enabling Safe Frames in 3ds Max Camera viewports crops the viewport and changes the aspect ratio to match the rendered output. This ensures that what you see in the viewport is what will be rendered in the final image. Let's turn Safe Frames on.

Exercise 13-5-1 Enable Safe Frames

1. Open the 3ds Max scene from the previous exercise called Exercise 13-2-1_ Cameras04.max and save it to an appropriate folder on your hard drive with a new incremental name. Right-click the Camera001 viewport to activate it.

2. Click on the Camera001 viewport label and then choose Show Safe Frames in the menu (see **Figure 13-18**). The scene in Camera001 viewport changes aspect ratio to match the current default render output settings.

FIG 13-18 Show Safe Frames can be enabled by clicking on the Camera001 viewport label.

3. Click in the Camera002 viewport to activate it and then use the keyboard shortcut *Shift+F* to enable Safe Frames for that viewport (see **Figure 13-19**). Now what you see in the viewports is what you will get when you render the scene.

FIG 13-19 Safe Frames can be enabled with the keyboard shortcut Shift+F.

4. Save the 3ds Max file. It should be called Exercise 13-2-1_Cameras05.max. Enabling Safe Frames in your Camera viewports is a good habit to avoid any surprises when rendering scenes under the pressure of deadlines.

Let's learn about some camera principles involving shooting angles and distances that are commonly used in traditional photography and film. Where the main object of your visualization is positioned in the scene and how close the main object appears to be to the viewer can have a major impact on the viewer's perception of the scene.

Rule-of-Thirds

Composing camera views using the age old rule-of-thirds technique devised in early paintings and continued in photography and film is a method of drawing the viewer's attention to specific objects or areas in a scene.

A scene with the main object centered in the camera view is usually perceived as static and "boring," it is highly recommended to compose a scene with the main object at the intersection of rule-of-thirds lines (see **Figure 13-20**).

FIG 13-20 Rule-of-thirds divides a camera view horizontally and vertically.

In Western societies, people read from left to right and top to bottom, and this natural process is carried over to viewing images. You can increase the impact of the main subject of the scene, in this case the trailer, by positioning it at one of the left intersections of the rule-of-thirds lines. It then becomes one of the first objects the viewer observes, resulting in a stronger visual impact (see **Figure 13-21**).

FIG 13-21 The trailer is placed at the lower left intersection of rule-of-thirds lines.

Camera Shots

There are also several traditional camera shots that are used effectively to control the viewer's perception of the scene. Let's have a look at few of the more commonly used shots from the film industry:

- *Long or establishing shots*
- *Medium shots*
- *Close-up shots*
- *Low-angle shots*
- *High-angle shots*

Long or establishing shots

These shots are used to introduce the viewer to the overall scene or situation by covering a large area to provide physical context in which the action occurs (see **Figure 13-22**). The viewer quickly realizes in this example that the story involves a trailer in an area similar to San Francisco.

FIG 13-22 A long or establishing shot provides physical context for the viewer.

Medium Shots

Medium shots can be accomplished by either moving the camera closer to some of the subjects in the scene or by zooming in with a higher focal length to draw the viewer's attention to greater detail in the scene (see **Figure 13-23**). The trailer becomes a bigger part of the scene's topic and the character comes into play. The architecture plays a lesser role in the scene. It's also important to remember to use the rule-of-thirds for all of your shots.

FIG 13-23 Increasing the lens focal length can be used for a medium shot.

Close-Up Shots

A close-up shot focuses the viewer's attention on specific details, often a character or a piece of furniture, for example. The mood of the scene changes as the character comes into focus and the lighting becomes dominated by shade. A close-up can be accomplished by moving the camera or changing the focal length, or a combination of the two methods (see **Figure 13-24**).

FIG 13-24 Close-up shots focus the viewer's attention on specific details.

Low-Angle Shots

Low-angle camera shots can be used to make the viewer seem less significant while the character in the scene becomes more important and powerful (see **Figure 13-25**).

FIG 13-25 Low-angle shots put the main character in control.

High-Angle Shots

High-angle shots, as you might suspect, are used to put the viewer in control of the scene and minimizing the impact of the character (see Figure 13-26). It's not a coincidence that in almost any court of law, the judge sits higher than the jury and the jury sits higher than the defendant.

FIG 13-26 High-angle shots put the viewer in control.

There are, of course, many variations of these basic camera shots available for you to manipulate the viewer's emotions, to draw the best impact from your presentation. Next time you watch a movie or television drama, pay closer attention to how camera angles and camera shots are traditionally used and then adapt those methods to your 3ds Max visualizations.

Although it is certainly possible to "break the rules," you must first learn and practice them before you can know when it is appropriate to introduce nontraditional methods in your own work.

Using the camera principles that you have learned here can help make your presentations more meaningful to the viewers, by applying the techniques they used to see in all other forms of traditional art.

Rendering Basics

Creating a 3D scene with objects, lights, and materials in 3ds Max is only a part of the presentation process. You also need to be able to create images that can be delivered to clients according to their specific needs.

The rendering engine of choice for this book is the mental ray renderer engine; a powerful and efficient method of calculating the effects of lighting and materials on 3D surfaces, rendering them to still images or animations. Mental ray offers a wide variety of material types, lighting options, and special effects that allow you to render quality images in a cost-effective amount of time.

Scenes that you have rendered in previous chapters, specifically in Chapters 11 and 12 on materials and mapping, used the mental ray renderer to calculate the effects of direct lights from Chapter 10. In this Chapter 14, you'll prepare 3ds Max to render still images of a simple scene from the previous chapters to learn the concepts of choosing an image resolution (size), a file type, and an output location for saving the files.

Some of the topics covered in this chapter are as follows:

- *Mental ray concepts*
- *Render Setup*
- *Render Frame window*
- *Render files*

The Render Setup dialog in 3ds Max is used to set the parameters for the output images. Here you'll learn a few basic options necessary for creating and saving rendered images that can be distributed to your clients.

You'll learn about the Render Frame window where you can adjust a variety of rendering options as you preview the rendering process and finished image.

You'll also learn about the commonly used still image file types such as png, exr, and jpg, just to name a few options available in 3ds Max.

Let's learn how to render with mental ray in 3ds Max.

14.1 Mental Ray Concepts

Mental ray is the "behind the scenes" mathematical calculations engine that processes your 3ds Max 3D scenes into a 2D image that can be viewed by anyone with a computer, or printed for off-line viewing.

Mental ray is a product of Mental Images, a division of the graphics card manufacturer, NVIDIA. Mental ray has been included in 3ds Max for a number of years and is constantly being developed and improved to make it easier for you to generate high-quality, efficient rendered images in a reasonable amount of time.

Mental ray works well with the photometric lights you learned about in Chapter 10. Photometric lights, when rendered with mental ray, use real-world calculations for light intensity and light attenuation to provide you with accurate renderings. Mental ray always calculates direct light, but it can also be used to calculate global illumination of the bouncing of light from surface to surface such as sunlight reflected from a white wall onto other objects, essentially multiplying the light sources to simulate real-world conditions.

This chapter will focus on the basics of setting up mental ray for rendering still images to give you a solid base of knowledge from which you can learn more detail as you produce rendered images. Without a good grounding in the fundamental process of rendering with mental ray, the more advanced aspects of rendering will make little, if any, sense and you will be frustrated by the trial-and-error required to get acceptable rendering results.

14.2 Render Setup

The methods of rendering scenes in 3ds Max presented in this book use mental ray as the rendering engine of choice for its versatility and quality. In this section, you'll learn about the Render Setup dialog where you can choose which rendering engine you prefer and ways you can adjust the parameters necessary for creating the type of rendered image you need to deliver to your client.

You will open the file from Chapter 12 containing the room with the cylinder and sphere, and the basic lighting setup for rendering direct light only. The rendering engine has already been set to *NVIDIA mental ray* in the exercise file by using the Assign Renderer rollout in the Render Setup dialog (see **Figure 14-1**). Click on the Render Setup button in the main toolbar and, in the Render Setup dialog, scroll up to make sure that your computer is set to use NVIDIA mental ray.

FIG 14-1 Use the Render Setup dialog to set NVIDIA mental ray as your current rendering engine.

In the Render Setup dialog, you will learn the following:

- *Time Output*
- *Output Size*
- *Render Output*

These settings, found in the Common tab of Render Setup, control whether you are rendering still images or animations, provide adjustable settings for the image resolution, and determine where and what type of files will be saved.

Let's make some adjustments in the Render Setup dialog.

Exercise 14-2-1 Render Setup Dialog

1. Open the 3ds Max file from the website called Exercise 14-2-1_Rendering01.max and save it to an appropriate folder on your hard drive with a new incremental name. In the main toolbar, click the Render Setup button to open the Render Setup dialog. By default, the Common tab should be currently displayed. In the Common Parameters rollout, Time Output area, you will see that the Single radio button is active (see Figure 14-2). This means that only a single image will be rendered as opposed to a range of animation frames rendered by the other options.
2. In the Output Size area, the default is Custom output with a width of 640 pixels and a height of 480 pixels. In the Output Size drop-down list, choose HDTV (video), and then click on the 1280 × 720 resolution preset button (see Figure 14-3). This changes the rendering resolution to a moderate HD compatible format. The image will take longer to render than the 640 × 480 resolution because there are more pixels to calculate.

Common tab

Single

FIG 14-2 Time Output Single radio button renders a single still image.

HDTV(video)

1280x720

FIG 14-3 Set the output resolution to HDTV 1280 × 720.

Note

The resolution preset is HDTV (video), but this render output is commonly used for both video animation and still images to fit the 16:9 width to height aspect ratio of high definition images that are becoming more common in production.

3. In the Render Setup dialog, scroll up to find the Render Output area, and then click the Files button to open the Render Output file dialog. In the File name field, enter **render test01** and click the Save as Type drop-down list. Choose PNG Image File (*.png) in the list to set the file output type (see **Figure 14-4**). Click the Save button and then click OK in the PNG Configuration dialog to save the default settings. This determines the name of the file, the file type, and the location where it will be saved (the default *render output* set by your current project). You'll learn more about the individual types of render files later in this chapter.

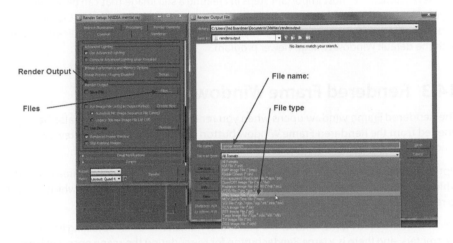

Render Output

Files

File name:

File type

FIG 14-4 The rendered file needs a name, a file type, and a location to save the rendered image file.

4. In the Render Setup dialog, click the big Render button at the bottom right. Mental ray will open the Rendered Frame window and reveal the rendered image by processing rectangular "buckets" randomly (see **Figure 14-5**). When the buckets have finished rendering, the image seen in the Rendered Frame window is also stored as a png file on your hard drive.

FIG 14-5 The rendered image is shown in the Rendered Frame window and saved as a png file to the hard drive simultaneously.

5. Close the Rendered Frame window and the Render Setup dialog, and then save the file. It should already be called Exercise 14-2-1_Rendering02.max. You have learned the necessary steps for rendering a scene to a file on the hard drive. The rendered image on the hard drive has a resolution of 1280 × 720 pixels and can be opened and viewed by any common graphics software.

You have learned the most important steps in creating a still image that can be shared with anyone having a compatible computing or viewing device. Use Windows File Explorer to locate the file called render test01.png on your hard drive, and then double-click it to open it with the default Windows image viewer program.

14.3 Rendered Frame Window

The Rendered Frame window opens when you render an image, but it can also be opened from the Rendered Frame Window button in the main toolbar to preview rendered images.

Options within the Rendered Frame Window dialog allow you to choose the area to render which is set by default to View, the entire viewport area. You can also choose which viewport to render and perform file operations on the rendered image.

Below the Rendered Frame window are sliders and numeric fields for adjusting image parameters, and there is a large Render button for re-rendering the scene once you have made adjustments. In Exercise 14-3-1, you will learn to enable a global illumination option called Final Gather to calculate the bounced light component in your scene. You will also make adjustments to the Image Precision (Antialiasing) slider to speed test renders.

Exercise 14-3-1 Rendered Frame Window Controls

1. Open the 3ds Max file called Exercise 14-2-1_Rendering02.max and save it to an appropriate folder on your hard drive with a new incremental name. In the main toolbar, click the Rendered Frame Window button to open the dialog (see **Figure 14-6**). You are set to render the entire view area and the Camera001 viewport at the top of the dialog. In the control panel at the bottom of the Rendered Frame Window, the Image Precision (Antialiasing) is set to Medium and Final Gather Precision is disabled.
2. Click the Render button to render the currently active viewport. You will see a File Exists warning dialog appear, reminding you that you set up 3ds Max to render a file called *render test01.png* in the previous exercise, and asking if you want to overwrite that file (see **Figure 14-7**). Click the Yes button to overwrite the file. This will re-render the buckets and save the file over the existing file. When the rendering is finished, you can see the Rendering Time in the status bar; make note of the time shown in your display (Author's Dell, Intel quad core i7, 8g ram: 0:26 seconds).

FIG 14-6 Rendered Frame window with various options for rendering.

FIG 14-7 Overwrite the existing file and note the rendering time of the image.

3. In the Rendered Frame window, Final Gather Precision slider, drag the slider one notch to the right to **Draft** mode global illumination to calculate the light bouncing from objects in the scene. In the Trace/Boxes Limits area, enter **2** in the FG Bounces numeric field (see Figure 14-8). 3ds Max will calculate the direct light, and then two iterations of bounced light. You'll learn more about global illumination in Chapter 28.

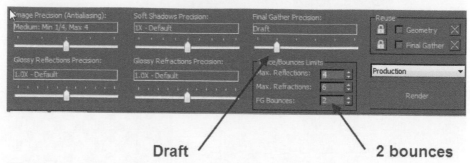

Draft **2 bounces**

FIG 14-8 Enable Final Gather global illumination at Draft mode and set it to calculate two bounces.

4. Click the Render button in the Rendered Frame window and then click Yes in the File Exists dialog. The Rendered Frame window will appear spotted as 3ds Max performs the Final Gather calculations before the render buckets display the fully rendered image (see Figure 14-9).

FIG 14-9 Final Gathered calculations display as spots before final rendering occurs.

5. The fully rendered scene is noticeably brighter, but has also taken much longer to calculate the bounced light and render the scene (Author's machine: 1:43 minutes) (see Figure 14-10). Rendering the bounced light component of any scene is important to create a convincing image, but it can slow production during test rendering.

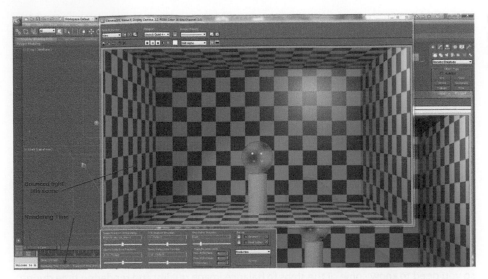

FIG 14-10 Final Gather produces a more convincing image at the expense of longer rendering times.

6. In the Rendered Frame window, Image Precision (Antialiasing) slider, drag the slider left one notch to **Low.** This will reduce the precision of smoothing diagonal edges during rendering and result in some speckling in the glossiness of the walls. Click the Render button, and then click Yes in the File Exists dialog. The scene will render more quickly, thereby restoring some of your production losses (Author's machine: 0:57 seconds). Because this scene has minimal diagonal details, the noticeable difference is around the edge of the sphere (see Figure 14-11).

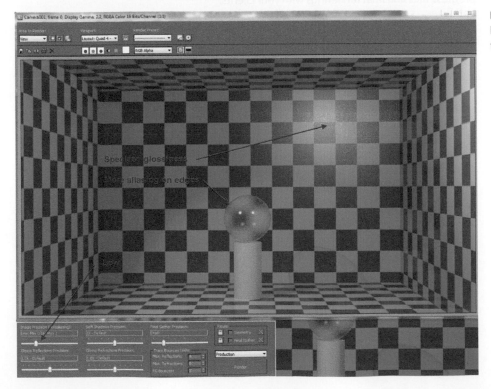

FIG 14-11 Reducing Image Precision is useful for speeding test rendering times.

7. Set the Image Precision (Antialiasing) slider back to the Medium position. Close the Rendered Frame window and save the file. It should already be called Exercise 14-2-1_Rendering03.max. You have learned to render a more convincing image by enabling Final Gather global illumination at the cost of the increased rendering times, and then lowered the Image Precision to regain some productivity during test renders.

Warning

Remember that you have lowered Image Precision for testing purposes and that you must restore the original Medium setting or higher for acceptable final renders.

Test rendering scenes in 3ds Max can be a time-consuming process that slows production, so you need to know some of the steps to balance image quality and rendering time during the test rendering phases. It is then important during the final render process to use settings that will maximize rendering quality.

14.4 Rendered Files Types

Rendering and saving files, either still images or animations, are necessary for sharing progress files and final renderings with your clients.

There are a number of file types available within 3ds Max for saving rendered images. Some of the more common file types for still images are as follows:

* *jpg* – jpg or jpeg stores still images with "lossy" compression techniques. The stored files are small in size, but have reduced quality.
* *tif* and *tga* – Similar file types of moderate compression with high quality.
* *png* – Portable Network Graphics files have high compression and high quality making them a good choice for 3ds Max users.
* *exr* – Special still image files containing accessible information for postprocessing.

A good choice of file type for still images (and animations) in 3ds Max is the png file. It combines high quality with good compression for efficient storage.

Exr files are very large, high-quality files that contain information about color, shadows, reflections, and so on, as separate "channels" for compositing in Autodesk Composite or Adobe After Effects.

Note

Animations should be rendered as a sequence of png or exr files; these still images can then be saved again as animated file types such as avi or mov for delivery to your client. Sequential still image can be rendered over multiple computers and are easier to edit if something goes wrong.

Exercise 14-4-1 Render Still Images

1. Open the 3ds Max file called Exercise 14-2-1_Rendering03.max and save it to an appropriate folder on your hard drive with a new incremental name. In the main toolbar, click the Render Setup button. In the Common Parameters rollout, Time Output area, make sure that the Single radio button is active. In the Render Output area, click the Files button to open the Render Output File dialog (see **Figure 14-12**). 3ds Max is already set to render png files, but you will make some changes.

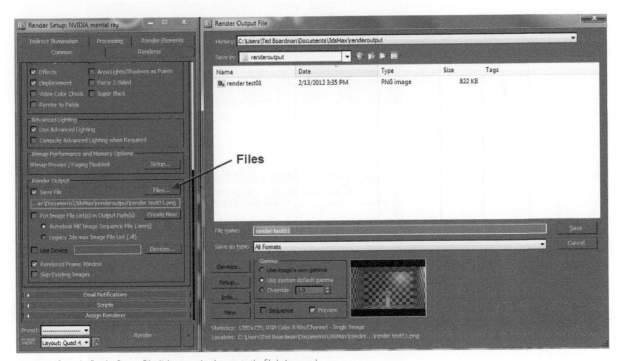

FIG 14-12 Open the Render Output File dialog to make changes to the file being saved.

2. In the File Name field, change the filename to **render test02**. In the Save as Type, choose PNG Image File (*.png). Click the Setup button to open the PNG Configuration dialog. Make sure the RGB 24bit (16.7 million) color option radio button is chosen and that no other checkboxes appear (see **Figure 14-13**). Click OK. Click the Save button in the Render Output File dialog and then click the Render button in the Render Setup dialog to render the new png file. This configuration creates high-quality color images with good compression for efficient file sizes.

3. In the main toolbar, click the Render Setup button again. In the Common Parameters rollout, Render Output area, click the Files button. Change the name of the file to **render test03** in the File Name field. In the Save as Type drop-down list, choose OpenEXR Image File (*.exr,*.fxr). Click the Save button to open the OpenEXR Configuration dialog (see **Figure 14-14**).

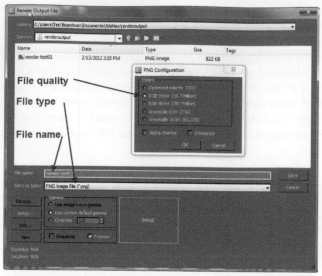

FIG 14-13 Enter a new file name and choose the file configuration options.

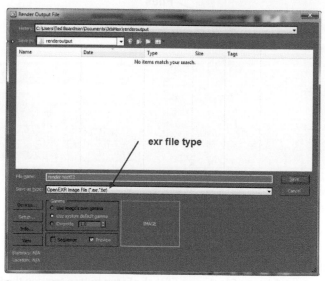

FIG 14-14 Render a file as an exr file type in 3ds Max.

4. In the OpenEXR Configuration dialog, G-Buffer Channels area, click the Add button to open a list of G-Buffer Channel options (see **Figure 14-15**). At this point, you do not have enough information to choose appropriate G-Buffer Channels, but this lesson illustrates the potential power of the exr file type in 3ds Max. Click the Cancel button to cancel the channel list, and then click the cancel button again in the OpenEXR Configuration dialog. Click the Cancel button again in the Render Output File dialog to close the option.

5. Close the Rendered Frame window, the Render Setup dialog, and then save the file. It should already be called Exercise 14-2-1_Rendering04.max. Rendering and saving still image files with different file types provide you a variety of editing options in the production pipeline.

FIG 14-15 The EXR file type in 3ds Max is a powerful file type option, which can store extra information as channels in your rendered files.

When rendering still images in 3ds Max, the png file type is a common choice for a good compromise between image quality and image size for more efficient storage. Saving image files with the exr file type allows you to save independent channels and elements of information that can then be processed during postproduction for more control over the final image.

Often when rendering files in 3ds Max, the client's needs and preferences will influence the file type you render to, and many times you might be required to render multiple file types for the same project. Experience will help guide you through proper choices of file types, but the png and exr file types are powerful and high-quality options for many situations.

Workflow

Workflow—image by Tangram3DS.

Workflow in 3ds Max

Now that you have a fundamental understanding of some of the important concepts in working with 3ds Max, it's time to delve a bit deeper into production workflow. The following chapters will consist of a series of hands-on exercises in which you will use various methods of modeling with modifiers and at subobject level, for example. You'll learn new tools and methods for modeling like Graphite Modeling Tools and Boolean operations.

As you develop an outdoor scene in the exercises, you'll learn to light it with the Daylight System in 3ds Max and then create new materials and apply mapping coordinates for more convincing objects in the rendered images.

In Part 1—Concepts, you learned to create materials and assign them to objects in the scene. However, in a production environment, it is often necessary to have more than one material on a single object. You'll learn to assign multiple materials to subobject selections, and using a special Blend material type with a process called "masking," you will learn to hide and reveal multiple materials.

You'll be introduced to fundamental animation techniques, global illumination methods, and some special effects included in 3ds Max. These techniques and methods will expand your overview of the entire production process so that you understand how it's possible to combine basic principles into complex visualization scenes.

Part 2 will include the following topics presented in a form that frees you from getting bogged down into the details of which buttons to push in which order to complete a given task.

- *Creating 3D primitives*: Use 3D primitives in 3ds Max as a basis for building real world objects.
- *3D procedural modeling*: Learn more about the power of modifiers and object cloning, as well as merging objects from libraries of objects.
- *Subobject editing*: Access subobject level options and edit geometry to add detail to scenes.
- *Surface types*: Discover the differences between mesh geometry, polygon geometry, and patch surfaces.
- *More object cloning*: 3ds Max has advanced tools for cloning arrays and tools for painting multiple objects on surfaces.
- *Graphite Modeling Tools*: Learn about "poly" modeling techniques using Graphite Modeling Tools.
- *Compound objects*: Compound objects is a class of tools such as ProBoolean and Shapemerge.
- *Exterior lighting*: Create and adjust a Daylight System to light an outdoor scene.
- *More materials*: Refresh your knowledge of Arch & Design materials and learn to create material libraries.
- *Multiple materials*: Use Multi/Subobject and Blend material types to apply multiple materials to single objects.
- *Introduction to animation*: Learn the fundamentals of keyframe animation techniques.
- *Intermediate modeling*: Graphite Tools and Lofting for complex modeling.
- *Intermediate animation*: Understand the fundamentals of animation Controllers, Constraints and Hierarchical Linking are important to the animation process.
- *Global illumination*: Learn the differences between Final Gather and Global Illumination techniques of calculating bounced light in 3ds Max.

- *Effects*: Special effects such as atmospherics and particles can enhance your visualization projects.
- *Introduction to IK*: Inverse Kinematics are powerful animation tools.
- *Character animation*: Learn the basics of creating a CAT character animation skeleton system.
- *Introduction to dynamics*: Dynamics in 3ds Max is used to create realistic rigid body collisions between objects.
- *Introduction to scripting*: Learn to create and run a simple script using the built-in programming language.
- *Intermediate rendering*: Alpha channel and Render Elements are important concepts in rendering.

The focus of Part 2 is to expand your knowledge of the overall workflow in a 3ds Max project. Your focus should be on how the coordination of various aspects of 3ds Max are woven together into a comprehensive process that can be created by individuals or shared amongst a collaborative workgroup. You'll practice applying the concepts you have already learned to more real world situations and learn about new tools and methods available in 3ds Max.

The scenes used in these chapters will be simple and the resulting rendered images are intended to be examples of fundamental workflow. Just as a "Getting Started with the Violin" book would not prepare you to play a Mozart symphony, this book will focus on basic techniques to provide you with a solid foundation of knowledge on which to build and practice a workflow that fits your particular needs.

Create 3D Primitives

Creating a 3D scene containing a windmill and landscape can be accomplished with 3D primitives in 3ds Max.

Some of the primitives covered in this chapter are as follows:

- *Plane* – A Plane 3D primitive will become the basis of your landscape.
- *Cylinder* – The Cylinder can be used as the basis for multiple objects in the scene.
- *Sphere* – The Sphere primitive will be edited into a hemispherical dome for the windmill roof.
- *Box* – A simple Box object will be used for the walkway railing posts.

Simple primitive geometry will become more complex as editing progresses while providing a workflow history that you can navigate in the Modify panel, stack view for increased flexibility when the client requests changes.

15.1 The Landscape

The client has asked you to create a scene of a Dutch style windmill on a foggy morning. The scene will have hilly landscape and a canal with several boats and the client has provided a sketch as a storyboard (see **Figure 15-1**).

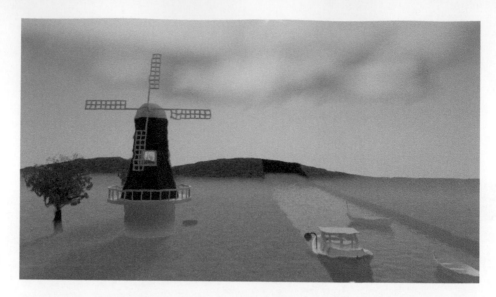

FIG 15-1 Windmill with canal on a foggy morning.

Using a Plane 3D primitive, you will create a flat landscape as the basis for your outdoor scene with a windmill. The plane will be created in the Top viewport on the default workplane, and then you will adjust the size in the Modify panel. Remember, although you can make changes to the parameters during the creation process, you will, at some point, be required to go to the Modify panel for further editing. A good habit is to create a primitive object of any size, and then go immediately to the Modify panel to adjust the parameters as required.

You will also review the file save, hold and fetch, and backup options as important aids in a safe production workflow.

Let's begin with a simple exercise to create the basic landscape object for your scene on the currently active World reference coordinate system grid, seen in the Top viewport.

Exercise 15-1-1 Create a Landscape

1. Open the file from the website called Exercise 15-1-1_Primitives01.max and save it to an appropriate folder on your hard drive with a new incremental name. The scene contains no objects, but has the units set to U.S. Standard and has grids enabled in the Top and Perspective viewports. In the Create panel, Geometry category, Object Type rollout, click the Plane button. In the Top viewport, left-click and drag from upper left to lower right to create a basic Plane object of any size (see **Figure 15-2**).
2. In the Modify panel, object name field, rename the object **Landscape001**. Click the color swatch to the right of the object name field, and then, in the Color Selector, choose a dark green color. In the Parameters rollout, enter **750'** in both the Length and Width numeric fields, and then press Enter. Click the Zoom Extents All Selected button at the lower right of the display to fill each viewport with the primitive object (see **Figure 15-3**). It is not necessary to change the object color, but it is sometimes helpful for recognizing objects in the scene if they are colored similar to what their materials will eventually be.

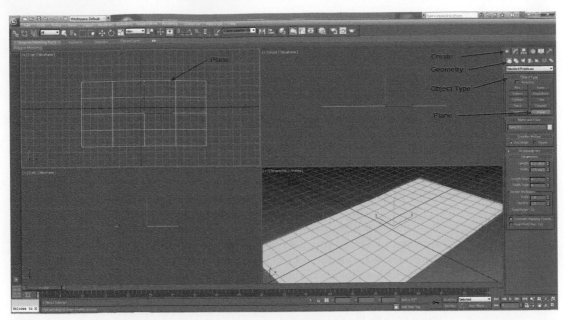

FIG 15-2 Create a basic plane in the Top viewport.

FIG 15-3 Rename the object, change its object color, and adjust the size parameters in the Modify panel.

3. Use the keyboard shortcut Ctrl+S to save the file. It should already be called Exercise 15-1-1_Primitives02.max. Also remember that automatic backup is on by default in 3ds Max. Every 5 minutes a new backup file is saved to the backup folder for a total of three backup files before the first backup file is overwritten and the cycle begins again.

The scene certainly doesn't look like much yet, but you have already performed an important part of a typical production workflow. Naming the objects logically as you create them is extremely important for good management throughout the creation process.

15.2 The Windmill and Base

The traditional Dutch style windmill will be an octagon mill building on a circular base. You will create the parts of the building in random positions around the center of your landscape, and then you will assemble the parts into a windmill at the end of the chapter.

Exercise 15-2-1 Create a Windmill and Base

1. Open the 3ds Max file called Exercise 15-1-1_Primitives02.max and save it to an appropriate folder on your hard drive with a new incremental name. In the Create panel, Geometry category, Object Type rollout, click the Cylinder button. In the Top viewport, left-click and drag to define the radius of a cylinder, and then release the mouse button and move the mouse forward to define a cylinder height. Left-click to set the cylinder height. Click the Zoom Extents All Selected button to fill all viewports with the new cylinder.

2. In the Modify panel, rename the object **Windmill_base001**. In the Parameters rollout, enter **7'6"** in the Radius numeric field. Enter **10'0"** in the Height numeric field. Enter **1** in the Height Segments numeric field, and then enter **24** in the Sides numeric field (see **Figure 15-4**). There are no plans to bend the windmill base, so by adjusting the number of height segments to 1, you reduce unnecessary geometry for a more efficient object. You then increase the geometry by adding more sides, with the result being a smoother appearing cylinder that is still efficient.

FIG 15-4 Modify the cylinder primitive to become the windmill base.

Note

The underscore character in the name Windmill_base001 is not necessary; however, it sometimes makes object names more readable on high-resolution computer screens.

3. In the Top viewport, create a new Cylinder primitive of any size. In the Modify panel, change the name to **Windmill001**. In the Parameters rollout, enter **7'6"** in the Radius numeric field, enter **24'0"** in the Height numeric field, enter **5** in the Height Segments numeric field, and then enter **8** in the Sides numeric field. Clear the Smooth checkbox (see **Figure 15-5**). 3ds Max remembers the edits you previously entered for the Cylinder primitive, so you need to increase the number of Height Segments so that the windmill can be tapered later. The Smooth option makes the object appear faceted so that you can clearly see the individual sides of the windmill.

FIG 15-5 Adjust the parameters of the windmill and disable the smooth option for a faceted surface.

Note

Smoothing is a process performed by 3ds Max to make simple geometry appear smooth. This allows low polygon objects (for efficiency) to appear more complex in the viewports and rendered images.

4. Save the file with Ctrl+S. It should already be called Exercise 15-1-1_Primitives03 .max. You should begin to see a pattern developing in your workflow. With a little bit of practice you will be creating objects of any size, going to the Modify panel to rename them and adjust their parameters.

You may be tempted to wait until later to rename objects, but that will certainly lead to confusion when you have a number of cylinders in a scene and each is indistinguishable from the other by name. Even if you're not sure what the name of the object will eventually be, it is better to assign a unique name to make the object easier to find later.

15.3 The Domed Roof

Many windmills have a domed roof and you will use the 3ds Max Sphere primitive and then modify it to become a hemisphere. The size of the sphere will be considerably smaller than the windmill, but in Chapter 16 you will modify the windmill so that the domed roof fits appropriately.

Exercise 15-3-1 Create a Domed Roof

1. Open the 3ds Max file called Exercise 15-1-1_Primitives03.max and save it to an appropriate folder on your hard drive with a new incremental name. In the Create panel, Object Type rollout, click the Sphere button and then in the Top viewport, click and drag a sphere primitive of any size near the other objects in the scene.
2. In the Modify panel, rename the object **Windmill_roof001**, enter **4'0"** in the Radius numeric field, enter **0.5** in the Hemisphere numeric field. Always remember to press Enter to finalize the last numeric field edited.
3. Click the Zoom Extents All Selected button to fill all viewports with the new hemisphere. As you can see from the Chop radio button in the Parameters rollout, the lower half of the sphere has been deleted (see **Figure 15-6**).

FIG 15-6 One half the sphere is chopped from the sphere primitive.

4. Save the file with the keyboard shortcut Ctrl+S. It should already be named Exercise 15-1-1_Primitives04.max. The hemisphere seems to have a lot of geometry that appears unnecessary compared to the other objects in the scene. You will edit the object later for a better fit and greater efficiency.

In many typical Dutch windmills, there is a platform walkway between the base and the windmill itself. In Exercise 15-4-1, you'll use a Cylinder primitive to create the walkway.

15.4 The Platform Walkway

The walkway that encircles the windmill between the base and the windmill building itself can be created with a Cylinder primitive object. You will refresh your memory of how to track the number of polygons in your scene by using the Statistics options. By tracking statistics, you can maintain a sense of how a newly created object affects the overall efficiency of your scene.

Let's create a walkway and enable Statistics.

Exercise 15-4-1 Create the Walkway

1. Open the 3ds Max file called Exercise 15-1-1_Primitives04.max and save it to the project folder on your hard drive with a new incremental name. The domed roof that you created in Exercise 15-3-1 should dominate the viewports. Click on the Zoom All navigation button, and then click and drag downward in any viewport to zoom all viewports out so that you can see the windmill parts (see Figure 15-7).

FIG 15-7 Use Zoom All to zoom out in all viewports simultaneously.

265

2. Create a Cylinder primitive in the Top viewport. Again, the settings from the last cylinder are remembered and the object is too segmented to create a smooth platform. Press the **7** keyboard shortcut to enable Statistics in the Top viewport. It reports that there are a total of 896 Polys in the scene (see **Figure 15-8**).

FIG 15-8 Enable statistics to see the number of polygons in the scene.

3. In the Modify panel, rename the object **Walkway001**. In the Parameters rollout, enter **12'6"** in the Radius numeric field, enter **1'0"** in the Height numeric field, enter **24** in the Sides numeric field, and then check the Smooth option to remove the faceted appearance in the viewport. These changes result in a total of 1088 Polys in the scene. Enter **1** in the Height Segments numeric field, and then observe that the number of polygons is back to 896 (see **Figure 15-9**). This illustrates how it is possible to increase the visual quality of your objects while maintaining efficiency. This is somewhat of a special case specific to this scene, but it is important that you are aware of the efficiency of your scenes as you work.

FIG 15-9 Balance the visual quality of the objects with the total number of polygons for best efficiency.

4. Save the file. It should already be called Exercise 15-1-1_Primitives05.max. A production workflow in 3ds Max is a constant battle between visual quality and physical efficiency of your objects, but you must pay close attention initially. When learning 3ds Max, a little bit of practice will allow you to anticipate future changes and the process will become easier. For example, you could have fewer than 24 sides for the walkway but the Smooth option would still give good visual quality. However, because the windmill base cylinder has 24 sides and is smooth, the walkway parameters now match the windmill parameters for consistency.

In Exercise15-5-1, you will create a single railing post from a Box primitive.

15.5 The Railing Post

The walkway of the windmill will eventually have a railing with many posts around the outer edge. Let's begin by creating a single post that can then be cloned in Chapter 19 with some new 3ds Max tools.

Exercise 15-5-1 Create a Railing Post

1. Open the file called Exercise 15-1-1_Primitives05.max and save it to an appropriate folder on your hard drive with a new incremental name. Saving a series of incremental 3ds Max scene files may take up a little bit of extra hard drive space, but the safety factor of having files that you can retrieve if something goes wrong will more than make up for the small cost of new hard drives.
2. In the Top viewport, create a Box primitive near the other objects.
3. In the Modify panel, rename the object **Railing_post001**. In the Parameters rollout, enter **0'4"** in the Length and Width numeric fields, and then enter **3'0"** in the Height numeric field. This creates a square railing post. When entering numeric values as an integer with no sign, the value will be recognized as feet, but when the numeric value is inches or feet and inches, you need to use the ' and/or the " signs appropriately (see **Figure 15-10**).

FIG 15-10 Create a railing post 4 inches square and 3 feet tall.

4. Save the file. It should already be called Exercise 15-1-1_Primitives06.max. You now have the basic objects you need to begin assembling the basic windmill structure: a base, a walkway, the building, and the domed roof.

In Exercise 15-6-1, you'll use the Align tool to stack the objects on top of and centered with each other to begin building the windmill structure. The Align tool, if you remember, is dependent on the Reference Coordinate System that is active in the viewport that is currently selected.

15.6 Align Objects

The Align tool, found in the main toolbar, can be used to very quickly assemble geometry by aligning the "bounding box" of each object to that of another. Think of the bounding box as a crate containing the object and you are actually aligning the crates not the physical geometry itself.

Objects are aligned in their respective *xyz* axes and the directions of those axes are determined by the Reference Coordinate System used in the active viewport. In Exercise 15-6-1, you will use Align to stack the objects on top of and centered to each other.

Exercise 15-6-1 Assemble the Windmill with Align

FIG 15-11 The windmill001 object is selected and will be aligned to windmill_base001.

1. Open the file called Exercise 15-1-1_Primitives06.max and save it to an appropriate folder on your hard drive with a new incremental name. Click the Select Object button in the main toolbar, and then right-click in the Top viewport to activate it. Select the Windmill001 object in the viewport (see **Figure 15-11**). This object will be aligned with Windmill_base001, which will remain stationary.

2. In the main toolbar, click the Align button, and then move the cursor over the edge of Windmill_base001 until you see the cursor change to a crosshair (see **Figure 15-12**). Left-click on the Windmill_base001 to open the Align Selection (Windmill_base001) dialog.

3. In the Align Selection (Windmill_base001) dialog, the default settings are to align both object's Pivot Point in all three axes based on the Screen reference coordinate system. This is a good starting point for the initial alignment, so you can click the Apply button to position the objects centered on each other with their bases on the current grid plane (see **Figure 15-13**). Clicking the Apply button sets the current new alignment and clears the axes checkboxes, but remains in the Align Selection dialog so that you can continue the alignment process.

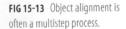

FIG 15-12 You must click on the object you want to align the selected object to.

FIG 15-13 Object alignment is often a multistep process.

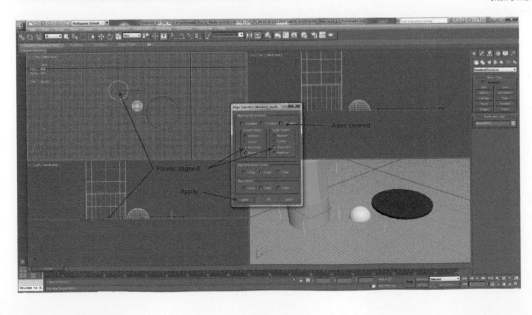

4. You now need to align the bottom of Windmill001 with the top of the Windmill_ base001, using, therefore, the z-axis in the active viewport. In the Align Selection dialog, check z Position. In the Current Object column, choose the Minimum radio button. In the Target Object column, choose the Maximum radio button (see **Figure 15-14**). The Minimum radio button refers to the furthest point on the selected object in the negative z-axis, and the Maximum radio button refers to the furthest point on the target object in the positive z-axis. This places the bottom of the windmill on the top of the base. Click the OK button to finalize the alignment.

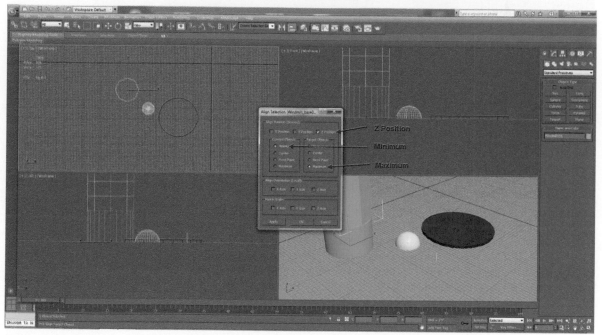

FIG 15-14 Align the bottom of the windmill to the top of the base in the z-axis of the Top viewport.

5. In the Edit pull-down menu, choose the Hold option in the menu. This saves all of your work up to this point in a buffer file on the hard drive. In the Top viewport, use the Align tool to align all of the other objects, except the Railing_post001, as shown on Figure 15-14. You will be repeating steps similar to the previous ones. Notice, however, that the Walkway001 must be placed on top of and centered with Windmill_base001, and the Windmill001 must be realigned to sit on the top of it (see **Figure 15-15**). If you make a mistake, you can use the Edit pull-down menu, and then choose Fetch to restore the scene to the starting point where you can begin again. The process is easy, it just takes a little forethought and practice before it becomes a completely automatic process.

Tip

You won't be able to easily select the objects by picking them in the Top viewport because they are all in alignment with each other. Use the keyboard shortcut H to select objects by name.

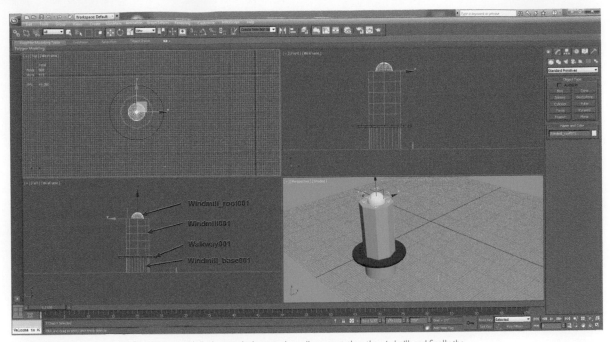

FIG 15-15 Align the objects in the Top viewport with the base at the bottom, the walkway next, then the windmill, and finally the domed roof.

6. Save the file. It should already be called Exercise 15-1-1_Primitives07.max. Your success with the Align tool in 3ds Max is dependent on your understanding of the Reference Coordinate Systems and how they relate to the active viewport. Significant productivity increases are possible with intelligent use of the Align tool. It is a basic concept that you must learn and assimilate into your workflow.

Again, the result of this exercise is not something that you'll want to show around to all your friends perhaps, but it is a very necessary beginning point in learning about efficient and flexible workflow in 3ds Max.

Many of your objects will start as 3D primitives that might eventually be modified into something which no longer resembles the original primitive object. Therefore, you need to name objects logically as soon as you create them so that you can use powerful tools like Select by Name to find objects in the scene quickly. Sifting through many objects with names such as Cylinder001-Cylinder100 until you find the object you want is counterproductive.

The Align tool is your friend. It can save countless hours of moving and rotating objects in the course of a single workday.

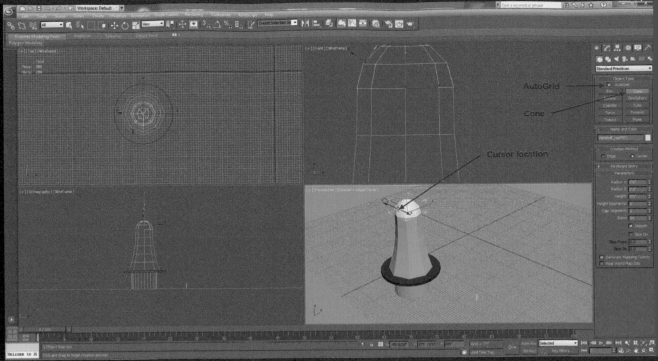

Procedural Modeling

Taking full advantage of the power of procedural modeling in 3ds Max is important for obtaining maximum productivity with the software. In this chapter, you will apply and adjust a Taper modifier to shape the windmill into tapered, curving walls. You'll then navigate the stack view history to the base node level and make an adjustment to the overall size of the windmill. This does not affect the parameters of the discrete modifier higher up in stack view. There is no physical limit to the number of modifiers, which can be applied to an object.

To maximize productivity in 3ds Max, you must also take advantage of the ability to merge objects from 3ds Max scenes into your current working scene. This allows you to build libraries of parts on your hard drive that may be shared with other team members who need an object that has already been created. You can also go directly into other working scenes instead of a parts library to merge one or multiple objects into your current scene. An important aspect of using the merge capabilities is your ability to catalog objects so that they can be easily found and updated as necessary.

Cloning objects provides you with high levels of flexibility and efficiency. Objects can be cloned as Instance or Reference clones that maintain a connection to the original object for flexible editing. The efficiency comes from the fact that an Instance or Reference clone does not need to store the original object's node information in memory.

Another possibility for increasing scene efficiency is attaching multiple objects into a single object to reduce the memory overhead a bit more and making it easier to select "ensembles" of objects. The attached objects can be edited as elements at subobject level or may be detached to become individual objects again. Flexibility and efficiency are keys in this workflow.

Some of the topics covered in this chapter are

- *Adding modifiers* – Add a modifier to edit the object and then navigate the stack view for flexible editing.
- *Merge and clone objects* – Import objects from other scenes and then clone them for efficiency and flexibility.

Let's begin by making some changes to the windmill from Chapter 15. The client has notified you that the windmill building should have curved and tapered sides and should be a different size. You will also adjust the domed roof to make it fit better and increase its efficiency.

Modifiers perform discrete operations on objects at the level in the Modify panel, stack view where they were applied. Objects are evaluated from the bottom of the stack view upward. This allows you to navigate through the stack view to make changes at various levels without changing the parameters of individual modifiers.

16.1 Adding Modifiers

Modifiers are applied to objects in the Modify panel, thereby creating a history of editing that can be navigated to increase the adaptability of making changes to objects. In Exercise 16-1-1, you will add a Taper modifier to the windmill to taper and curve the walls and then navigate to the original object's node level to make changes to its parameters.

You'll also make changes to the domed roof to fit the new windmill walls and increase the objects' efficiency. Adding a hub to the domed roof will prepare the windmill to accept blades in Exercise 16-2-1. You will use AutoGrid during the creation of the hub for more accurately positioning the new object directly on a specific surface.

Exercise 16-1-1 Taper the Windmill

1. Open the file from the website called Exercise 16-1-1_Procedural01.max and save it to an appropriate folder on your hard drive with a new incremental name. The scene contains the objects created in Chapter 15. Right-click in the Perspective viewport to activate it and then right-click on the Shaded viewport label. Choose Edged Faces in the menu (see Figure 16-1).
2. Edged Faces displays 3D objects in both shaded and wireframe mode in any Shaded viewport for easier editing. In the Perspective viewport, select Windmill001. In the Modify panel, Modifier list, choose the Taper modifier. An orange gizmo appears around the windmill, and the Taper parameters are displayed in the Modify panel (see Figure 16-2).

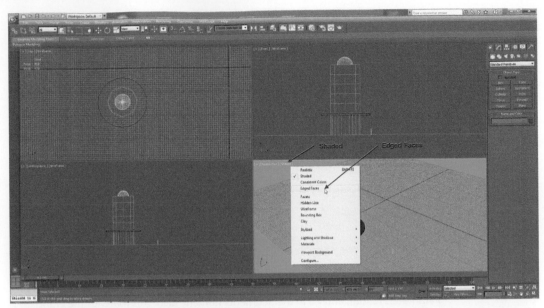

FIG 16-1 Enable Edged Faces in the shaded Perspective viewport.

FIG 16-2 Apply a Taper modifier to the windmill.

3. In the Parameters rollout, Taper area, enter **−0.45** in the Amount numeric field. This tapers the cylinder so that it is slightly less than half its original size at the top. In the Parameters rollout, Taper area, enter **−0.5** in the Curve numeric field. This curves the sides of the windmill. You can zoom into the top of the windmill in the Front viewport to see that it matches the domed roof (see **Figure 16-3**). Let's make changes to the domed roof to make it more like the windmill.

FIG 16-3 Adjust the Taper modifier to create curved walls.

4. In the Front viewport, select the Windmill_roof001 hemisphere. In the Modify panel, Parameters rollout, enter **8** in the Segments numeric field. This matches the eight sides of the windmill, but loses the domed shape. In the Parameters rollout, choose the Squash radio button (see **Figure 16-4**). This restores another segment in the dome making it appear more rounded, while still maintaining good efficiency. However, the client wants a larger windmill.

FIG 16-4 Balance the visual quality and the efficiency of the domed roof.

5. In the Perspective viewport, select the Windmill001. In the Modify panel, stack view, highlight Cylinder to navigate to that level of the object's history. Enter **9'0"** in the Radius numeric field and press Enter. This increases the radius of the windmill without affecting the amount of taper or curvature (see **Figure 16-5**). In the stack view, highlight the Taper modifier at the top of the stack to return to that level. It is always best to remember to navigate back to the top of the stack to ensure that all modifiers are being applied to the object. The domed roof now needs adjusting to match the walls.

FIG 16-5 Navigate the stack view to edit the base object node: Cylinder.

6. In the Perspective viewport, select the Windmill_roof001 and then in the Modify panel, Parameters rollout, enter **5'0"** in the Radius numeric field so that it matches the size of the walls. Let's add a windmill blade hub to the domed roof and learn about AutoGrid.

7. In the Create panel, Geometry category, Object Type rollout, click the Cone button. Check the AutoGrid checkbox. In the Perspective viewport, move the cursor over the domed roof surface and see that the transform gizmo "reads" the surfaces below the cursor to place the positive z-axis perpendicular to that point on the surface (see Figure 16-6). You have to be in Create mode for a specific object type before AutoGrid becomes available.

FIG 16-6 AutoGrid will create objects directly on and perpendicular to the surface below the cursor.

8. When the cursor is just above the first segment, left-click and drag to define the base of a Cone primitive. Release the left mouse button and then move the cursor to describe the height of the Cone projecting away from the domed roof. Left-click to set the height. Move the mouse slightly to define the top radius of the Cone that is smaller than the base and then left-click to set the radius (see Figure 16-7). In the Object Type rollout, clear the AutoGrid checkbox. Don't worry about the size, you will modify it in the next step.

FIG 16-7 Create a Cone primitive perpendicular to the surface of the domed roof.

9. In the Modify panel, rename the object to **Blade_hub001**. In the Parameters rollout, enter **1'0"** in the Radius 1 numeric field, enter **0'6"** in the Radius 2 numeric field, enter **2'0"** in the Height numeric field, enter **1** in the Height Segments numeric field, and enter **8** in the Sides numeric field. Click the Zoom Extents All Selected button to fill all viewports with the cone (see Figure 16-8). The base of the cone was created tangent to the curved surface and needs to be moved into the domed roof.

FIG 16-8 Rename the cone and adjust its parameters.

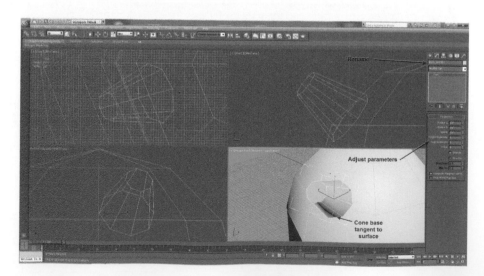

10. In the main toolbar, click the Select and Move button. In the Reference Coordinate System drop-down list, choose Local. In the Perspective viewport, choose the Local z-axis arrow shaft and then move the cone into the domed roof so that you no longer see the bottom edges of the cone (see **Figure 16-9**). "Eyeballing" the position of the blade hub is sufficient so no mathematical information is needed to determine how far the object should be moved. Sometimes if it looks right, it is right.

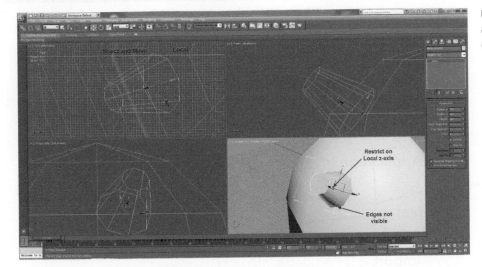

FIG 16-9 Move the blade hub along its Local z-axis into the domed roof.

11. In the Perspective viewport, select the Windmill001 and then click the Zoom Extents All Selected button to zoom out a bit. Save the file. It should already be called Exercise 16-1-1_Procedural02.max.

Learning to apply modifiers and then navigating the Modify panel stack view to make changes at various levels is an important factor in increasing your productivity in 3ds Max. You have also learned to use AutoGrid to create new primitive objects directly on the surface of the existing objects, thereby reducing the extra step of aligning those objects.

16.2 Merge and Clone Objects

Windmills generally have blades and it just so happens that you have a windmill blade saved in the file on the hard drive from another project. Rather than re-creating a windmill blade for the project, it would be more efficient to be able to merge the object from the existing scene into the current scene.

Merging an object or objects from one 3ds Max file to another is an option in the File, Import command. You can bring all the objects in a selected file into the current scene, or you can choose individual objects that you want to import from a list.

In Exercise 16-2-1, you will merge the windmill blade into the current scene, adjust the position of the blade's pivot point, and then orient and align the blade with the hub that you have created in the domed roof. Pivot points of objects can be adjusted in the Hierarchy

panel. This again will require knowledge of the Local Reference Coordinate System because you don't currently know at what angle the hub was created.

In Exercise 16-2-2, you'll clone the windmill blade for a total of four blades on the hub and then you will attach the blades to the hub to reduce node space being tracked in memory.

Exercise 16-2-1 Merge Windmill Blade

1. Open the 3ds Max file called the Exercise 16-1-1_Procedural02.max and save it to an appropriate folder on your hard drive with a new incremental name. In the Application button, hover the cursor over the Import option and then click Merge in the menu (see **Figure 16-10**). This will open the Merge File dialog.

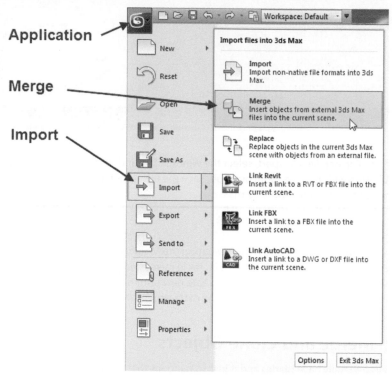

FIG 16-10 Merge is found in the Application menu, under Import.

2. In the Merge File dialog, navigate to the appropriate folder for Chapter 16 on the website and then double-click on the file called 16-3_Windmill_blade.max. In the Merge dialog, highlight the Windmill_blade001 object in the list (see **Figure 16-11**). Click the OK button. The windmill blade is the only object in the 3ds Max file you are merging from. The object is imported into the current scene and becomes the selected object. Let's adjust the pivot point of the blade to a point near the bottom of the shaft.

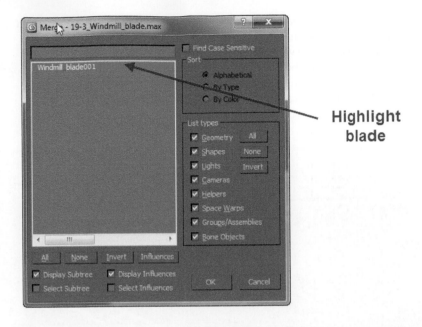

FIG 16-11 You must highlight the object or objects you want to merge into your current scene.

Highlight blade

3. Use the keyboard shortcut Alt+Q (Isolate Selection) to isolate the selected windmill blade and then click Zoom Extents All Selected to fill all viewports with the object. In the Hierarchy panel, Adjust Pivot rollout, click the Affect Pivot Only button (see Figure 16-12). The pivot point transform gizmo will appear as a red, green, and blue tripod. This allows you to transform the object's pivot point without affecting the object itself.

FIG 16-12 Pivot points can be adjusted in the Hierarchy panel.

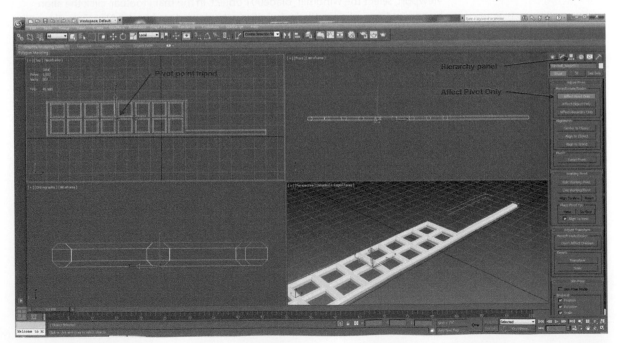

4. In the main toolbar, click the Select and Move button. Notice that you are still in Local Reference Coordinate System. Right-click in the Top viewport to activate it and then move the pivot to just inside the lower end of the shaft at the right (see Figure 16-13). Click the Affect Pivot Only button to toggle it off. Use the keyboard shortcut Alt+Q to return all the objects to the scene. The next task is to orient the windmill blade's Local Reference Coordinate System to match that of the windmill hub.

FIG 16-13 Move the pivot point to the base of the blade shaft.

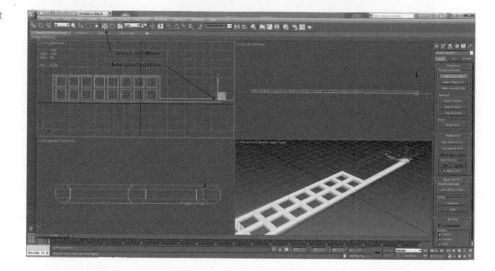

5. In the main toolbar, click the Select Object button and then in the Perspective viewport, select the Windmill_blade001 object. In the main toolbar, click the align button and then click on Blade_hub001 in the domed roof. In the Align Selection dialog, click the *XYZ* axes checkboxes in the Align Orientation (Local) area (see Figure 16-14). Click the OK button. This orients the blade to the hub by Local Reference Coordinate System axes and then outlines the pivot points of the two objects.

FIG 16-14 Align two objects based on their Local Reference Coordinate Systems.

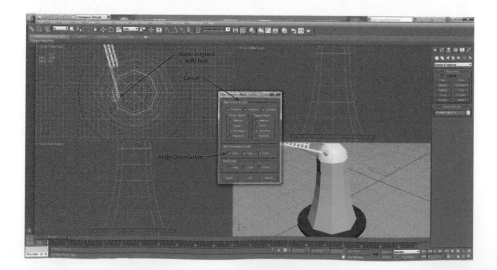

6. Use Select and Move to move the blade in its Local positive z-axis to about one-third the distance from base to top of the hub. This will ensure that it is clear of the domed roof when it rotates. Save the file. It should already be called Exercise 16-1-1_Procedural 03.max.

Merging objects from other 3ds Max files is an efficient method of reusing the existing models. It is important that the objects are cataloged so that everyone involved in production can easily find and access objects that will be used over and over.

Aligning objects based on their Local Reference Coordinate Systems with the Align tool is much more efficient and accurate than trying to move and rotate them in 3D space.

One windmill blade would certainly cause problems, so in order to balance the windmill you'll clone the existing blade for a total of four blades. Cloning the blades as Instance clones will reduce the overhead by allowing the four blades to share the node information from the original object. To gain further efficiency, you learn to apply an Edit Mesh modifier and use it to attach the four blades to the hub. This creates one object with one node space in memory, but it also allows you to navigate the modifier stack to Element subobject level to edit or transform the blades providing you with flexibility and efficiency.

Exercise 16-2-2 Clone and Attach Windmill Blades

1. Open the 3ds Max file called the Exercise 16-1-1_Procedural03.max and save it to an appropriate folder on your hard drive with a new incremental name. Zoom out in the viewports so that you have enough room to see the extra blades as they are cloned. In the main toolbar, click the Select and Rotate button. In the Reference Coordinate System drop-down list, choose Local (see **Figure 16-15**). Remember that the Reference Coordinate System is "sticky" to each transform: although it was previously set to Local for Select and Move, when you chose Select and Rotate you will notice how the Reference Coordinate System changes to View.

 Let's also adjust the rotation Angle Snap settings.

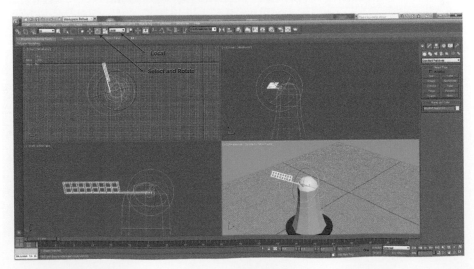

FIG 16-15 You will clone by rotating about the Local Reference Coordinate System.

2. In the main toolbar, right-click on the Angle Snap Toggle button to open the Grid and Snap Settings dialog. In the General area, enter **90** in the Angle numeric field (see **Figure 16-16**). Close the dialog. This restricts rotation to 90° only making it easier to clone accurately.

FIG 16-16 Set the Angle snap restriction to 90°.

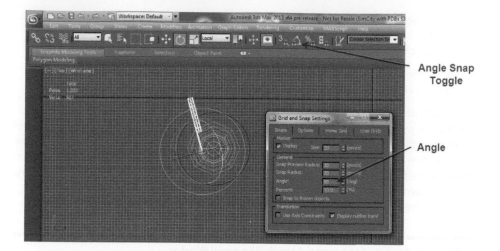

Angle Snap Toggle

Angle

3. In the main toolbar, click the Angle Snap Toggle button to turn it on (setting the snap angle does not enable the tool, you still need to click in the button to activate it). Hold the Shift key and then use the rotate gizmo's z-axis restrict circle to rotate the selected blade 90° clockwise. Release the left mouse button, and in the Clone Options dialog, choose the Instance radio button and enter **3** in the Number of Copies numeric field (see **Figure 16-17**). Click the OK button. You should have three additional equally spaced Instance clones of the original windmill blade, totaling four blades in all. Click the Angle Snap Toggle button in the main toolbar to turn it off.

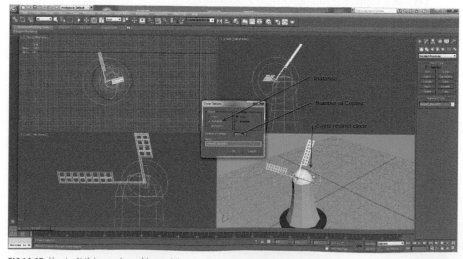

FIG 16-17 Use the Shift key to clone objects while rotating.

4. In the main toolbar, click the Select Object button. In the Perspective viewport, select the Windmill_hub001 object. In the Modify panel, Modifier list, choose Edit Mesh. In the Modify panel, Edit Geometry rollout, click the Attach List button. In the Attach List dialog, highlight the four Windmill_blade objects (see **Figure 16-18**). In the Attach List dialog, click the Attach button to finish the process. Five objects become one object for added efficiency. Plus you can still edit the parameters of the Cone base node.

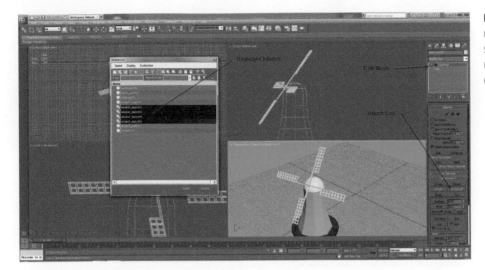

FIG 16-18 You can attach multiple objects to create a single object with the Edit Mesh modifier and maintain some editing flexibility.

Note

You could have used the Edit Poly modifier in the previous step to attach the objects. Objects in 3ds Max can be Poly or Mesh interchangeably depending on your editing needs. Mesh objects are more efficient but don't have all the editing control of Poly objects.

5. Save the file. It should already be called Exercise 16-1-1_Procedural04.max. Again, the Local Reference Coordinate System saves the day by allowing you to clone the windmill blades in a logical manner without knowing the angle of orientation.

Procedural modeling with modifiers for maximum editing flexibility, in combination with the use of the Local Reference Coordinate System, makes what might otherwise be a complex task relatively simple.

Make sure that you understand the concepts and the process of using these tools together and then practice on some scenes with other objects that you create. Work simply at first until you have committed the process to your memory and then it will become an automatic response when it's appropriate in your workflow. These seemingly insignificant tools, when combined, become a powerful workflow that let you get the bulk of your production work done quickly and easily so that you can later spend time on more important tasks.

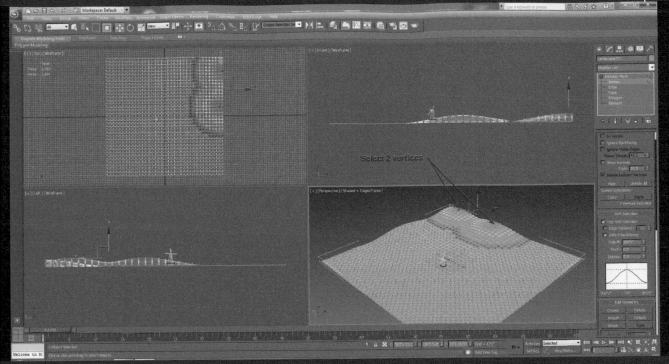

Subobject Editing

By working in subobject editing in the Modify panel you can access the smaller subobject components that make up 3D objects. In this chapter, you will learn about a specific surface type called a Mesh surface. A mesh surface in 3ds Max is made up of triangular faces and is the original 3D surface type in 3ds Max.

When you create a 3D primitive object in 3ds Max, you have access to its parameters in the Modify panel, where you can change parameters such as height and width, for example. For more detailed editing, you need to access the subobject components, which can then be transformed or can have modifiers applied to the subobject selection set.

In this chapter, you will learn two methods of accessing subobject level editing of mesh objects: Edit Mesh modifier and Editable Mesh object.

Edit Mesh modifier is applied to the object in the Modify panel and will appear in the stack view to allow access to subobject level components and editing tools. Applying Edit Mesh modifiers to objects can offer flexibility in editing by allowing you to navigate the stack view from one modifier to the other. However, if you change the topology of geometry, that is, add or subtract subobject level components, you can lose your ability to navigate the stack view. Also, for each Edit Mesh modifier you add to an object, you double the memory footprint of that object, decreasing overall efficiency. For best results, you need to balance flexibility and efficiency.

You can also convert any object to an Editable Mesh by right-clicking on it and choosing the option in the menu. You lose the ability to change the original parameters, but you will have

access to the subobject level components and editing tools in the Modify panel. Converting a primitive object to Editable Mesh does not alter the memory footprint of the object significantly and provides you with the same editing tools you will find in the Edit Mesh modifier.

Only experience will teach you which option is right, Edit Mesh modifier or convert to Editable Mesh, for any given circumstance. In this chapter, you will use each method to learn the workflow of accessing subobject level editing, and then you will edit the existing landscape for your scene at subobject level. You will be introduced to the workflow of using Soft Selection that allows weighted editing of surrounding subobject level components based on parameters you set.

The subobject components of 3D mesh objects in 3ds Max are as follows:

- *Vertex* – A vertex is a dimensionless point in 3D space.
- *Edge* – An Edge connects two vertices.
- *Face* – A Face is a triangular surface with three vertices and three edges.
- *Polygon* – A Polygon is a collection of adjacent faces surrounded by visible edges.
- *Element* – An Element is a collection of faces or polygons.

In this chapter, you will be concerned with editing at Vertex subobject level.

Some of the topics covered in this chapter are as follows:

- *Edit Mesh modifier and Editable Mesh* – Two methods of accessing subobject components of 3D geometry.
- *Changing object's topology* – Adding or deleting subobject components such as element, polygon, face, and edge can affect the ability to navigate the Modify panel, stack view.

Let's begin by learning to add the Edit Mesh modifier to the landscape and accessing some of the subobject level components. You will not actually be doing any permanent edits in this exercise but you'll refresh your knowledge of the Hold and Fetch commands that allow you to save a "bookmark" of your work with the Hold command, and then Fetch the stored information to provide an extra level of safety in your workflow.

17.1 Edit Mesh Modifier and Editable Mesh

Modifiers are applied to objects in the Modify panel, stack view, and are discrete editing tools forming a history that you can navigate for flexible editing. The Edit Mesh modifier allows you to access the subobject level components of a mesh surface, and then provides you with many options for editing selection sets of subobject level components. Each time you add an Edit Mesh modifier in the stack view, you double the memory occupied by everything below the new modifier in the stack. More than one Edit Mesh modifier can be added to a single object if needed, but at a cost of efficiency.

You can also right-click on an object in 3ds Max and, in the Quad menu, convert the object to an Editable Mesh to access the same editing tools you found in the Edit Mesh modifier. Converting to Editable Mesh does not add significantly to the memory footprint of the object, but you lose the ability to edit the object's original parameters. The Editable Mesh becomes the base node in the stack view.

In Exercise 17-1-1, you will use the Hold tool to save the current state of your scene. You'll then add an Edit Mesh modifier to the landscape and learn to select and edit some of the subobject components. However, the edits you perform are not permanent, so you will use the Fetch command to restore the scene to its previous state.

Exercise 17-1-1 Edit Mesh Modifier

1. Open the file from the website called Exercise 17-1-1_Sub-object01.max and save it to an appropriate folder on your hard drive with a new incremental name. The scene contains the windmill parts and landscape from previous chapters. In the Edit pull-down menu, click Hold. This saves the current state of your 3ds Max scene in a buffer file on the hard drive, which can be restored later with the Fetch command (see **Figure 17-1**).

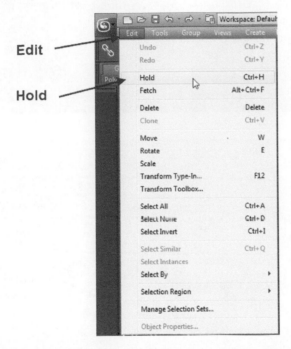

FIG 17-1 Use the Hold command so you can restore back to this scene state later.

2. In the Perspective viewport, select the Landscape001 object. In the Modify panel, Modifier list, choose the Edit Mesh modifier. The modifier is entered above the Plane-based node in the stack view. Click the + to the left of Edit Mesh in the stack to expand the list of subobject components (see **Figure 17-2**).

3. In the Stack view, highlight Vertex subobject level. You will see the vertices at the intersections of the visible edges turn blue to indicate you are in subobject Vertex mode. In the Perspective viewport, select one of the vertices by picking it. The selected vertex will turn red to indicate that it is selected and may now be transformed or edited (see **Figure 17-3**). In the Selection rollout, there are also buttons for selecting subobject level components.

4. Highlight Edge subobject level in the stack view, and then pick on one of the visible white edges of the landscape. Edges connect two vertices. Highlight Face in the stack view, and then click anywhere on the surface of the landscape. All faces are triangular and will turn red when selected. Highlight Polygons in the stack view, and then click in the same place you selected the face on the landscape. In a mesh object, a polygon is a selection of faces bordered by visible white edges (see **Figure 17-4**). Try selecting at Element subobject level and you will see that in this particular object the Element is the object itself.

FIG 17-2 Expand the Edit Mesh modifier in stack view to access subobject level components.

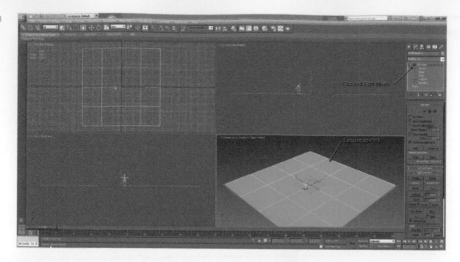

FIG 17-3 Selected (red) subobject components can be transformed or edited.

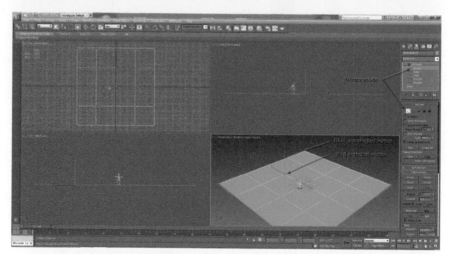

FIG 17-4 A polygon in a mesh object is a collection of faces bordered by visible white edges.

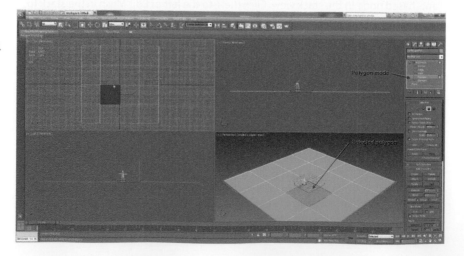

5. In the stack view, click on the word Edit Mesh at the top of the stack. This exits subobject level editing and returns control back to the whole object. None of these subobject components should be highlighted in the stack view and none of the buttons in the Selection rollout should be yellow when you have exited subobject editing mode (see Figure 17-5). It is important that you properly exit subobject editing mode when you are finished, otherwise you won't be able to select any other objects in the scene.

FIG 17-5 Exit subobject editing mode properly.

6. In the Edit pull-down menu, choose Fetch, and then click the Yes button in the About to Fetch, OK? dialog that appears. This will return you to the original file you saved with the Hold command in case you have done any unwanted editing in subobject mode. Save the file. It should already be called Exercise 17-1-1_Sub-object02.max.

By applying an Edit Mesh modifier, you gain access to subobject level editing. You must, however, select one of the subobject components in the geometry before you can actually do any subobject editing. The subobject level component will turn red to indicate it is selected. When you are finished at subobject level, it is important that you properly exit subobject mode before proceeding with your work.

Exercise 17-1-2 Editable Mesh

1. Open the file called Exercise 17-1-1_Sub-object02.max and save it to an appropriate folder on your hard drive with a new incremental name. In the Perspective viewport, select the Landscape 001 object. Right-click on the object and, in the Quad menu, hover your mouse over Convert To, and then choose Convert to Editable Mesh (see Figure 17-6).

FIG 17-6 You can convert objects to Editable Mesh from the Quad menu.

2. In the Modify panel, stack view, expand Editable Mesh by clicking the + to the left of the name. This expands the subobject levels with the same options as in the Edit Mesh modifier in Exercise 17-1-1 (see **Figure 17-7**). Editable Mesh is the only entry in stack view. The parameters for the original Plane 3D primitive are lost.

FIG 17-7 The only editing capabilities are found in the Editable Mesh object.

3. In the stack view, highlight Vertex subobject level. In the Perspective viewport, select a vertex along a back edge of the Editable Mesh. In the main toolbar, click the Select and Move button, and then move the vertex in the positive z-axis direction (see **Figure 17-8**). The vertex moves and its adjacent edges change angle, but the surrounding vertices are not affected. In the stack view, highlight Editable Mesh to exit subobject mode.

FIG 17-8 Move a vertex in the positive z-axis to edit the Editable Mesh.

Note

You have been selecting subobject level components by clicking on them in the viewports, but all of the selection options you learned about in Chapter 4 are valid except the Select by Name tools.

4. In the Edit pull-down menu, choose Fetch, and then click the Yes button in the About to Fetch, OK? dialog. Even if you have closed the previous 3ds Max session and opened it again to begin this exercise the information stored with the Hold command is still on the hard drive. The stored information will stay the same until you use the Hold command again. Save the file. It should already be called Exercise 17-1-1_sub-object03.max.

In this exercise, you moved a vertex at subobject editing level with a result you probably expected. In Section 17.2, you will edit the landscape to place low hills or mounds along the back edge.

17.2 Changing Topology

The topology of an object is the relationship of subobject components that make up the 3D surface. In this section, you will change the topology of the landscape by creating new vertices, and so on, with a modifier called Quadify Mesh, and then you will convert the resulting mesh to an Editable Mesh. This "bakes" the new information and removes the modifier from the stack. You'll then move a vertex with Soft Selection enabled, which will affect the surrounding vertices in a weighted manner.

Exercise 17-2-1 Landscape Hills

1. Open the 3ds Max file from the previous exercise called Exercise 17-1-1_Sub-object03.max and save it to an appropriate folder on your hard drive with a new incremental name. In the Perspective viewport, select Landscape001, and then right-click and convert to Editable Mesh. In the Modify panel, Modifier list, choose Quadify Mesh. This modifier subdivides the existing surface so that the new polygons are 4% the size of the original object. In the Modify panel, Parameters rollout, enter **2** in the Quad Size % numeric field, and then press enter to complete the edit (see **Figure 17-9**).

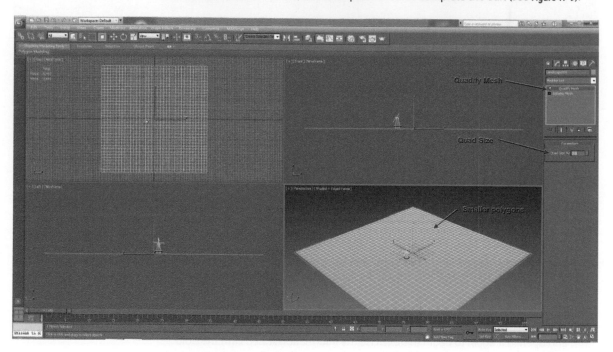

FIG 17-9 Quadify Mesh modifier subdivides the existing object.

2. Right-click on the landscape, and then convert it to Editable Mesh. The modifier is removed from the stack and the object is a simple Editable Mesh with the added geometry.

3. In the Modify panel, stack view, expand Editable Mesh, and then highlight Vertex subobject level. In the Perspective viewport, select a vertex along one of the back edges of the landscape. Expand the Soft Selection rollout, and then check the Use Soft Selection option. Enter **200'0"** in the Falloff numeric field. This expands the influence of Soft Selection to 200 feet from the selected vertex (see **Figure 17-10**). The color coding in the surrounding vertices indicates the "weight" or influence that edits to the selected vertex have on them. The selected vertex is red and will be transformed absolutely. The orange vertices will be affected somewhat less, the yellow, green, and the blue vertices even less respectively based on the Falloff amount.

4. In the main toolbar, click the Select and Move button, and then move the selected vertex in the Perspective viewport slightly in the positive z-axis (You want a hill, not a mountain). Select another vertex along the back edge, hold the Ctrl key and add another vertex nearby to the selection set, and then move them slightly in the positive z-axis (see **Figure 17-11**).

FIG 17-10 Soft Selection weights the influence of editing on the selected vertex or vertices.

FIG 17-11 Create several small hills along the backside of the landscape with Soft Selection.

5. Exit subobject level by highlighting Editable Mesh in the stack view, and then save the file. It should already be called Exercise 17-1-1_Sub-object04.max. Editing at subobject level provides you with more detailed control of your objects and offers specialized tools for flexible editing. The edits you performed can be accomplished in Edit Mesh modifier or in Editable Mesh equally well.

Learning to access subobject editing gives you access to many new tools for adding detail to your models. There are many forms of subobject editing and the workflow you have learned with Edit Mesh modifier and Editable Mesh objects can be used throughout 3ds Max.

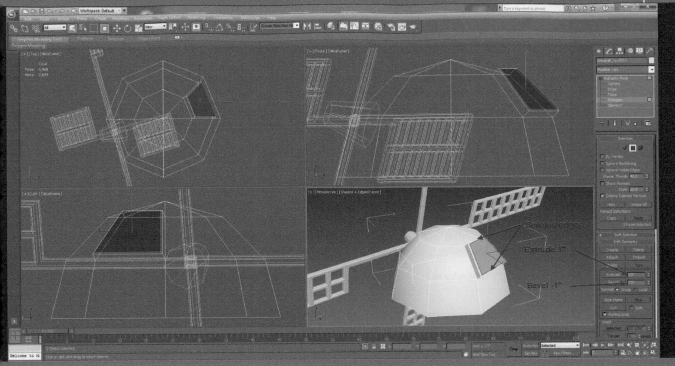

Geometry Types

In previous chapters, you have created 3D primitive objects in 3ds Max and then edited them with the Edit Mesh modifier or converted them to Editable Mesh geometry; either method offers the same set of tools for editing at subobject level. The basic subobject component of Mesh geometry is a triangular face. You might remember that a collection of triangular faces surrounded by visible white edges is also called a Polygon subobject component.

Another geometry type available in 3ds Max is the Poly geometry, with the basic subobject component a four-sided Polygon. Although it might appear similar to the Polygon subobject level component of Mesh geometry, the Poly geometry polygon is not a collection of triangular faces, but a subobject component in its own right.

The major differences between Mesh and Poly geometry for the purposes of your workflow are in the editing tools available for each surface type. Poly geometry, the newer form of surface type in 3ds Max, has more powerful and flexible editing tools available, making it a good choice for modeling. But because the render engines in 3ds Max can render only triangles, all geometry types must be converted to triangular Mesh surfaces "behind the scenes" during rendering. This makes complex Poly geometry less efficient than an equivalent Mesh geometry.

Very often in a production workflow, geometry is converted from Mesh to Poly and back again several times throughout the editing process, so that you can choose the most appropriate editing tools for a particular need.

In the previous chapter, you created the hills in a landscape object by selecting and moving one or several vertices, using the Soft Selection option to "weight" the influence of surrounding vertices as you moved the selected vertex/vertices to create a mound. The hill you created, however, was perfectly round as the weighted influence radiates equally in all directions from the selected vertex. In this chapter, you will create a new landscape surface using a Patch Grid as the initial surface type and then working at subobject Vertex level to more easily make flowing surfaces with a high degree of control.

Some of the topics covered in this chapter are as follows:

- *Mesh editing tools* – This will be a refresher for using Editable Mesh tools at subobject level.
- *Poly editing tools* – You will be introduced to the workflow of Poly editing tools.
- *Patch Grid* – With Patch Grid geometry, you will learn to edit the slope of a surface between adjacent vertices.

Let's begin by exploring the basic differences between Mesh geometry editing and Poly geometry editing while adding a bit of detail to the windmill from the previous scene.

You'll then learn about Patch Grid by creating a hilly landscape in a new 3ds Max scene and to use the Replace tool in the original scene to substitute the old landscape for the new.

18.1 Mesh Editing Tools

Again, you are familiar with the Edit Mesh modifier and the Editable Mesh geometry from Chapter 17, and this section will reinforce the workflow of editing at subobject level. You will use the Edit Mesh modifier to create and access a hatch in the domed roof of the windmill using the Extrude and Bevel editing tools at the Polygon subobject level.

While using Extrude to create the initial hatch, you'll learn to manually manipulate the surface to "eyeball" the hatch, and then you will use numeric values in the Bevel editing option for a more accurate control.

Exercise 18-1-1 Create a Roof Hatch

1. Open the file from the website called Exercise 18-1-1_Geometry01.max and save it to an appropriate folder on your hard drive with a new incremental name. This is essentially the same scene you created in Chapter 17. Press the keyboard shortcut H to open the Select From Scene dialog and then highlight Windmill_roof001 and Blade_hub001 in the dialog list (see Figure 18-1). Click the OK button to select the objects.

2. Use the keyboard shortcut Alt+Q to isolate the selection. The windmill blades are part of the selection because you used an Edit Mesh modifier in Chapter 17 to attach them into a single entity. In the Perspective viewport, select the Windmill_roof001 and then click the Zoom Extents All Selected button to fill all viewports with the object.

3. Hold the Shift key and, in the Perspective Viewport, click and hold the mouse wheel and then use Arc Rotate to make the back of the domed roof visible. You will place the hatch in the polygon (collection of triangles surrounded by a visible white edge) opposite the blade hub. Right-click on the domed roof and, in the Quad menu, choose Convert To and then choose Convert to Editable Mesh in the submenu (see Figure 18-2).

FIG 18-1 Select Windmill_roof001 and Blade_hub001 using Select From Scene.

FIG 18-2 Convert Windmill_roof001 to an Editable Mesh.

4. In the Modify panel, stack view, expand Editable Mesh and highlight Polygon subobject mode. In the Perspective viewport, select the polygon opposite the hub. It will be shaded red when selected (see **Figure 18-3**). If the polygon itself is not shaded red and only the edges appear red, then you might have selected a polygon on the opposite side of the mesh, behind the intended polygon according to your view of the mesh. If you don't select the correct polygon on the first click, just keep clicking in the same spot to toggle between polygons below the cursor.

FIG 18-3 The polygon will highlight in red when selected.

5. In the Modify panel, Edit Geometry rollout, click the Extrude button to place it into manual mode. Move the cursor over the selected polygon in the Perspective Viewport and you will see a new extrude cursor appear. Left-click on the selected polygon and drag the mouse upward to extrude the polygon a little (see Figure 18-4). Left-click to set the Extrude amount, which you can see in the numeric field to the right of the Extrude button, to somewhere between four and five inches. Click the Extrude button to toggle it off.

FIG 18-4 Click the Extrude button for manual control of the extrusion amount.

6. In the Extrude numeric field, enter **0'1"** and then press Enter. This performs another extrude operation with an exact amount. In the Bevel numeric field, enter **−0'1"** to bevel the new polygon inward to form a beveled edge around the new access hatch (see Figure 18-5). As soon as you press Enter, the numeric fields reset themselves to 0'0".

FIG 18-5 You can also Extrude and Bevel numerically for accurate amounts.

7. In the Modify panel, stack view, highlight Editable Mesh to exit subobject mode. Use the keyboard shortcut Alt+Q to exit isolation mode and make the other objects in the scene visible again. Save the file, it should already be called Exercise 18-1-1_ Geometry02.max. Even though you are editing a Mesh object, you still have access to a Polygon subobject mode; a collection of two triangular faces in this case. The editing steps are a linear process – once you extrude a polygon, for example, the edit is immediately applied and you can move on to the bevel process.

Mesh geometry has many editing tools for creating complex surfaces in 3ds Max and the resulting geometry is efficient because it does not need to be converted internally before rendering. The subobject editing tools are linear, meaning that once you have performed several steps, it can be difficult to make changes to the edits from step one, for example. However, you can add multiple Edit Mesh modifiers containing the same editing tools and offering the advantage of deleting the edits performed by deleting the modifier itself. Remember however, that each time you add an Edit Mesh modifier, the memory footprint of the object doubles.

Let's perform some similar edits using the Poly editing tools accessed by converting an object to Editable Poly.

18.2 Poly Editing Tools

Poly geometry has a topology that is primarily four-sided polygons, although it is sometimes necessary to have three-sided polygons or polygons with more than four sides to create a particular object.

The basic workflow of either applying an Edit Poly modifier or converting an object to Editable Poly is the same as with Mesh geometry. Each method gives the same subobject editing tools that may work similarly to those found in the Mesh object options, though many function a bit differently, allowing you to preview the changes made by the tool before committing to the edit. This improves the flexibility of the workflow for Poly geometry.

In Exercise 18-2-1, you will isolate the Windmill_base001 object and then edit the geometry to place an inset door with a doorframe. The exercise will be simple, so that you can focus your attention on how the workflow of Poly geometry varies from the workflow of Mesh geometry.

Exercise 18-2-1 Windmill Door

1. Open the 3ds Max file from the previous exercise called Exercise 18-1-1_ Geometry02.max and save it to an appropriate folder on your hard drive with a new incremental name. Select the Windmill_base001 object in the Perspective viewport and then use the keyboard shortcut Alt+Q to isolate the selection. Click the Zoom Extents All Selected button to fill all viewports with the object. Right-click in the Front viewport to activate it.
2. Right-click on the object in the Front viewport, choose Convert To in the Quad menu, and then choose Editable Poly in the submenu. In the Modify panel, stack view, expand Editable Poly for a list of subobject components. In stack view, highlight Edge subobject level. In the Front viewport, use the Ctrl key to select the three center vertical edges (see Figure 18-6). The edges will turn red when selected.

FIG 18-6 Select the three vertical edges at the front of the windmill base. Ctrl key allows you to add to a selection set.

3. In the Modify panel, Edit Edges rollout, click the Settings button to the right of the Connect button. This opens a "caddy" that floats in the viewport with adjustable parameters (see Figure 18-7). It's difficult to see, but the Connect tool has created a new edge through the midpoints of the three selected edges that will be used to define the top of the doorway.
4. In the caddy, highlight the Slide numeric field and then enter **35** to move the edge up 35 units along the vertical edges (see Figure 18-8). You are still in the Settings caddy for the Connect tool and haven't yet committed to the edit. It is still possible to change your current edit or to adjust some of the other options at this point.

FIG 18-7 Poly geometry editing has Settings options for many tools to allow you to preview your edits before committing to them.

FIG 18-8 The Slide option slides the new edge up and down along the original edges.

5. Once you have previewed the edit, you can click the OK check button to accept it (see Figure 18-9). The + button could be used to apply the current edit and still continue editing, or you could cancel the edit by clicking the X button. This workflow provides you with a "what you see is what you get" flexibility not available in the Editable Mesh geometry.

FIG 18-9 You can accept the current edits by clicking the OK button.

6. In the Front viewport, select the edge below the center of the new horizontal connect edge. In the Edit Edges rollout, click the Remove button (see **Figure 18-10**). Removing this edge defines a new polygon bordered by visible white edges.

FIG 18-10 You can remove the visible edges to combine polygons.

Note

In the Front viewport, it will appear as though the edge is still there, but you are actually seeing the edge beyond on the backside of the windmill base. In the shaded Perspective viewport, you can clearly see that the edge has been removed.

7. In the Modify panel, stack view, highlight the Polygon subobject mode. You will see the newly defined polygon turn red to indicate that it is selected. In the Edit Polygons rollout, click the Settings button to the right of Inset to open the Inset caddy. Enter **0'4"** in the Amount numeric field and press Enter. You can see that the selected polygon has been inset by 4 inches on each side to create new "doorframe" polygons (see **Figure 18-11**). Click the OK button to complete the process.

FIG 18-11 The Inset command posts the edges of the selected polygon inward to create new polygons.

8. In the Edit Polygons rollout, click the Settings button for the Extrude command and then enter **−0'6"** in the Height numeric field of the caddy. This pulls the selected polygon inward (see **Figure 18-12**). Click the OK check button to finalize the edit.

9. Use the Ctrl key to select the polygons that make up the doorframe. There should be six polygons and you can see the count in the Selection rollout. Click the Extrude Settings button and then enter **0'2"** in the Height numeric field. This extrudes the doorframe out from the surface of the windmill base (see **Figure 18-13**). Click the OK check button to finalize the edit.

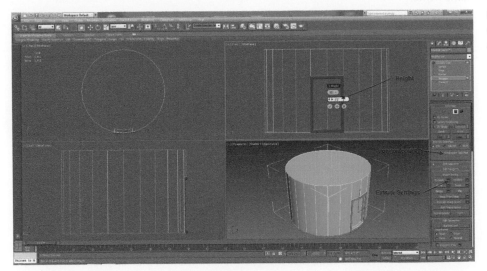

FIG 18-13 Extrude the doorframe polygons outward away from the windmill base.

10. In the Modify panel, stack view, highlight Editable Poly to exit subobject mode. Use the Alt+Q keyboard shortcut to restore the other objects in the scene and then save the file. It should already be called Exercise 18-1-1_Geometry03.max. The Settings buttons that open the adjustment caddies in Editable Poly or in the Edit Poly modifier give you a chance to preview your edits before committing to them for a more flexible editing experience.

Although the basic workflow for Editable Poly or Edit Poly modifier is very similar to the Mesh object editing tools, the Settings caddy present in the Poly editing tools give you a bit more freedom to experiment with changes before actually deciding to commit those edits to the geometry. There are also many more tools for Poly geometry, some of which you will learn more about in upcoming chapters.

Let's learn about a completely different type of geometry in 3ds Max called the Patch Grid.

18.3 Patch Grid

The Patch Grid geometry in 3ds Max, called Quad Patch, is a flat plain surface with unique editing capabilities. In this section, you will create a landscape from a Quad Patch, convert it to Editable Patch, and then move its vertices upward to form gentle rolling hills.

Although this is similar to what you did to create the previous landscape using Editable Mesh and Soft Selection, the Quad Patch offers more control in making smooth curves in surfaces. The curvature of the edges is weighted toward the other vertex at the end of the edge. This allows you to adjust the slope and curvature of the "hills" by editing far fewer vertices.

Once you have the new landscape with the name Landscape001 (same name as the previous landscape) created in a new 3ds Max scene, you'll save it to the hard drive. You'll open the previous windmill scene that has the Editable Mesh landscape, access the Import, Replace command, and replace the current landscape with the Patch Grid landscape of the same name.

Again, the intent of this exercise is not simply to replace one object with another, but to introduce you to the power of the Replace command. In a production setting, Replace might be used to replace simple stand-in geometry, adopted for more efficiency in the viewports while you are working, with the final more complex geometry that will be used at render time.

Let's create the landscape in a new scene and then replace the existing one.

Exercise 18-3-1 New Landscape

1. Reset 3ds Max or open a new empty scene. Save the empty scene to a file called Landscape_patch.max in an appropriate folder on your hard drive. In the Create panel, Geometry rollout, click the Standard Primitives drop-down list and then choose Patch Grids (see Figure 18-14).
2. In the Object Type rollout, click the Quad Patch button. In the Perspective viewport, click and drag a Quad Patch of any size. In the Modify panel, Parameters rollout, enter 750'0" in the Length and Width numeric fields, and then enter 4 in the Length Segs and Width Segs numeric fields for four segments in each direction. In the Perspective viewport, click on the Shaded viewport label and then choose Edged Faces in the menu. Press Enter to finalize the numeric data entry and then click the Zoom Extents All Selected button to fill the viewports with the new object (see Figure 18-15).

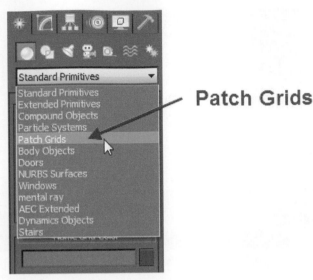

Patch Grids

FIG 18-14 The Quad Patch object is found in the Patch Grids menu.

FIG 18-15 Create and modify a Quad Patch with four segments in each direction.

3. Right-click in the Perspective viewport, choose Convert To in the quad menu, and then choose Convert to Editable Patch in the submenu (see Figure 18-16). The Modify panel now displays the geometry editing tools for a Patch object.

4. In the Modify panel, stack view, expand Editable Patch and then highlight the Vertex subobject mode. In the main toolbar, click the Select and Move button. In the Perspective viewport, move a couple of the vertices along the back edges in the World positive z-axis (see Figure 18-17). Make sure that you are moving the vertices in the right axes to create low hills.

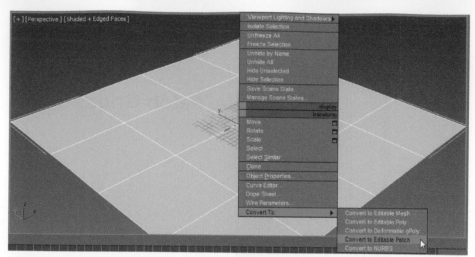

FIG 18-16 Convert the Quad Patch primitive to an Editable Patch object.

FIG 18-17 Use the Transform Gizmo to restrict vertex movement in the World positive z-axis.

5. In the Modify panel, stack view, highlight Editable Patch to exit subobject mode. Rename the object **Landscape001** and then save the file.

6. Open the 3ds Max file from the previous exercise called Exercise 18-1-1_Geometry03. max. In the Application button, Import option, choose Replace (see **Figure 18-18**).

7. In the Replace File dialog, navigate to the folder where you saved the file from Exercise 18-2-1 and then double-click on it. It should be called Landscape_patch .max. In the Replace dialog that appears, highlight Landscape001 in the list. It should be the only object in the list and it must have the exact same name as the object in your current scene that you want to replace. Click the OK button and then click the Yes button when prompted to replace the materials along with the objects

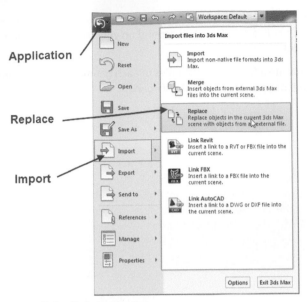

FIG 18-18 The Replace command is found in the Import options.

(see Figure 18-19). Your choice here doesn't really matter because there were no materials assigned to the Quad Patch landscape.

FIG 18-19 You can replace materials in the current scene with the imported materials or not.

8. Click the Zoom Extents All Selected button to fill the viewports with the landscape and you will see that gentle rolling hills created with the Quad Patch. Save the file. It should already be called Exercise 18-1-1_Geometry03.max.

Different situations call for different geometry types for maximum editing control. Whether you use Mesh, Poly, or Patch surfaces will depend on your personal workflow and your client's requirements.

Take the time to create a few simple examples of each geometry and experiment with the many editing options you'll find in the Modify panel.

More Object Cloning

Cloning an object in 3ds Max can be accomplished by transforming the object while holding the Shift key and then choosing the type of clone (copy, instance, or reference) with the option of creating a single clone or multiple clones, each with the same offset of the original transformation. This method of cloning is useful for creating a line of office desks where the exact offset distance is not critical, for example. You can create a similar array by using the Shift key while rotating an object.

However, there will be many times when you need more control over exactly how the array is spaced and whether the array occupies one, two, or three dimensions. The Array tool in 3ds Max presents you with a dialog where you can enter the numeric values for the offsets, either linear or radial, and then choose the type of clone you require. This might be used to create a rectangular array of bolts on a piece of machinery in a numerically correct pattern, for example.

Sometimes you'll need to evenly space object clones between two given points in a scene; for example, you might need a line of trees between two buildings that are 10 feet apart. The Spacing tool will provide you with the ability to perform such an array, plus you have an option of choosing a 2D shape in the scene and having objects evenly distributed along, be it a straight line or curved path.

Then there are other situations where objects need to be cloned in a more random, free-form distribution pattern. For that, 3ds Max has the Object Paint tool where you can use the mouse cursor to paint an area to distribute object clones.

In this chapter, you will perform several exercises to learn the fundamental workflow of each of the cloning options.

Some of the topics covered in this chapter are as follows:

- *Array tool* – The Array tool is used to create linear or circular arrays of object clones.
- *Spacing tool* – The Spacing tool is used to distribute object clones between two points or along a path.
- *Object Paint tool* – You can use Object Paint to "paint" object clones over a surface.

Let's start off by making a radial array of the railing posts around the circular walkway of the windmill.

19.1 The Array Tool

The Array tool in 3ds Max provide you with a powerful option of creating numerically correct offset clones of objects either in a linear or radial array. The Array dialog can be a bit intimidating the first few times you try it, but with just a little practice you'll master the tool in no time.

For a 3D linear array, you need to enter the offsets in the axes based on the Reference Coordinate System for the active viewport, the type of clone, and then the number of dimensions of the array. A typical 3D linear array can be seen in **Figure 19-1**.

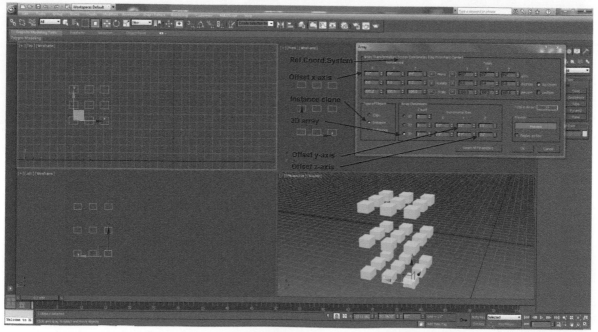

FIG 19-1 Linear 3D array.

A 2D radial array uses the selected objects current pivot point position and can include an offset angle and a position offset value to create an array of objects that might be very difficult to accomplish manually (see **Figure 19-2**).

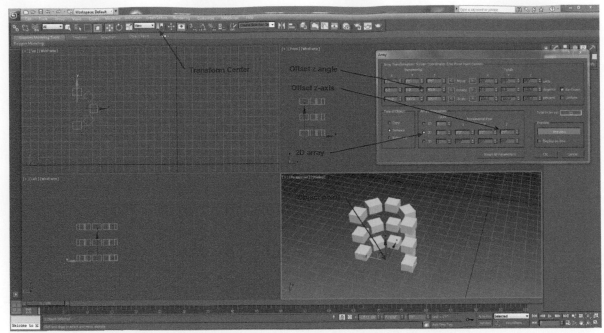

FIG 19-2 A radial array can have a radial and a linear offset.

Let's try a simple radial array to distribute railing posts around the outside edge of the windmill walkway. This will require you to "borrow" the pivot point of the walkway with the Pick reference coordinate system to ensure correct distribution, and you will need to learn about Transform Center options for determining the correct axis of rotation. You must also have an object or objects selected in 3ds Max before the Array tool will be available in the menu.

Exercise 19-1-1 Array Walkway Railings

1. Open the file from the website called Exercise 19-1-1_Cloning01.max and save it to an appropriate folder on your hard drive with a new incremental name. This is the windmill scene with a repositioned railing post on the walkway and a tree. Right-click in the Top viewport to activate it. In the main toolbar, click the Select and Rotate button, and then set the Reference Coordinate System to Pick. In the Top viewport, pick the edge of the blue Walkway001. This creates a new Reference Coordinate System called Walkway (see Figure 19-3).
2. Click and hold on the Use Pivot Point Center button to the right of the Reference Coordinate System drop-down menu, and then click the bottom flyout called Use Transform Coordinate Center (see Figure 19-4). The railing post will now use the walkway's pivot point instead of its own for rotations.

Note

When you create a Pick reference coordinate system, in this case called Walkway001, it will remain an option in the Reference Coordinate System drop-down menu for the duration of this 3ds Max work session.

FIG 19-3 For Select and Rotate, create a new Pick reference coordinate system using the Walkway001.

FIG 19-4 Set the center of rotation at the pivot point of Walkway001.

3. Use the keyboard shortcut H to highlight Railing_post001 in the Select From Scene dialog. Click OK to select the object. In the Tools pull-down menu, choose Array. In the Array dialog, enter **36** in the z-axis Rotate numeric field. In the Type of Object area, make sure that Instance radio button is chosen. In the Array Dimensions area, make sure that 1D radio button is chosen and that the Count is set to 10. Click the Preview button at the right of the dialog. This arrays the railings every 36° around the walkway (see **Figure 19-5**). However, the spacing of the railing posts is too much for safety, so you need to add more posts.

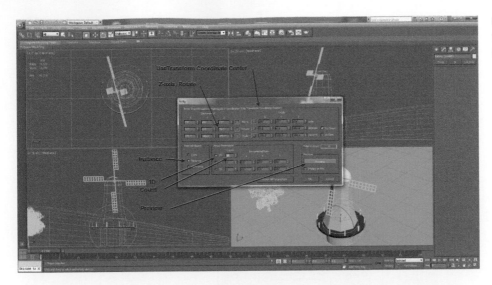

4. In the Array dialog, enter **12** in the z-axis Rotate numeric field, and then press Enter to refresh the preview. This places the railings close together, but only one-third of the way around a complete circle. In the Array Dimensions area, Count numeric field, enter **30**, and then press Enter (see **Figure 19-6**). There are now 30 railing posts spanning the full 360° and the preview allows you to see the results before committing to it. Click the OK button to finish the array.

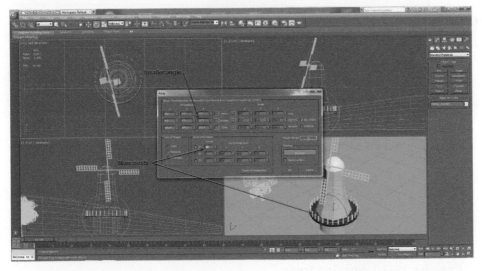

FIG 19-6 Decrease the angle between each post and increase the number of posts.

5. Save the file. It should already be called Exercise 19-1-1_Cloning02.max. The Array tool in 3ds Max provides you with many options for cloning objects. You should create a new 3ds Max scene with just one or two 3D objects and experiment with making linear and radial arrays. Remember that for radial arrays the position of the object's pivot point and the Transform Center option is important for accurate control.

Let's try cloning the tree in the scene with the Spacing tool.

19.2 The Spacing Tool

The Spacing tool in 3ds Max has two fundamental techniques for creating arrays of objects: distributing objects between two points and distributing objects along a 2D path.

You can, of course, determine the number of objects, the count, and the clone type when using the Spacing tool, but there are also many options that determine exactly how the objects are distributed at the beginning and end of the points or path, and whether the objects rotate to follow the curvature of the path (see **Figure 19-7**).

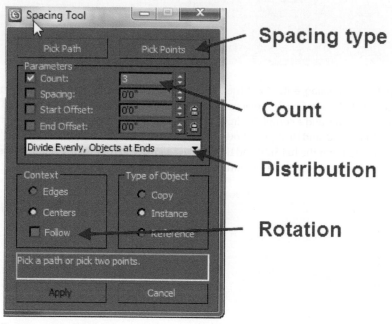

FIG 19-7 The Spacing tool has flexible options.

In Exercise 19-2-1, you'll learn to space a few trees between points, and then space trees along a 2D path. As with the Array tool, you can see a preview of the results of your adjustments before applying the spacing to the scene.

Exercise 19-2-1 Spacing Trees

1. Open the 3ds Max file from the previous exercise called Exercise 19-1-1_Cloning02. max and save it to an appropriate folder on your hard drive with a new incremental name. In the Top viewport, zoom out until you see the windmill, the tree, and a curved path at the upper left of the viewport. Select the tree called Tree_decid01.
2. In the Tools pull-down menu, hover the cursor over Align, and then choose Spacing tool in the submenu (see **Figure 19-8**).

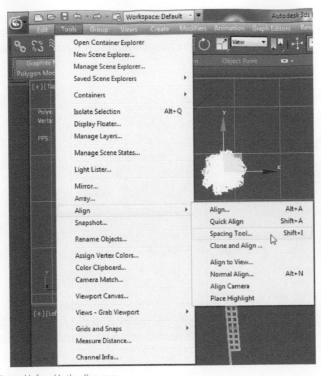

FIG 19-8 The Spacing tool is found in the align menu.

3. In the Spacing tool dialog, click the Pick Points button. In the Top viewport, left-click between the tree and the windmill, and then release the mouse button and move the cursor up and to the right a short distance. You will see a blue "rubber band" line. Left-click to set the second point. Three clones of the tree will be distributed evenly along the line defined by the two pick points (see **Figure 19-9**). The original tree remains in place.

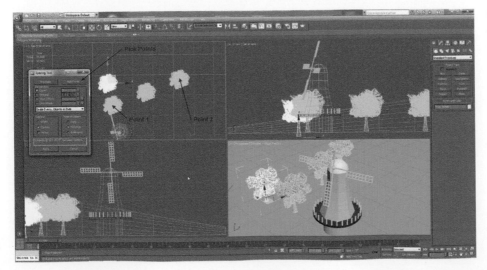

FIG 19-9 Picking two points in a viewport defines the endpoints of the spacing line.

4. In the Spacing tool dialog, enter **5** in the Count numeric field, and then press Enter. The viewport will update with five trees divided evenly, with objects at the ends (the pick points) (see **Figure 19-10**). Click the Apply button to finalize the cloning process.

FIG 19-10 Change a parameter, and then press Enter to update the preview.

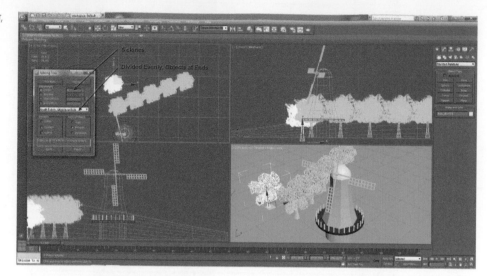

5. The tree should still be selected in the Top viewport. In the Spacing tool dialog, click the Pick Path button. Move the cursor over the curved line called tree_path01 (you can also use the keyboard shortcut H to select it from a list), and then when the cursor changes to a crosshair click the line. You now have five clones of the tree distributed along the curved path. You can also see in the information box at the bottom of the dialog that the objects are spaced 20'11 24/32" between centers (see **Figure 19-11**).

FIG 19-11 Trees are evenly distributed along a curved path.

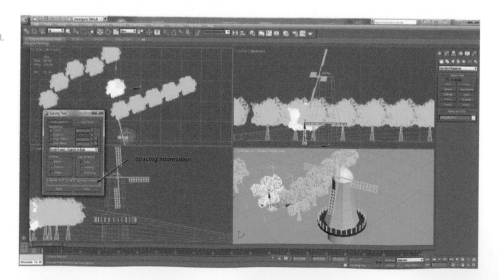

6. In the Spacing tool dialog, check the Spacing option, and then clear the checkbox in the Count option. Enter 15'0" in the Spacing numeric field, and then press Enter to see the scene update. There are now six trees spaced 15'0" apart beginning at the first vertex of the path (at the left end, in this case). In the Spacing tool dialog, Context area, check the Follow checkbox. The trees will rotate to remain perpendicular to the curvature of the path (see Figure 19-12). Click the Apply button to finalize the cloning process, and then click the Close button to close the dialog.

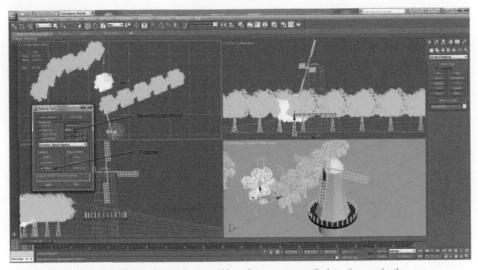

FIG 19-12 You can also space objects by a given distance and have them rotate perpendicular to the curved path.

7. Save the file. It should already be called Exercise 19-1-1_Cloning03.max. The Spacing tool offers options for distributing objects that are not available in the Array tool. Again, try creating your own scene with only one of two objects and practice with the Spacing tool so that it becomes a natural part of your workflow.

The Object Paint tool in 3ds Max provide you with a more free-form method of distributing objects in a scene. Let's learn the fundamentals of how it functions.

19.3 The Object Paint Tool

The Object Paint tool in 3ds Max is not found in the Tools pull-down menu, but is part of the Ribbon menu just below the main toolbar.

In this section, you'll learn to expand the Ribbon menu and make adjustments to the Object Paint brush options before choosing the object you want to paint in the scene. You'll then choose the original tree and paint a few clones around the scene.

Exercise 19-3-1 Object Paint Trees

1. Open the 3ds Max file from the previous exercise called Exercise 19-1-1_Cloning03. max and save it to an appropriate folder on your hard drive with a new incremental name. In the Ribbon menu, click the Object Paint tab, and then click the Show Full Ribbon button just to the right of it (see **Figure 19-13**).

FIG 19-13 The Object Paint tool is found in the ribbon menu.

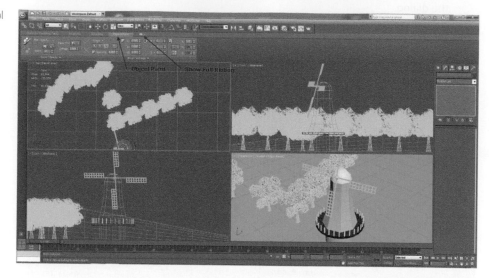

2. Enter **300** in the Spacing numeric field at the bottom center of the Ribbon menu, Brush Settings area, and then press Enter. This sets the spacing to 300 inches (see **Figure 19-14**).

FIG 19-14 Set the spacing before painting objects.

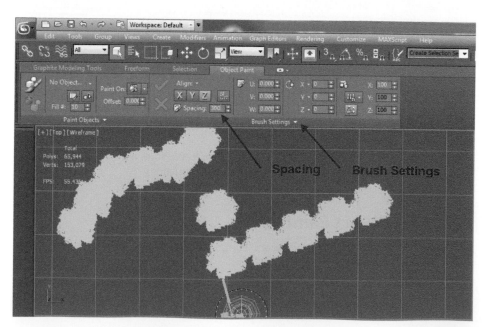

Note

A "glitch" in the 3ds Max interface may keep you from seeing anything but the last integer and three decimal places of the numeric value you enter.

3. In the Top viewport, select the original tree. Click the Edit Object List button in the Paint Objects area, and then, in the Paint Objects dialog, click the Add Selected button. The name of the tree shows in the Ribbon menu (see **Figure 19-15**). Close the Paint Objects dialog.

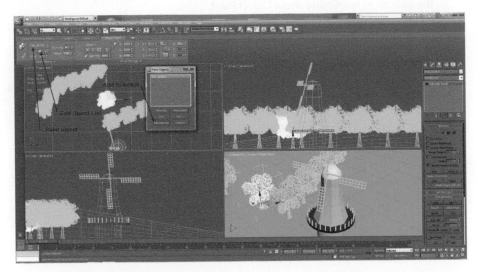

FIG 19-15 You can choose the selected object as the paint object, and multiple objects can be added to the list.

4. In the Ribbon menu, Paint Objects area, click the large Paint button at the upper left corner. In the Top viewport, click and drag the cursor in a semicircle around the original tree. This distributes a tree every 300 inches along the path described by the cursor (see **Figure 19-16**). Click the Minimize to Tabs button in the Ribbon menu to close the expanded tabs.

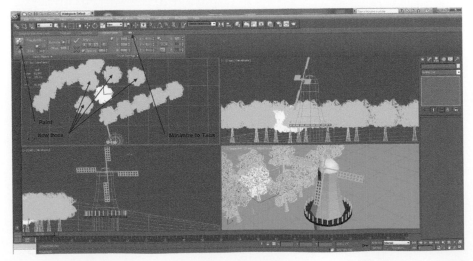

FIG 19-16 Paint a few trees in the Top viewport.

Warning

Trees in 3ds Max can sometimes have very large numbers of polygons and you should be careful about placing more than necessary in a scene.

5. Save the file. It should already be called Exercise 19-1-1_Cloning04.max. The Object Paint tool is convenient for placing objects more randomly in a scene than it is possible with the Array and Spacing tool. Experiment in a simple scene with some of the options to learn more about Object Paint.

Your ability to choose the right 3ds Max tool for distributing objects throughout a scene can enhance your productivity. You must develop a workflow with the tools by first learning how they work and then practicing until they become a natural part of your repertoire of 3ds Max tools.

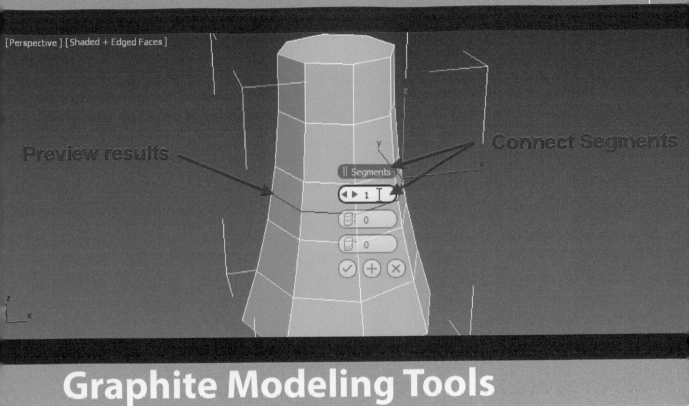

[Perspective] [Shaded + Edged Faces]

Preview results

Connect Segments

Graphite Modeling Tools

Graphite Modeling Tools is a collection of Poly editing tools found in the Ribbon menu in 3ds Max. In Chapter 18, you used Poly editing tools found in the Modify panel after converting the windmill to an Editable Poly object. Graphite Modeling Tools have much of the functionality of the Modify panel editing, but also add an extensive set of tools for selecting and editing at subobject level.

In this introduction to Graphite Modeling Tools, you'll learn the process of accessing the Ribbon menu and working with some of the basic functions to get a feel for how the tools differ from the Modify panel Poly editing tools. Graphite Modeling Tools also make extensive use of tooltips to interactively help you through the options available.

You'll then edit your windmill building with Graphite Modeling Tools to create multiple windows in much the same way you created the door in Chapter 18, while being introduced to some of the unique workflow available in Graphite Modeling Tools.

Some of the topics covered in this chapter are as follows:

- *Introduction to Graphite Modeling Tools* – Learn some of the basic functions of accessing and applying Graphite Modeling Tools.
- *Graphite Modeling Tools workflow* – Use Graphite Modeling Tools to create multiple windows simultaneously in the windmill.

20.1 Introduction to Graphite Modeling Tools

Graphite Modeling Tools are located in the Ribbon menu and display differently depending on what objects are selected in the scene. For example, if you have no objects selected in the scene, the Graphite Modeling Tools options are grayed out. If you expand the Ribbon menu and then hover the cursor over the Graphite Modeling Tools tab in the Ribbon menu, a tooltip will appear explaining what you need to do to use the tools (see Figure 20-1).

FIG 20-1 Tooltips are available extensively throughout Graphite Modeling Tools.

If the selected object does not have an Edit Poly modifier or has not been converted to Editable Poly, then the options are available in the Graphite Modeling Tools for adding the modifier or converting the object. If the object has the Edit Poly modifier or is an Editable Poly object, then the full range of Graphite Modeling Tools is available in the Ribbon menu.

The Graphite Modeling Tools workflow is well suited to "organic" objects such as soft furniture or characters where a modifier-based or lofting workflow is not particularly appropriate. But because of the linear nature of editing with Graphite Modeling Tools, it is a good idea to carefully plan your approach to the creation process before starting any actual modeling. This planning process requires experience with the tools, so it is recommended that you begin using Graphite Modeling Tools by creating simple objects to familiarize yourself with as many options as possible before undertaking complex modeling tasks.

Exercise 20-1-1 Basic Graphite Modeling Tools Functions

1. Open the file from the website called Exercise 20-1-1_Graphite01.max. You will not keep any edits you make, so you don't need to save this file. In the Edit pull-down menu, choose Hold to save the file to the Hold buffer on your hard drive. In this exercise, you will not be actually making any permanent changes, so it is best to take the extra safety measure in case something gets changed by mistake and then is automatically saved. The scene is the windmill with just a few trees.

2. Right-click in the Perspective viewport to activate it and then select the Windmill001. The object has an Edit Poly modifier. In the Ribbon menu, double-click the Graphite Modeling Tools to expand the options (see Figure 20-2). Use the keyboard shortcut Alt+Q to isolate the selection and hide all of the other objects in the scene.

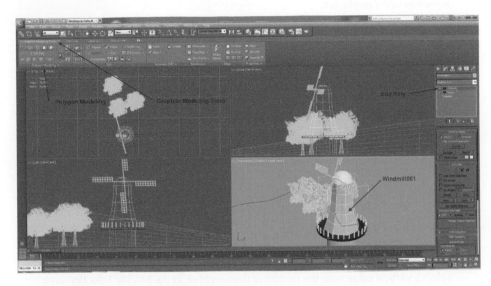

FIG 20-2 Full Graphite Modeling Tools options available for an object with an Edit Poly modifier.

3. In the Graphite Modeling Tools menu, Polygon Modeling area, click the Edge subobject button to toggle it on. In the Perspective viewport, select any vertical edge at the bottom of the windmill. The selected edge will turn red. In the Modify Selection area, hover the cursor over the Loop button. The tooltip appears explaining the functionality of Loop selection (see Figure 20-3). The Ribbon menu expands to show all of the available tools for editing at edge subobject level.

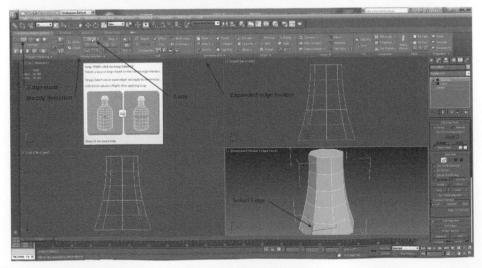

FIG 20-3 Loop selection options are a powerful tool in Graphite Modeling Tools.

4. Click the Loop button and you will see that the edges that are adjacent end to end are added to the selection set. The loop is terminated when there are no more adjacent edges or a sharp angle transition occurs (see Figure 20-4). This is faster and more reliable than using the Ctrl key to add individual edges to the selection set. You can also double-click on one edge to select the corresponding loop, making your selection task even faster.

FIG 20-4 Edges adjacent end to end form a loop.

5. In the Perspective viewport, click in an empty space to deselect all edges and then select a vertical edge near the middle of the windmill. In the Modify Selection area, click the Ring button. A ring of vertical edges belonging to adjacent polygons around the windmill is selected (see Figure 20-5).

FIG 20-5 Edges belonging to adjacent polygons form a ring.

6. In the Ribbon menu, Loops area, click the down arrow to the right of the Connect button and then choose Connect Settings (see Figure 20-6). Hovering the cursor over the button displays a tooltip explaining Connect Settings.

FIG 20-6 The Connect tool has a Connect Settings options similar to the Edit Poly modifier or Editable Poly object.

7. A Connect Edges caddy appears in the active viewport. Hover the cursor over a numeric field to highlight it and the name of the parameter will appear at the top of the caddy. You can preview the connect operations on the geometry (see Figure 20-7).

FIG 20-7 Parameters can be edited in the caddy numeric fields.

8. Three buttons at the bottom of the caddy accept the results, apply and continue the command on the currently selected edges, or cancel the operation (see **Figure 20-8**). Click the red X button on the right to cancel the operation.

FIG 20-8 Three different options for the caddy operation.

9. Use the keyboard shortcut Alt+Q to exit isolation mode. In the Polygon Modeling area, click the Edge subobject button to exit subobject mode. Close 3ds Max without saving the file. The workflow of Graphite Modeling Tools has some similarities with Editable Poly or Edit Poly modifier, but there are many more options for selecting and editing at subobject mode.

Let's use Graphite Modeling Tools to create multiple windows around the middle of the windmill.

20.2 Graphite Modeling Tools Workflow

The best workflow for Graphite Modeling Tools is to use the Settings options for tools when it is available. This opens the appropriate caddy containing the parameter numeric fields and other options. As you change the parameters, you will see the edits appear on the geometry in your scene and then you can either accept the edits as is, apply the edits and continue editing, or cancel the operation. Again, the workflow for Graphite Modeling Tools is linear and you need to be sure that the edits you are performing are correct before continuing, as it is rather difficult to undo multiple steps without destroying the entire work history.

In Exercise 20-2-1, you will work at Polygon subobject level to select every other polygon around the middle of the windmill, and then use the Inset, Extrude, and Bevel options to create three windows simultaneously.

Exercise 20-2-1 Create Windmill Windows

1. Start 3ds Max, and then open the 3ds Max file from the website called Exercise 20-1-1_Graphite01.max and save it to an appropriate folder on your hard drive with a new incremental name. In the Perspective viewport, select the Windmill001 and then use Alt+Q to isolate the selection.
2. In the Ribbon menu, Polygon Modeling area, click the Polygon button to access Polygon subobject mode. In the Perspective viewport, use the Ctrl key to select two adjacent horizontal polygons in the middle of the windmill (see Figure 20-9).

FIG 20-9 Select two adjacent polygons to indicate a horizontal loop direction.

3. In the Ribbon menu, Modify Selection area, click the Dot Loop button. Dot Loop selects every other polygon in the polygon loop in the direction indicated in the previous step (see Figure 20-10). On more complex geometry, this can save significant time when selecting every other polygon by avoiding the process of arc rotating around the geometry as you build your selection set.

FIG 20-10 Dot Loop selects, by default, every other polygon in the direction indicated.

> **Note**
>
> The Dot Loop command can be adjusted to skip any number of polygons between selected polygons, for example, you could choose to select every fourth polygon in a loop.

4. In the Ribbon menu, Polygons area, click the Inset down arrow and choose Inset Settings to open the caddy in the Perspective viewport. In the Amount numeric field, enter **0'6"** and then press Enter to preview the result (see Figure 20-11). Each polygon is inset from its edges to create new polygons that will define the window frame. Click the OK (green check) button to accept the results.

FIG 20-11 Inset the selected Polygons by 6 inches to form window frames.

5. In the Polygons area, access Extrude Settings and then enter **–0'6"** in the Height numeric field to extrude the polygon inward. Click the OK button to accept the results (see Figure 20-12).

FIG 20-12 Extrude the selected polygons inward to create a window.

6. Using the control key, select the two adjacent polygons that make up the frame for one window, and then click the Loop button in Modify Selection area to select the other two window frame polygons. In the Ribbon menu, click on Modify Selection to open the drop-down menu and then click the Similar button (see Figure 20-13). This will select the window frame polygons for the other windows.

FIG 20-13 Complex selection sets can be easily built in Graphite Modeling Tools.

7. Use the Extrude Settings tools to extrude the selected polygons **0'2"**. Use the Bevel Settings tools to enter **0' 0 1/2"** in the Height numeric field and then enter **−0' 0 1/2"** in the Inset numeric field (see Figure 20-14). Click the OK button to finalize the Bevel operation. The Bevel operation creates a chamfered edge around the window frame to catch the light.

FIG 20-14 Extrude and then Bevel the window frame polygons.

8. Exit subobject editing mode and then use Alt+Q to exit Isolate Selection mode. Save the file, it should already be called Exercise 20-1-1_Graphite02.max. Although there are many, many options to be explored in Graphite Modeling Tools, this simple exercise has provided you with an overview of the basic workflow.

Graphite Modeling Tools provide powerful options for selecting and editing at subobject level of Poly objects. The windows in Exercise 20-2-1 could have been created in the Edit Poly modifier or Editable Poly Modify panel tools, but there would have been many more manual steps involved.

Experiment with simple Poly objects and investigate as many of the tools as you possibly can to see how they function and interact with each other.

Compound Objects

Compound Objects in 3ds Max are tools, not physical objects in the sense of a Standard primitive, for example. Compound Objects use two or more existing objects, 2D or 3D, and combine them to edit the form of one or the other into a new single object. In Chapter 9, you used the Compound Object tool called Lofting to create a complex 3D object from 2D shapes.

Compound Objects provide editing tools with options that are not readily available in other 3ds Max tools by using 2D or 3D geometry as part of the tool itself. Because Compound Objects in 3ds Max are in some way combining 3D surfaces, the resulting object can be complex and memory intensive to keep track of the original objects being used. There is also a moderate chance that the tool will fail because 3ds Max works only with surface information and not volume information, as in CAD software performing similar functions.

Some of the topics covered in this chapter are as follows:

- *ProBoolean* – ProBoolean compound object is used to combine two 3D objects, subtract one 3D object from another 3D object, or calculate the intersecting area of two 3D objects.
- *ShapeMerge* – It "cuts" a 2D shape into the surface of a 3D object to define new edges and polygons.
- *Scatter* – The Scatter tools randomly distribute clones of one object over the surface of another.

21.1 ProBoolean Compound Object

Compound Objects in 3ds Max are located in the Create panel, Standard Primitives drop-down list. In this section, you'll focus your attention on the ProBoolean compound object type. ProBoolean allows you to create compound 3D objects from multiple 3D objects. The types of Boolean operations available are Union, Intersection, Subtraction, Merge, Attach, and Insert. The following exercise will use the Subtract option to delete a box that represents a keyway for a millstone to help you learn the workflow of ProBoolean.

You will notice in the Object Type rollout that there is also a button for Boolean. This is an older form of 3ds Max Boolean operations that have been left in the program so that older files that used Boolean would still be compatible with newer versions. You should always use ProBoolean, as it is more reliable and efficient.

In Exercise 21-1-1, you will find an object called Mill_stone001 that was created from a 2D Donut with a Bevel modifier applied, and then converted to Editable Poly. The modeler forgot to add a keyway, which is a notch cut from the interior of the millstone that would keep it from slipping on its shaft as the shaft turned.

You will use ProBoolean to subtract a box called Mill_stone_keyway001 that is already positioned correctly. You'll then learn to edit the size of the keyway in the new compound object created by ProBoolean.

Exercise 21-1-1 Cut a Keyway from a Millstone

1. Open the file from the website called Exercise 21-1-1_Compound objects01.max and then save it to an appropriate folder on your hard drive with a new incremental name. The windmill scene now contains a millstone, a keyway, and a 2D shape defining the banks of a canal. Use the keyboard shortcut H to open the Select From Scene dialog and then double-click the Mill_stone001 object in the list to select it. This is operand 1. Click the Zoom Extents All Selected button to fill all viewports with the millstone and the keyway (see **Figure 21-1**).

FIG 21-1 The millstone has a keyway already in position.

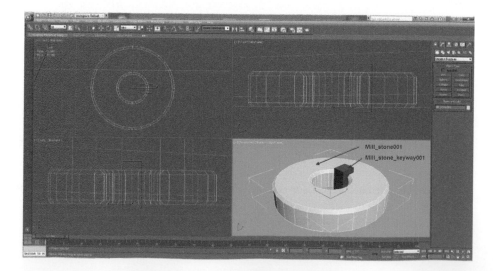

2. In the Create panel, click the Standard Primitives drop-down list and choose Compound Objects. In the Object Type rollout, click the ProBoolean button. In the Pick Boolean rollout, click the Start Picking button. In the Perspective viewport, click on Mill_stone_keyway001. This is operand 2 (see **Figure 21-2**). The keyway will disappear and its volume that was overlapping the millstone is cut away. Click the Start Picking button again to toggle it off.

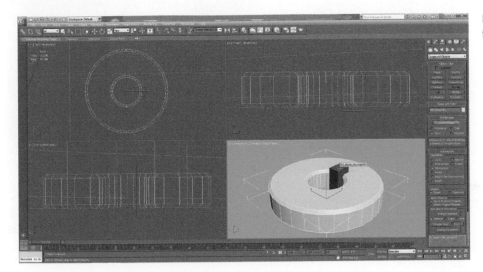

FIG 21-2 Subtract the keyway from the millstone.

3. In the Modify panel, stack view, expand ProBoolean and then highlight Operands. In the Parameters rollout, highlight 1:Subtr-Mill_stone_keyway001 (see **Figure 21-3**). The original object type Box for the keyway appears now at the bottom of the stack view.

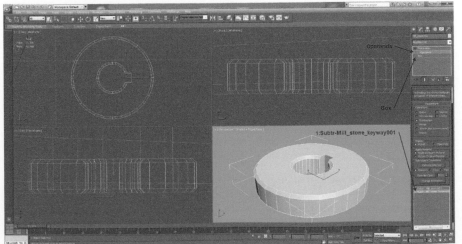

FIG 21-3 Operands can be accessed in Modify panel, stack view.

4. In the Modify panel, stack view, highlight Box. In the Parameters rollout, enter **1'0"** in the Width numeric field and then press Enter. The keyway will be cut deeper into the millstone (see **Figure 21-4**). In the Modify panel, stack view, highlight ProBoolean at the top of the stack to exit operand editing mode.

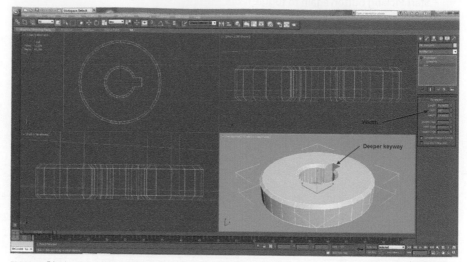

FIG 21-4 Edit the operand parameters to affect the Boolean operation.

5. Click in an empty space in any viewport to deselect all of the objects and then use Zoom Extents All Selected to fill all viewports with all objects in the scene. It should already be called Exercise 21-1-1_Compound objects02.max.

ProBoolean is a very powerful tool when other options to perform the same editing are not available or practical, but remember that Boolean operations are memory intensive because 3ds Max must keep track of all of the operands and all of the operations.

Let's have a look at another similar Compound Object that cuts 2D shapes into 3D surfaces to define new edges and polygons.

21.2 ShapeMerge Compound Object

ShapeMerge projects a 2D shape into a 3D surface to define new polygons and edges. Once the new edges and polygons are defined, they can be selected and edited as any other selection set. In Exercise 21-2-1, you will use ShapeMerge to project a rectangle shape into the surface of the landscape to cut the edges for a canal.

The first object to be selected during a ShapeMerge operation is the 3D surface to be cut. The ShapeMerge compound object is applied and then you must pick the 2D shape in the scene to define the cut in the surface.

As soon as a ShapeMerge operation is complete and you select the new polygons, you should use Named Selection Sets so that you may easily retrieve the selected polygons later.

Exercise 21-2-1 Create a Canal

1. Open the file from the previous exercise called Exercise 21-1-1_Compound objects02.max and save it to an appropriate folder on your hard drive with a new incremental name. In the Top viewport, select the Landscape001 object. You will notice that the rectangle in the scene shows many vertices. Having sufficient vertices is important to increase the reliability of the ShapeMerge operations (see **Figure 21-5**).

FIG 21-5 The 3D surface to be cut is selected before performing ShapeMerge.

> **Note**
>
> The rectangle was edited at Segment subobject level with the Divide command to add extra vertices along the long edges. The vertices are then displayed in the viewport by changing the Object Properties to enable Show Vertex Ticks. The rectangle has also been moved slightly below the landscape because it will be projected in the positive local z-axis direction and this ensures that it will "see" the entire surface.

2. In the Create panel, Geometry category, Compound Objects list, Object Type rollout, click the ShapeMerge button. In the Pick Operand rollout, click the Pick Shape button (see **Figure 21-6**).

FIG 21-6 Use the Pick Shape button to select the 2D shape in the scene that you want to cut into the 3D surface.

3. In the Top viewport, pick the shape called canal_edge001. You might see new white edges appear on the surface of the landscape and the shape name is added to the Operands list, but otherwise there is little to indicate the operation was successful (see Figure 21-7). Click the Pick Shape button to toggle it off.

FIG 21-7 Pick the 2D shape you want to merge into the surface and it is added to the Operands list.

4. In the Modify panel, Modifier list, choose Edit Poly modifier. In the Modify panel, stack view, expand Edit Poly and then highlight Polygon subobject level. The newly defined polygons will turn red to indicate they are selected. In the main toolbar, Named Selection Sets field, enter **canal** and then press Enter (see Figure 21-8). This ensures that you will be able to reselect the polygons when you are in subobject Polygon level in this modifier.

FIG 21-8 Save the newly defined polygons in a Named Selection Set.

5. In the Modify panel, Edit Polygons rollout, click the Settings button for Extrude to open the caddy in the active viewport. Enter **–20'0"** in the Height numeric field. This extrudes the new polygons downward to form a canal (see Figure 21-9). Click the OK button in the caddy to finalize the operation.

FIG 21-9 Extrude the selected polygons downward to form a new canal.

6. In the Modify panel, stack view, highlight Edit Poly to exit subobject mode. Save the file. It should already be called Exercise 21-1-1_Compound objects03.max. The ShapeMerge compound object enables you to define new polygons sets by projecting 2D shapes into 3D surfaces.

Let's learn about one more Compound Object called Scatter that can be used to distribute objects over a surface.

21.3 Scatter Compound Object

Scatter compound object is used to distribute clones of an object over the surface of another object in a random pattern. You first select the 3D objects that you want to scatter and then choose the surface that you want to use as a Distribution object, i.e., the surface over which other objects will be scattered. The Distribution object is then hidden, leaving you with just the newly scattered objects visible in the Scatter compound object.

To scatter objects over selected polygons of a surface, you need to first select the polygons at subobject level before using the Scatter compound object.

In Exercise 21-3-1, you will create a small orchard of trees over a few selected polygons of the landscape.

Exercise 21-3-1 Create an Orchard

1. Open the 3ds Max file from the previous exercise called Exercise 21-1-1_Compound objects03.max and save it to an appropriate folder on your hard drive with a new incremental name. In the Top viewport, select the object called Tree_decid01 and then use Zoom Extents All Selected to fill all viewports with the object. Use the mouse wheel to zoom out to see some of the surrounding landscape.
2. In the Top viewport, select the Landscape001 object. In the Modify panel, stack view, highlight Polygon subobject level. Select a polygon next to the trees and then hold the Ctrl key and add two more polygons to the selection set (see Figure 21-10). In the Modify panel, stack view, highlight Edit Poly modifier to exit subobject mode.

FIG 21-10 Select landscape polygons where you want to scattered trees.

3. In the Top viewport, select the tree again. In the Create panel, Geometry category, Compound Objects list, Object Type rollout, click the Scatter button. In the Pick Distribution Object rollout, click the Pick Distribution Object button and then pick

the landscape object in the Top viewport. The landscape will appear to change color, but you are now seeing the distribution object that has been created and the tree has moved to the middle of the landscape (see Figure 21-11).

FIG 21-11 A new distribution object is created over the landscape and a single tree is "scattered."

4. In the Scatter Objects rollout, Source Object Parameters area, enter **4** in the Duplicates numerical field. This scatters four trees randomly over the distribution object, but you only want trees scattered over the selected polygons in the earlier step. In the Scatter Objects rollout, Distribution Object Parameter area, check the Use Selected Faces Only option and then the four trees are scattered over the selected polygons (faces) (see Figure 21-12).

FIG 21-12 Check Use Selected Faces Only to scatter the trees on the previously selected polygons.

5. Expand the Display rollout and check the Hide Distribution Object option. This hides the distribution object that was derived from the landscape surface, so that it will not interfere with rendering (see Figure 21-13).

FIG 21-13 It is important to remember to hide the distribution object to prevent it from rendering.

6. In the main toolbar, click the Select Object button to exit Scatter compound object. Click in an empty space in any viewport to deselect all objects and then click Zoom Extents Selected All. Save the file. It should already be called Exercise 21-1-1_ Compound objects04.max. The four new trees are treated as a single compound object.

This is an introduction to just a few of the Compound Objects available in 3ds Max, but ProBoolean, ShapeMerge, and Scatter are some of the more commonly used in general production.

Practice using each Compound Object you have learned in this chapter on simple scenes, so that the workflow becomes ingrained in your memory. The order in which you performed the steps of each Compound Object is important.

Exterior Daylight

A Daylight System in 3ds Max has several functions, such as simulate direct daylight and cast shadows, simulate light bounced in the atmosphere, and position the light based on location, date, and time.

You begin by placing a "compass" by clicking and dragging in the middle of your landscape in the Top viewport, which can then be adjusted to determine the direction of North based on your location on earth. You then move the mouse to create a light source consisting of Sun and Skylight that will illuminate the scene and cast shadows, and then click to set its position. Another part of the Daylight System, which is automatically added, is an animation controller that allows you to enter a geographic location and date and time information for accurate shadows.

An important role of the Daylight System is to cast accurate shadows that provide visual contrast and "anchor" your objects to the surface they sit on for a more convincing scene.

An exterior daylight scene in 3ds Max is certainly not convincing if the sky is black, so you'll learn to place an mr Physical Sky map in the 3ds Max environment to provide accurate background color for your scene. The mr Physical Sky map automatically adjusts its color and intensity based on the date and time of day, and the location of the Sun, such as dawn, high noon, or evening's golden hour in the scene.

Some of the topics covered in this chapter are

- *Daylight System* – Daylight System is not a light per se but is a system of components used to simulate daylight in 3ds Max scenes.

- *Introduction to Shadows* – Shadows are import elements in rendered scenes that add visual depth and "weight" to objects.
- *mr Physical Sky* – mr Physical Sky is a special map type that calculates environmental sky backgrounds for your scenes.

22.1 Exterior Daylight

Exterior daylight is simulated with the Daylight System found in Create panel, Systems category. Daylight System is a physically accurate source of light for calculating light intensities and shadows for any place on earth at any date and time.

It is called a Daylight System because it consists of multiple components: the compass defining the North direction; the light sources, Sun and Skylight; and the animation controller for adjusting the position of the Sun in the sky.

Because you are using the mental ray renderer, you will switch from the default light types to the appropriate light sources called mr Sun and mr Sky, which simulate physically correct daylight. Daylight is extremely bright so to compensate that you are prompted to enable mr Photographic Exposure Control that will allow you to regulate the amount of light reaching the renderer. You have already had experience with exposure control in Chapter 10.

Let's place a Daylight System in the windmill scene from the previous chapter, and then adjust some Daylight parameters and the position of the Sun in the sky.

Exercise 22-1-1 Create a Daylight System

1. Open the file from the website called Exercise 22-1-1_Daylight01.max and then save it to an appropriate folder on your hard drive with a new incremental name. The windmill scene is currently using the default lighting in 3ds Max and needs a Daylight System to be more convincing. Right-click in the Top viewport to activate it.
2. In the Create panel, Systems category, Object Type rollout, click the Daylight button. You are prompted in the Daylight System Creation dialog to use mr Photographic Exposure Control set to an exposure value of EV = 15 (see **Figure 22-1**). Click the Yes button to add mr Photographic Exposure Control.

FIG 22-1 Daylight is found in the Systems category of the Create panel.

Note

There is also a system called Sunlight, which is an older version to be used with the Scanline renderer.

3. In the Top viewport, left-click in the middle of the landscape and drag the cursor slowly to see a gray compass rose appear. When the compass rose is slightly larger than the landscape, release the left mouse button and move the mouse forward on the mouse pad. This moves the Sun and Skylight components away from the landscape (see Figure 22-2). Left-click in the viewport to set the position of the light sources. The size of the compass rose and the distance of the lights from the landscape are not particularly important.

FIG 22-2 Creating a Daylight System is a multistep process.

Note

It sometimes takes a bit of practice to create the compass rose as it can resize quickly as you move the cursor. If you are not happy with your initial result, for example, the compass seems too large or small, use the keyboard shortcut Ctrl+Z to undo the step and then try again.

4. Save the file. It should already be called Exercise 22-1-1_Daylight02.max. The Sun and Skylight components are in place, and the compass rose is indicating the direction of North. The mr Photographic Exposure Control has been added during the process to adjust the amount of light used by the mental ray renderer to compensate for the brightness of daylight.

Let's adjust some of the Daylight parameters to change the default light types from Standard lights to Photometric mental ray lights. This will provide physically correct lighting for your outdoor scene.

Exercise 22-1-2 Adjust Daylight Parameters

1. Open the file from the previous exercise called Exercise 22-1-1_Daylight02.max and then save it to an appropriate folder on your hard drive with a new incremental name. Select Daylight001 in any viewport. In the Modify panel, Daylight Parameters rollout, click the Sunlight drop-down list and choose mr Sun. In the Skylight drop-down list, choose mr Sky. In the mental ray Sky dialog, you are prompted to add an mr Physical Sky environment map (see **Figure 22-3**). Click the Yes button to add the map to the environment. The drop-down list will change from Skylight to mr Sky. Let's create a camera in the scene.

FIG 22-3 Changing the default Skylight to mr Sky prompt you to add mr Physical Sky map to the environment.

2. Right-click in the Top viewport to activate it, and then in the Create panel, Cameras category, Object Type rollout, click the Target button. In the Top viewport, click near the cluster of four trees and drag to the center of the windmill, and then release the mouse button to create the camera target (see **Figure 22-4**).

FIG 22-4 Create a target camera in the Top viewport.

3. Right-click in the Perspective viewport to activate it, and then use the keyboard shortcut C to switch the viewport to a Camera001 viewport. Click the Truck Camera navigation buttons at the lower right of the display, and then click and drag downward in the Camera001 viewport. In the Modify panel, Parameters rollout, Stock Lenses area, click the 28 mm button to provide a wider angle lens (see **Figure 22-5**). Your scene may not be exactly the same as the image.

FIG 22-5 Adjust the Camera001 viewport for a view of the windmill.

4. In the main toolbar, click the Render Production button at the far right. The Render Frame window will show a scene flooded with sunlight with objects casting shadows, but there is a gray area below the mr Physical Sky background, which you will adjust in Exercise 22-1-3 (see **Figure 22-6**).

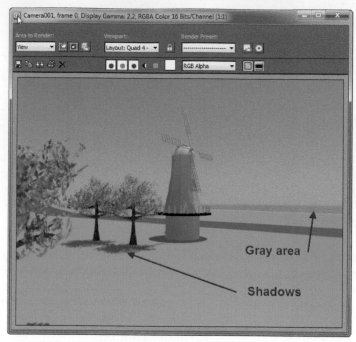

FIG 22-6 The rendered scene has sunlight, shadows, and a sky background.

5. Close the Render Frame window, and then save the file. It should already be called Exercise 22-1-1_Daylight03.max. Placing a Daylight System may require a bit of practice the first few times you try it, but it soon becomes an easy process. When using the mental ray renderer, it is usually best to use mr Sun and mr Sky as the light source options. You are automatically prompted for the mr Physical Sky, which renders as a blue sky background by default.

Let's learn to adjust the position of the Sun to simulate Amsterdam, Netherlands, on the first day of summer.

Exercise 22-1-3 Adjust Daylight Position

1. Open the file from the previous exercise called Exercise 22-1-1_Daylight03.max, and then save it to an appropriate folder on your hard drive with a new incremental name. Select Daylight001 in any viewport. You cannot move this object with the Select and Move tool because of the special animation controller assigned as a part of the Daylight System. In the Motion panel, Control Parameters rollout, you'll see the animation controller parameters that let you adjust the location, date, and time you want the Daylight System to simulate (see **Figure 22-7**).

FIG 22-7 The position of a Daylight System is adjusted in the Motion panel.

2. In the Control Parameters rollout, Time area, enter **10** to change the time to 10:00 in the morning. The date is set to the first day of summer in the current year. In the Location area, click the Get Location button. In the Geographic Location dialog, Map drop-down list, choose Europe. In the City area, choose Amsterdam, Netherlands, in the list (see Figure 22-8). Click the OK button.

FIG 22-8 Change the time of day and location for accurate Sun positioning.

3. Right-click in the Camera001 viewport to activate it, and then click the Render Production button in the main toolbar. In the Render Frame window, you will see that the shadows are longer due to the earlier time and the Sun is positioned differently due to the new location (see **Figure 22-9**).

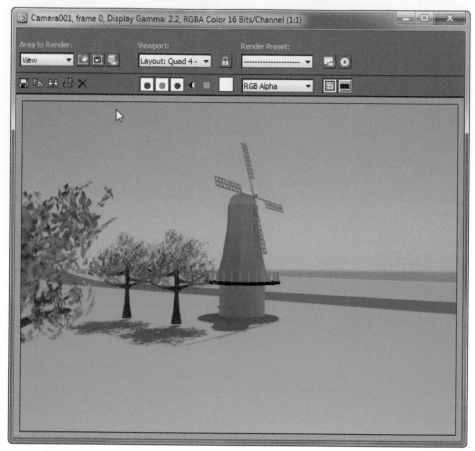

FIG 22-9 The rendered image shows a change in shadow angle and lighting.

4. Close the Render Frame window and then save the file. It should already be called Exercise 22-1-1_Daylight04.max. The Daylight System light sources cannot be moved manually by default but can be adjusted in the Motion panel with the animation controller parameters.

The animation controller parameters are based on U.S. Navy astronomical data and are extremely accurate. Let's take a look at some of the shadow options available for Daylight System with mr Sun and mr Skylight sources.

22.2 Introduction to Shadows

Shadows have a very important role in making any scene convincing to the viewer, but this is especially important for exterior daylight scenes. Without shadows, objects might appear to float above the surfaces they are sitting on and scenes lack visual contrast critical to a convincing rendered image.

The default setting is to have the Sun source cast shadows by default, but disabling them can sometimes significantly speed test rendering. For more accurate shadows, there are also different shadow types that you'll have a look at in Exercise 22-2-1.

Exercise 22-2-1 Daylight Shadows

1. Open the file from the previous exercise called Exercise 22-1-1_Daylight04.max and save it to an appropriate folder on your hard drive with a new incremental name. Select Daylight001 in any viewport. In the Modify panel, mr Sun Basic Parameters rollout, clear the On checkbox in the Shadows area. Right-click in the Camera001 viewport and then click the Render Production button (see **Figure 22-10**). This simple scene renders faster (3 seconds faster on the author's machine), but the objects appear to be floating above the landscape without shadows. Check the On checkbox to enable the shadows again.

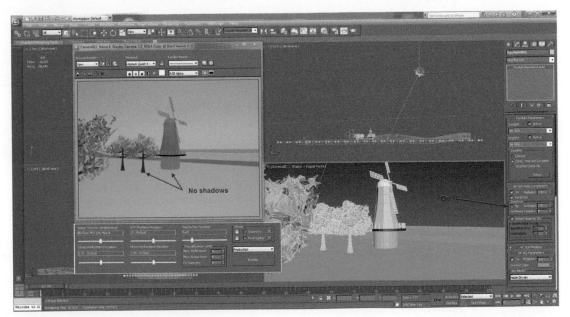

FIG 22-10 Shadows can be disabled for faster test renders.

2. mr Sun and mr Sky use Raytrace shadows, which have hard sharp edges. In the mr Sun Basic Parameters rollout, Shadows area, enter **10** in the Softness numeric field and then enter **5** in the Softness Samples numeric field. This more closely simulates

the Sun on a partly cloudy day by blurring the edges of the shadows somewhat. Render the Camera001 viewport to see the result (see Figure 22-11).

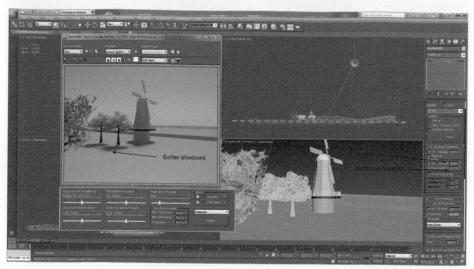

FIG 22-11 Softer shadows simulate sunlight on a partly cloudy day.

3. Close the Render Frame window and then save the file. It should already be called Exercise 22-1-1_Daylight5.max. Shadows are important for a convincing rendered image, but in a complex scene with many objects shadows can add significantly to render times.

Let's adjust the mr Physical Sky to eliminate the gray horizon line.

22.3 mr Physical Sky

mr Physical Sky is a special type of map in 3ds Max, which does not get applied to surfaces but is used in the rendering environment to simulate the sky in daylight scenes. The sky is calculated to be deep blue directly overhead, becoming somewhat hazier toward the horizon to simulate the effect of denser atmosphere.

The horizon of mr Physical Sky does not necessarily correspond to the horizon of your camera view and landscape. Let's adjust the mr Physical Sky horizon position in the next exercise.

Exercise 22-3-1 Adjust mr Physical Sky

1. Open the 3ds Max file from the previous exercise called Exercise 22-1-1_Daylight05. max and save it to an appropriate folder on your hard drive with a new incremental name. Activate the Camera001 viewport and render it to refresh your memory of the gray horizon line (see Figure 22-12).

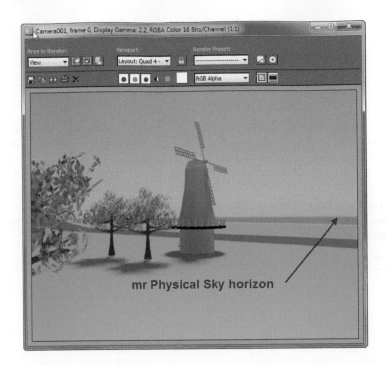

mr Physical Sky horizon

FIG 22-12 The mr Physical Sky horizon does not match the landscape horizon from this camera view.

2. In the Modify panel, mr Sky Advanced Parameters rollout, Horizon area, enter **−0.5** in the Height numeric field. Negative numbers move the horizon downward. Render the Camera001 viewport and you should see that the gray line has disappeared below the landscape horizon (see **Figure 22-13**).

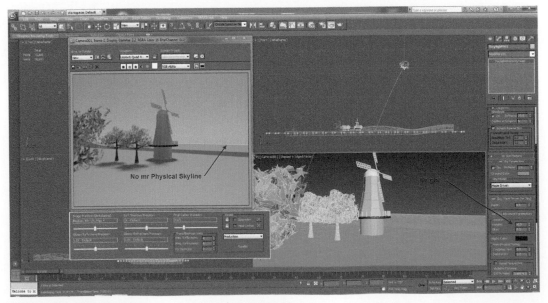

FIG 22-13 The mr Physical Sky horizon can be adjusted up or down as necessary.

Note

Due to a difference in your camera adjustments, you may need to use a slightly different value in the Height numeric field to adjust your particular mr Physical Sky horizon.

3. Save the file. It should already be called Exercise 22-1-1_Daylight05.max. When first learning to use mr Physical Sky, it is easy to overlook the horizon position and not notice it until the client points it out.

Creating and adjusting a Daylight System is relatively easy once you have done it once or twice. Two important aspects to remember are that you modify the quality of the light in the Modify panel and then you adjust the position of the light in the Motion panel.

More Materials

Some of the topics covered in this chapter are

- *More about the Arch & Design material* – Learn more techniques toward making convincing materials.
- *Substance maps* – 3ds Max Substance maps are powerful parametric maps.
- *Material libraries* – Create material libraries to store materials so that they can be available to other 3ds Max scenes.

23.1 More on Arch & Design Material

Arch & Design materials in 3ds Max are a productive option for use with the mental ray renderer. You have learned the fundamentals of creating and assigning Arch & Design materials to objects in the scene, with a map applied as a pattern and several of the parameters adjusted. In this chapter, you'll learn to add to the complexity by combining map patterns within map patterns for multiple levels of flexibility.

You'll create a landscape material by applying a Noise map to the material's Diffuse Color Map slot. This Noise map will be a "container" to hold two other maps to give the landscape its color. You will first adjust the Noise map pattern and then add the subsequent maps to replace the black and white pattern. Finally, you will adjust the original Noise map parameters for a smoother transition between color maps.

Exercise 23-1-1 Create a Landscape Material

1. Open the file from the website called Exercise 23-1-1_Materials01.max and then save it to an appropriate folder on your hard drive with a new incremental name. This is the windmill scene with a water surface added in the canal. All objects have object color at this point and you need to begin to assign materials. In the main toolbar, click the Material Editor button to open the Slate Material Editor. Right-click in the View1 pane and then choose Materials, mental ray, Arch & Design material (see **Figure 23-1**). This creates a new node in the View1 window.

FIG 23-1 Create a new Arch & Design material node in the Slate Material Editor.

2. Double-click the material node heading to open its parameters in the Edit pane. Rename the material as Landscape. In the Main Material Parameters rollout, Reflection area, set the Reflectivity and Glossiness to **0.0**. Click and drag from the Output button on the right side of the material node to the landscape in the scene (see **Figure 23-2**). Release the mouse button to assign the material.

3. In the Slate Material Editor, View1 pane, right-click, and then choose Maps, Standard, Noise. Click and drag from the Noise map Output button to the Landscape material, Diffuse Color Map Input button. Double-click the Noise map heading to open its parameters in the Edit pane (see **Figure 23-3**). The Noise map is a random pattern using black and white as the default colors.

FIG 23-2 You can assign a material by dragging from its Output button to the object in any viewport.

FIG 23-3 Connected a Noise map to the material's Diffuse Color Map slot.

4. In the Noise Parameters rollout, Noise Threshold area, enter **0.5** in the High numeric fields, and then enter **0.49** in the Low numeric field. Right-click in the Camera001 viewport and then click the Render Production button in the main toolbar to render the scene (see Figure 23-4). The pattern renders as a hard-edged black and white random pattern. The closer the High (maximum = 1.0) and Low (minimum = 0.0) threshold numbers are to each other, the harder the edge between the colors. This pattern allows you to clearly see the distribution of the color areas so that they may be adjusted for size. The pattern is a bit small so you will adjust it in the next step.

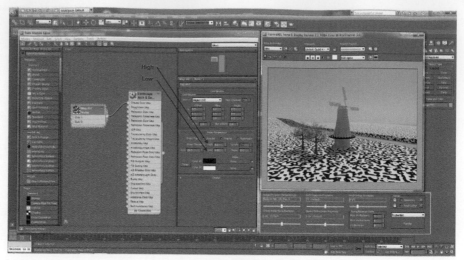

FIG 23-4 Adjust the Noise map to have a hard edge between colors.

> **Note**
>
> This randomly generated pattern is set in the Coordinates rollout to use Object xyz coordinates, which means it needs no other mapping coordinates to project onto the surface. This procedural map is also calculated at render time and won't display correctly in the viewports so the scene must be rendered for an accurate representation of the map pattern.

5. In the Noise Parameters rollout, enter **75.0** in the Size numeric field and then press Enter. Use the Render button in the Render Frame window to render the Camera001 viewport again to see that the pattern is larger. The black and white is not an appropriate landscape color so let's add patterns within the black and white areas with other maps using the appropriate colors.
6. In the Slate Material Editor, right-click to the left of the Noise map and then choose Maps, Standard, Noise. Connect the Output button of the new Noise map to the Input button of Color 1 in the original Noise map. Double-click on the new Noise map heading (the map border will turn dotted) to open its parameters in the Edit menu. In the Noise Parameters rollout, click the Color #1 color swatch and then in the Color Selector, change the color to dark green. Click the Color #2 color swatch, and then change the color to light green (see **Figure 23-5**). Click OK in the color selector to close it. Render the Camera001 viewport and you will see that you now have a pattern of mottled green and solid white.
7. In the Slate Material Editor, right-click below the green Noise map and then choose Maps, Standard, Speckle. A Speckle map is black dots on a white background by default. Connect the Output of Speckle to the Input of Color #2 in the original Noise map. This substitutes the white areas with a Speckle map. Double-click the Speckle map to open its parameters in the Edit pane. Change the Speckle map Color #1 to yellow and Color #2 to dark brown. Render the Camera001 viewport (see **Figure 23-6**). In the Color Selector, click the OK button to close it. You now have a mixed pattern of greens and browns, but the hard edge between the patterns is unconvincing. Let's fix that.

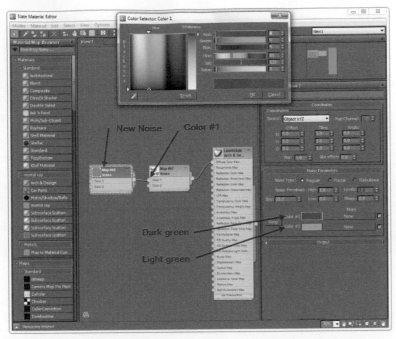

FIG 23-5 Create a new Noise map for Color #1 with dark green and light green colors.

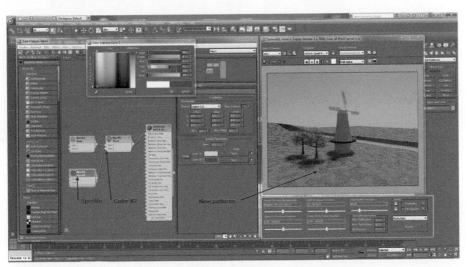

FIG 23-6 Substitute the white areas of the original Noise map with brown and yellow Speckle map.

8. Double-click on the original Noise map heading to open its parameters in the Edit menu. In the Noise Parameters rollout, Noise Threshold area, enter **0.75** in the High numeric field and then enter **0.35** in the Low numeric field. This softens the edge between the colors of the original map. Render the Camera001 viewport and you will see a more convincing random pattern of earth and plant colors (see **Figure 23-7**).

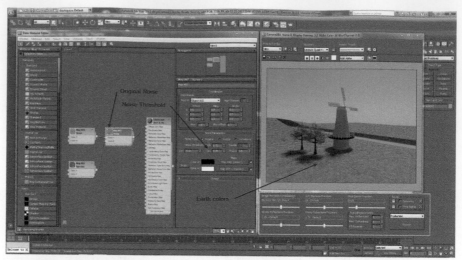

FIG 23-7 Readjust the original Noise map Threshold parameters for a softer edge.

9. Close all windows and dialogs and then save the file. It should already be called Exercise 23-1-1_Materials02.max. Maps can be nested to any depth for more complex patterns. Experiment with the parameters associated with the Noise and Speckle maps, especially the color combinations, to try a variety of landscape colors.

As always, keep in mind that the lessons throughout this book are intended to show you how 3ds Max concepts can be worked into a production workflow and not to show you "the" method of creating landscape materials. The lesson here is that you can combine maps within maps to add layers of flexibility in designing materials.

Let's use an Arch & Design material template to create water for the canal in the scene.

Exercise 23-1-2 Create a Water Material

1. Open the file from the previous exercise called Exercise 23-1-1_Materials02 .max and then save it to an appropriate folder on your hard drive with a new incremental name. Open the Slate Material Editor and then right-click on View1 and choose Create New View in the menu (see **Figure 23-8**). In the Create New View dialog, enter Water in the name field and then click OK to create the new view and make it the active view. Views are a method of separating materials for better organization.
2. Right-click in the Water view and create a new Arch & Design material. Double-click the material node heading to open its parameters in the Edit window. Rename the material Water. Assign the new material to the Water001 plane in the canal.
3. In the Templates rollout, click the Select a Template drop-down list and then choose Water, Reflective surface. When you hover the cursor over an option in the drop-down list, a description of the material appears at the upper left (see **Figure 23-9**). This adds a special map called Ocean and connects it to the Water Bump slot.

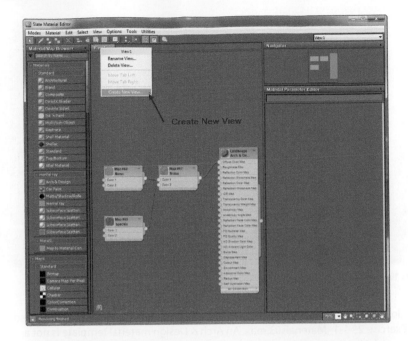

FIG 23-8 Create a new View in the Slate Material Editor for better organization.

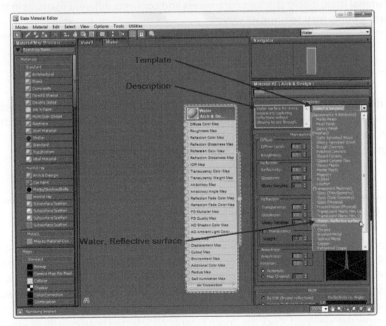

FIG 23-9 Load an Arch & Design material template for water with a reflective surface.

4. Double-click the Ocean map in the Water view to open the Ocean Parameters in the Edit pane. There are many parameters that can be adjusted to affect the size and type of waves for the water material. In the Camera001 viewport, use the Orbit Camera navigation buttons for a view down the canal and then render the Camera001 viewport (see Figure 23-10). The water surface is a dark green color, reflective, with small wavelets on the surface.

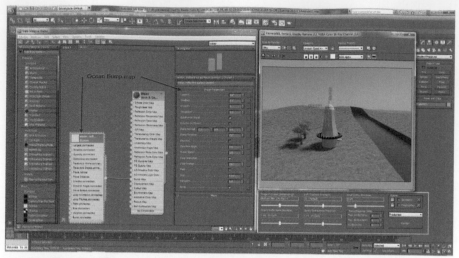

FIG 23-10 A special Bump map creates wavelets for the water template.

5. Close all Windows and dialogs and then save the file. It should already be called Exercise 23-1-1_Materials03.max. An Arch & Design material template is not a material itself; it only changes parameters and connects different maps, as in this case a Bump map to simulate waves.

23.2 Substance Maps

A powerful type of map in 3ds Max is the Substance map. A Substance map is a special programming routine that can be connected to multiple slots in a material to provide you with a variety of adjustable parameters. In this section, you will use one of the preprogrammed Substance maps to create a material for the millstone in the scene.

Exercise 23-2-1 Create a Stone Material

1. Open the 3ds Max file from the previous exercise called Exercise 23-1-1_Materials03 .max and save it to an appropriate folder on your hard drive with a new incremental name. Select the object in any viewport called Mill_stone001 and then use the keyboard shortcut Alt+Q to isolate the selection. Activate the Camera001 viewport and then use the keyboard shortcut P to switch from a Camera viewport to a Perspective viewport. Click the Zoom Extents All Selected button to fill all viewports with the millstone (see **Figure 23-11**).

2. Open the Slate Material Editor and then create a new view called Stone. Right-click in the Stone view and choose a new Arch & Design material from the menus. Right-click to the left of the material node and in Maps, Standard, choose Substance. Double-click on the new map heading to open its parameters in the Edit pane (see **Figure 23-12**).

FIG 23-11 Select and isolate the Mill_stone001.

FIG 23-12 Open a Substance map and then make it active in the Edit pane.

3. In the Substance Package Browser rollout, click the Load Substance button. In the Textures folder, choose Granite_02.sbsar (see **Figure 23-13**). This loads a map definition file into the Substance map.

4. In the new Substance map, connect the Diffuse Output button to the material's Diffuse Color Map Input button. Connect the Substance map Bump Output button to the material's Bump Map Input button. A new appropriate map will be placed between the Substance map and the material. The Edit pane displays Granite parameters. Click on the material node heading and then click the Lay Out Children button at the top of the Slate Material Editor (see **Figure 23-14**). This organizes the child maps in a more logical layout.

FIG 23-13 A Substance map requires a special definition file with the .sbsar file ending.

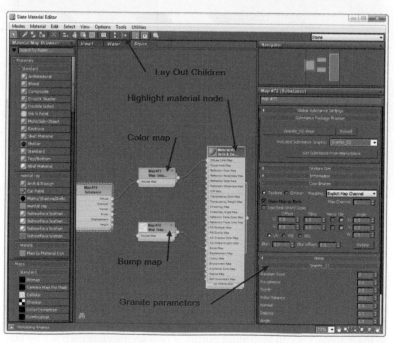

FIG 23-14 You can organize your materials by picking the node and then using Lay Out Children.

5. Double-click the material node heading, then in the Edit pane change the name of the material to **Granite**, and then in the Main Material Parameters rollout, Reflection area, set the reflectivity and Glossiness to **0.0** (see **Figure 23-15**). Assign the material to the millstone in the scene.

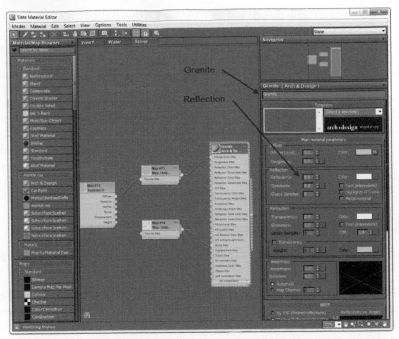

FIG 23-15 Rename the material and disable reflectivity and glossiness.

6. The material will not render because the millstone does not have mapping coordinates. Make sure Mill_stone001 is selected and then in the Modify panel, Modifier list, choose UVW Map. In the Modify panel, Parameters rollout, choose Cylindrical radio button and then check Cap. This mapping coordinate projection most closely fits the shape of the object. Render the Perspective viewport (see Figure 23-16).

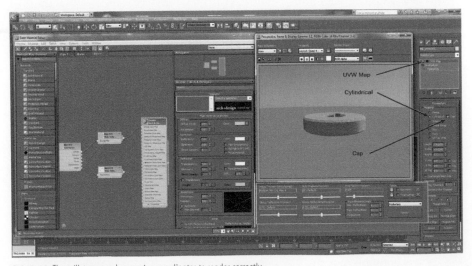

FIG 23-16 The millstone needs mapping coordinates to render correctly.

7. Close all windows and dialogs and then use the keyboard shortcut Alt+Q to exit Isolate Selection mode. In the Perspective viewport, use the keyboard shortcut C to switch to the Camera001 viewport. Save the file. It should already be called Exercise 23-1-1_Materials04.max.

A Substance map contains much more information than a standard image or procedural map and when you load a Substance definition and connect the outputs to the appropriate material inputs, the Substance map knows to use a color map, a bump map, or a displacement map according to the slot to which it has been connected. Although additional substance maps can be purchased, it's possible for you to program your own.

23.3 Material Libraries

Material libraries in 3ds Max are special files for storing material definitions onto your hard drive so that they are accessible from any other 3ds Max file.

Up to this point in the book, you have been creating materials and assigning them to objects in the scene. When the 3ds Max file is saved, the material definitions are saved with the objects and are available again when you reopen the file. However, if you start or open a new 3ds Max file, those material definitions are no longer accessible.

Material libraries containing the material definitions are small files so it's possible to save a material in multiple material libraries efficiently. For example, you should probably save all of the materials for a given scene in a project Material Library, perhaps named Windmill .mat and then you could save all your stone materials in a library called Stone.mat. The same material definition would be stored in two files and with proper management everyone on the production team will know where to look for specific materials.

Let's create a Material Library for the windmill scene and save the materials that you have created into the library.

Exercise 23-3-1 Put Scene Materials in a Library

1. Open the file from the previous exercise called Exercise 23-1-1_Materials04.max and save it to an appropriate folder on your hard drive with a new incremental name. Open the Slate Material Editor. In the Material/Map Browser pane, scroll down to the bottom of the Scene Materials rollout.
2. Right-click on the Scene Materials rollout heading and then choose Save As New Material Library. This operation will scan the entire scene to find maps and materials that are stored in the scene, in the renderer, and in the environment (mr Physical Sky map, for example) (see Figure 23-17).
3. In the Save As New Material Library dialog, click the Save As button. In the Save As New Material Library navigation, enter Windmill in the File Name field and then click the Save button (see Figure 23-18). The file will automatically be saved into the /materiallibrary folder of your current project folder structure.

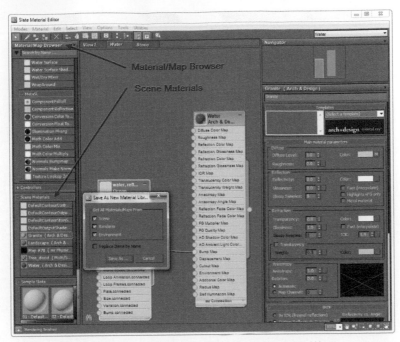

FIG 23-17 Materials will be gathered from all areas of the current scene and stored in a material library.

FIG 23-18 By default, the file is saved in the /materiallibrary folder of your current project folder structure.

4. At the top of the Material/Map Browser pane, click the Material/Map Browser Options black arrow to the left of the search window and then choose Open Material Library (see **Figure 23-19**).

5. In the Import Material Library navigation dialog, double-click Windmill. The Windmill.mat material library is opened at the top of the Material/Map Browser and you can drag and drop the materials into the View pane as required (see **Figure 23-20**).

FIG 23-19 Open existing material libraries in Material/Map Browser Options.

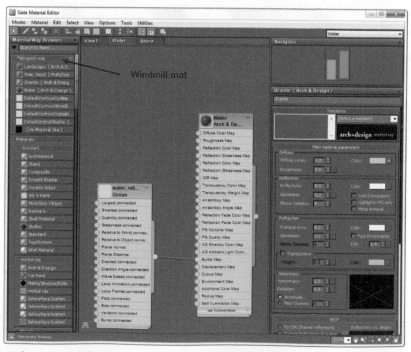

FIG 23-20 Opening a material library places it at the top of the Material/Map Browser.

6. Close the Slate Material Editor and save the file. It should already be called Exercise 23-1-1_Materials05.max. You have stored your scene materials into a new Material Library onto your hard drive so that it can be accessed from any other 3ds Max file. Material libraries are a very important management tool in a production environment.

You have learned to create more complex materials with nested maps, Arch & Design material templates, and by using Substance Maps. These methods provide you with tools for creating complex materials to make your 3ds Max scenes more convincing to the viewer.

Take the time to come up with some of your own materials and experiment with different maps and templates.

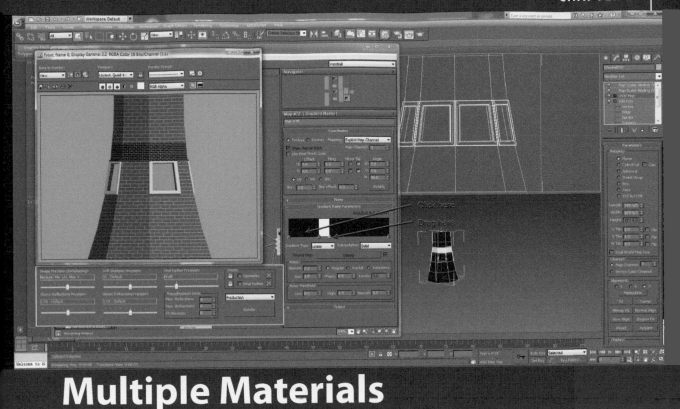

Multiple Materials

You have been assigning a material to an object in a 3ds Max scene by connecting a material node output in the Slate material editor to an object in the scene or by using the Assign Material to Selection option in the Slate material editor. If you apply a different material to the object, the original material is replaced.

However, there are many situations that require multiple materials on single objects. In the case of the current windmill scene you've been working with, the siding of the windmill will be a orange tile material, the window frames will be white paint material, and the windmill glass will get a transparent glass material. That's three materials assigned to the windmill object. Then, just to make life difficult for you, the client will decide to have a horizontal blue stripe for the windmill siding.

In this chapter, you'll learn to assign materials to the appropriate parts of the windmill, and because the client has not yet decided exactly where the blue horizontal stripe will be positioned, you'll also learn a flexible option for applying the siding materials to the windmill using Blend material and a mask.

Both methods of assigning multiple materials to objects are critical for productivity as they provide you with a high degree of flexibility for quickly changing an object's materials.

Some of the topics covered in this chapter are

- *Multi/Subobject material* – Assign multiple materials to objects with a combination of Multi/Subobject submaterials matched to Material ID numbers on the geometry.

- *Blend material* – Display multiple materials on an object with a Blend material and a mask.
- *Multiple mapping modifiers* – You can apply multiple mapping modifiers to a single object by matching Map Channel numbers to their respective maps.

24.1 Multi/Subobject Material

Multi/Subobject material is found in the Standard materials menu and, by default, has 10 submaterials. The Multi/Subobject material is simply a "container," which holds the 10 submaterials in order, each with a Material ID number assigned to it.

Objects in a 3ds Max scene have Material ID numbers assigned to each face or polygon which you can edit at Face or Polygon subobject level. The Material ID number assigned to the face or polygon determines which of the submaterials is applied to it.

In the 3ds Max windmill scene, you have previously edited the windmill building geometry to add four windows, each made up of a window frame and a window pane. In this section, you will edit the windmill building geometry to assign Material ID numbers 1 to 3. Material ID number 1 will be assigned to the siding polygons of the windmill. Material ID number 2 will be assigned to the window frame polygons. Material ID number 3 will be applied to the windowpane polygons.

In the Slate material editor, you will create a Multi/Subobject material and then connect three materials that have already been created to the proper input buttons of the Multi/Subobject material. The Multi/Subobject material will then be assigned to the windmill.

The process is simple, and you create a Multi/Subobject material with multiple submaterials and then match the Material ID numbers on the geometry to the appropriate material.

In the following exercise, you'll use Named Selection Sets that have already been created at Polygon subobject level to select the appropriate geometry for applying Material ID numbers.

Exercise 24-1-1 Assign Materials to the Windmill

1. Open the file from the website called Exercise 24-1-1_Multi Materials01.max and then save it to an appropriate folder on your hard drive with a new incremental name. In the Camera001 viewport, select the Windmill001 and then use the keyboard shortcut Alt+Q to isolate the selection. Use Zoom Extents All Selected to fill all viewports with the windmill.
2. In the Modify panel, stack view, make sure that Edit Poly is expanded and then highlight Element subobject level. Pick the windmill in any viewport and all polygons will be highlighted in red to indicate they are selected. In the Modify panel, Polygon: Material IDs rollout, enter **1** in the Set ID: numeric field (see **Figure 24-1**). This ensures that you are beginning with Material ID 1 assigned to all polygons.

FIG 24-1 Begin by assigning Material ID 1 to all polygons.

Note

All primitive 3D objects in 3ds Max have Material ID numbers assigned by default when created. It is best to begin Material ID assignments by making sure that all polygons have Material ID 1 and then edit them as necessary.

3. In the Modify panel, stack view, highlight Polygon subobject level. In the main toolbar, Named Selection Sets drop-down list, choose window frames. This is a previously created selection set of the polygons which make up the four window frames in the scene. In the Polygon: Material IDs rollout, enter **2** in the Set ID: numeric field (see **Figure 24-2**). This changes the Material ID number of the window frame polygons from 1 to 2 to receive the second material in a Multi/Subobject material.

FIG 24-2 Change the Material ID numbers of the window frames to 2.

373

4. In the Named Selection Sets drop-down list, choose the window panes to select the window pane polygons in the windows, and then change the Material ID number to 3. In the Modify panel, stack view, highlight Edit Poly to exit subobject mode. The appropriate Material ID numbers are assigned to polygons, so let's create a matching Multi/Subobject material.

5. In the main toolbar, click the Material Editor button to open the Slate material editor. You should see a new view called Windmill with four materials: Paint_white, Window_glass, Tile_orange, and Tile_blue (see **Figure 24-3**).

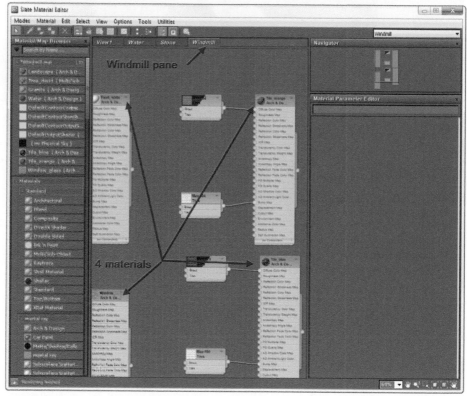

FIG 24-3 The scene contains four new materials in the Windmill view pane.

Note

If you do not see the materials, you can open the Windmill Material Library from the Chapter 24 Max files website location and drag the four materials mentioned in Step 5 into the view pane.

6. In the Windmill view pane, zoom out a little and then right-click to the right of all the material nodes. In the Materials menu, Standard menu, choose Multi/Subobject (see **Figure 24-4**). This places a Multi/Subobject material node with 10 submaterials in the view pane.

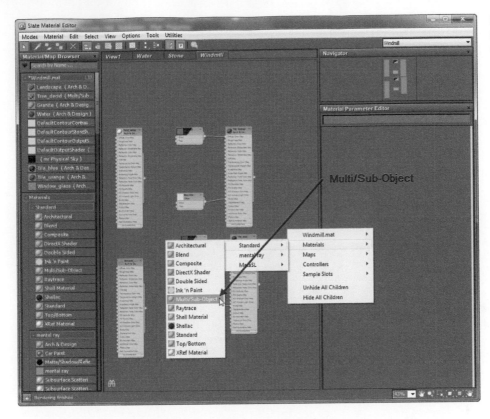

FIG 24-4 Create a Multi/
Subobject material node in the
view pane.

7. Connect the output node of Tile_orange to the input node (1) of the Multi/
 Subobject material. Connect the output node of the Paint_white material to the
 input node (2) and then connect the output node of Window_glass to the input
 node (3). Double-click on the heading of Multi/Subobject material to open its
 parameters in the Edit pane (see **Figure 24-5**). The Multi/Subobject material applies
 submaterials to appropriate Material ID number assigned to polygons. In the Edit
 pane, rename the Multi/Subobject material Windmill.
8. Connect the Multi/Subobject material output node to Windmill001 in the
 Camera001 viewport. The materials should appear on the appropriate polygons,
 but the tile pattern for Tile_orange is too much large and needs mapping
 coordinates. In the Modify panel, Modifier list, choose MapScaler(WSM) modifier in
 the World-space modifiers (WSMs) area near the top of the list. In the Modify panel,
 Parameters rollout, enter **2'0"** in the Scale numeric field (see **Figure 24-6**). This creates
 a MapScaler Binding(WSM) at the top of the stack view and projects the tile pattern
 in a 2' × 2' space.

Note

World-space modifiers apply their effects to the space in which an object exists
rather than directly to the object, as in the Object-space modifiers that you have
been using up to now.

FIG 24-5 Connect the appropriate material output to the matching Material ID number in the Multi/Subobject material.

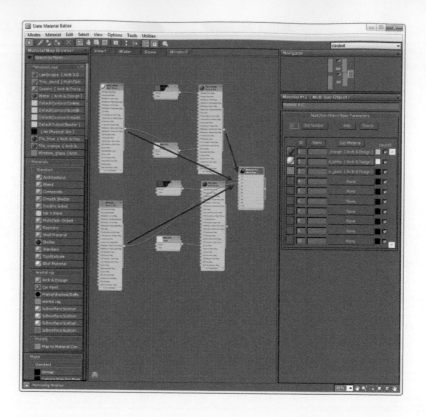

FIG 24-6 Apply a MapScaler(WSM) modifier and adjust to project the tiles in a 2' × 2' space.

9. Use the keyboard shortcut Alt+Q to exit isolation mode and then render the Camera001 viewport. You can see in the Rendered Frame window that Tile_orange material renders on the windmill walls, Paint_white material renders on the window frames, and the windowpanes are clear glass (see **Figure 24-7**).

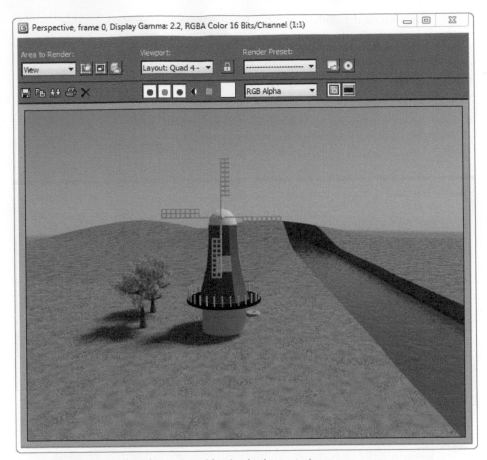

FIG 24-7 The rendered image shows the correct materials assigned to the correct polygons.

10. Close all windows and dialogs and then save the file. It should already be called Exercise 24-1-1_Multi materials02.max. Again, the process is simple. You need to use a Multi/Subobject material that has submaterials in the appropriate Material ID number slots and then you need to edit the geometry to assign matching Material ID numbers to the proper polygons.

The Multi/Subobject material method of applying multiple materials to single objects is extremely effective in many cases, but there are situations where the object's geometry does not match the area in the way you want the materials to be assigned. For situations like that, you will learn to use a Blend material with masking in the following section.

24.2 Blend Material

The client has notified you that they need to have a horizontal stripe of blue tiles just above the windows of the windmill. However, the existing geometry of the windmill does not have polygons in the right places to use the Multi/Subobject material method of applying multiple materials.

3ds Max has a Standard material type called Blend that is a container for two other materials. In this case, you will apply the Multi/Subobject material to Material #1 and then connect a new Tile_blue material to Material #2. Then, to reveal the two materials in the proper locations you will use a Gradient Ramp map as a mask. Where the mask map is black the Tile_orange material will show, and where the mask map is white the Tile_blue material will show.

You then have the flexibility to edit the Gradient Ramp mask to easily reposition the blue stripe anywhere on the windmill independent of polygons.

Exercise 24-2-1 Add a Horizontal Stripe

1. Open the file from the previous exercise called Exercise 24-1-1_Materials02.max and save it to an appropriate folder on your hard drive with a new incremental name. Select Windmill001 and then use the keyboard shortcut Alt+Q to isolate the selection. Open the Slate material editor.
2. In the Windmill view pane, right-click to the right of the Multi/Subobject material node and then choose Materials, Standard, Blend in the menus. Double-click on the Blend material heading to open its parameters in the Edit menu. The Blend material already has two Standard materials assigned to it. In the view pane, click the heading of one of the materials to select it, hold the Ctrl key, and then add the other material to the selection set by clicking on its heading. Press Delete on the keyboard to delete the two materials (see **Figure 24-8**). Rename the Blend material Tile_stripe.

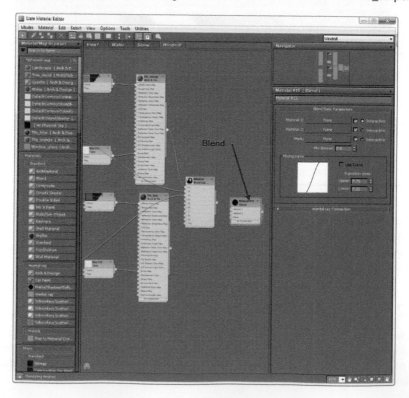

FIG 24-8 Create a Blend material and then delete the two Standard materials connected to it.

3. In the view pane, connect the output of the Multi/Subobject material to Material #1 of the Blend material and then connect the output of Tile_blue to Material #2 of the Blend material. Then, connect the output of the Blend material to the windmill in the scene to assign it. The Windmill001 will turn gray in the Camera001 viewport, but the material assignments are still the same. Render the Camera001 viewport and you will see that Tile_blue material (Material #2) does not show because it is being overridden by the Tile_orange submaterial of the Windmill Multi/Subobject material (Material #1) of the Blend material (see Figure 24-9). Close the Render Frame window and let's add a mask to the Blend material.

FIG 24-9 You must use a Mask in the Blend material to reveal both materials.

4. In the view pane, right-click to the right of Tile_blue and then choose Maps, Standard, Gradient Ramp to apply a Gradient Ramp map node to the Slate material editor. Connect the output of the Gradient Ramp map to the input of the Mask in the Blend material. In the Edit pane, Blend Basic Parameters rollout, choose the Interactive radio button to the right of Mask. Select the Gradient Ramp map node by clicking on its heading and then right-click on the heading and choose Show Shaded Material in Viewport (see Figure 24-10). The Gradient Ramp pattern on the windmill is being projected by the 2' × 2' MapScaler(WSM) modifier. Let's adjust the Gradient Ramp map.

5. Double-click on the Gradient Ramp heading to open its parameters in the Edit pane. In the Coordinates rollout, Angle area, enter **90** in the W: numeric field to rotate the Gradient Ramp to run horizontally. In the Gradient Ramp Parameters rollout, Interpolation drop-down list, choose Solid to provide a hard edge between the gradient flag colors. Right-click on the middle flag in the gradient and then choose Edit Properties in the menu. In the Flag Properties rollout, click the Color swatch and then in the Color Selector, set the color to pure white. Click the OK button. Right-click in the Front viewport to activate it. Click the Render Production button in the main toolbar to render the viewport (see Figure 24-11). There are clearly alternating orange and blue tile stripes running horizontally, but the client only wants one stripe. The problem is that all three maps' coordinates are being managed by a single MapScaler(WSM) modifier set to cover 2' × 2'.

FIG 24-10 The Mask in a Blend material must be Interactive to show in the viewports.

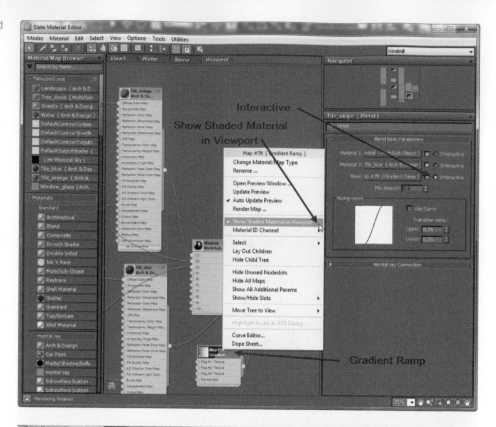

FIG 24-11 Rotate the Gradient Ramp map and create a Solid interpolation between pure black and pure white.

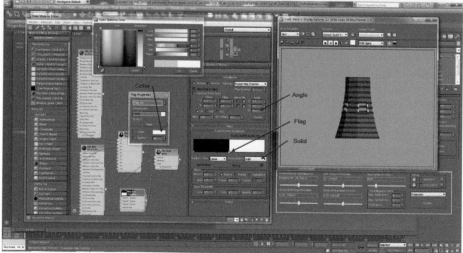

6. Close all windows and dialogs, use Alt+Q to exit isolation mode, and then save the file. It should already be called Exercise 24-1-1_Multi materials03.max. The client has also decided that the blue bricks should be twice as large as the orange bricks. In the following section, you will learn to apply multiple mapping coordinate modifiers so that each map can have its own independent mapping coordinates.

24.3 Multiple Mapping Modifiers

The windmill materials are assigned, but there is a problem with the map patterns within the materials. All the patterns are being projected by a MapScaler(WSM) modifier, which is set to cover a 2' × 2' area on all surfaces. This is appropriate for the initial tile pattern, but not for the Blend mask which should only reveal a stripe of Tile_blue material just above the windows. Also, the client has requested that the Tile_blue pattern be double the size of the Tile_orange pattern.

The solution to this problem is to use multiple mapping coordinate modifiers, but because in the evaluation process of the Modify panel, stack view, the modifiers are evaluated from the bottom up and the top modifier affects everything below it; you also need to make use of an option called Map Channels in both the mapping coordinate modifiers and many of the map types.

You, therefore, need to match the Map Channel numbers for each mapping coordinate modifier to the Map Channel numbers in the map they are to control. Let's fix the materials on the windmill.

Exercise 24-3-1 Map Channels and Mapping

1. Open the 3ds Max file from the previous exercise called Exercise 24-1-1_Materials04. max and save it to an appropriate folder on your hard drive with a new incremental name. Select Windmill001 and then use the keyboard shortcut Alt+Q to isolate the selection. Activate the Front viewport and then zoom in to the midsection of the windmill. Render the Front viewport so you can see the patterns clearly (see Figure 24-12).

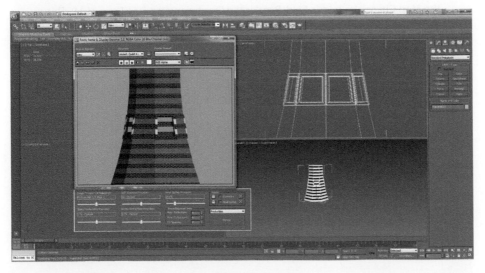

FIG 24-12 The client wants a larger orange brick and one stripe of blue brick above the windows.

2. In the Modify panel, Parameters rollout, you will see that the MapScaler(WSM) modifier is set to apply the coordinates to Channel 1. Open the Slate material editor, and in the Windmill view pane, double-click the orange Tile map node to open its

parameters in the Edit pane. In the Coordinates rollout, you will see that the Map Channel number is also set to 1 (see **Figure 24-13**). This is fine because the Tile_orange is the correct size. Let's apply another MapScaler(WSM) modifier for the Tile_blue material.

FIG 24-13 The original MapScaler(WSM) modifier will control the coordinates of Tile_orange material.

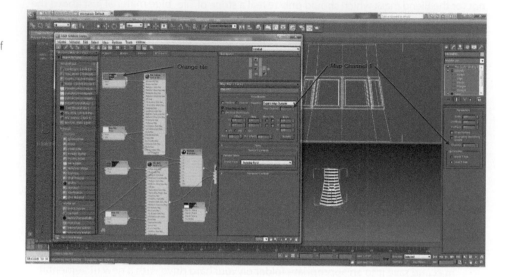

3. In the Modify panel, Modifier List, choose MapScaler(WSM). The mapping coordinates change because this MapScaler(WSM) is also set to Map Channel 1 by default and now controls all the maps. In the Parameters rollout, enter **4'0"** in the Scale numeric field. In the Slate material editor, Coordinates rollout, enter **2** in the Map Channel numeric field. Render the Front viewport (see **Figure 24-14**). This MapScaler(WSM) modifier now only controls Tile_orange as you can see in the rendered image. Close the Render Frame window.

FIG 24-14 Tile_orange is now controlled by the top MapScaler(WSM) modifier in stack view.

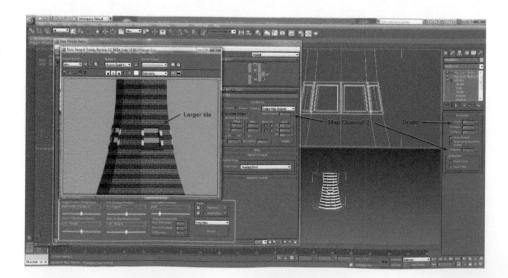

4. In the Slate material editor, Windmill view pane, double-click on the Gradient Ramp map node and then in the Coordinates rollout, enter **3** in the Map Channel numeric field. In the Modify panel, Modifier list, choose UVW Map modifier. Make sure the Front viewport is active, and in the Parameters rollout, Alignment area, click the View Align button and then click the Fit button. In the Channel area, enter **3** in the Map Channel numeric field. Render the Front viewport (see **Figure 24-15**). This projects the Gradient Ramp map over the entire windmill from the front and displays Tile_blue on the bottom half and Tile_orange on the top half.

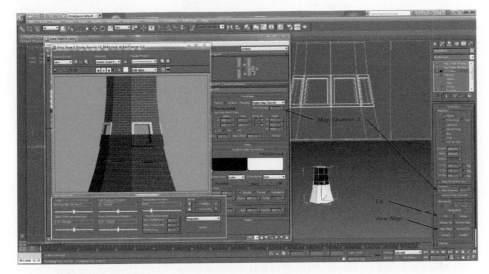

FIG 24-15 The UVW Map modifier controls mapping coordinates for the Gradient Ramp mask.

5. In the Slate material editor, Edit pane, Gradient Ramp Parameters rollout, click and drag directly on the middle flag in the gradient and then drag it left to position 30 (see **Figure 24-16**). This positions the solid edge of the gradient above the top of the windows.

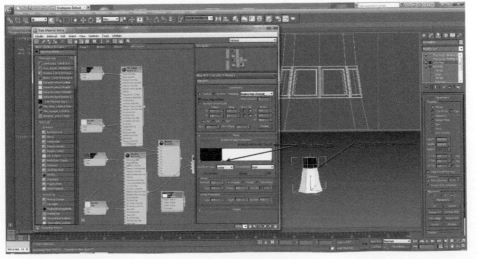

FIG 24-16 Move the middle gradient flag to place the black/white edge of the gradient above the top of the windows.

6. In the Gradient area, click in the black area to create a new black flag and then drag it to the right to position 40. This results in a thin white stripe in the mask. Render the Front viewport (see Figure 24-17). The result is a horizontal blue stripe of smaller tiles above the windows. Experiment with adjusting the Gradient Ramp flags to see that you can rapidly adjust the stripe's size and position, and by creating new flags, you can add new stripes.

FIG 24-17 Create a black flag and move it to the right of the existing flag for a white stripe bordered by black areas.

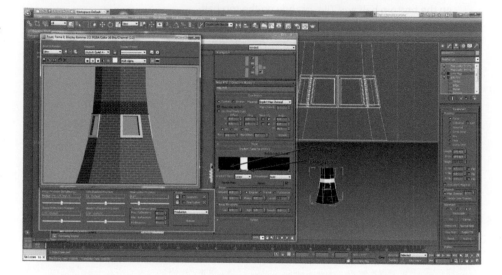

7. Use the keyboard shortcut Alt+Q to exit isolation mode. Close all windows and dialogs and then save the file. It should already be called Exercise 24-1-1_Multi materials05.max. You now have the flexibility to change each map's size and position in the Blend material quickly and efficiently by adjusting the appropriate mapping coordinate modifier or the parameters of the map itself.

Applying multiple materials to a single object can be done using Multi/Subobject materials and Material ID numbers or with Blend material and masking. Each method has its place in your production pipeline. The flexibility of both methods is enhanced through the use of multiple mapping coordinate modifiers with Map Channels matched to the maps you need to control. There are 99 Map Channels available to provide maximum flexibility.

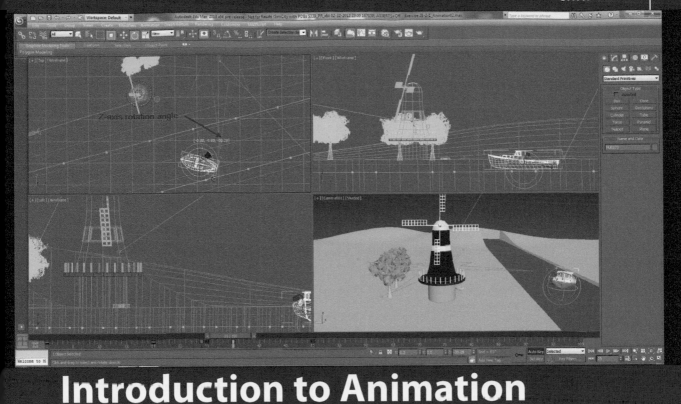

Introduction to Animation

Animation is an important part of the functionality of 3ds Max that breathes life into an otherwise static presentation. The basic concepts behind animation are derived from the traditional "cartoon" animation techniques where a master animator sketches objects at key points in time and then passes those sketches to the junior animators whose job is to draw all the "in-between" positions that transition from one pose to the next.

An important user interface element of animation is the Auto Key button. While the Auto Key button is toggled on and you have set 3ds Max to some point in time other than frame 0, almost any changes you make will become recorded as a keyframe and will generate animation. To minimize the chances that you animate changes and edits by mistake, the 3ds Max interface displays many elements in a bright red color to indicate that the Auto Key button is toggled on.

You will learn to use the track bar and Time slider to determine at which point in time keyframes will be recorded. 3ds Max also has video recorder-like buttons to play animations back in the viewports or jump to the beginning or end of an animation.

3ds Max is set, by default, to a duration of 100 frames. At a standard video animation rate of 30 frames per second (fps), that is, the equivalent of 3.3 seconds of time when the animation frames are saved, you'll also learn to adjust the duration of animations.

In one exercise, you'll animate a small boat that has been added to the windmill scene moving from one side of the canal to the other. This will require keyframes to record position changes and rotation changes for a convincing animation of a moving boat.

Transformations are not the only things that can be animated in 3ds Max, and so you'll learn to apply a Bend modifier to trees in the windmill scene and then animate the Bend parameters to simulate the trees blowing in the wind.

Some of the topics covered in this chapter are as follows:

- *Animation user interface*: Basic animation can be created and managed on the track bar at the bottom of the 3ds Max interface.
- *Keyframe animation*: Keyframe animation records changes made to the 3ds Max scene in keys on the track bar.
- *Animating modifiers*: Modifier parameters can also be animated to deform objects over time.

Let's begin by having a closer look at the 3ds Max interface to refresh your memory of the animation features.

25.1 Animation User Interface

Fundamental animation relies on three aspects of the 3ds Max interface; the Auto Key button, the track bar, and the time slider. The time aspect of the track bar can be changed in the Time Configuration dialog. You can also use the Play Animation button in the 3ds Max user interface to visualize the animation in the currently active viewport.

For any animation to be recorded, you must move the time slider forward in time on the track bar to some frame other than frame 0 (the beginning), you must toggled the Auto Key button on, and then you must edit something in the 3ds Max scene. The result is an animation of the changes you made, starting at frame 0 and finishing at the point in time that you performed the edit. Keyframes will appear at frame 0 and at the current frame on the track bar. "Scrubbing" or dragging the time slider back and forth will step through the automatically calculated in-between steps to transition from one key to the next.

Hundred frames of animation is an arbitrary duration used as a place to start your animation process. The actual length of animations should be determined at the time of pre-planning your project.

Let's have a look at the important components for basic animation in the 3ds Max interface (see Figure 25-1).

The track bar below the 3ds Max viewports represents points in time based on 30 fps (frames per second) with a default active frame on frame 0 at the far left of the track bar.

The time slider button is located above the track bar and is labeled 0/100 in its default position on frame 0. You can click and drag or "scrub" the time slider to set the current time to any value on the track bar. The numbers on the button will update to indicate that you are on frame 25/100, for example.

The Auto Key is below the right end of the track bar and can be toggled on and off as necessary. When the Auto Key button is toggled on, the time slider track and the border of the currently active viewport are highlighted in red as a warning that any changes made to

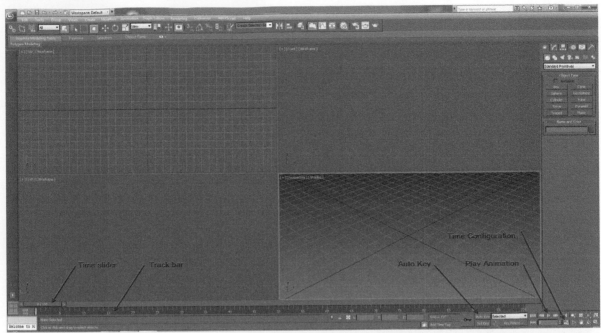

FIG 25-1 Animation interface components.

your scene may be recorded and result in animation (**Figure 25-2**). The red warning should be taken seriously as any editing actions will become animations if you are on a frame other than frame 0 and the Auto Key button is toggled on.

FIG 25-2 When Auto Key is on, elements turn red in the viewport as a warning.

The animation playback buttons also include Go to Start, Previous Frame, Play Animation, Frame, and Go to End for navigating through the track bar. The Time Configuration button is located below the Go to End button (see Figure 25-3).

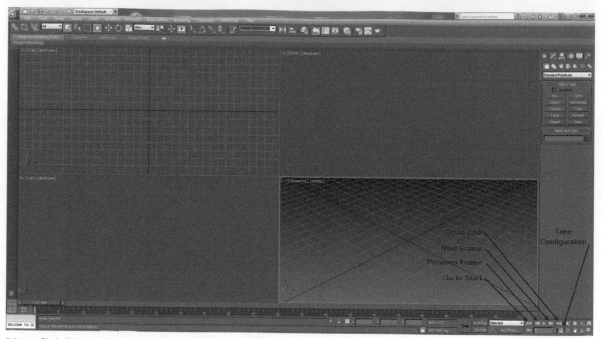

FIG 25-3 Playback buttons allow you to navigate the track bar.

Let's create an animation.

25.2 Keyframe Animation

When the Auto Key button is toggled on in 3ds Max and the time slider is on a frame other than frame 0, most changes to the 3ds Max scene will be recorded as keyframes and an animation is created starting at frame 0 or at a previously created key.

Animation keys for transformations, move, rotate, and scale, are recorded on the track bar at the current frame.

> **Note**
>
> Animation keys for other editing actions are found in the animation Graph Editors.

In Exercise 25-2-1, you will animate the transformation of a boat moving from one side of the canal to another. This will require both position and rotation keys for smooth action. You will learn to create keys to record the current position or rotation of the boat and then to edit the scene to generate new animation keys.

The boat will remain stationary for the first 20 frames of the animation and so you'll learn to create keys that don't require the Auto Key button to be toggled on. This is a good practice when you are first learning animation to make sure you have absolute control of the transformations.

Focus on the process of recording animation keys in time and not on the actual motion of the boat. Once you understand how key framing works at a fundamental level, then you can go on to more complex animations.

Exercise 25-2-1 Animate a Boat

1. Open the file from the website called Exercise 25-1-1_Animation01.max and save it to an appropriate folder on your hard drive with a new incremental name. In the Top viewport, select the boat at the lower right corner of the viewport or you can select it by its name HULL01. In the main toolbar, click the Select and Move button and then in the Reference Coordinate System drop-down list, choose Local. This will help move the boat along its own axes. Right-click on the time slider to open the Create Key dialog. This allows you to record the current transformations of the boat in a key at the current frame 0 that will act as a starting point for your animation (see Figure 25-4). Click the OK button to set the keys.

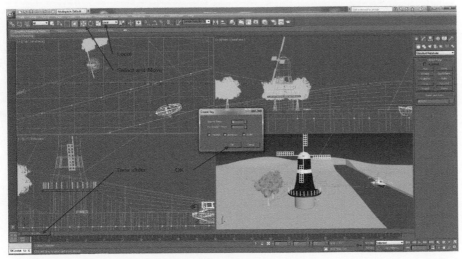

FIG 25-4 Create transformation keys at frame 0 to record the starting position of the boat.

2. Click and drag the time slider to frame 20 and then right-click on the time slider to record the same position, rotation, and scale again. This ensures that the boat will remain stationary for the first 20 frames of the animation (see Figure 25-5). Click the OK button.

FIG 25-5 New transformation keys at frame 20 keep the boat stationary for the first 20 frames.

3. Drag the time slider to frame 30. Toggle the Auto Key button on. In the Top viewport, move the boat forward along its Local *x*-axis until the front of the boat just passes the blue segment of the water surface. A key is automatically created at frame 30 (see **Figure 25-6**). Toggle the Auto Key button off and then scrub (click and drag) the time slider back and forth to see the boat move between frames 20 and 30.

FIG 25-6 Use Auto Key to record a position change at frame 30.

4. Drag the time slider to frame 50 and then toggle Auto Key on. In the Top viewport, move the boat forward, slightly forward of the windmill, and to the other side of the canal. The edge of the canal is indicated by a green line (see **Figure 25-7**). Toggle the Auto Key button off. Scrub the time slider and you will see the boat move forward and then slide sideways and forward to the other side of the canal. The boat needs some rotation to be more convincing.

FIG 25-7 At frame 50, position the boat to the other side of the canal and forward of the windmill.

5. Drag the time slider to frame 29 and then right-click on the time slider. In the Create Key dialog, clear the Position and Scale checkboxes and then click the OK button. This records only the current rotation of the boat at frame 29 to act as a starting point for rotating the boat so that it doesn't begin to rotate at frame 20: the last rotation key in the track bar. Drag the time slider to frame 35 and then toggle the Auto Key button on. Click on the Select and Rotate button in the main toolbar and then in the Top viewport rotate the boat roughly 30° about the z-axis in a clockwise direction. Click to set the rotation angle (see **Figure 25-8**). Toggle the Auto Key button off. Scrub the time slider back and forth and you will see the boat move forward in a straight line and then turn toward the windmill.

FIG 25-8 Record an animation key for a 30° clockwise rotation at frame 35.

6. Drag the time slider to frame 45 and then toggle the Auto Key button on. In the Top viewport, rotate the boat clockwise about 30° (see **Figure 25-9**). Toggle the Auto Key button off.

FIG 25-9 Rotate the boat clockwise at frame 45 to create a key.

7. Toggle the Auto Key button on. Click the Select and Move button in the main toolbar. Drag the frame slider forward to frame 65 and then move the boat forward in the Top viewport until the back is just visible in the Camera001 viewport at lower right corner (see **Figure 25-10**). Toggle the Auto Key button off.

FIG 25-10 Animate the boat to its final resting position.

8. Click the Play Animation button and watch the animation in the active Top viewport. The boat moves forward and turns, continues forward, and then turns again to slide into position. Right click on the Camera001 viewport to activate it and watch the

animation there. Click the Stop Animation button to end the animation. Notice on the track bar that position keys are red and rotation keys are green. On frames where you recorded starting points for the animation, you can see red, green, and blue keys on top of each other.

> **Note**
>
> Color coding is used throughout 3ds Max to indicate transform axes or keys. RGB = XYZ = UVW = PRS (Position, Rotation, Scale keys). This helps in quickly identifying axes or transforms in many windows and dialogs.

9. Close all windows and dialogs and save the file. It should already be called Exercise 25-2-1_Animation02.max. Although it might seem a bit unnecessary to keep toggling the Auto Key button on and off, it is an extremely good habit to get yourself into. There is nothing more disappointing than to work for a while only to realize that every edit you have performed was recorded as an animation.

In Section 25.3, you will learn the process of animating modifier parameters to create trees blowing in the wind.

25.3 Animating Modifiers

As mentioned earlier, almost everything in 3ds Max can be animated when edited with the Auto Key button toggled on. In this section, you'll learn to simulate the wind blowing the trees in the scene by applying a Bend modifier and then animating the Angle parameter.

If you recall creating the trees, you might remember that you used the Instance clone option in the Scatter compound object for some of the trees and the Shift/Transform method to clone the other. Because they are Instance clones, you can apply the modifier to any one of the trees and they will all be affected.

Exercise 25-3-1 Trees in the Wind

1. Open the 3ds Max file from the previous exercise called Exercise 25-2-1_Animation02. max and save it to an appropriate folder on your hard drive with a new incremental name. Make sure the Select Object button is toggled on in the main toolbar. In the Perspective viewport, select either of the trees next to the windmill. In the Modify panel, Modifier list, choose Bend (see **Figure 25-11**). The two trees near the windmill display the orange gizmo of the Bend modifier to indicate that the modifier will affect both objects. However, if you look at the cluster of trees in the Top viewport beyond the windmill, there are no orange gizmos, but they will still be affected because the Instance option was part of the Scatter compound object.

FIG 25-11 All Instance clone trees will be affected by the Bend modifier.

2. Toggle the Auto Key on and then drag the time slider to frame 25. In the Modify panel, Parameters rollout, Bend area, enter **10** in the Angle numeric field. Make sure the Bend Axis Z radio button is chosen to bend the tree in their Local z-axis and then press enter. Notice that the spinners to the right of the numeric field have read brackets to indicate the parameter is animated (see **Figure 25-12**). Toggle the Auto Key button off. You can see that the orange gizmo is bent slightly as are the trees.

FIG 25-12 Bend the trees 10° in their Local z-axis.

3. Drag the time slider a few frames away from frame 25 and notice that there are two keys: one at frame 0 that recorded the original bend angle and the key at frame 25 recording the 10° bend. At frame 50, you want the tree to return to its original upright position (stored at frame 0). Select the key at frame 0. It will turn white to

indicate it is selected. Hold the Shift key and then drag the selected key to frame 50. You will see a double horizontal arrow as you move the key. This clones the animation key (see **Figure 25-13**). Scrub the time slider and you will see that the tree bends in one direction and then returns back to vertical.

FIG 25-13 You can clone animation keys by transforming with the Shift key.

4. Clone animation key from frame 50 to frame 75 and then clone the animation key from frame 0 to frame 100. This completes a cycle of animation from vertical to a 10° bend at frame 25, back to vertical at frame 50, another 10° bend at frame 75, and finally back to vertical at frame 100 (see **Figure 25-14**). Scrub the time slider to see the animation or click the Play Animation button to see the motion.

FIG 25-14 Clone animation keys to create a waving action over the entire time duration.

5. Select any of the animation keys on the track bar and then right click on the key and choose Tree_decid002: Angle (the name of your selected tree may be different) in the menu. In the dialog with the name of the object, you can change the frame for the currently selected key or the Bend angle value (see Figure 25-15). If you do edit a parameter, it affects the current key and does not create a new key. Close the dialog because you don't actually need to edit this key.

FIG 25-15 Right-click on a key to access editing parameters for the key.

6. Save the file. It should already be called Exercise 25-2-1_Animation03.max. Object parameters in the Modify panel can be animated while the Auto Key button is toggled on and the time slider is at a frame other than frame 0. Animated parameters are indicated by red brackets.

Keyframe animation, in its fundamental form, is relatively straightforward. You toggle the Auto Key button on, move the time slider to a frame other than frame 0, and then either transform the object or change a parameter associated with the object or its modifiers. The result is an animation that begins at frame 0 or at a previously created key and ends with the final edit that was automatically keyframed.

You can transform and clone keys in the track bar using the Shift key and you can edit a key's parameters by right clicking the key and choosing its name in the menu.

Intermediate Modeling

The more methods of modeling you know in 3ds Max and the deeper your knowledge about each method will increase your productivity accordingly. This chapter will introduce you to some more advanced features of Graphite Modeling Tools to give you a preview of some of the incredible power available. In the course of creating a grain sack for the windmill, you'll learn about the Bridge tool in Graphite Modeling Tools used to bridge two openings in a surface and then you'll learn to use Nonuniform Rational Mesh Smooth (NURMS) smoothing to give the object a more organic form.

You'll open the windmill scene again and use Lofting to create a railing around the walkway. The focus of the lesson is the flexibility of Lofting as a modeling tool in situations where you need to show the client multiple options quickly. You'll also learn to adjust parameters to balance the efficiency and visual integrity of the model.

Some of the topics covered in this chapter are as follows:

- *More Graphite Modeling Tools*: The Bridge tool and NURMS are covered.
- *Lofting*: Flexibility and efficiency are two advantages of lofting.

Let's begin by using Graphite Modeling Tools to create an organic grain sack that might be used to store the flour created by the windmill. You will start out with basic Editable Poly objects and end with a grain sack that looks soft and natural.

26.1 More Graphite Modeling Tools

Starting with a cylinder and a cone that have been converted to Editable Poly objects, you will use Graphite Modeling Tools to create a lumpy, organic grain sack for your windmill scene. You'll learn about using Border subobject level and the Bridge tool in Graphite Modeling Tools to bridge a surface between two openings in the geometry and then adjust it to be a curved surface. The object will still look nothing like a grain sack until you enable the NURMS option that adds geometry to smoothen the surface into a more organic form. Then to make the grain sack more organic, you'll use the Freeform paint deformation tools for a rougher surface.

Exercise 26-1-1 Create a Grain Sack

1. Open the file from the website called Exercise 26-1-1_Modeling01.max and save it to an appropriate folder on your hard drive with a new incremental name. The scene contains a simple eight-sided cone and an eight-sided cylinder. In the Ribbon menu, click the Graphite Modeling Tools tab and then hover the cursor over Polygon Modeling. Click the Polygon subobject button and then click on the polygon at the top of the cylinder. It will turn red when selected (see **Figure 26-1**). Press the Delete key to remove the polygon.

FIG 26-1 Use Graphite Modeling Tools to highlight the polygon at the top of the cylinder.

2. You need to remove the top and bottom polygons of the cone also, but they are a different object and you either have to exit subobject mode and then repeat the process for the cone or attach the two objects into a single Editable Poly. Let's attach the objects. In Polygon Modeling, exit Polygon subobject mode. In the Geometry (All) tab, click the Attach button (the blue boxes) (see **Figure 26-2**). Do not click the Attach Settings down arrow. In the Perspective viewport, pick the cone-shaped object to attach it to the cylinder. It will turn blue to indicate it has been attached.

FIG 26-2 Attach the cone to the cylinder to create a single Editable Poly object.

3. In Polygon Modeling, click the Polygon subobject button and then select and delete the end Polygons of the cone element. You'll need to use ArcRotate (hold the Alt key and press down on the mouse wheel) to view the underside of the cone. The polygon edges that make up the new openings are known as the Border subobject. In Polygon Modeling, click the Border subobject button. In the Perspective viewport, select the bottom Border of the cone and then hold the Ctrl key and pick the top Border of the cylinder. They will both turn red to indicate they are selected (see Figure 26-3).

FIG 26-3 Select the Borders at the top of the cylinder and at the bottom of the cone.

4. In the Ribbon menu, Borders tab, click the Bridge Settings button (the down arrow) and then choose Bridge Settings (see Figure 26-4).

FIG 26-4 The text and down arrow access the Settings caddy for a command.

5. In the Bridge Settings caddy, enter **3** in the Segments numeric field. Enter **1.5** in the Taper numeric field. This provides tapered sides for the bridge surface (see **Figure 26-5**). Click the OK check button to finish the process.

FIG 26-5 In the Bridge Settings caddy, edit parameters for tapered and curved sides.

6. In the Ribbon menu, Edit tab, choose Use NURMS. The object turns into a much more organic form and a new tab called Use NURMS appears in the Ribbon menu. In the Use NURMS tab, enter **2** in the Iterations numeric field and then click the Isoline Display button to show all the geometry in the viewport (see **Figure 26-6**). NURMS subdivision adds geometry to smooth sharp edges and round the object into a more organic form.

FIG 26-6 NURMS is a method of subdividing the object to smooth the surface.

7. Save the file. It should already be called Exercise 26-1-1_Modeling02.max. While the grain sack is certainly more organic than it was when you started, it needs to have a more "relaxed" look to be convincing.

In Exercise 26-1-2, you'll learn to use Freeform deformation tools to push and pull Editable Poly objects into an even more organic form.

Trying to make a smooth object look more organic by adding wrinkles and bumps to the surface can be a daunting task when working at subobject level. It's difficult to get a natural look when pushing and pulling vertices or polygons.

Graphite Modeling Tools has a series of Freeform tools, one of which is called Paint Deform, which has several variations on modeling tools that you can "paint" directly on the surface. In Exercise 26-1-2, you will use the Push/Pull tool and the Relax/Soften tool to make the grain sack look more natural.

Exercise 26-1-2 Freeform Tools

1. Open the 3ds Max file from the previous exercise called Exercise 26-1-1_Modeling02.max and save it to an appropriate folder on your hard drive with a new incremental name. Make sure the grain bag is selected in the Perspective viewport. Right click on the object and convert it to Editable Poly. This "bakes" the NURMS information into the geometry. In the Freeform Ribbon menu, choose the Paint Deform tab. This reveals the buttons for the Paint Deform tools (see Figure 26-7).

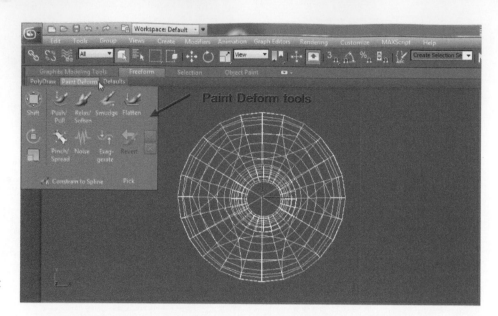

FIG 26-7 There are many Paint Deform tools.

2. In the Paint Deform tab, click the Push/Pull button and then move the cursor over the surface of the grain bag in the Perspective viewport. The cursor will be a large circle with a line pointing from its center indicating the brush size and the direction of the deformation. Click and drag the cursor over the surface and move the brush as if you were painting. The cursor will turn red and the surface will slowly deform outward beneath the cursor (see **Figure 26-8**).

FIG 26-8 Painting with Push/Pull deforms the surface outward.

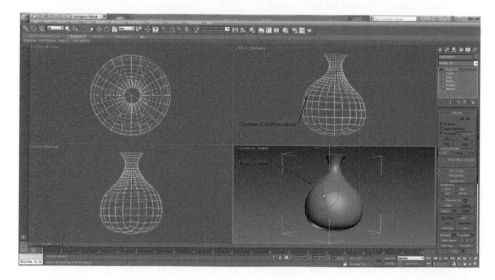

Note

The default action for Push/Pull is to "pull" geometry outward. If you hold the Alt key while painting, the tool will become a "push" tool for forming the geometry inward. The Relax/Soften tool works similarly.

3. In the Freeform menu, Paint Options tab, enter **10** in the Size numeric field and enter **2** in the Strength numeric field (see **Figure 26-9**).

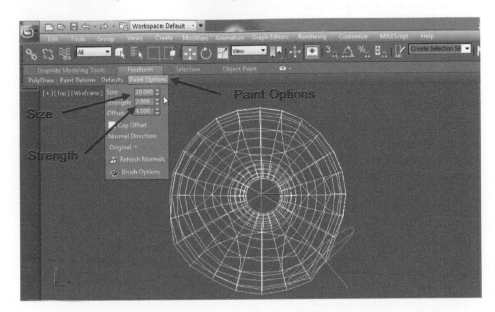

FIG 26-9 The size of the brush and the strength of the action can be adjusted.

4. Paint with the new cursor, set to a reduced brush size and increased strength, over the surface to make smaller deformations in an outward direction. Paint over the surface and you will see more smaller deformations protruding further from the surface because of the increased strength.
5. In the Paint Deform tab, click the Relax/Soften button. Paint over the high areas on the surface and you will see them begin to relax back toward their original positions. You can use ArcRotate to work your way around the object and "paint" a more organic look (see **Figure 26-10**). Don't worry if your grain sack is beginning to look like a bag of rocks; Paint Deform takes a little bit of practice.

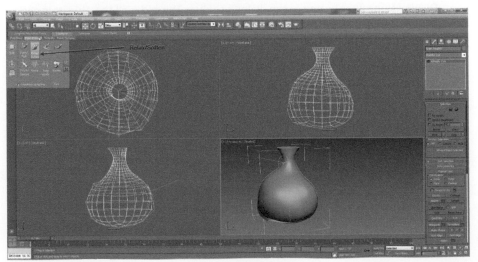

FIG 26-10 Relax/Soften softens the effect of aggressive Push/Pull.

6. Save the file. It should already be called Exercise 26-1-1_Modeling03.max. You can continue practicing on this model and try some of the other Paint Deform tools to see how they affect your geometry.

26.2 Lofting

In Chapter 9, you were introduced to the fundamental process of Lofting in 3ds Max, and in this chapter, you'll apply it to a more real world situation. Lofting requires a minimum of two 2D shapes: a path and a shape.

A good workflow is to position the path where you want the 3D object to be created and then use the Get Shape command in the Loft compound object to attach an Instance clone of the shape on the path to define the cross-section of the 3D object.

Let's presume that your client has asked you to create a railing around the walkway of your windmill, but the client is not exactly sure what cross-section would be best and would like you to offer several options. This is an ideal situation for applying Lofting because you can quickly substitute one cross-section shape for another and view the results immediately in the scene. Once the client has made a decision of which option would be best, you can then quickly adjust Path Steps and Shape Steps to optimize the lofted 3D object for the best visual quality and efficiency balance.

The windmill scene you will use in Exercise 26-2-1 already has a circle positioned at the top of the railings (loft path) and two 2D shapes (loft shapes) to be used as alternate cross-sections for the lofted object. Let's create a railing.

Exercise 26-2-1 Loft a Railing

1. Open the file from the website called Exercise 26-2-1_Modeling01.max and save it to an appropriate folder on your hard drive with a new incremental name. Use the keyboard shortcut H to open the Select From Scene dialog and then click the Display None filter button in the dialog's toolbar. This hides all the objects in the list. Then click the Display Shapes button to reveal only the 2D shapes in the list. Highlight railing_path, railing_shape001, and railing_shape002 and then click the Display All button to return all objects to the list (see **Figure 26-11**). Click the OK button.
2. Use the keyboard shortcut Alt+Q to isolate the selection. Click Zoom Extents All Selected to fill all viewports with the selected shapes. In the Top viewport, select the circle called railing_path. Again, the path defines where the lofted object will be created. In the Create panel, Geometry category, click the Standard Primitives drop-down list and choose Compound Objects. In the Object Type rollout, click the Loft button (see **Figure 26-12**). This opens the Loft creation tool.
3. In the Creation Method rollout, click the Get Shape button. In the Top viewport, pick the railing_shape001 (red). The 3D railing appears as a cross-section lofted around the circle (see **Figure 26-13**). Press the Esc key to exit Get Shape mode. Exiting Get Shape mode is a good habit to avoid accidentally picking another shape and replacing the current lofted shape.

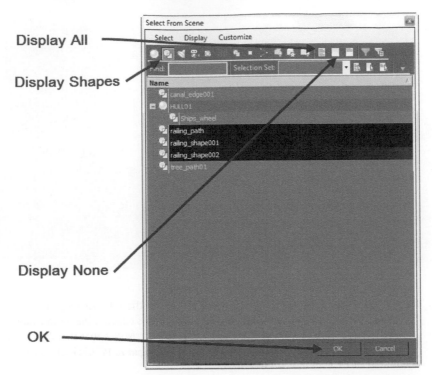

FIG 26-11 Select the three 2D railing shapes.

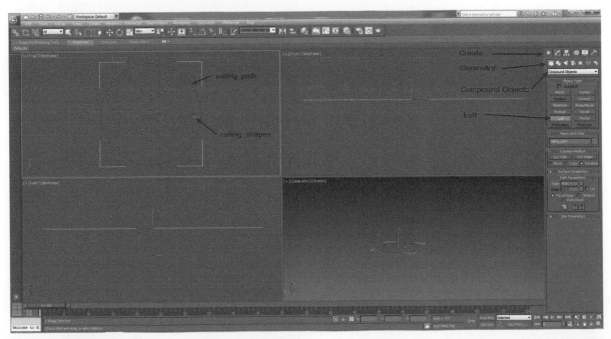

FIG 26-12 The Loft command is deep in the menu hierarchy.

FIG 26-13 The 2D shape is lofted around the circle to create the railing.

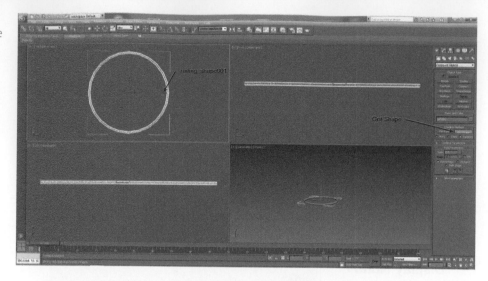

4. In the Top viewport, right click on the lofted object and then choose Object Properties from the Quad menu. In the Object Properties dialog, Object Information area, Name field, enter **Railing001** to rename the object. Notice that the object has 2304 Faces, making it a relatively complex object (see **Figure 26-14**). Click OK to close the dialog and accept the name change.

Name

Faces

FIG 26-14 The Object Properties dialog contains useful information and options.

5. Right click on the Camera001 viewport and then press the keyboard shortcut P to switch to a Perspective viewport. Use the mouse wheel to zoom in on the railing for a closer look. Click on the [Shaded] viewport label and choose Edged Faces to display both the wireframe and the shaded geometry. In the Modify panel, Skin Parameters rollout, Options area, enter **2** in the Shape Steps numeric field and then press Enter (see **Figure 26-15**). The railing becomes more efficient by eliminating intermediate steps between vertices that define curvature, thereby reducing the number of faces. If you check Object Properties again, you will see that there are 1152 faces in the object, about half the original. The railing still looks the same, but it appears a bit segmented and not round.

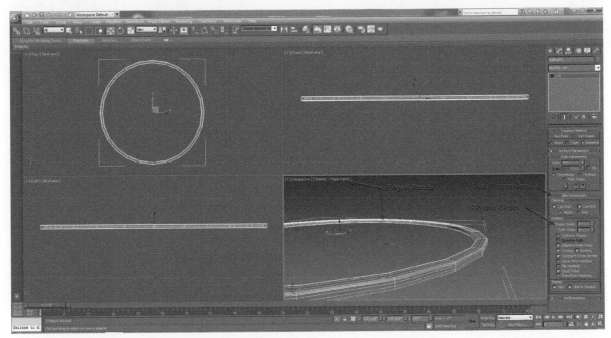

FIG 26-15 Reducing Shape Steps increases efficiency while maintaining visual quality.

6. In the Modify panel, Skin Parameters rollout, Options area, enter **8** in the Path Steps numeric field and then press Enter. This increases the number of intermediate steps along the path that define curvature. A check of the Object Properties dialog shows that the number of Faces has increased to 1728, a bit less efficient but better visual quality for a good balance (see **Figure 26-16**). Click OK to close the dialog.
7. In the Modify panel, Creation Method rollout, click the Get Shape button. In the Top viewport, pick railing_shape002 (green). Zoom in on the shapes. The original lofted shape is replaced with the new, more complex shape and has increased the number of faces to 2592. However, the Path Steps in the Shape Steps remain optimized for the more complex railing (see **Figure 26-17**).
8. Right click on the Perspective viewport, then press C to switch back to Camera001 viewport, and then use the keyboard shortcut Alt+Q to exit isolation mode. The

FIG 26-16 For a better looking, railing and minimal increase in the number of faces increase Path Steps.

FIG 26-17 You can quickly substitute a new cross-section shape with Get Shape to show the client an alternate railing.

railing is positioned on the walkway. Save the file. It should already be called Exercise 26-2-1_Modeling02.max. Lofting is flexible and efficient and should be a common modeling tool in your day-to-day workflow.

Graphite Modeling Tools provide modeling options that are not available in other modeling techniques and you have reasonable control over the number of faces or polygons as you are creating the objects. However, this type of polygon modeling is not particularly flexible if you need to undo some of the work you've done.

Lofting can be used as a basis for organic models, but is perhaps better suited for more linear geometry, which requires flexibility and efficiency combined. The modeling technique you choose will depend on your requirements and production workflow, but the more you know about the various techniques, the more intelligent your choices will be.

Intermediate Animation

Keyframe animation that you learned in Chapter 25, transforming objects while the Auto Key is toggled on, is an excellent method of animating simple motion. Once you create several keys on the track bar, you can then move the keys around to change the animation.

It is important to understand that practically every object in 3ds Max has a Position XYZ animation controller assigned to it by default. This allows you to move objects freely in space. The Euler XYZ controller is assigned to all objects to allow free rotations in space and, as you learned previously, to animate them when the Auto Key button is toggled on and the time slider is at a frame other than frame 0.

However, when the animated motion you require becomes more complex, that method of keyframe animation can be very limiting. In this chapter, you will learn about changing animation controllers to affect the behavior of object motion or rotation in the scene. You'll also be introduced to animation constraints, controllers that require outside information to define the motion or rotation.

Also, rather than moving animation keys on the track bar, you'll be introduced to the Track View-Curve Editor, a dialog that allows you to view and edit animation as curves. This provides more visual feedback for fine-tuning your animation.

You will learn the basic concepts and practices of hierarchical linking, establishing a parent/child relationship between objects to provide more control when animating.

Some of the topics covered in this chapter are as follows:

- *Controllers/Constraints*: Controllers and constraints are the animation "modifiers" in 3ds Max.
- *Track View-Curve Editor*: Expand the control of animation keys and curves in Track View-Curve Editor.
- *Hierarchical linking*: Establishing a parent/child relationship between animated objects.

The windmill scene has a pair of dories (small open boats) in the canal that you will animate moving across the water. However, one of the dories must take several turns before coming to rest, and while you could animate the dory using the keyframe method you learned earlier, it will be much easier to change its default Position XYZ controller to a Path Constraint. This allows you to pick a 2D path on the water surface to describe the animation of the pivot point of the dory.

Note

It is helpful to understand that when you animate an object, you are actually animating its pivot point.

You will replace the default Euler XYZ rotation controller of another dory with a Look-At constraint and then pick the first dory as the Look-At target. This will cause the second dory to always rotate toward the first dory as it moves through the scene.

You'll then use Track View-Curve Editor to make adjustments to the animation, and finally you will hierarchically link a flag and flagpole in the scene to the first dory. The dory becomes the parent object, and wherever the parent goes, the child (or children) must go with it, but the child can have its own motion.

27.1 Controllers and Constraints

Every object and many parameters have controllers assigned to them in 3ds Max that are used to define the animation of objects. Constraints are controllers that require outside information used as targets to define the animation of objects.

Let's animate the dories.

Exercise 27-1-1 Animate the Dories

1. Open the file from the website called Exercise 27-1-1_Animation01.max and save it to an appropriate folder on your hard drive with a new incremental name. In the Top viewport, select Dory002. This object can be moved freely in space because it has the default Position XYZ controller assigned to it, but you want to animate the dory using the question mark–shaped path surrounding the dory (dory_path001) (see **Figure 27-1**). Notice also there is a flag and flagpole at the back of the dory.
2. In the Motion panel, Assign Controller rollout, highlight position: Position XYZ in the Controller list, and then click the Assign Controller button. In the Assign Position Controller dialog, double-click Path Constraint (see **Figure 27-2**). This substitutes the existing position controller with the new Path Constraint, which will require outside information to function. If you try to move the dory at this point it will not move.

FIG 27-1 The dory will be animated along the path.

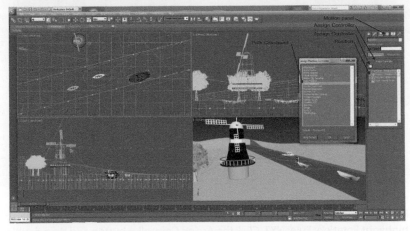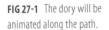

FIG 27-2 Replace the default Position XYZ controller with the Path Constraint.

3. In the Motion panel, Path Parameters rollout, click the Add Path button. In the Top viewport, pick the dory_path001 question mark shape. The pivot point of the dory jumps to the first vertex of the path, and the name of the path appears in the Target list (see Figure 27-3). You can see that animation keys have automatically been placed

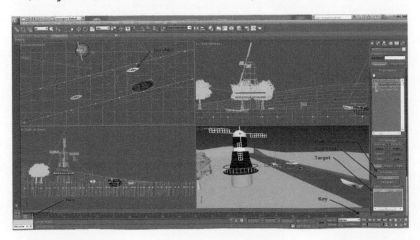

FIG 27-3 Add the 2D shape as a Path target, and the pivot point of the dory is animated along the path.

at frame 0 and frame 100. Scrub the time slider and you will see the boat is animated over the entire time duration. It also keeps its orientation as it travels along the path. Let's fix the object's orientation next.

4. In the Path Parameters rollout, check the Follow checkbox. This causes the dory to orient itself perpendicular to the path's curvature as it travels along the path. Scrub the frame slider and you will see the boat turn as it moves. However, the boat is traveling backward. In the Path Parameters rollout, Axis area, check the Flip checkbox (see **Figure 27-4**). The orientation of an object animated along a path will depend on its original creation parameters. Let's change the rotation controller of the other dory.

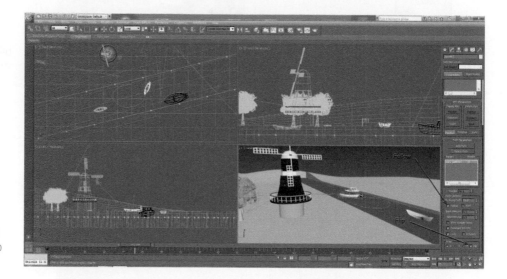

FIG 27-4 Follow orientates the boat perpendicular to the curvature of the path, and Flip reverses it on the path.

5. In the Top viewport, select Dory01. In the Motion panel, Assign Controller rollout, highlight Rotation: Euler XYZ. Click the Assign Controller button and then double click Look-At constraint (see **Figure 27-5**). This constraint requires a Look-At target.

FIG 27-5 Assign a Look-At Constraint to dory01's rotation.

6. In the Look-At constraint rollout, click the Add Look-At Target button and then pick Dory002 in the Top viewport. The side of Dory01 now points at Dory002. In the Select Look-At Axis area, choose the Y radio button. This orients the front of the dory toward Dory002 (see **Figure 27-6**). Scrub the time slider and you will see the dory orient itself toward the other dory as it moves along the path.

FIG 27-6 The Look-At Constraint orients (rotates) an object towards the target object.

7. If you watch Dory01 in the Camera001 viewport, you will notice that it rolls to one side when the Dory002 comes close. Look-At rotation objects sometimes need to be told "which way is up." In the Source/Upnode Alignment area, check the Flip checkbox in the Source Axis area and then choose the Y radio button in the Aligned to Upnode Axis area (see **Figure 27-7**). This keeps the boat upright as it rotates.

FIG 27-7 Sometimes the Look-At objects need to know which way is up.

8. Save the file. It should already be called Exercise 27-1-1_Animation02.max. The problem now is that if you scrub the time slider, you will see that Dory002 collides with HULL01. You'll fix that in Exercise 27-2-1.

27.2 Track View-Curve Editor

It is fine to slide animation keys of the selected object along the track bar for adjusting the simplest animations when it's clear what the keys are representing. However, as your animations become more complex and sophisticated, determining which key on the track bar does what can be daunting.

In the following exercise, you will learn to use the Track View-Curve Editor to view position function curves of two animated objects and then adjust them to avoid collisions.

Exercise 27-2-1 Adjusting Animation

1. Open the 3ds Max file from the previous exercise called Exercise 27-1-1_Animation02 .max and save it to an appropriate folder on your hard drive with a new incremental name. Make sure the Top viewport is active and then scrub the time slider to see that at frame 30 both HULL01 and Dory002 are about to collide with each other (see **Figure 27-8**). Position the time slider on frame 30. You will use Track View-Curve Editor to slow the dory down to avoid collisions.

FIG 27-8 The boats are about to collide at frame 30.

2. In the Top viewport, select HULL01 and Dory002. In the Graph Editors pull-down menu, choose Track View-Curve Editor. The Track View-Curve Editor dialog shows color-coded curves representing the positions and rotations of the HULL01 and a cyan-colored Percent curve for Dory002 (see **Figure 27-9**). You will be interested in the x-axis position of HULL01 (red curve) and the Percent curve of Dory002 (cyan curve).

FIG 27-9 The Track View-Curve Editor shows function curves for transformation on selected objects.

3. In Track View-Curve Editor, hierarchy column, highlight X Position for HULL01, hold the Ctrl key, and highlight Percent for Dory002. This displays the curves and you can see that around frame 36 the curves intersect, indicating a near collision of the object's pivot points (see Figure 27-10). You will add a new control point to the Percent curve at frame 30 and then adjust its value to slow the dory down.

FIG 27-10 A pivot point collision occurs near frame 36.

4. Highlight Percent for Dory002 to view its curve. In the Track View-Curve Editor toolbar, click the Add Keys button. In the function curve window, pick the cyan curve where it intersects the vertical yellow lines (current frame) to add a new control key to the curve (see Figure 27-11). Click the Move Keys button to toggle Add Keys off to avoid adding another key by mistake.

FIG 27-11 Add a new control key to the Percent curve at frame 30.

417

5. At the top center of the Track View-Curve Editor are numeric fields for the Frame number and the Value (percent along the path). To slow the dory down, you need to lower the value at the current frame. Enter **7** in the Value numeric field. Where the Percent curve is flatter, the object is traveling slower. It is only 7 percent of the way along the path at frame 30. Scrub the time slider and you will see that the boats just barely make it past each other at frame 41 (see **Figure 27-12**).

FIG 27-12 At frame 30, the dory is now only 7 percent of the way along the path, thereby avoiding a collision.

6. Close the Track View-Curve Editor and save the file. It should already be called Exercise 27-1-1_Animation03.max. By changing the percentage curve of the dory which is controlled by a Path Constraint, you can change the speed at any point in time by adding a new key and adjusting its value. The problem now is that the animated Dory002 has gone off without its flag and flagpole. In Section 27.3, you'll learn some fundamentals about hierarchical linking.

27.3 Hierarchical Linking

Many times in 3ds Max animation, animated objects need to stay in proximity to each other as they move and rotate through space, but the objects must have their own animation as well.

Rather than animate each object individually and hope that you get things coordinated, you can use a concept called hierarchical linking. A "child" object is linked to a "parent" object and wherever the parent goes, the child has to go with it, but the child can have its own action.

In this scene you want the flagpole to travel with the dory, but the flagpole should be free to move or rotate within the confines of the boat if you need to reposition it. Also, the flag should stay with the flagpole as it moves and rotates with the boat through the scene, but the flag should have the ability to move independently too.

You will open the previous 3ds Max scene, link the flag as a child to the flagpole parent, and then move the flagpole to the new position of the dory where it will become a child of the dory parent. The result will be that when the boat moves and rotates, so will the flag and flagpole, but they can have their own independent motion.

Exercise 27-3-1 Link the Flag, Flagpole, and Dory

1. Open the file from the previous exercise called Exercise 27-1-1_Animation03.max and save it to an appropriate folder on your hard drive with a new incremental name. Select Flag_pole001, Flag001, and Dory002. Use the keyboard shortcut Alt+Q to isolate the selection Move the flag and the flagpole to the back of the dory (see Figure 27-13).

FIG 27-13 Place the flag and flagpole at the back of the dory.

2. In the Front viewport, select Flag001. In the main toolbar, click the Select and Link at the far left. Move the cursor over the flag in the Front viewport and when you see the link cursor and click and drag to the Flag_pole001. Release the left mouse button when you see this cursor change (see Figure 27-14).

FIG 27-14 Click and drag from the child object and then release over the parent object to create the link.

419

3. In the main toolbar, click the Select and Rotate button. In the Top viewport, select Flag_pole001 and then rotate slightly toward the back (see Figure 27-15). As you rotate the flagpole, the flag follows correctly because the flag is a child of the flagpole parent.

FIG 27-15 Rotating the parent (flag pole) affects the child (flag).

4. In the main toolbar, click the Select and Link button. In the Front viewport, click and drag from the flagpole (child) to the dory (parent) to establish a hierarchical link. Zoom out in the orthographic viewports and then scrub the time slider to see that all the objects move together (see Figure 27-16).

FIG 27-16 The dory is the grandparent, the flagpole is the parent, and the flag is the child.

5. Use the keyboard shortcut Alt+Q to exit isolation mode and then save the file. It should already be called Exercise 27-1-1_Animation04.max. Hierarchical linking may be used as deeply as necessary. A child can only have one parent, but a parent can have many children.

A variety of animation controllers and constraints can be applied in 3ds Max to determine the type of animation parameters available for objects. Animation controllers act directly and have parameters that can be adjusted, but animation constraints require outside "target" objects to define the animation capabilities.

Track View-Curve Editor can be used to view function curves representing the animation parameters of an object that can be adjusted visually and numerically for better control.

Hierarchical linking is very useful to establish a parent/child relationship between objects. The child object is selected and then linked to the parent object and the process may be nested as deeply as necessary.

Experiment on a very simple scene with just a few 3D objects and 2D shapes and assign different controllers and constraints to see how they function. Then open Track View-Curve Editor and adjust the various curves so that you have a feeling for how everything works in conjunction with each other.

Global Illumination

In Chapter 22, you learned to light the windmill scene with the direct light from the sun and sky. The result was not particularly convincing because the shadows and shaded portions of the scene were pure black. Any surface that is not in the path of the light rays emitted from the light source received no light.

In the real world, direct illumination strikes a surface and then is bounced from that surface until it strikes another surface, and so on. This indirect illumination transfers light energy and with it some of the surfaces' color throughout the scene, raising the overall lighting levels, especially in the shadows and shaded areas.

3ds Max with the mental ray rendering engine has the ability to calculate indirect illumination, and in this chapter, you will learn the fundamentals of how it works to make your renderings more convincing to the viewer.

Some of the topics covered in this chapter are as follows:

- *Introduction to global illumination*: Global illumination is, in general, computer visualization terminology, the result of all light sources combined.
- *Global Illumination in 3ds Max*: You will learn to use Global Illumination in 3ds Max as a method of calculating light bounced from surface to surface.
- *Final Gathering*: You'll also learn about another method of calculating bounced light called Final Gathering in 3ds Max.
- *Ambient Occlusion*: This Arch & Design material attribute is used to simulate shadows at the intersection of two surfaces to add depth to the scene.

28.1 Introduction to Global Illumination

Global illumination can be a confusing term for new users of computer visualization. In general terms, it means the lighting effect from all combined light sources in a scene. It is possible to have many different light sources contributing to this overall lighting effect: direct light from the sun and sky, direct lighting from artificial light fixtures, and direct light from glowing objects in a scene.

Another important source of light in global illumination is the indirect light that is the result of light bouncing from one surface to another. The amount of indirect light contribution is determined by the intensity of the light sources (direct light) and the reflectivity of the surfaces' materials (indirect light).

When rendering in 3ds Max with the mental ray rendering engine, you have two basic options for calculating indirect illumination (bounced light): Global Illumination and Final Gathering.

Global Illumination, in 3ds Max terms, is a specific method of tracing the path of light energy (photon) from the light source to the first surface and then on to the subsequent surfaces along its new path. Upon each bounce, energy and color is transferred from one surface to the next, resulting in indirect illumination. The photons must hit at least two surfaces to have any effect (see **Figure 28-1**).

FIG 28-1 Enabling Global Illumination would trace light energy bouncing from surfaces, providing indirect illumination.

The other method of calculating bounced light in 3ds Max is called Final Gathering, where each of the rendered pixels is compared with its neighbors' and then adapted to blend into its surroundings, simulating the transfer of light from one surface to another (see **Figure 28-2**).

Discussions of global illumination can often be highly technical, with impressive jargon and mathematical concepts that leave new users of 3ds Max totally overwhelmed and bewildered. In this book you will learn the "big picture" of how global illumination functions using analogies rather than technical terminology. Once you understand the process, it will be easier to make sense of the technical aspects as you apply the Global Illumination methods to more complex scenes.

FIG 28-2 Enabling Final Gathering would alter the color and brightness of pixels based on an analysis of their surroundings.

28.2 Global Illumination in 3ds Max

Again, 3ds Max uses the term Global Illumination as a specific method of calculating bounced light in mental ray where photons are emitted from light sources and bounced from surface to surface. Let's use honeybees as an analogy to better understand the process of Global Illumination in 3ds Max.

The honeybee hive is equivalent to the 3ds Max light source, it's where all the energy is stored. The bees consume that energy and leave the hive to travel to flowers. A hive can only supply a set amount of energy (photons in 3ds Max terms) and each bee takes an equal amount.

The bees travel to flowers (surfaces in 3ds Max) to pick up pollen and then transfer it to other flowers until they run out of energy. As they travel from flower to flower, they transfer genetic information that eventually will affect the flowers they travel to. For example, if a bee lands on a red flower and transfers its pollen to a white flower, the result will eventually be a pink flower. Similarly in 3ds Max, light energy and color information is transferred from surface to surface affecting each surface along its path. This transfer of energy is subject to attenuation in the same way you learned about in this books' discussion of direct light, eventually the photon has little or no effect.

Bees that do not find flowers simply dissipate their energy and have no effect on the environment. Photons that do not strike surfaces also have no effect in a 3ds Max scene.

In Exercise 28-2-1, you will open a windmill scene that has a white material assigned to all the objects except the windmill itself, which maintains the materials you applied in Chapter 23. You will render the scene using direct light first and then save that rendered image in RAM Player. You'll then enable Global Illumination with the default settings and render the scene again to compare the effects of indirect illumination. You'll then make some adjustments to increase the quality of Global Illumination in the scene.

Exercise 28-2-1 Global Illumination

1. Open the 3ds Max file from the website called Exercise 28-2-1_GI01.max and save it to an appropriate folder on your hard drive with a new incremental name. Make sure the Camera001 viewport is active and then click the Render Production button in the main toolbar. In the Rendering pull-down menu, choose RAM Player. In the RAM Player dialog, click the Open Last Rendered Image in Channel A and then click the OK button in the RAM Player Configuration dialog to accept the default settings (see Figure 28-3). 3ds Max is set to render direct light only, resulting in black shadows and shading. Minimize the RAM Player, but do not close it.

FIG 28-3 Rendering direct light only reduces black shadows and shading.

2. In the main toolbar, click the Render Setup button. In the Render Setup dialog, click the Indirect Illumination tab. In the Caustics and Global Illumination (GI) rollout, Global Illumination (GI) area, check the Enable checkbox to turn Global Illumination on. Check the Maximum Sampling Radius option and then enter **1'0"** in the Maximum Sampling Radius numeric field (see Figure 28-4).
3. In the Render Setup dialog, click the Render button at the lower right. The result should be a scene with many multicolored circles where light energy has bounced from surface to surface transferring color and brightness information (see Figure 28-5). However, the sampling radius is too small to effectively blend the indirect illumination.

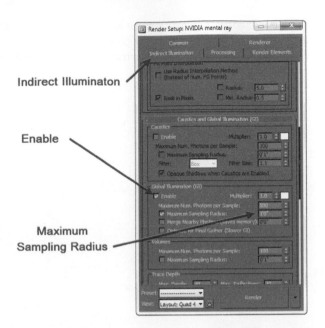

Indirect Illuminaton

Enable

**Maximum
Sampling Radius**

FIG 28-4 Global Illumination
is enabled in Render Setup,
Indirect Illumination.

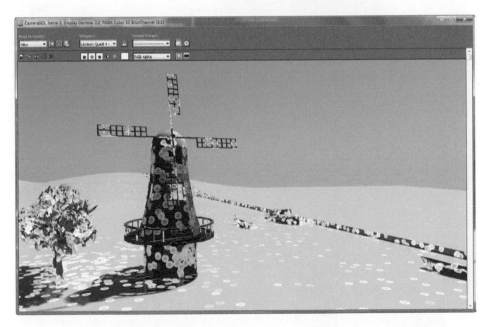

FIG 28-5 Enabling Global
Illumination calculates light
bouncing from surface to
surface.

4. In the Render Setup dialog, Caustics and Global Illumination (GI) rollout, Global
 Illumination (GI) area, enter **10'0"** in the Maximum Sampling Radius numeric field
 and then render the scene again. The result is a much smoother transfer of color
 information and lighting from surface to surface, resulting in the illusion of indirect
 illumination. Change the Maximum Sampling Radius to **5'0"** and then render again.
 The smaller radius results in less blending, but better definition of some of the surfaces

(see **Figure 28-6**). A good Global Illumination result is achieved by balancing the numeric values for both sampling radius and number of photons per sample. Each scene will be different and it's important that you approach the changes systematically.

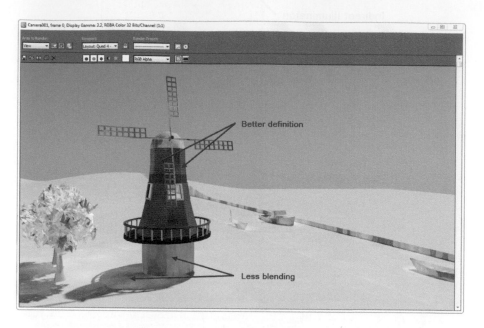

FIG 28-6 Increasing the sampling radius blends the indirect illumination.

5. Maximize the RAM Player and then click the Open Last Rendered Image in Channel B and accept the defaults in the dialogs. Click and drag the cursor in the RAM Player window and you'll see a comparison of the rough Global Illumination calculations on the right compared with the direct light only rendering on the left (see **Figure 28-7**).

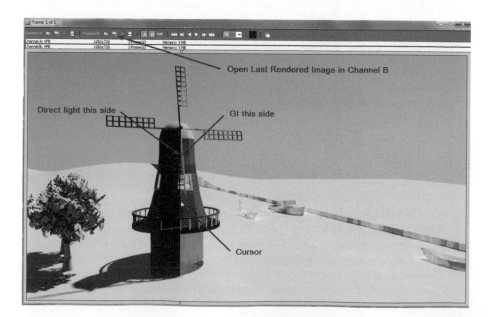

FIG 28-7 RAM Player can be used to compare images in Channel A and Channel B.

6. Close all windows and dialogs and save the file. It should be called Exercise 28-2-1_GI02. max. As mentioned earlier in the chapter, Global Illumination is best used for interior scenes or scenes that are enclosed by geometry so that the photons from the light sources are used efficiently, bouncing off various surfaces. In this outdoor scene, many of the photons are lost when they travel into space.

Let's see what happens in this scene with Final Gathering as the indirect illumination calculation method.

28.3 Final Gathering

Another method of calculating bounced light in mental ray is with Final Gathering, where pixels in the rendered image are compared with their neighbors and adjusted to blend in to the surroundings more convincingly.

An analogy that can be used for Final Gathering indirect illumination is that of a chameleon. The pixel is a chameleon sitting on, for example, a gray rock. To one side of the chameleon is a green bush and on the other side are some red flowers. Above the chameleon is a clear blue sky.

The chameleon starts with its natural coloring and then perceives the surrounding colors and does its best to blend in. The pixel in a 3ds Max scene performs similar calculations and changes its original color based on the samples of its surroundings.

Let's begin by opening the scene from the last exercise and rendering it again, putting the Global Illumination rendering in Channel A of the RAM Player so that you can compare it with the result from Final Gathering calculation methods.

Exercise 28-3-1 Enable Final Gathering

1. Open the file from the previous exercise called Exercise 28-2-1_GI02.max and save it to an appropriate folder on your hard drive with a new incremental name. Render the Camera001 viewport and then open the rendered image in Channel A of the RAM Player. In the Render Setup dialog, Indirect Illumination tab, Caustics and Global Illumination (GI) rollout, Global Illumination (GI) area, clear the Enable checkbox to turn Global Illumination off.
2. In the Render Frame Window, Final Gather Precision area, drag the slider one notch to the right to Draft mode and then click the Render button. The render window will appear mottled as Final Gathering samples the pixels in the scene on the first pass (see Figure 28-8). A second pass then renders the scene based on the Final Gathering calculations.
3. In the RAM Player, click the Open Last Rendered Image in Channel B button and accept the defaults in the dialogs. Click and drag the cursor in the RAM Player window to compare the two side-by-side images. Two things are immediately apparent: the distribution of indirect illumination is much smoother and the scene

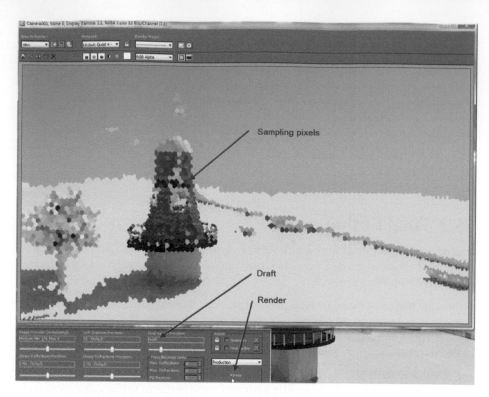

FIG 28-8 Final Gathering analyzes a sampling of pixels and adjusts them based on their surroundings.

has a blue component that simulates the effects of the blue sky on shadows and materials (see Figure 28-9). All areas of the rendered scene are sampled by Final Gathering, including the blue sky, whereas in Global Illumination, the photons were lost in space and did not bounce off the blue sky.

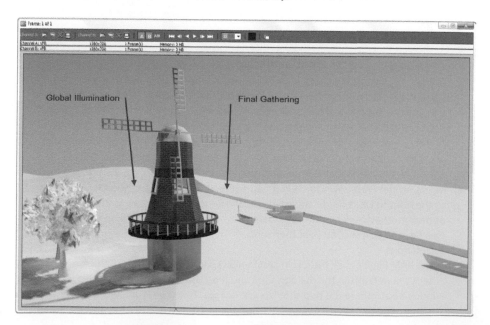

FIG 28-9 Final Gathering samples the pixels in every area of the rendered image for calculating indirect illumination.

4. Close all windows and dialogs and then save the file. It should already be called Exercise 28-2-1_GI03.max. Final Gathering is designed for outdoor scenes, but is often useful in calculating indirect illumination for many indoor scenes, as well.

Global Illumination can result in higher accuracy at a cost of longer rendering times when the number of photons cast from light sources is increased and the sampling area is balanced to provide a smooth result. Again, this works well in scenes that are completely enclosed by geometry and usually requires experimentation to reach the "sweet spot."

Final Gathering is generally a faster process that may result in some lack of detail, but includes areas of mr Physical Sky background, which makes it especially well-suited to outdoor scenes. However, it is generally recommended that you try Final Gathering on any scene to see if the results are acceptable and then move to Global Illumination, if necessary.

Another possible workflow is to first render with Global Illumination to obtain a rough, blotchy result to capture some of the accuracy and then render that result with Final Gathering. This combination method can increase productivity and give better results for many situations.

Let's have a look at Ambient Occlusion in the Arch & Design material in the scene.

28.4 Ambient Occlusion

Although not a form of global illumination, Ambient Occlusion is a material attribute that can be an important factor in quality rendering in mental ray. Ambient Occlusion is found in the Arch & Design material and samples the scene to locate surfaces that intersect or are in contact with each other. A shadow-like effect is then added to the scene to increase the viewer's perception of depth and weight. The effect can be subtle but profound at the same time and is an efficient way to enhance most of your renderings.

Exercise 28-4-1 Ambient Occlusion

1. Open the file from the previous exercise called Exercise 28-2-1_GI03.max and save it to an appropriate folder on your hard drive with a new incremental name. Open the Slate material editor and, in the View1 pane, double-click the heading for Paint_white material node to open its parameters in the Edit pane. In the Special Effects rollout, check Ambient Occlusion (see **Figure 28-10**).
2. Enter **64** in the Samples numeric field to increase the number of samples calculated for increased accuracy. Enter **1'0"** in the Max Distance numeric field to create the special effect further away from every intersections it finds. Click the color swatch to the right of Shadow Color and, in the Color Selector, change the color to pure black (see **Figure 28-11**).

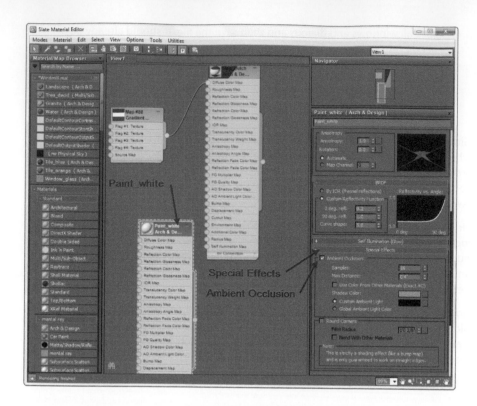

FIG 28-10 Enable Ambient Occlusion in the Special Effects rollout of Arch & Design material.

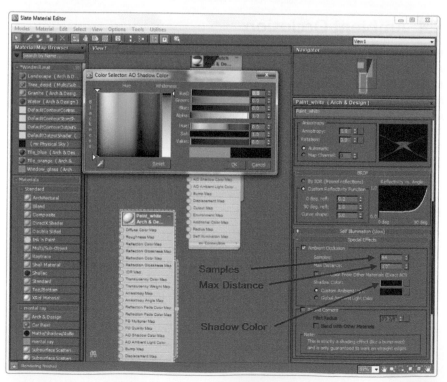

FIG 28-11 It's best to start with moderately high values to test Ambient Occlusion.

3. Render the Camera001 viewport and you will see darkened areas at the intersection of surfaces that have Paint_white material assigned to them (see Figure 28-12). This provides a "crisper" intersection between surfaces. Are you having trouble seeing the effect? Let's choose Render Elements to render the Ambient Occlusion in its own window.

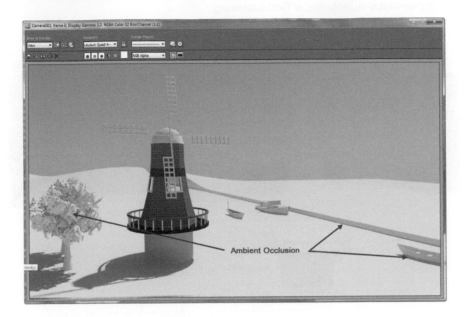

Ambient Occlusion

FIG 28-12 Ambient Occlusion appears as a dark shadow at the intersection of surfaces.

4. In the Render Setup dialog, Render Elements tab, Render Elements rollout, click the Add button. In the Render Elements dialog, choose mr A&D Raw: Ambient Occlusion (see Figure 28-13). Click the OK button and the Ambient Occlusion Render Element will be added to the list.

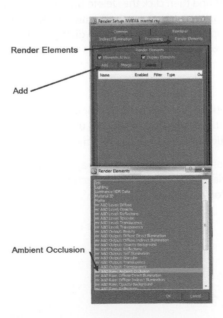

Render Elements

Add

Ambient Occlusion

FIG 28-13 Add Ambient Occlusion to the Render Elements list.

433

5. In the Render Setup dialog, click the Render button. The scene will render normally and then another render pass will produce an image of just the Ambient Occlusion solution, which clearly shows the effects (see **Figure 28-14**). This subtle effect can go a long way in enhancing the detail in your scene without excessively high sampling in either Global Illumination or Final Gathering.

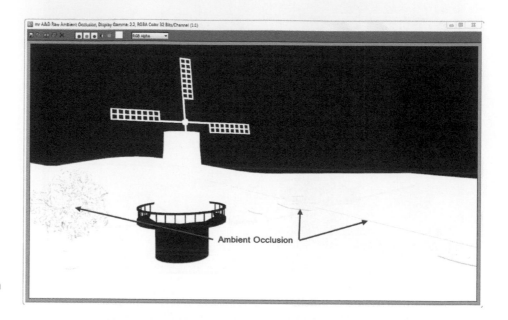

FIG 28-14 Ambient Occlusion Render Elements pass.

6. In the Render Setup dialog, Render Elements tab, highlight mr A&D Raw: Ambient Occlusion in the list and then click the Delete button to remove it. While the image could be used in postproduction, you have only rendered it here to see the effects of Ambient Occlusion. Close all windows and dialogs and then save the file. It should already be called Exercise 28-2-1_GI04.max.

Rendering in 3ds Max with mental ray is a flexible and efficient method of calculating the effects of global illumination (indirect illumination) using either Global Illumination or Final Gathering or a combination of the two calculation methods.

For an efficient method of enhancing your mental ray renderings, you can enable the Ambient Occlusion special effects component of Arch & Design materials to add more contrast at the intersection of surfaces in the scene.

Effects

Effects, sometimes called special or digital effects, can be used to enhance your scenes to make them more convincing to the viewer. For example, in the outdoor windmill scene that you've been working on throughout this book, a few simple atmospheric effects may be used to change the mood of the scene from noon to early morning.

Atmospheric effects are applied to the scene and they can be based on the World coordinate system, as in ground fog, or placed inside containers called Atmospheric Helpers to simulate clouds.

When using the mental ray renderer, the Photometric lights in the scene have values determined by real world physics. Atmospheric effects in 3ds Max have been around since long before mental ray was available, and they work on a different scale of lighting. To match values between the Daylight system brightness levels and the legacy atmospheric effects, you will learn to adjust a setting called Physical Scale.

3ds Max also contains a particle generation effect called Particle Flow. You will learn to simulate a flock of birds flying from one tree to the next by setting up a schematic Particle Flow system. In this case, because the birds are seen at a distance, you will simply use the particles generated by Particle Flow and not digitally modeled birds. The point of the lesson is to learn the workflow of creating a particle system.

Some of the topics covered in this chapter are as follows:

- *Fog effect*: Atmospheric fog can add depth to your scenes.
- *Simulate clouds*: Fire Effect in 3ds Max can simulate 3D clouds.
- *Introduction to Particle Flow*: You will learn to set up a simple Particle Flow system to simulate a flock of birds.

29.1 Atmospheric Effects

Atmospheric effects such as fog and clouds can add a sense of depth to your scenes and help focus the viewer's attention where you want it. In this section, you'll create two types of atmospheric effects: ground fog and clouds.

The goal will be to turn the windmill scene from an afternoon, bright sun scene into a more moody early morning simulation with overhead clouds. The morning fog will be layered and denser at ground level than at eye level. The clouds will be overhead and will help fill the negative space of the empty sky and force the viewer's attention to the horizon. In the scene you will open, the sun has already been repositioned for 6:00 AM and will be shining in the viewer's eyes to illustrate how the mr Physical Sky background displays the sun's disk in the sky.

The atmospheric ground fog is an environmental atmospheric effect associated with the World coordinate system while the clouds are positioned within an Atmospheric Helper, which acts as a container for the clouds.

This scene is set to use Final Gathering to calculate indirect illumination and to speed rendering; you will learn to reuse the Final Gathering solution by saving it to your hard drive so that it can be used without recalculating the indirect illumination each time you render.

Exercise 29-1-1 Create Fog

1. Open the 3ds Max file from the website called Exercise 29-1-1_Effects01.max and save it to an appropriate folder on your hard drive with a new incremental name. Make sure the Camera001 viewport is active and then click on the Rendered Frame Window button in the main toolbar. In the Rendered Frame Window, Reuse area, check the Final Gather checkbox. This will cause 3ds Max to save the Final Gathering solution for the next render. Click on the Render button. When the rendering has finished, toggle the Lock button to the left of Final Gather (see Figure 29-1). 3ds Max has saved the Final Gathering solution to your hard drive and will reuse it the next time you render to avoid recalculation. The sun's disk is created automatically by mr Physical Sky.

Note

If the lighting or materials change in the scene or if new large objects are added, you should clear the indirect illumination solution by clicking the red X button and then recalculating a new solution file.

2. Close the Rendered Frame Window. In the Rendering pull-down menu, choose Environment. In the Environment and Effects dialog, Atmosphere rollout, click the Add button and then double-click Fog in the Add Atmospheric Effect dialog (see Figure 29-2). This will add the effect to the list and make available its editing parameters.

FIG 29-1 Check Final Gather in Rendered Frame window, render the scene, toggle the lock on.

Fog

Add

FIG 29-2 Add the Environmental effect called Fog to your scene.

3. In the Fog Parameters rollout, Fog area, notice that the color swatch is white. Choose the Layered radio button to create layered fog. In the Layered area, enter **5'0"** in the Top numeric field, choose the Top Falloff radio button, and then enter **2** in the Density numeric field (see **Figure 29-3**). Render the Camera001 viewport. The lower one quarter of the screen becomes much darker, especially along the horizon. You need to adjust Physical Scale to match the brightness of the mental ray sun with the old-style effects.

Top — Layered

White

Top

Density

FIG 29-3 Adjust the Fog parameters.

4. Open the Rendered Frame Window, Reuse area, click the Lock button to unlock the Final Gather solution, and then click the red X to the right of Final Gather. In the Delete Files dialog, click the Yes button to confirm deletion of the saved Final Gather solution file. The next step will change the lighting values in the scene, resulting in an overexposed rendering if the current Final Gather solution is used.

5. In the Environment and Effects dialog, mr Photographic Exposure Control rollout, Physical Scale area, choose the Unitless radio button and enter **80000** (eighty thousand) in the Unitless numeric field (see **Figure 29-4**). This value approximately

mr Photographic Exposure Control

Unitless

FIG 29-4 The Physical Scale must be set to Unitless and match the brightest light in the scene, in this case the sun.

matches the number of lumens generated by the sun. Render the Camera001 viewport and you will see a layer of ground fog tapering off at about 5 feet above the ground. The problem is the horizon is distracting because you are looking through fog to infinity. Let's fix that by adding Noise to the horizon.

6. In the Environment and Effects dialog, Atmosphere rollout, make sure that Fog in the Effects list is highlighted. In the Fog Parameters rollout, Layered area, check the Horizon Noise checkbox and then enter **10** in the Size numeric field (see **Figure 29-5**). Render the Camera001 viewport and you will see that the Noise has resulted in a more convincing look, especially at the horizon.

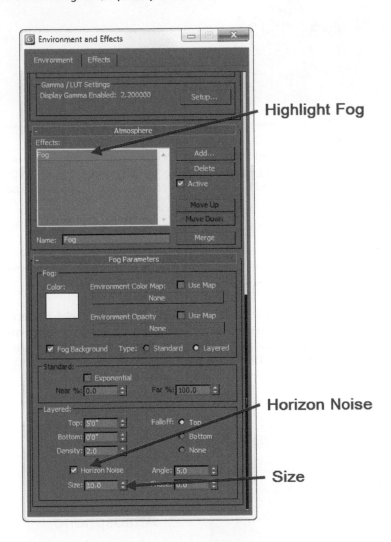

FIG 29-5 Add Horizon Noise to break up the top edge of the fog.

7. Close all windows and dialogs and then save the file. It should already be called Exercise 29-1-1_Effects02.max. The addition of the Environment Atmospheric fog changes the mood of the scene to better reflect the early morning hour. The fog begins at the World coordinate plane and then extends up to the height you set to create a layered affect over the landscape (see **Figure 29-6**).

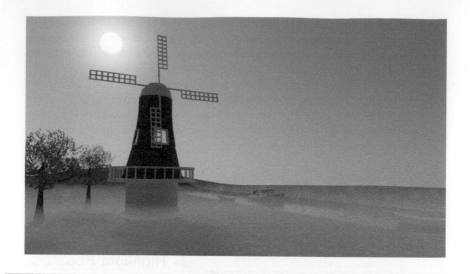

FIG 29-6 Layered fog creates an early-morning mood.

Let's try a different approach to add clouds in the sky by using an atmospheric effect called Fire Effect. As its name implies, it's intended to create fire and explosions, but with the right settings (and Physical Scale), it can be used to make convincing clouds with many possible variations.

This type of atmospheric effect requires a container called an Atmospheric Apparatus Helper in the scene.

Exercise 29-1-2 Create Clouds

1. Open the 3ds Max file from the previous exercise called Exercise 29-1-1_Effects02 .max and save it to an appropriate folder on your hard drive with a new incremental name. Right-click in the top viewport to activate it. In the Create panel, Helpers category, click the Standard drop-down list and then choose Atmospheric Apparatus (see **Figure 29-7**).

FIG 29-7 Atmospheric Apparatus are containers for environmental effects.

2. In the Object Type rollout, click the BoxGizmo button, then click in the Top viewport near the tree at the upper left, and then drag down and to the right beyond the larger boat. Release the left mouse button, push the mouse forward, and then click to set the height. In the Modify panel, BoxGizmo Parameters rollout, enter **200′0″** in the Length and the Width numeric fields and then enter **25′0″** in the Height numeric field. Click the Select and Move button in the main toolbar, and in the Camera001 viewport, move the BoxGizmo up so that its bottom is just above the windmill blade (see **Figure 29-8**).

FIG 29-8 Create a BoxGizmo Helper and move it above the windmill blades.

3. In the Atmospheres & Effects rollout, click the Add button, and in the Add Atmosphere dialog, double-click Fire Effect (see **Figure 29-9**).

FIG 29-9 Fire Effect can be added from the Modify panel or from the Environment and Effects dialog.

4. In the Atmospheres & Effects rollout, highlight Fire Effect in the list and then click the Setup button to open the Environment and Effects dialog. In the Fire Effect Parameters rollout, Shape area, enter **0.75** in the Regularity numeric field, enter **1000** in the Flame Size numeric field, and enter **2.0** in the Density numeric field (see **Figure 29-10**). Render the Camera001 viewport and you will see a fire-like cloud: interesting perhaps, but not convincing. Let's make some minor changes.

FIG 29-10 Adjust the Fire Effect parameters.

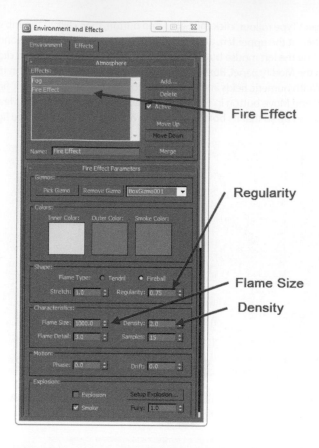

5. In the Fire Effect Parameters rollout, edit the Inner Color color swatch to pure white and then edit the Outer Color color swatch to pure black. Render the Camera001 viewport and you will see a more natural looking cloud (see **Figure 29-11**).

FIG 29-11 Make the Inner Color white and the Outer Color black.

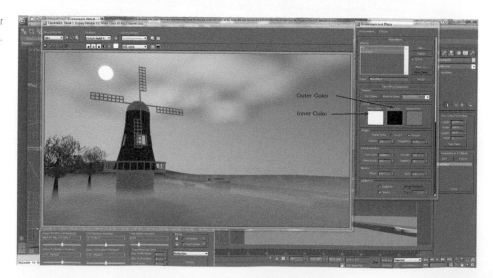

6. Close all windows and dialogs and then save the file. It should already be called Exercise 29-1-1_Effects03.max. The Fire Effect's parameters can all be edited and the BoxGizmo can also be edited and animated to produce dynamic cloud effects.

Let's learn the fundamentals of creating a Particle Flow system in 3ds Max.

29.2 Introduction to Particle Flow

Particle Flow is an event-driven feature of 3ds Max used to generate particle systems to simulate special effects from steam and smoke, spraying water, or even a flock of birds, for example. You create a Particle Source to emit particles and then you add Operators to edit the particles' behavior.

Particle Flow uses a special dialog called Particle View where you schematically place the Particle Source and the Operators and then wire them together to obtain the desired behavior.

Exercise 29-2-1 A Flock of Birds

1. Open the 3ds Max file from the website called Exercise 29-2-1_Effects03.max and save it to an appropriate folder on your hard drive with a new incremental name. Select the two trees in the upper left corner of the Top viewport and then use the keyboard shortcut Alt+Q to isolate the selection. Click several times on the Zoom Extents All Selected button to fill all viewports (except Camera001) with the two trees (see **Figure 29-12**).

FIG 29-12 Isolate the two trees near the windmill.

2. In the Create panel, Geometry category, click the Standard drop-down list and then choose Particle Systems. In the Object Type rollout, click the PF Source button. In the Top viewport, click and drag a Particle Source icon midway between the trees (see **Figure 29-13**). Scrub the time slider and you will see particles being emitted downward from frame 0 to frame 30.

FIG 29-13 Create a PF Source icon between the trees.

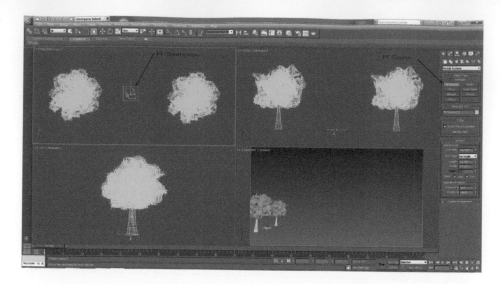

3. Use the Align tool in the main toolbar to align the PF Source icon with the tree on the left. Align Center to Center in all 3 axes. In the Modify panel, Setup rollout, click the Particle View button. This opens the Particle View dialog showing the PF Source and an Event that controls the behavior of the particles (see **Figure 29-14**).

FIG 29-14 Particle View contains an Event with Operators describing the behavior of the particles.

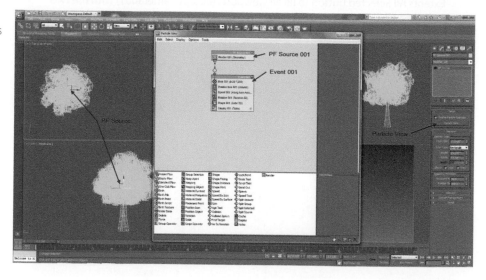

4. Highlight Birth 001 operator in Event 001. In the Birth 001 rollout, enter **30** in the Emit Start numeric field. Enter **50** in the Emit Stop numeric field and then enter **20** in the Total numeric field (see **Figure 29-15**). This tells the particles when to start, stop, and how many there should be. Scrub the time slider to view the new particle settings.

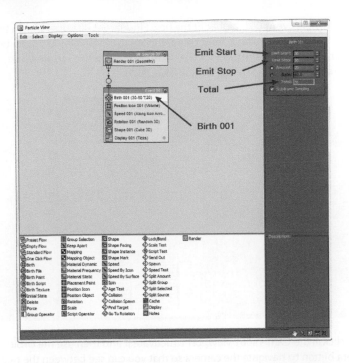

FIG 29-15 Adjust Birth 001
to control when particles
are emitted and how many
there are.

5. In the Particle View dialog, Operators pane, click and drag the Find Target operator
 and then drop it in Event 001 between Rotation 001 and Shape 001. You will see a
 blue line appearing when it is safe to release the left mouse button and drop the
 operator (see Figure 29-16). A Find Target icon will be placed near the tree.

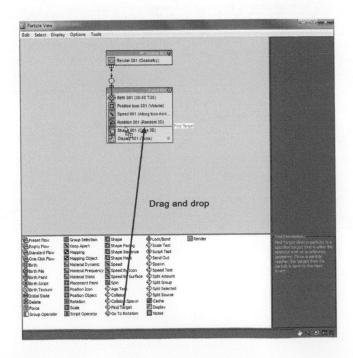

FIG 29-16 Add a Find Target
operator by dragging and
dropping to Event 001.

6. In Particle View, Event 001, highlight the new Find Target 001 operator. In the Edit pane, Find Target 001 rollout, Target area, choose the Mesh Objects radio button, and then click the Add button. Pick the rightmost tree in the Top viewport. The name of the tree will be added to the list (see **Figure 29-17**).

FIG 29-17 Pick the second tree as a Find Target mesh object.

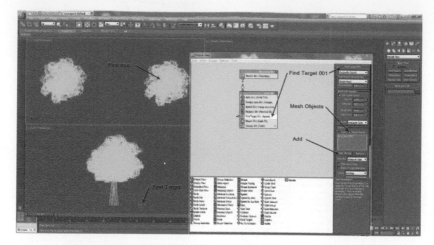

7. Right-click in the Camera001 viewport to activate it and then use the Orbit Camera button to navigate the camera so that you can see between the trees. Drag the time slider to frame 70 and you will see the particles traveling from the first tree to the second tree. Render the Camera001 viewport and you will see the "flock of birds" between the two trees (see **Figure 29-18**). Alright, it's not really a flock of birds, but you see some of the power and the basic workflow of creating a Particle Flow system.

FIG 29-18 The default particles render as cubes in the scene.

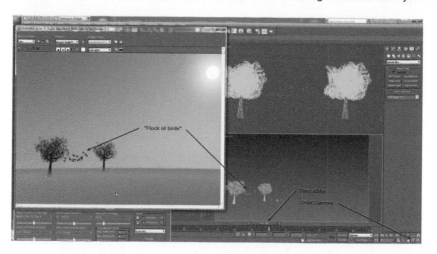

8. Use the keyboard shortcut Alt+Q to exit isolation mode. Close all windows and dialogs and then save the file. It should already be called Exercise 29-1-1_Effects04 .max. The workflow for Particle Flow is aided by the graphical nature of the Particle View dialog. You can easily see the operators associated with an Event, you can drag-and-drop operators, and you can edit their parameters all in the same dialog.

Special effects in 3ds Max can be useful for changing the mood or adding interesting details to hold the viewer's attention. Use them sparingly though: effects placed in the scene that don't add substantially to the purpose of the presentation become useless distractions.

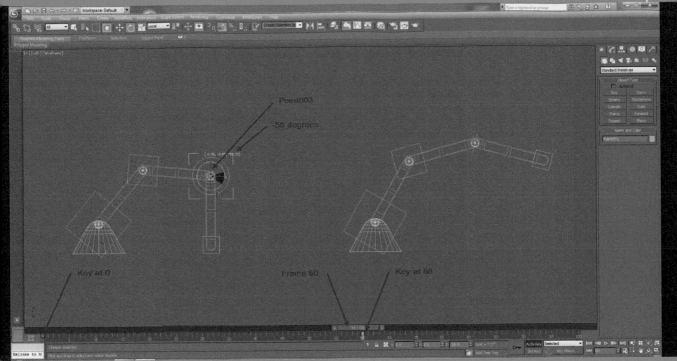

Introduction to IK/FK

Inverse Kinematics (IK) and Forward Kinematics (FK) are both methods of controlling hierarchically linked chains of objects. In this case, you will manipulate the arms of a crane using each of the methods to learn the workflow using kinematics in animation.

Fundamentally, when you have a chain of hierarchically linked objects, the control of those objects either begins at the root object (FK) and passes control up the chain or begins at the end child object (IK) and passes control down the chain. When planning your hierarchical chain, you can determine the root object by asking yourself "If this object moves do I want everything else to move with it?" If the answer is yes, then that object will be your root object.

Pivot points are an essential component of animation and you will review the process of manipulating an object's pivot points and using the Align tool for accuracy and efficiency. You'll also learn how to use Dummy Helper objects and Point Helper objects as aids to animation.

IK, through which control flows from the child object down to the root object, will use the HI Solver (history independent solver) to simplify manipulation of the hierarchically linked chain.

Some of the topics covered in this chapter are as follows:

- *IK/FK*: Learn the differences between IK and FK.
- *Hierarchical linking*: Review hierarchical linking and pivot points.
- *HI Solver*: Use a HI Solver to apply IK to a crane.

30.1 Inverse Kinematics and Forward Kinematics

IK and FK are methods of passing control through hierarchically linked objects for the purposes of animating those objects.

To understand IK, you need to have a working knowledge of FK. If you want to use FK to, say, animate an arm reaching to pick up an object, you'd have to set the keyframes first for the upper arm, then for the forearm, and finally for the hand. Each new position would require you to repeat the steps, resulting in many keyframes that would be difficult to edit.

IK would simplify this task by letting you set keyframes only for the hand and then have the other objects in that hierarchically linked chain move and rotate accordingly, keeping their proper relationships to the hand while remaining connected to the body.

30.2 Hierarchical Linking and Pivot Points

Hierarchical linking is a parent/child control relationship between objects; when the parent moves the child must move with it, but the child can have its own motion. Pivot points are the local centers of rotation indicated by the position of the local axis tripod for any selected objects.

Working together, hierarchical linking and pivot points provide you with the control necessary to easily animate complex systems.

The scene in the next exercise contains a crane base, three arms, three pins, three Dummy objects, and one Point object. Objects have been positioned to form a crane, and your task is to adjust the pivot points of the pins and then link the objects in a hierarchical chain from the Dummy004 at the end to Crane_base001, the root object.

The pins at each rotating joint are created from an Extended Primitive object called ChamferCyl and still have the pivot points in their original position. You should always make sure that pivot points are in logical positions for your hierarchical chain, in this case, the geometric center of each pin.

The Dummy and Point Helper objects will be included in the hierarchical chain to make it easy to grab manipulators for animating the crane. The hierarchy will look like the following:

Crane_base001
Dummy001
Pin001
Arm001
Dummy002
Pin002
Arm002
Point003
Pin003
Arm003
Dummy004

You always start hierarchical linking from the object furthest from the root object, the "child-most" object: you link it to its parent, then select that parent and link it to its parent, etc. Using the Select by Name feature in 3ds Max can be useful in hierarchical linking.

Let's adjust the pin's pivot points and then link the objects in the hierarchical chain. Take a deep breath and think about the linking process based on the hierarchical list above, then proceed with the process. It will seem a bit confusing at first, but if you make a mistake you can select all the objects and click the Unlink Selection button in the main toolbar and start again.

Exercise 30-2-1 Create a Hierarchical Chain

1. Open the 3ds Max file from the website called Exercise 30-2-1_IKFK01.max and save it to an appropriate folder on your hard drive with a new incremental name. The objects are all in proper alignment, but the pin's pivot points all need to be at the geometric center of the pin to make sense in this crane structure. Right-click on the Left viewport and then use the keyboard shortcut Alt+W to maximize the viewport. Use the keyboard shortcut H to open the Select From Scene dialog and then double-click Pin001 (Figure 30-1).

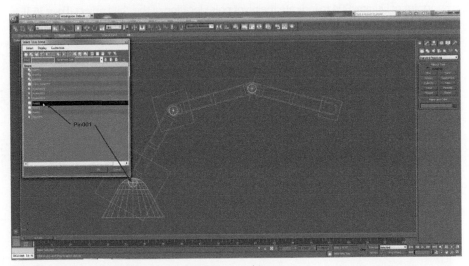

FIG 30-1 Adjust the pin's pivot points to be in the geometric center of the pin.

2. In the Hierarchy panel, Adjust Pivot rollout, click the Affect Pivot Only button. In the Alignment area, click the Center to Object button to ensure that the pivot point is in the geometric center of the object (Figure 30-2). Click the Affect Pivot Only button to toggle it off. Repeat this process for the other two pins. You won't see any apparent change in the object's pivot point because it is already centered as seen from the Left viewport. However, the pivot point will move toward you to align itself in the screen's z-axis (you might want to verify that by restoring all 4 viewports—Alt+W again—and checking the pivot point's position in the Front viewport).

FIG 30-2 Pivot points are accessed in the Hierarchy panel.

3. In the Left viewport, select Dummy004 at the end of the crane. In the main toolbar, click the Select and Link button at the far left. Click and drag from the edge of the dummy to somewhere on Arm003 and then release the left mouse button when you see the cursor change to complete the link. A rubber band will connect the cursor and the pivot point of Dummy004 to indicate the pivot point location of the child object (**Figure 30-3**).

FIG 30-3 Link Dummy004 (child) to Arm003 (parent).

4. While you are still in Select and Link mode, you can click and drag from Arm003 to Pin003 (zoom in if necessary). Click on Pin003 to select it and then press the keyboard shortcut H to open the Select Parent dialog. Highlight Point003 in the list and then click the Link button (**Figure 30-4**). 3ds Max knows that you are in Select and Link mode and presents a list of objects that are eligible link objects; notice how Arm003 is not present in the Select parent list, since it is already Pin003's child and, therefore, cannot be its parent at the same time. This makes it easier to link to the correct object in a crowded scene.

5. Refer to the indented list in the introduction of Section 30.2 and continue linking the objects in order. You will need to revert back from Select and Link mode to Select Object mode if you want to select objects using the Select from Scene dialog (keyboard shortcut H) before linking them. When you have finished linking, click the Select Object button in the main toolbar and then press the keyboard shortcut H to open the Select From Scene dialog. Click the + to the left of Crane_base001 to expand its child and then continue expanding the entire hierarchy. It should read the same as the list (Figure 30-5).

6. Close all windows and dialogs, use Alt+W to minimize the viewport and then save the file. It should already be called Exercise 30-2-1_IKFK02.max. Hierarchical linking involves a bit of planning and forethought to determine which parent object controls which child object. In the case of a linking mistake, however, you can select an object or objects and then you can use the Unlink Selection button to break the link and start again.

This hierarchy contains Dummy and Point helper objects. They perform exactly the same function to provide extra pivot points and control objects in hierarchical linking. The Dummy object has no editing parameters and will never render. The Point object has parameters that allow different configuration and size changes. The Point object will also never render.

Keep in mind that the Dummy and Point helper objects are used to manipulate the arms by rotating the pins at the joints. In the next exercise, you'll clone the crane and then apply FK to the original Crane.

Exercise 30-2-2 Forward Kinematics

1. Open the 3ds Max file from the previous exercise called Exercise 30-2-1_IKFK02 .max and save it to an appropriate folder on your hard drive with a new incremental name. Zoom out in the Left viewport and pan so that the crane is on the left side of the viewport, then select all the objects that make up the crane. Click the Select and Move button in the main toolbar, hold the Shift key, and then clone the selected objects as Instance to the right (Figure 30-6). Click OK to complete the clone process. Let's animate the crane on the left using FK.

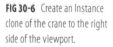
FIG 30-6 Create an Instance clone of the crane to the right side of the viewport.

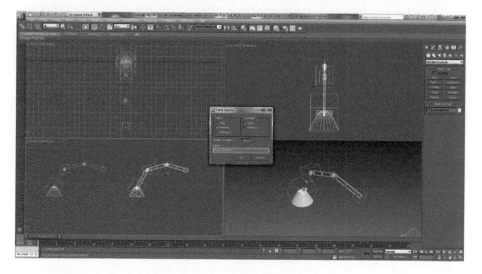

Note

Instance cloning will allow you to have changes made to the geometry of one crane to affect both cranes. However, Instance clone replicates only modifications and so any animations you perform on one crane will not affect the other.

2. Use the keyboard shortcut Alt+W to maximize the Left viewport, pick anywhere in the viewport to clear the selection set, and then click Zoom Extents All Selected to fill the viewport with both cranes. In the main toolbar, click the Select and Rotate button and then set the Reference Coordinate System to Local. Select Dummy001 near the base of the crane. In the main toolbar, toggle the Angle Snap Toggle on

to enable rotations at 5° increments. Click the Auto Key button to toggle it on and then drag the time slider to frame **20**. Rotate Dummy001 in its Local z-axis **-10°** (clockwise) (**Figure 30-7**). This rotates the dummy and all the children, which includes the pin and the entire arm structure.

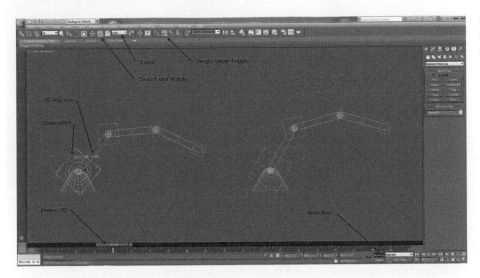

FIG 30-7 Dummy001 is the parent of the entire arm structure.

3. Move the time slider to frame **40** and then rotate Dummy002 **-10°** in its Local z-axis. This dummy controls all the arm elements "forward," but does not affect anything behind it in the hierarchy (**Figure 30-8**).

FIG 30-8 Forward Kinematics affects objects forward of the selected object in the hierarchy.

4. Move the time slider to frame 60 and then rotate the Point003 helper object **-55°** in its Local z-axis to rotate the end arm into a vertical position (**Figure 30-9**). Each time you have created an animation key, 3ds Max has automatically placed a starting rotation key at frame 0. This means that all objects begin rotating at frame 0. Toggle the Auto Key button off and then scrub the time slider slowly back and forth to see the animation.

FIG 30-9 Each object begins rotating at frame 0.

Note

If you had wanted Dummy002 to start rotating at frame 20 (when Dummy001 is finished), you could have selected Dummy002, moved the time slider to frame 20, and then right-clicked on the time slider to record the current rotation at frame 20. This key would determine the starting point for Dummy002's rotation.

5. Save the file. It should already be called Exercise 29-2-1_IKFK03.max. FK can be useful for simple animations where each object must be at a specific rotation angle, but FK is often extremely time-consuming when it generates many keys that can be difficult to edit later.

Let's animate the second crane with IK and learn the difference between the two.

30.3 The HI Solver

IK needs a "solver" to manage animation of the hierarchy. For the type of animation required by the crane in your scene, the best choice is HI Solver (history independent solver). History independent means that the solver only needs to calculate back to a previous key to determine its animation and not all the way back to frame 0, which can be mathematically intensive in long animations.

Once your hierarchy is established, you create the HI Solver between the elements in the hierarchy you want to control. A hierarchy can have multiple HI Solvers. Let's assign a couple of HI Solvers to the second crane.

Exercise 30-3-1 Assign a HI Solver

1. Open the 3ds Max file from the previous exercise called Exercise 30-2-1_IKFK03 .max and save it to an appropriate folder on your hard drive with a new incremental name. In the Left viewport, select Dummy005 (large dummy near base) and in the Animation pull-down menu, IK Solvers menu, choose HI Solver (Figure 30-10).

FIG 30-10 The HI solver will begin at the large dummy near the base and end at the small dummy near the tip.

2. Move the cursor to Dummy007 at the end of the arm and you will see a rubber band connected to the cursor. Click on Dummy007 to place an HI Solver between the first dummy and the second. Lines show you the connections of the HI Solver, and if you look closely, you will see a crosshair that is selected called the End Effector, which is the control object for this HI Solver (**Figure 30-11**).

FIG 30-11 The HI solver displays the IK connection with white lines and places an End Effector at the end of the IK chain.

3. Select Dummy006 and then create a new HI Solver from it to Dummy007. This creates a new End Effector called IK Chain002 (**Figure 30-12**). This new HI Solver controls only the outer two arms of the crane.
4. Save the file. It should already be called Exercise 30-2-1_IKFK04.max. The HI Solver recognizes the hierarchy of the objects and connects them with an End Effector, which will function as the control object when you animate the crane.

In the next exercise, you will animate the crane using the End Effectors.

FIG 30-12 Add another HI solver to control the outer two arms.

Exercise 30-3-2 Inverse Kinematics

1. Open the 3ds Max file from the previous exercise called Exercise 30-2-1_IKFK04. max and save it to an appropriate folder on your hard drive with a new incremental name. Use the keyboard shortcut H to open the Select From Scene dialog and then double-click IK Chain001 to select it. In the main toolbar, toggle the Select and Move button on and make sure you are in Local reference coordinate system. Right-click on the time slider and then in the Create Key dialog (**Figure 30-13**). Click the OK button to record the current position at frame 0.

FIG 30-13 Begin by creating a key to record the position of IK Chain001 at frame 0.

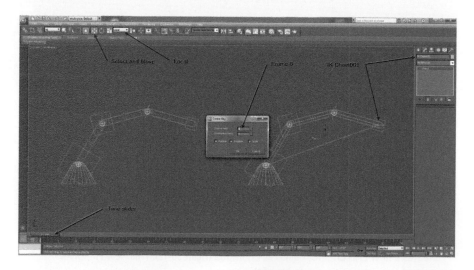

2. Drag the time slider to frame 25, right-click on the time slider, and create a new key at frame 25. Click OK. This ensures that the animation of IK Chain001 will not begin until frame 25. Move to frame 50. Toggle the Auto Key button on and then move IK Chain001 to the left until the lower arm is approximately vertical (**Figure 30-14**). IK Chain001 controls the entire arm, but is restricted in its movement by IK Chain002.

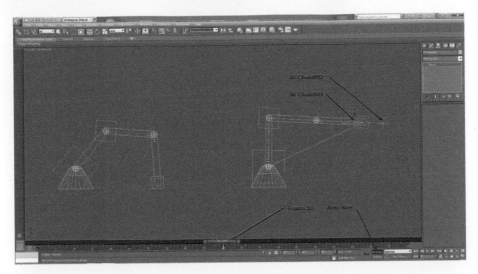

FIG 30-14 IK Chain001 is restricted by IK Chain002.

3. Select IK Chain002 and then move it to the left of IK Chain001. This manipulates only the outer two arms of the crane. Move the time slider to frame 65. Use the Ctrl key to select both IK Chain001 and IK Chain002 and then move both End Effectors below the base until the lower arm is horizontal (Figure 30-15).

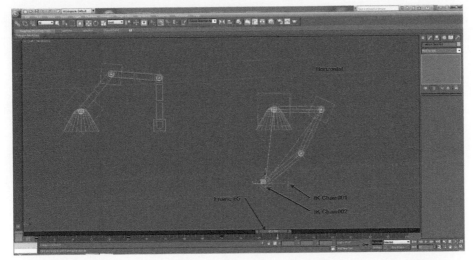

FIG 30-15 Moving both IK Chains simultaneously provides maximum flexibility.

4. Toggle the Auto Key button off and then scrub the time slider to see the animations, or click the Play Animation button to play it back over time. Stop the animation if it is playing and then save the file. It should already be called Exercise 30-2-1_IKFK05 .max. Experiment with creating more animation in the scene. Use both FK and IK on the respective cranes.

Whether you use FK or IK will depend on your situation, as either method is valid if it accomplishes your goal. FK usually requires more steps and so it is better suited to simple repetitive animations, while IK can provide more flexibility and range of motion while animating fewer objects in complex hierarchical systems.

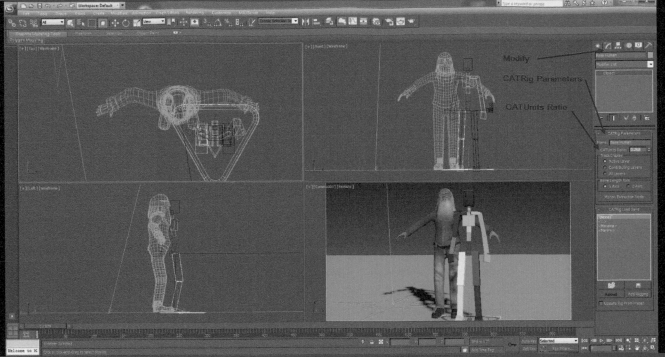

Introduction to CAT

Character Animation Tools (CAT) is a system of bone skeletons used to animate characters in 3ds Max. The bones are hierarchically linked using a technique called Forward Kinematics (FK)-driven Inverse Kinematics (IK) that allows you to position your character initially using FK and then using IK to animate the character.

The process begins by creating a CAT skeleton; both two-legged and multilegged skeletons are available, such as humans and spiders, for example. In this chapter, you will use a human type skeleton to animate a simple character.

The CAT skeleton must be aligned with the character using FK to position the bones within the character. You'll learn to make minor adjustments for a better fitting skeleton.

Once the skeleton is sufficiently aligned with the character's mesh, you will learn to add a Skin modifier that connects the vertices of the character to individual bones. The default method of attaching vertices to the bones is with envelopes that surround each bone. Mesh vertices that are inside the envelope are affected by any movement or rotation of the bone with either absolute or weighted influence.

Finally, you will use a built-in CAT walk cycle to move the character, make adjustments to the envelopes to fine tune the influence of bones to surrounding vertices, and work on some of the aspects of animation applied to the bones of the skeleton.

Some of the topics covered in this chapter are as follows:

- *Create a CAT Parent*: Learn to create an animation skeleton.
- *Align CAT to character*: Manipulate skeleton bones to match a character.
- *Skin character*: Attach the skeleton bones to the character skin.
- *CATMotion Editor*: Learn to edit the motion of bones for a more convincing walk cycle.

31.1 Character Animation Tools

FK and IK are both used to create character animations, and 3ds Max has CAT that provides preconfigured hierarchically linked skeletons.

The first step is to create a skeleton, and in this chapter, you will use a skeleton called Base Human, which has bones similar to the human anatomy. The character mesh's pivot point has been positioned at the World Coordinate System origin 0, 0, 0, which can be a good position to start the initial alignment process.

CAT Parent skeletons can be found in the Create panel, Helpers category, under CAT Objects. Let's begin by creating a skeleton for the character mesh in a scene with a ground plane and a Daylight System.

Exercise 31-1-1 Create a CAT Parent

1. Open the 3ds Max file from the website called Exercise 31-1-1_Character01.max and save it to an appropriate folder on your hard drive with a new incremental name. An odd character standing with arms outstretched is positioned at 0, 0, 0. In the Create panel, Helpers category, click the Standard drop-down list and then choose CAT Objects (see **Figure 31-1**).

FIG 31-1 A character awaits its skeleton.

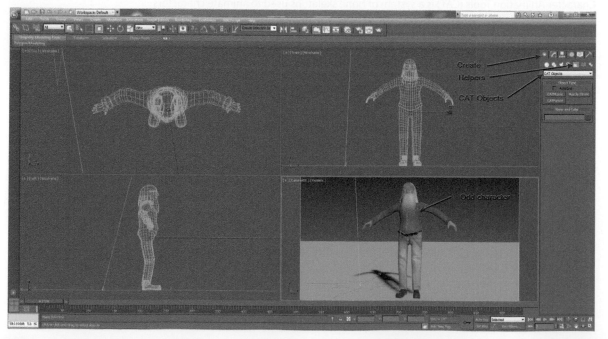

2. In the Object Type rollout, click the CATParent button. In the CATRig Load Save rollout, highlight Base Human. Right-click on the Top viewport to activate it, and then click and drag the cursor to one side of the character mesh. As you drag the cursor, watch the skeleton grow in the Front viewport until the skeleton's collarbones are about where the character's collarbones should be. Release the left mouse button (see **Figure 31-2**).

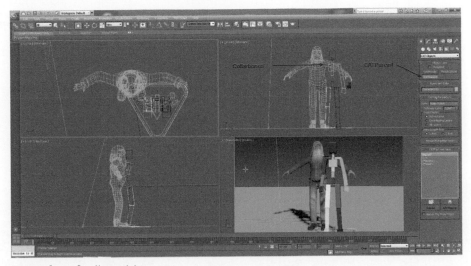

FIG 31-2 Create a Base Human skeleton.

3. In the Modify panel, CATRig Parameters rollout, CATUnits Ratio, enter **0.268** in the numeric field to make the skeleton a bit shorter; as you can see and learn how the overall scale of the skeleton can be adjusted after it has been created (see **Figure 31-3**).

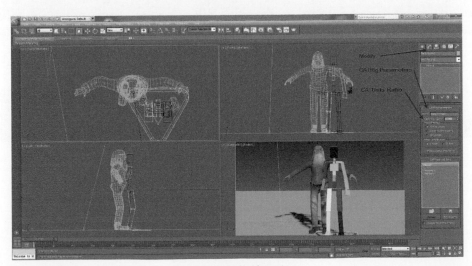

FIG 31-3 The overall scale of the skeleton can be adjusted in the Modify panel.

4. Save the file. It should already be called Exercise 31-1-1_Character02.max. Creating a CAT skeleton is a simple click and drag process. The CATParent object is the triangular base over which the bones are created.

Let's align the CAT skeleton to the character's mesh, which has its pivot point positioned at 0, 0, 0.

Exercise 31-1-2 Align CAT to Character

1. Open the 3ds Max file from the previous exercise called Exercise 31-1-1_Character02 .max and save it to an appropriate folder on your hard drive with a new incremental name. In the Top viewport, select CATParent. In the main toolbar, toggle Select and Move on. In the Status bar at the bottom of the display, right-click on the spinners for the X:, Y:, and Z: numeric fields (see **Figure 31-4**). Right-clicking a spinner will set it to zero or its lowest possible value.

FIG 31-4 Align the pivot point of the CATParent to the World reference coordinate system origin (0, 0, 0).

2. Select the character mesh called TedB_body001, right-click, and then choose Freeze Selection in the Quad menu. The mesh will turn gray in the viewports to indicate that it is frozen and cannot be selected or edited. Select the CATParent. In Motion panel, Setup Mode, use Select and Move and Select and Rotate, each in Local reference coordinate system, then move and rotate the individual bones of the skeleton so that they fit inside the mesh (see **Figure 31-5**). Work in all viewports as necessary.

FIG 31-5 Using the Local reference coordinate system, align all individual bones to the inside of the frozen mesh.

Note

Aligning a skeleton to a mesh can seem a bit difficult at first, but becomes much easier with a little practice. It is not necessary that the bones be in exactly the right anatomical position, but the closer you come, the easier it will be throughout the production pipeline. For this exercise, an approximate fit is fine.

3. Right-click on the active viewport and then choose Unfreeze All from the Quad menu to unfreeze the character mesh. Save the file. It should already be called Exercise 31-1-1_Character 03.max. Aligning the bones to the skeleton is a simple, but potentially time-consuming process.

 The next step is to attach the character mesh to the bones in preparation for animation. In Exercise 31-1-3, you will apply the Skin modifier.

Exercise 31-1-3 Skin the Character

1. Open the 3ds Max file from the previous exercise called Exercise 31-1-1_Character03 .max and save it to an appropriate folder on your hard drive with a new incremental name. In the Top viewport, select the character mesh (TedB_body001). In the Modify panel, Modifier List, choose Skin. In the Modify panel, Parameters rollout, click the Add button to the right of Bones. In the Select Bones dialog, highlight Base HumanPelvis and then click the Select button (see **Figure 31-6**). This adds all the bones in the hierarchy below the Pelvis (all bones) to the list.

FIG 31-6 Add all the bones to the Skin modifier.

FIG 31-7 Add an animation layer to the CATParent skeleton.

2. In the Top viewport, select the Base Human triangle. In the Motion panel, Layer Manager rollout, click and hold on the Abs button and then choose the last flyout. This adds a CATMotion layer that contains animation information (see **Figure 31-7**).

3. In the Layer Manager rollout, click the red Setup/Animation Mode Toggle button to toggle to Animation mode. Scrub the time slider and you will see that the character has an unusual walk cycle, and there are areas of distortion in the mesh around the waist (see Figure 31-8).

FIG 31-8 In animation mode, the bones distort the character mesh.

4. Return the time slider to frame 0 and toggle the Setup/Animation Mode toggle back to setup mode. In the Front viewport, select the character mesh. In the Modify panel, Parameters rollout, click the Edit Envelopes button. In the Name list, highlight Base HumanPelvis. You will see the two envelopes, inner and outer, and vertices colored to indicate the weight of the influence of the Pelvis bone. Red vertices move absolutely with the bone, orange vertices somewhat less, yellow vertices even less, and blue vertices not at all (see Figure 31-9). This works similarly to the Soft Selection you used in to make hills in the landscape in Chapter 17.

FIG 31-9 Enable Edit Envelopes to see the influence of the bone on surrounding vertices.

5. In the main toolbar, click the Select and Move button and make sure the current reference coordinate system is set to View. In the Front viewport, move the control points (small gray squares) at the top of the inner envelope upward to the characters beltline and then move the top control points of the outer envelope about midway up the waist (see **Figure 31-10**). Click the Edit Envelopes button to toggle it off. The influence of the Pelvis bone covers a larger area to affect more vertices.

FIG 31-10 Increase the size of the inner and outer envelopes to give the Pelvis bone influence over more vertices.

6. In the Top viewport, select the CATParent triangle and, in the Motion panel, click the Setup/Animation Mode Toggle button to toggle to animation mode. Scrub the time slider to see that the distortion has been minimized at the characters beltline (see **Figure 31-11**). Toggle the Setup/Animation Mode Toggle button back to setup mode and return the time slider to frame 0. There is more distortion in the mesh, but you see the fundamentals of how the Skin modifier works and you can go back later to fine tune the envelopes.

FIG 31-11 You can toggle back to animation mode to check the envelope edits.

7. Save the file. It should already be called Exercise 31-1-1_Character03.max. Adjusting Skin modifier envelopes to distribute the effect of each bone convincingly throughout the character mesh also becomes much easier with practice.

The default animation causes the character to roll and twist considerably while going through the walk cycle. In Exercise 31-1-4, you will learn to use the CATMotion Editor to reduce the rolling and twisting of the Pelvis, the rib cage, and the head.

Exercise 31-1-4 CATMotion Editor

1. Open the 3ds Max file from the previous exercise called Exercise 31-1-1_Character03 .max and save it to an appropriate folder on your hard drive with a new incremental name. In the Top viewport, select the CATParent triangle. In the Motion panel, Layout Manager rollout, click the CATMotion Editor button (green animal paw print). In the left column, expand PelvisGroup and then expand Pelvis. Highlight Twist. Right-click on the spinner's for the Scale numeric field to set it to 0, which will flatten the Twist curve (remove all twist) (see Figure 31-12). After scaling down to zero, the Scale value in the numeric field resets back to 100.0.

FIG 31-12 Remove all twist motion of the Pelvis bone.

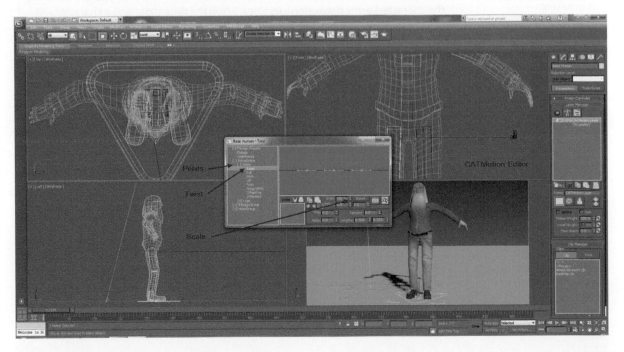

2. Highlight Roll in the left column and then right-click on the Scale spinner to set its value to 0. This removes any rolling motion of the Pelvis (see Figure 31-13).

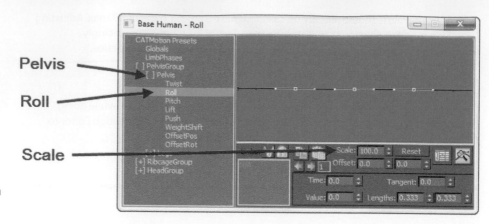

FIG 31-13 Remove all roll from the Pelvis bone.

3. Expand the RibcageGroup and then expand Ribcage. Set the Scale values of Twist and Roll to 0. Expand HeadGroup and then expand Head. Set the Scale values of Twist and Roll to 0. In the Layer Manager rollout, toggle the Setup/Animation Mode Toggle to animation mode. Scrub the time slider to see that the character walks more normally. Close the Base Human-Roll dialog. In the main toolbar, click the Select and Rotate toggle button and then make sure you are in Local reference coordinate system. Position the time slider at frame 0. In the Front viewport, rotate the upper arm bones (Base HumanRUpperarm and Base HumanLUpperarm) to bring the characters arms down along its sides. Scrub the time slider and a character will walk even more normally (see **Figure 31-14**).

FIG 31-14 Remove twist and roll from the torso and head bones and then use FK to move the arms along the characters sides.

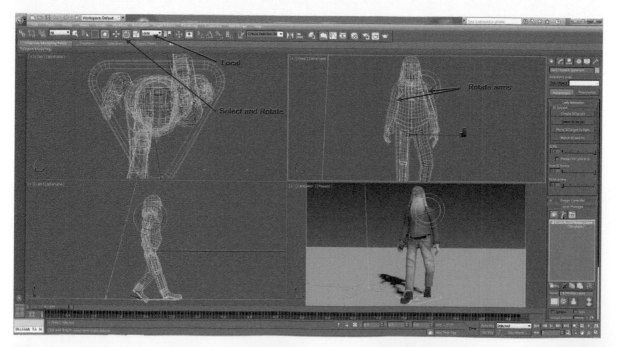

4. Save the file. It should already be called Exercise 31-1-1_Character04.max. There is still lots of work that can be done to make the character walk more convincingly, but these are the fundamental steps that you need to know to begin the character animation process in 3ds Max.

Animated characters are an absolute necessity in some 3ds Max scenes that are character oriented, but having characters move convincingly in architectural or engineering animations can also add interest and impact to the viewer. Character Animation Tools provides many preset options that make the job of animating characters easier.

Dynamics

Animating the collision and interaction of objects in 3ds Max using keyframe methods can be a frustrating process, usually with poor results. Because of the randomness of objects as they interact with gravity and each other, many keys would need to be created and then adjusted many times to achieve convincing results.

Included in 3ds Max, MassFX is a simulation software used to automatically apply gravity to selected objects and then calculate their interactions as they collide with each other. The objects can be rigid body objects, hard surfaces that do not distort upon collision, or cloth surfaces that drape and fold as they interact with gravity, air friction, and other objects in the scene.

In this chapter, you'll learn to simulate a barrel rolling down a ramp in the interior of the windmill and then colliding with another stack of barrels. You will determine the weight and friction parameters of the barrels to control the behavior during collision.

There is also a flag suspended from the ceiling, simply a flat plain that looks like a solid surface. You will use the cloth component of MassFX to allow the flag to drape naturally as if suspended from the beams and reacting to gravity.

Rigid body objects can be dynamic, kinematic, or static, while cloth objects can be either dynamic or kinematic. Dynamic objects are subject to gravity and interact with other objects in the scene. Kinematic objects can affect other objects, but are not affected by other objects. Static objects are rigid body objects that cannot be animated as part of the MassFX simulation, though they can collide with dynamic objects.

Some of the topics covered in this chapter are as follows:

- *Introduction to Dynamics*: Learn about dynamics in 3ds Max.
- *MassFX rigid body*: Set up a rigid body dynamics simulation.
- *MassFX cloth*: Simulate cloth with MassFX.

32.1 Introduction to MassFX

MassFX is the software module included in 3ds Max, which makes it possible to create simulations of colliding bodies and cloth animations. Such random animations add a level of believability to your scenes that would be extremely difficult to keyframe manually.

MassFX includes two fundamental types of objects: rigid body and cloth. Rigid body objects are hard surfaces that interact with gravity to create convincing collisions and interactions with other MassFX objects in the scene. Cloth objects simulate the flexibility of draping cloth or similar materials such as rubber.

You need to begin by adding rigid body or cloth objects to a class of behavior. Rigid body objects can be dynamic, kinematic, or static, and cloth objects can be either dynamic or kinematic.

Dynamic objects affect and are affected by other dynamic or kinematic objects in the scene. Kinematic objects affect other objects, but are not affected by those objects. Remember that static objects cannot themselves be animated, but interact with dynamic objects.

Once you have assigned the objects to a specific class of behavior, you can then adjust parameters such as weight, friction, or bounciness, for example. The properties you assign determine how the objects react with each other when the simulation is calculated.

Gravity is automatically applied with realistic strength as soon as you preview the simulation. If the preview is not to your satisfaction, you can then readjust parameters and run the preview again until you achieve the desired results. You can then tell MassFX to calculate the final result and apply the necessary keyframes to your animation.

32.2 MassFX Simulations

As mentioned earlier in this chapter, MassFX calculations can be either rigid body collisions or cloth simulations.

In Exercise 32-2-1, you will open a scene of the interior of your windmill. In the room is a barrel sitting on a ramp and a stack of barrels sitting on the floor. Your task will be to use MassFX to cause the barrel to roll down the ramp and collide with the stack of barrels, sending them tumbling.

You'll begin by assigning the initial behavior type to objects in the scene. The timbers and walls and floor will be Static objects. They will not be animated, but must interact with the barrels as they fall. The barrels, on the other hand, will be Dynamic objects because you want them to react to impacts with other barrels.

On the first try, using the default settings, the result will be rather uninteresting. You will then adjust barrel parameters to add weight to the barrel rolling down the ramp and reduce the weight and friction of barrels in the stack to simulate empty barrels.

In the second exercise, you'll make the flag hanging from the ceiling of the windmill interior scene more convincing. The flag will also be a Dynamic object. However, if you use the default settings, the flag will simply fall from the ceiling and interact with the barrels and floor. You want the flag to appear to be hanging naturally from the timbers, so you will have to "fix" some of the vertices of the flag in space and then allow it to drape as if connected to the ceiling beams.

Let's have some fun.

Exercise 32-2-1 MassFX Rigid Body

1. Open the 3ds Max file from the website called Exercise 32-2-1_Dynamics01.max and save it to an appropriate folder on your hard drive with a new incremental name. This scene is the interior of the windmill. Right-click on the empty space to the right of the main toolbar buttons and then choose MassFX toolbar from the menu. This opens a floating MassFX toolbar in the interface (**Figure 32-1**).

FIG 32-1 Open the MassFX toolbar.

2. In the main toolbar, Named Selection Sets drop-down list, choose timbers to select all the timbers in the walls and ceiling. Hold the Ctrl key and click on the walls to add Windmill_interior001 and the Ramp001 objects to the selection set. These objects will all become Static MassFX objects (see **Figure 32-2**). The walls, floor, and ceiling are all one enclosed object with thickness.

FIG 32-2 The walls, floor, ceiling, and ramp will remain static in the MassFX simulation.

3. In the MassFX toolbar, click and hold on the Set Selected as Static Rigid Body button (second from left) and make sure you are using the Static Rigid Body option (see **Figure 32-3**). Static objects are not affected by gravity and cannot be animated. You will see new visible edges appear on the selected objects in the viewports. This is a shell created by MassFX that determines the actual collision detection surface.

FIG 32-3 Objects are assigned an initial behavior in the MassFX toolbar.

4. Select the Windmill_interior001 object in the Camera001 viewport. In the Modify panel (a MassFX Rigid Body modifier was applied), Physical Shapes rollout, you'll see Element 1 and Element 2 in the Modify Shapes list; because the walls, floor, and ceiling have thickness, they contain two elements, interior and exterior. In the Physical Shapes rollout, you can see that the Shape Type is Convex by default. This is fine for the timbers and the ramp because they are all convex surfaces. In the Shape Type drop-down list, choose Original (see Figure 32-4). This will take more time for the MassFX engine to calculate, but corresponds to the actual shape of the surface. Highlight Element 2 in the list and then set its Shape Type to Original.

FIG 32-4 Set the interior and exterior elements of the walls, floors, and ceiling to use Original geometry to determine collisions.

5. In the main toolbar, Named Selection Sets drop-down list, choose barrels. In the MassFX toolbar, click and hold on the Set Selected as Static Rigid Body button and then choose Set Selected as Dynamic Rigid Body. This assigns the default Dynamic body parameters to all the barrels based on their size. Hold the Alt key and, in the Camera001 viewport, pick the barrel at the front left of the viewport (Barrel007) to deselect it. In the Modify panel, Physical Material rollout, enter **10** in the Mass numeric field. Enter **0.1** in the Dynamic Friction numeric field (see Figure 32-5). These adjustments make the stacked barrels much lighter and more "slippery."

6. In the Camera001 viewport, select only Barrel007 on the ramp and then set its mass to **500** and its Dynamic Friction to **0.3**. This makes the barrel much heavier as if it were full of something.

FIG 32-5 Change the stacked barrels properties to make them lighter and slipperier.

7. In the MassFX toolbar, click the Start Simulation button. Gravity should cause the barrel to roll down the ramp, into the stack of barrels tumbling them around the room (see **Figure 32-6**). The collisions have been calculated in the action previewed, but no keyframes have been written yet. If you need to make adjustments, you can click the Reset Simulation Entities to their Original State button in the MassFX toolbar, change some parameters, and then preview the simulation again. Let's create the animation keys.

FIG 32-6 You can preview the simulation and then make adjustments and press Start Simulation again.

8. In the MassFX toolbar, click and hold on the World Parameters button and then choose the Simulation Tools flyout. In the MassFX Tools dialog, Simulation rollout, click the Bake All button (see **Figure 32-7**). This creates animation keys at each frame for each dynamics object. If you need to adjust the parameters again, you can use the Unbake All button.

FIG 32-7 You can bake or unbake keys on the timeline to convert the simulation to animation.

> **Note**
>
> This simulation runs longer than the 100 frames set by default in 3ds Max. You can increase the number of frames by clicking the Time Configuration button and adjusting the End Time numeric value to see more frames.

9. Save the file. It should already be called Exercise 32-2-1_Dynamics02.max. Think about the time you might have spent animating this random collision of multiple barrels and be thankful for MassFX. There are many more parameters that can be adjusted to fine tune your results, but beginning with the fundamentals is important before starting to experiment.

Rigid body collisions do not deform the objects themselves. In Exercise 32-2-2, you will turn the flag at the ceiling into a cloth object, which deforms and drapes according to weight and gravity.

Exercise 32-2-2 MassFX Cloth

1. Open the 3ds Max file from the previous exercise called Exercise 32-2-1_Dynamics02.max and save it to an appropriate folder on your hard drive with a new incremental name. In the Camera001 viewport, select the flag hanging from the ceiling. In the MassFX toolbar, click the Set Selected as mCloth Object button (T-shirt) to apply the mCloth modifier to the flag. Let's pin the corner vertices of the flag in place.

2. In the Modify panel, stack view, expand the mCloth modifier and highlight Vertex subobject mode. In the Front viewport, drag a selection window around one corner of the flag's vertices, hold the Ctrl key, and then drag a selection set around a few vertices at the other corner. In the Group rollout, click the Make Group button. In the Make Group dialog, enter the name flag corners in the Group Name field (see **Figure 32-8**). Click the OK button.

FIG 32-8 Make a group of selected vertices to "pin" in space.

3. In the Group rollout, click the Pin button. The vertices are no longer affected by gravity. In the Modify panel, stack view, click on mCloth at the top of the stack to exit subobject mode. In the MassFX toolbar, click the Start Simulation button and you will see the flag drop and distort as if it were made of fabric. In the Modify panel, mCloth Simulation rollout, click the Bake button to place animation keys at each frame on the timeline, recording the distortion of the flag. Click the Play Animation button at the bottom right of the display to see the barrels tumble and the flag wave (see **Figure 32-9**).

FIG 32-9 Pin the Group of selected vertices, start the simulation, and then bake the animation.

4. Save the file. It should already be called Exercise 32-2-1_Dynamics02.max. Rigid body and cloth dynamics simulations can add a convincing animation to your scenes. MassFX Tools is a powerful and reliable method of creating complex random animations quickly and easily.

While there is much more to learn about MassFX Tools, this fundamental introduction will put you on the right path for creating impressive random animations that simulate real world physics for many situations. Begin slowly in your experimentation by adjusting only one or two parameters at a time to see what the result will be before moving on and making more adjustments. Learn from your mistakes and build a base of knowledge that you will be able to apply in a production situation with confidence.

Introduction to Scripting

Scripting is the process of writing program modules designed to extend the capabilities of a software package. Many of the software programs you will use in 2D or 3D visualization have a specific programming language built-in to make it relatively easy for users to customize the software.

The original designers of 3ds Max, the Yost Group, wanted a program that could be extended by users to eliminate repetitive tasks specific to their needs and to write routines that add functionality that the designers hadn't thought of.

The scripting language included in 3ds Max is called MAXScript and is a natural language programming code that uses many terms and processes familiar to anyone who works with 3ds Max. MAXScript is powerful enough to access most areas of 3ds Max to provide you with the ability to do almost anything the software is capable of. Because MAXScript is a part of 3ds Max, you must be running 3ds Max to access it.

You don't need to be a programming guru to begin using MAXScript. There are sample scripts that ship with 3ds Max and many more are available on the Internet. For those of you interested in writing your own MAXScript routines, you can use the 3ds Max Help pull-down menu to access the information necessary to begin (see Figure 33-1).

FIG 33-1 Use the 3ds Max Help menu to access information about MAXScript.

One aid to learning MAXScript is to use the MacroRecorder. The steps you perform are automatically recorded in the MAXScript language as you work in 3ds Max. Reviewing this can help you learn the language syntax and to cut and paste the generated code into your scripts.

The 3ds Max interface uses the MAXScript Listener window and the MAXScript Editor window to facilitate scripting.

Some of the topics covered in this chapter are as follows:

- *Introduction to MAXScript*: Learn to access MAXScript programming language and run the MacroRecorder.
- *Open a MAXScript*: Open and view a MAXScript.
- *Run a MAXScript*: Run a MAXScript to extend the capability of 3ds Max.

33.1 MAXScript

MAXScript is the language built into 3ds Max for creating custom tools and processes to increase your productivity. It can be used to extend the capability of existing commands in 3ds Max or to create completely new tools that the base program does not include.

You will be introduced to the MAXScript Listener, which is an interactive interpreter for the MAXScript language. You can enter MAXScript commands in the Listener window as a tool for developing small scripting fragments or learning the language syntax.

In this section, you will enable the MAXScript MacroRecorder that automatically records any steps you perform in 3ds Max. The code generated by MacroRecorder can then be cut and pasted into your own MAXScript routines or simply be used as a guide for learning MAXScript.

Let's try opening a script in the MAXScript Listener to see what it looks like.

33.2 Open a MAXScript

A good way to learn about scripting is to open existing scripts and analyze the flow and syntax of the MAXScript language. You can use the MAXScript Listener or the MAXScript Editor to view the scripts.

In Exercise 33-2-1, you'll open a script that ships with 3ds Max for the purpose of creating Microsoft's Flight Studio objects. The script is moderately complex, but is a good example of the layout of a script and the language used within the script. Much of the terminology will be somewhat familiar in 3ds Max terms.

Exercise 33-2-1 MAXScript Listener

1. Open 3ds Max with a new empty scene. In the MAXScript pull-down menu, choose MAXScript Listener (see Figure 33-2). This is one of the several locations from which you can access MAXScript Listener.

FIG 33-2 You can use the MAXScript pull-down menu to open MAXScript Listener.

2. The MAXScript Listener is divided horizontally into two panes, the pink top pane where you can enter MAXScript commands and the white bottom pane where the results of those commands are reported. If you cannot see the pink pane, just hover your mouse on the top edge of the white pane until you see arrows indicating that you can click and drag down to reveal the pink pane. In the MAXScript Listener dialog, click the File button and then choose Open Script. In the Open File dialog, navigate to the folder C:\Program Files\Autodesk\3ds Max 2013\scripts\FlightStudio. Double-click the file called flightstudio_tools.ms. The script opens in the MAXScript Editor window (see Figure 33-3).

FIG 33-3 Open a script to view the syntax in the MAXScript Editor window.

Note

3ds Max can be used to create objects that are then exported to Microsoft's Flight Studio program.

3. Scroll down through the Editor window and you will see that the MAXScript language is based on logical terms for the most part. You could edit the existing script in the MAXScript Editor or use it to write your own new code. Close the MAXScript Editor dialog. In the MAXScript Listener pull-down menu, choose MacroRecorder and then choose the Enable option (see **Figure 33-4**).

FIG 33-4 Enable the MacroRecorder in the MAXScript Listener window.

4. In the Create panel, Geometry category, Object Type rollout, click the Box button and then create a small box in the Perspective viewport. You can see the MAXScript commands being generated as you create the box (see **Figure 33-5**). There is also a MAXScript Mini Listener at the lower left of the 3ds Max interface.

FIG 33-5 MacroRecorder records the MAXScript commands as you work in 3ds Max.

5. Close the MAXScript Listener window and delete the box you create. There is no need to save the file, and so you can exit 3ds Max or continue on to the next exercise.

33.3 Run a Script

Opening a MAXScript in 3ds Max allows you to view and edit, but does not execute the script itself. To perform the 3ds Max functions written into the MAXScript, you need to first run the script to load it into 3ds Max's memory and to load up any interface options designed into the MAXScript.

When you run a MAXScript, there are several ways the script can be accessed. Sometimes it appears in the Utilities panel and sometimes it can have an interface or dialogue of its own.

In Exercise 33-3-1, you will run a script by Alessandro Ardolino that allows you to place and edit stones in a stone wall or a stone floor.

Exercise 33-3-1 MAXScript Mini Listener

1. Open a new 3ds Max empty scene. Right-click in the MAXScript Mini Listener window and then choose Open Listener Window in the menu. This is just another method of accessing MAXScript tools.
2. In the MAXScript Listener dialog, click the File button and then choose Run Script in the menu. Navigate to the folder on the website called \Chapter 33_Introduction to scripting\Max_files\aa_stoneplacementtools and, in the Choose Editor File dialog, double-click on the file called aa_stonePlacementTools_1x0.mse (see **Figure 33-6**).

FIG 33-6 You can run a MAXScript by double-clicking on it in the Choose File Editor dialog.

3. The aa_stonePlacementTools 1.0 dialog will appear in your viewports. In the stone wall area, click the Create Grid button, then you will see a multicolored stack of stone placeholders appear in the viewport (see **Figure 33-7**).

FIG 33-7 The first step is to create placeholders for stones in a stone wall.

4. In the stone wall area, click the Create Stones button. A red progress bar will advance from left to right, indicating that the MAXScript is generating stones, and then when it is finished, a rough stone wall appears in your viewport (see **Figure 33-8**).

FIG 33-8 Convert the placeholder boxes to stones.

5. Experiment with creating stones using the other options in the creation dialog and then exit 3ds Max. You do not need to save the file.

MAXScript is a powerful extension for increasing your productivity. Simple scripting can be accomplished quite easily, and with some experience and practice, you could learn to write much more complex production tools.

Intermediate Rendering

You learned to render images in 3ds Max in Chapter 14, and now you will learn some rendering options important for production.

Some of the topics covered in this chapter are as follows:

- *Alpha channel*: Learn to render files with "alpha channel," levels of transparency useful in 3ds Max maps or images.
- *Render elements*: Learn to separate specific elements, such as specular highlights or reflections, as you render the finished image.

34.1 Alpha Channel

Understanding alpha channels in images requires a little knowledge of computer rendering history. When computer rendering was developed in the 1980s, computers were significantly less powerful than they are today. Slow computer processors and graphics cards coupled with limited memory of both the rendering computers (render farm) and the client's computer (used for viewing the finished images) restricted the quality that could be cost-effectively processed.

A common file type for viewing on computers was called the gif file type, which was limited to a maximum of 256 total possible colors. This meant that images with gradations in lighting and shading tended to show severe banding because there weren't enough colors for smooth gradations. These were called 8-bit depth images (2 to the power of 8 = 256).

As computers became more powerful, the software and hardware engineers developed 16-bit depth images that provided much smoother gradations in the rendered images, with a total of about 65,000 colors available (2 to the power of 16 = 65,536). Many of these images were rendered as bmp file types.

Even more power led to the development of 24-bit depth images such as the jpg file type, which can display over 16 million colors (2 to the power of 24 = 16,777,216) for gradations that are smooth to the human eye (see Figure 34-1).

FIG 34-1 The 8-bit depth image on the left shows severe banding.

You might be asking yourself what does this have to do with alpha channels? Although 16 million colors are plenty for smooth gradations, computer images were beginning to be layered, or composited, on top of each other to make production more efficient and enhance the quality of the finished images. This compositing process often required that parts of the image be removed to allow layers lower in the stack to show through in the final image. This required tedious handwork to cut out the unwanted parts of an image. This led to the development of 32-bit depth file types (png, exr, tif, for example), which contain just over 16 million colors, the same as 24-bit depth images. The extra 8-bits of data (256 levels) stored in the new files is reserved for transparency information, known as the alpha channel. This allows for composited layers.

When you saved your rendering to a file in Chapter 14, you chose the png file type because it offers relatively high compression without any loss in quality. The result is smaller file sizes while maintaining better quality than some other formats, in other words efficiency.

Another common file type used for 3ds Max renderings is the jpg file type. This file is also compressed, but uses a compression method that combines information in areas of similar color, which can result in degraded quality. Jpg files cannot have alpha channel transparency, making it somewhat less useful as an all-around map type in 3ds Max.

Let's create a 32-bit depth image and use it to create a decal material in 3ds Max, where the transparency information is used as a mask.

The 3ds Max scene in Exercise 34-1-1 contains 2D text that has been converted to a surface and has a white material applied that is not affected by scene lighting, so it remains consistently white over the entire surface. There is also a box in the scene with a UVW Map modifier applied with the default projection.

A material has been assigned to the box with diffuse color created by a Composite map. The Composite map contains two solid color maps and a slot for a mask. You will render the mask as a png file with alpha channel. Black pixels in the rendered mask will be transparent, white pixels will be opaque, and gray pixels will be somewhere in between, depending on their "whiteness." The mask will reveal one or the other base color.

Exercise 34-1-1 Decal Materials

1. Open the 3ds Max file from the website called Exercise 34-1-1 and save it to an appropriate folder on your hard drive with a new incremental name. Right-click on the Top viewport to activate it and then on the Views pull-down menu, and choose Restore Active Top View (Save Active Top View was used previously) to fill the viewport with the text. Use the Shift+F keyboard shortcut to enable Show Safe Frames to see exactly what will be rendered at the current output resolution (see Figure 34-2).

FIG 34-2 You can easily render your own alpha channel images in 3ds Max.

2. In the main toolbar, click the Render Setup button. In the Parameters rollout, Render Output area, click the Files button. In the Render Output File dialog, navigate to an appropriate folder on your hard drive. In the File Name text field, enter Text_test. In the Save as Type drop-down list, choose PNG Image File (*.png). Click the Setup button and then choose RGB 24-bit radio button and check Alpha channel in the PNG Configuration dialog (see Figure 34-3). Click OK, click the Save button, and then click the Render button.

FIG 34-3 Render a 24-bit depth png file with alpha channel to use as a mask.

3. In the rendered Frame Window, click the Display Alpha Channel button and then use the mouse wheel to zoom in on the rendered image. Opaque areas are pure white, transparent areas are pure black, and you can see the gray "antialiasing" pixels at the edge of the letters used by the computer display to smooth the edges (see **Figure 34-4**). Close the Rendered Frame Window. In the Render Setup dialog, Common Parameters rollout, Render Output area, clear the Save File checkbox so that you don't accidentally overwrite the file you just rendered. Close the Render Setup dialog.

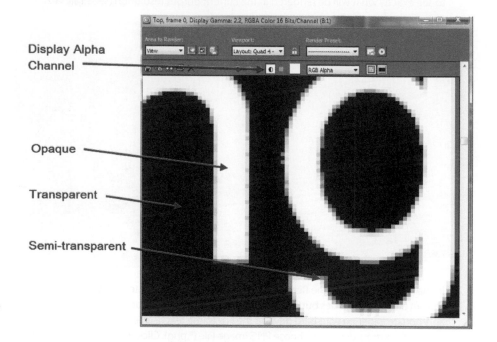

Display Alpha Channel

Opaque

Transparent

Semi-transparent

FIG 34-4 You can view the alpha channel information in the Rendered Frame Window.

4. In the main toolbar, click on the Material Editor button to open Slate material editor. The material applied to the box in the scene contains a blue layer, a green layer, and a map node containing a bitmap similar to the one you just rendered. Double-click on the bitmap node heading to open it in the Edit pane. In the Bitmap Parameters rollout, Mono Channel Output area, choose the Alpha radio button and make sure the Image Alpha radio button is chosen in the Alpha Source area (see **Figure 34-5**). This ensures that the alpha channel will be used and not the diffuse color of the image.

5. In the Slate material editor, View1 pane, click and drag from the output node of the bitmap to the input node Layer 2 (Mask). In the Camera001 viewport, you will see that the mask is revealing the blue map color through the green background color based on the alpha channel information in the image (see **Figure 34-6**). The bitmap is being projected by the UVW Map modifier over the entire box. Let's make some adjustments to create a decal.

6. Right-click on the Camera001 viewport. Select the box in the scene. In the Modify panel, Parameters rollout, Mapping area, enter **2'0"** in the Length numeric field and enter **3'0"** in the Width numeric field. The text becomes smaller, but is repeated over and over because of Tile option in the map (see **Figure 34-7**).

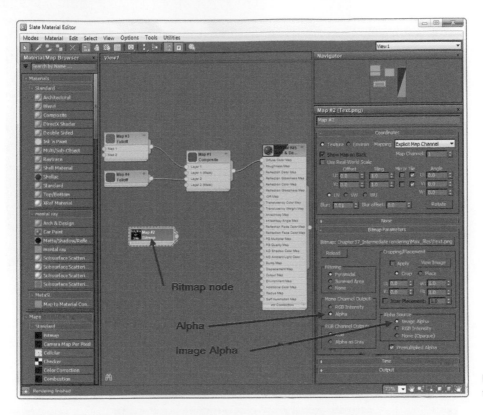

FIG 34-5 The alpha channel of the bitmap is used as the mask.

FIG 34-6 The alpha channel transparency reveals the blue layer through the green layer.

7. In the Slate material editor, Edit pane, Coordinates rollout, clear the checkbox for the Tile options. Render the Camera001 viewport and you will see that the alpha channel information now creates a single mask decal (see Figure 34-8). The material is very flexible because the base colors can be changed and a new map can be substituted at any time.

FIG 34-7 The Tile option in a map repeats the pattern horizontally and vertically.

Note

The position and the size of the decal can now be adjusted with the Offset and Tiling numeric fields in the Coordinates rollout.

FIG 34-8 The alpha channel mask is applied as a decal to the surface.

8. Close all windows and dialogs and then save the file. It should already be called Exercise 34-1-1_Decal Alpha map02.max. This exercise is one example of creating a decal map and using alpha channel. However, decal maps may also be applied for placing images and logos on a racecar, for example, and the Composite map can be made up of many layers and masks for a high degree of flexibility.

The alpha channel information stored in 32-bit depth images is also useful for Cutout maps in the Arch & Design material to create the illusion of transparency or as Bump maps to create the illusion of raised surfaces. The quality of the alpha channel, especially at the edges of opaque and transparent areas, is better than when using similar grayscale images.

34.2 Render Elements

Alpha channel information is the only one element that can be extracted or used from rendered images in 3ds Max. Many "elements" of a 3ds Max scene can be rendered separately as independent files to be reused for other purposes. For example, you can render a Z Depth element of a scene, which assigns a whiteness value that is brighter for objects closer to the camera (see Figure 34-9). This image can then be used in compositing software to create the illusion of distance blurring or fogging in your scene.

In Exercise 34-2-1, you will learn to set up render elements for reflections and specular highlights. These elements could then be layered into Autodesk's Composite compositing software, Adobe's After Effects, or Adobe's Photoshop to enhance the original image.

FIG 34-9 Z depth render elements can be used in compositing software for special effects.

Exercise 34-2-1 Render Elements

1. Open the 3ds Max scene from the website called Exercise 34-2-1_Render elements01.max and save it to an appropriate folder on your hard drive with a new incremental name. The scene contains several Standard Primitive objects with simple materials of varying glossiness and reflectivity.

2. In the main toolbar, click the Render Setup button. You will need to save the rendered image, so click the Render Elements tab in the Render Setup dialog. In the Render Elements rollout, click the Add button. In the Render Elements list, scroll down and highlight Reflection and then hold the control key and highlight Specular (see Figure 34-10). Click OK to add them to the list.

FIG 34-10 Add the render elements you want to extract in the Render Elements tab.

3. In the Selected Element Parameters area, click the ellipsis button (...) and navigate to an appropriate folder on your hard drive. You can accept the default names that are automatically given to the render elements (see Figure 34-11). Click the Save button to save the files. Make sure the Camera001 viewport is active.

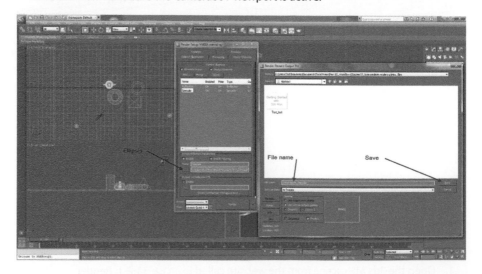

FIG 34-11 Save the render elements files to an appropriate folder.

4. In the Render Setup dialog, click the Render button. The scene will render normally but you are not saving the rendered image to your hard drive. Soon after the scene finishes rendering, two other render windows will appear; one contains

only the reflection information and the other contains only the specular highlight information. These images would be used during the compositing steps, enhancing or decreasing the effect of each layer as needed to create the best possible final image (Figure 34-12). Both files have also been saved to your hard disk for later use.

FIG 34-12 Separate render windows with reflections and specular highlights appear after the image is rendered.

5. Close all windows and dialogs and save the file. It should already be called Exercise 34-2-1_Render elements02.max. Awareness of render elements will be a factor in your productivity in the real world workflow. The render elements are simply isolated data from your normally rendered image saved as a separate file for post-processing.

The intermediate rendering topics of alpha channel and render elements will help provide you with increased flexibility and power in your workflow in a production environment.

Index

Boldface page numbers refer figures.

A

Absolute mode 65–7
Absolute/Offset toggle button **66**, 66–7
Affect Pivot Only button 71, 72, 281, 282, 451
alignment rules 161
align objects 268–71, **268–71**
Align Selection dialog 269, 282
Align tool 268, 270, 271
alpha channel 491–2, **493**, 494–7
Alpha radio button 494
Ambient Occlusion: Arch & Design material 431, **432**; intersection of surfaces 433; render elements pass **434**; shadow-like effect 431
Angle Snap settings 283, **284**
Angle Snap Toggle button 284
animating modifiers 386, 393–6
animation 250, 385; character, talking head 194; controllers 343, 348–50, 421; dories 412–16; interface components 386, **387**; keys 388, **391**, **391**; mode **467**; playback 9, **9**; playback buttons 388, **388**; user interface 386–8
Application button 6, **6**, **14**, **27**, 308, **309**
applying modifiers 134–8
Arch & Design material 195, 199, **205**, 355; in Slate Material Editor 202, 356; for water **361**
array tool: 3D linear array 312, **312**; 2D radial array 312, **313**; walkway railings 313–15, **314**, **315**
assign controller rollout 414
assign materials 207–9
assign position controller 412
Atmospheric Apparatus Helper 440, **440**
atmospheric effects 435; clouds 440–3; fog 436–40, **437**, **440**
Atmospheric Helpers 435, 436
attach/detach 124–7
Attach Mult button 126, **126**
AutoGrid 277, **277**, **279**
Auto Key 386, **387**, **390**
axis tripod *see* transform axis tripod

B

backlight in three-point lighting 191, **193**
backup files, management **29**, 30–3
barrel parameters, stacked **478**
base human skeleton **463**
bend center 136
bend modifier **137**
Bevel editing tools 298, 301
Bevel operation 331, **331**
Blend material 372, 377–8, **378**, **380**; horizontal stripe 378–80
Boolean operation 336; operand parameter for **336**; types of 334
border subobject 398, 399
bounced light: energy bouncing from surfaces **424**; final gathering 429–31, **430**; global illumination **427**; rendering **426**
bounding box corners 73, 78
boxes, create 74, **75**
BoxGizmo button 441, **441**
box primitive 36, **37**, **39**
bridge settings, caddy 400, **400**
bridge tool 398
Bump map 362, 363

C

caddy operation 327, **328**
CAD software 105
camera: concepts 222; Dolly 10; parameters **226**, 226–8, **227**; principles 232–9; target and free 222–6
Camera shots: close-up 238, **238**; high-angle 239, **239**; long/establishing 236–7, **237**; medium 237, **237**
Camera viewport 222, 346, 347, 350; controls 228–32; Dolly Camera button 230, **230**; FOV setting 231, **231**; navigation button **228**; Orbit Camera button 230, **230**; Perspective button 231, **231**; Roll Camera button 232, **232**; Truck Camera button 228–89, **289**
Camera001 viewport 477, 480
Camera viewport navigation buttons **20**
canal, creating 337–9
candelas (cd) 182
CATMotion Editor 469–71
CATParent skeleton **466**
CATRig Parameters rollout 463
ChamferCyl 450
character animations, talking head 194
Character Animation Tools (CAT): align to character 464–5; create parent 462–4
character mesh 464, 465, **467**
checkboxes 13, 18
Checker map 206, 208; diffuse color provided by 207; show shaded material for 209
child object 418, **419**, 421
Circular Selection Region 82, **83**
clone animation keys 395, **395**
cloned cylinders **143**
cloning in objects *see* object cloning
cloning modifiers 142–6
cloth objects 474
clouds effects 440–3
color coding 393
command panel 16, 17; create 8, **9**; modify 18
complementary commands 31
Composite map 492, 496
Compound Objects 149, 154, 333; ProBoolean 334–6; scatter 340–2; ShapeMerge 336–9; tools **154**
compound shapes as 3D object 119–22
cone primitives 278
Configure Columns dialog 89, **89**, 90
Connect button 302
Connect Settings options 326, **327**
connect tool 302
controllers and constraints 412–16
copy clone 94, **98**, 100
Create command panel 8, **9**
Create Key dialog 389, 391, 458
curvature 156, 158
cylinder primitives 156, **262**, 263, 265

Printed and bound by CPI Group (UK) Ltd, Croydon, CR0 4YY

21/10/2024

01777094-0015